DATE DUE

Mr. Collier's Letter Racks

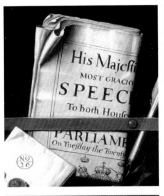 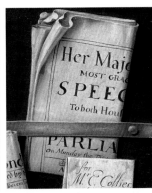 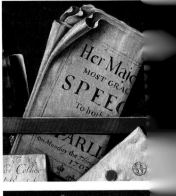

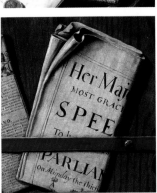 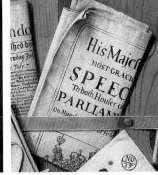 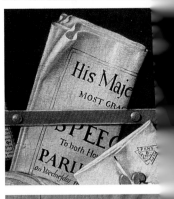

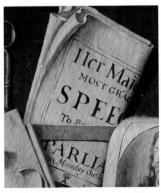 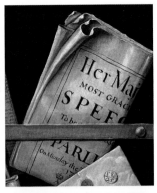 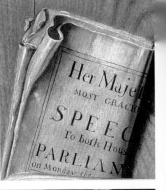

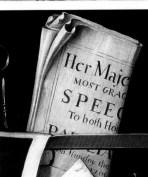 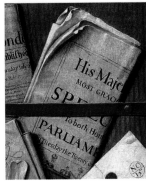 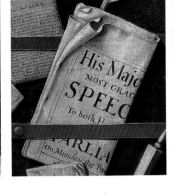

Mr. Collier's Letter Racks

A TALE OF ART & ILLUSION AT THE THRESHOLD OF THE MODERN INFORMATION AGE

Dror Wahrman

OXFORD
UNIVERSITY PRESS

OXFORD
UNIVERSITY PRESS

Oxford University Press, Inc., publishes works that further
Oxford University's objective of excellence
in research, scholarship, and education.

Oxford New York
Auckland Cape Town Dar es Salaam Hong Kong Karachi
Kuala Lumpur Madrid Melbourne Mexico City Nairobi
New Delhi Shanghai Taipei Toronto

With offices in
Argentina Austria Brazil Chile Czech Republic France Greece
Guatemala Hungary Italy Japan Poland Portugal Singapore
South Korea Switzerland Thailand Turkey Ukraine Vietnam

Copyright © 2012 by Oxford University Press, Inc.

Published by Oxford University Press, Inc.
198 Madison Avenue, New York, NY 10016

www.oup.com

Oxford is a registered trademark of Oxford University Press

Library of Congress Cataloging-in-Publication Data
Wahrman, Dror.
Mr. Collier's letter racks : a tale of art and illusion at
the threshold of the modern information age / Dror Wahrman.
p. cm.
Includes bibliographical references (p.) and index.
ISBN 978-0-19-973886-1
1. Collier, Edward, 17th cent.—Criticism and interpretation.
2. Trompe l'oeil painting—Netherlands.
3. Art and society—Netherlands—History—17th century.
4. Newspapers in art. I. Title. II. Title: Mister Collier's letter racks.
ND653.C56W34 2012
759.9492—dc23 2011042929

1 3 5 7 9 8 6 4 2

Printed in China
on acid-free paper

For my father, Jacob Wahrman,
who would have loved this story

Contents

Mr. Collier's Letter Racks

Introduction: Puzzles

I

In the chronologically arranged display of the Indianapolis Museum of Art, hovering indecisively in a corner between the seventeenth and the eighteenth centuries, is an unobtrusive painting titled *Still Life, about 1696* (fig. 0.1). I had lived for eight years just down the road before I happened upon it one spring afternoon shortly before closing time.

The painting is remarkable for its surprisingly modern trompe l'oeil effect. It presents itself not as a piece of art, but rather as an illusion of a three-dimensional yet peculiarly perspective-less object: a letter rack. On the "rack" three leather straps, attached with irregularly placed nails, hold an assortment of objects that are dispersed across the canvas while often lying slightly on top of one another. The top "strap" holds a feathered quill, a pen knife, a pamphlet of a speech by the king, and a newspaper. Behind the middle one is a blank notepad titled "Memorye," a sealed letter with a face on the red seal, and another letter with an address that doubles as the artist's signature: "For Mr. E. Collier/ Painter att/ London." At the center of the bottom strap is a double-sided yellow comb, flanked on both sides by slightly phallic red and black sticks of sealing wax, burnt at one end.

I had never heard of Edward Collier. The museum caption identifies him as a minor Dutch painter who worked in Holland and England in the late seventeenth and early eighteenth centuries. His painting has

Fig. 0.1 (following page): Edward Collier, *Still Life, about 1696*. 19⅛ x 24¼ in. Indianapolis Museum of Art, James E. Roberts Fund.

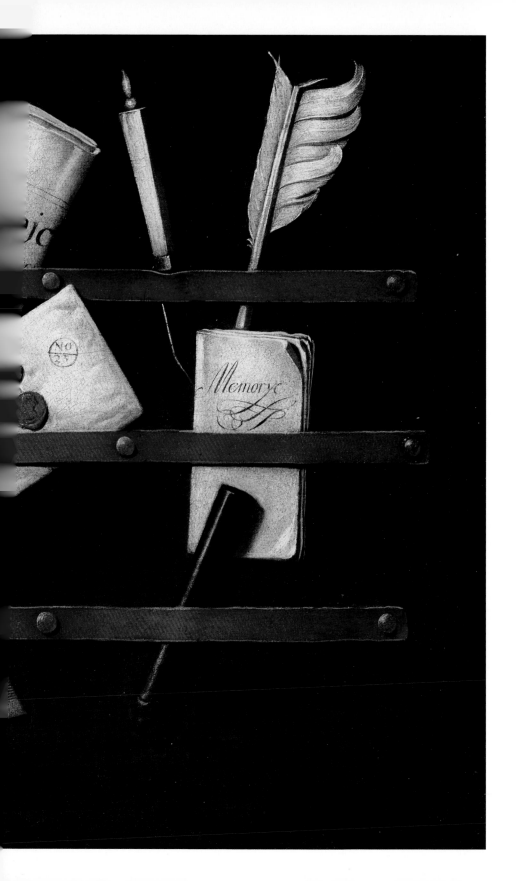

enough disconnected, enigmatic objects and finer details to encourage the beholder to lean forward and peer closely, but such an encounter is likely to end with brief puzzlement. I was about to move on—the museum guards were beginning to shoo us out—when it suddenly occurred to me that there *was* something peculiar about this painting, something that I, as a historian of Britain, was in a position to notice.

The peculiarity was a political one. This canvas was painted, we are told, in 1696. Britain had recently undergone a momentous political upheaval known as the "Glorious Revolution." In a move unprecedented in the annals of the monarchy, the English elite more or less fired their king and hired another. The new king, William III from the famous William-and-Mary duo, was the one whose speech dominated the upper center of Collier's composition. A Dutch prince, formerly known as William of Orange, he had arrived in London in 1688, supposedly by invitation of the most powerful men in England, to replace the previous monarch from the House of Stuart, James II (also the father of William's wife, Mary), whose Catholic tendencies had rendered him increasingly unacceptable in the eyes of the English Protestant elite. James escaped to Europe, either having abdicated or having been driven out, depending on one's political point of view. In the eyes of those who believed that God, not men, appointed monarchs, such a substitution of royal line was illegitimate. William and Mary therefore demanded from all their new subjects an oath of loyalty, which many refused to take. The supporters of the now exiled James II, who wanted to see his restoration, were known as "Jacobites." They were to remain a major thorn in the side of British political stability for the next half century.

The main beneficiary of the Glorious Revolution was in many ways the English Parliament, which had set key terms in the revolutionary arrangement while gaining valuable power at the expense of the monarchy. So here Collier painted a speech delivered to a parliament that many believed had overstepped its authority, by a king—ruling by himself since Mary's death in 1694—whose claims to this title were perhaps a deception or an illusion. And he chose to position this speech prominently in a painting that was itself an illusion, a trompe l'oeil, proclaiming in its very form that things are not what they seem. Was this then a muted dig at the king's assertion of legitimacy? Such a political reading of the painting is perhaps encouraged by the sealed letter right beneath the king's speech. A seal, after all, is a guarantee of veracity and authenticity, the very issues that might have put King William on the defensive. Collier, moreover, called attention to the seal by making it such a striking red circle at the center of

the composition; and the clear face on the seal could serve as a reminder for a royally minted coin bearing the image of a (legitimate) monarch. In short, I thought to myself as I scrambled out the museum doors, have I not just discovered something that always gives historians pleasure, a covert act of political subversiveness?

I returned home with a small mission: to try to confirm the hunch that Edward Collier was a crypto-Jacobite. I did not dwell then on the oddity that a Dutch artist would prefer the cause of a Francophile Catholic English king to that of a Dutch prince, even though Collier himself had followed this prince to London in the wake of the very same Glorious Revolution that I believed him to repudiate. And indeed it did not take long to unearth damning evidence that Collier was apparently guilty as charged. Several examples of his art from the period after 1688 included portraits of Charles I, the Stuart king executed in the English Civil War. These I took to be clear expressions of Stuart sympathies, thus confirming my initial suspicion.

As it turns out, I was completely wrong. But at that point the question of Collier's partisan politics became less pressing. Collier, I learned, had not attracted much attention from art historians and exhibition curators, and those who mention him typically dispense with his art with one or two examples. But once I managed to collect and place side by side a larger number of Collier's paintings I began noticing other peculiar things. Disappearing letters, faux monograms, insinuated messages, impossible title pages, unstable spellings, stray fonts: the list went on and on. I did not understand what I saw, and had no idea what was coming. Collier's oeuvre was like an intricate puzzle, egging me on to uncover clue by minute clue, decipher message after hidden message, and learn to appreciate joke after private joke.

Nothing in these paintings is really what it seems. This is because Collier was an artist who specialized in trompe l'oeil paintings, although this term would not be coined for another century. Such eye-deceiving paintings try to fool the beholder into believing that they are the real thing they represent: a painting trying to pass for a window together with the view through the window, for instance. They are illusionist deceptions. Usually, momentary deceptions: the real pleasure of a trompe l'oeil is at the moment of the realization that this is *not* a window but a canvas on a wall pretending to be one. In Collier's hands, however, illusions and deceptions took on a new and more unusual kind of life. It is not only that Collier pushed the envelope of illusionist potential further than many others, though this he certainly did, carefully lacing his paintings with

layer upon layer of games and puzzles, deceptions upon deceptions upon deceptions, so that the beholder can hardly help being taken for a ride. Deceptions for Collier were not merely an artistic skill, or even primarily a self-reflective comment on the practice of art. Rather they became a critical tool, a means for revealing as well as concealing. Collier was a consummate artistic magician, ever refining his own bag of tricks while constantly standing vigilant lest someone else pull a fast one on him.

But who would want to? It is here that Collier's unusual tendencies intersected with the particular historical moment in which he chose to exercise them. Collier witnessed what can be described as a new information age, one with distinctive characteristics and novel preoccupations. What made Collier's work so rich was the fortuitous coincidence of the skill of the illusionist artist with this new media regime that to his trained eye was brimming with illusionist possibilities. Deciphering and reassembling Collier's message-in-a-painted-bottle, moreover, proved to be an uncanny experience, since the issues that preoccupied him with regard to the media revolution of the turn of the eighteenth century are surprising prefigurations of concerns that accompany our own media revolution of the twenty-first.

II

Take one instance of Collier's games, an intricate and telling multi-layered device within the confines of one five-by-seven-inch painted object in which he revealed his skill in simultaneously both critiquing and committing misrepresentation.

That object is a title page of an almanac. In the letter rack in figure 0.2, it is the red-and-black publication at the top left. Well known to the original viewers of this painting, almanacs, printed annually, were probably the most widespread publications in their world after the Bible. One in every three English families in the second half of the seventeenth century are thought to have bought their own almanac, part calendar and part astrological prognostication, part how-to book and part sermon, part information and part entertainment.

The particular example in this painting is called *Apollo Anglicanus*, or *The English Apollo*. Buzzwords that stand out on the title page—"understanding," "this Year," "tables," "moons"—make it clear that this is, in fact, an almanac. On top of it, focused on the word "assisting," Collier placed an eye-catching

magnifying glass, a visual gesture that seems to extend an invitation, even a challenge, to take a detailed searching look at the title page underneath.

So let us pick up the gauntlet. Examined with a magnifying glass, one anomaly stands out almost immediately: the date on the almanac has been changed (fig. 0.3). What looks at the top of the painted page like 1676 masks a partly whitewashed date beneath, 1696. This painting has been tampered with.

I am not the first person to have noticed this. The website of the Hunterian Art Gallery in Glasgow, where the painting is located, reports on a recent examination by a group of art history students armed with a microscope. The date of the almanac, they concluded, is a pentimento: a term from the Italian word for "repent," which denotes such an apparition, in which layers of paint become sufficiently transparent to unearth an alteration where the artist had experienced a change of mind.

Did Collier really "repent" one date and change it for another? The art-historians-in-training arrived at this conclusion by applying the standard examination procedures of their profession strictly by the book. But what if the artist himself was not playing by the book? Given that other paintings from Collier's easel do not appear to reveal hidden secrets through the wearing down of paint layers, given that Collier was an artist constantly experimenting with ways to trick the unsuspecting eye, and given the coincidence of a taunting magnifying glass that just happens to lie right on top of that element in the painting which appears to display the faint visual signs of a supposed deterioration, this is at the very least a strong possibility.

Consider therefore Collier's possible "models" for this painting: the actual title pages of the *Apollo Anglicanus* for 1676 and 1696 (fig. 0.4). This almanac was a long-standing serial publication, launched in 1654 by one Richard Saunders, the inspiration for the "Richard" in Benjamin Franklin's *Poor Richard's Almanack*. When Saunders died in 1675, the almanac continued to be compiled and published annually under his name, itself a perhaps innocuous deception of the unsuspecting reader and a common practice in a competitive yet conservative market with several established brands. But from 1693 onward the name on the almanac's title page suddenly dropped an *s* and became "Richard Saunder."

This alteration seems like a typographical error that befell the almanac's printers one year and was perpetuated thereafter. Yet the almanac

Fig. 0.2 (following page): Edward Collier, *Trompe l'Oeil Letter Rack*, c. 1696. 48.9 x 61.6 cm. © Hunterian Museum and Art Gallery, University of Glasgow.

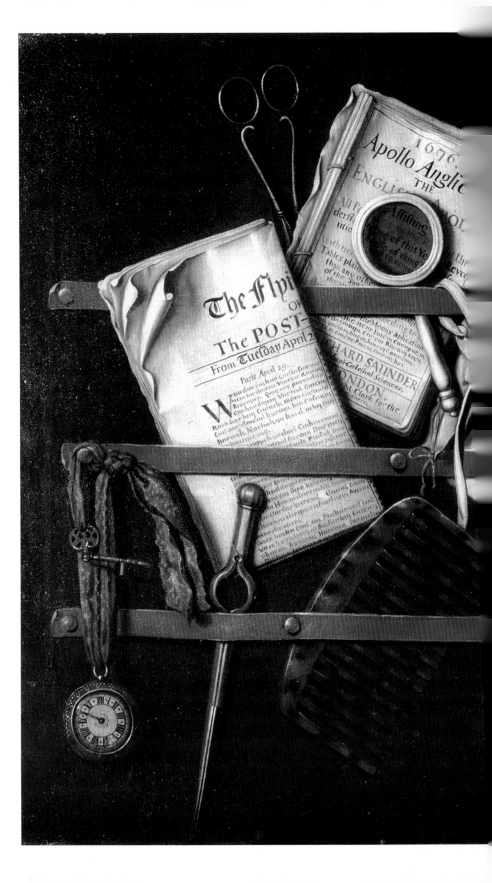

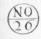

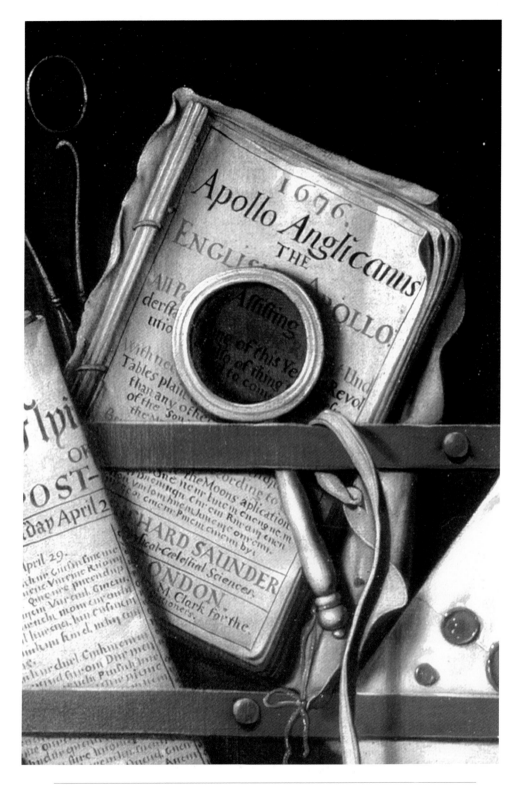

Fig. 0.3: *Trompe l'Oeil Letter Rack*, c. 1696 (fig. 0.2, detail).

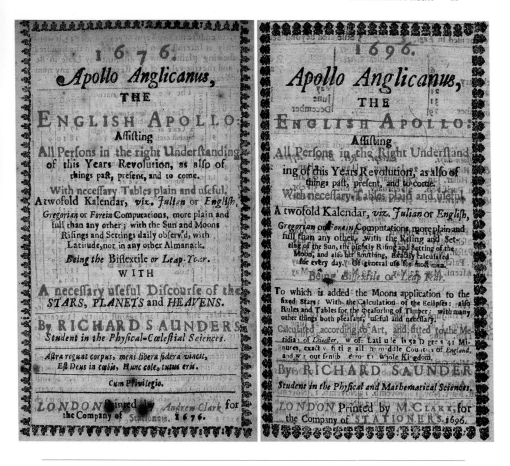

Fig. 0.4: *Apollo Anglicanus*, title pages for 1676 and 1696. Reproduced by permission of The Huntington Library, San Marino, California.

experts insist that in fact there *was* a Richard Saunder from Leicestershire, a different man from the earlier Richard Saunders of Warwickshire, who took over the latter's *Apollo Anglicanus* in 1684 and carried it deep into the eighteenth century. One may nevertheless wonder why Saunder waited nine more years before putting his own name on the title page of his almanac, why his paper trail appears to commence only around the time that he took over the almanac in the early 1680s, and whether assuming that he adopted this rare name together with the almanac is not more plausible than positing a coincidence that defies the mathematics of probability.[1] Be that as it may, here is an easy way to tell a 1676 from a 1696 edition of the *Apollo Anglicanus*. Since Collier's painting clearly has the author as "RICHARD SAUNDER," not Saunders, the artist was modeling his image after the latter-day almanac. This in any case makes

perfect sense, since Collier only arrived in London in 1693, the year in which this change had first occurred.

A further variation between the title pages of the 1676 and the 1696 almanacs was much more significant than the dropping of a letter in a name. It had to do with the credentials of the (alleged) author. The 1696 almanac—the book, not the painting—described Saunder on its title page as a "Student in the Physical and Mathematical Sciences." But the line underneath his name in the painting clearly reads ". . . sical-Cœlestial Sciences." These are the words that had described Saunders in the 1676 issue: "Student in the Physical-Cœlestial Sciences."

This difference was huge. The earlier form of the author's credentials proclaimed the almanac to be an astrological publication. Saunders was indeed an astrologer and chiromancer, best known for the prediction that if people organized their sexual relations around the scientific—read astrological—observations of the stars, the stock of the human race would surely improve rather than degenerate. The later formulation, by contrast, declared the almanac and its author to be part of the new wave of modern science. This change in the *Apollo Anglicanus* was deliberate, carefully executed, and pathbreaking. In late 1685 King James II, for complex political and religious reasons, proclaimed a ban on astrological predictions in almanacs. Most almanac publishers adapted simply by dropping their astrological information. But under the leadership of Saunder, by training a mathematician and surveyor, the *Apollo Anglicanus* took a more radical intellectual stance. It responded to the royal ban by reversing itself to become the first English *anti-astrological* almanac.[2] Its pages from 1686 onward turned to mocking astrology as a matter of course. Given the market-driven effort of almanac publishers to maintain continuity of format and appearance, however, this radical change was not immediately apparent. And yet by 1689, within three years, the reversal was registered on the title page in the change to the author's credentials. From a "Student in the Physical-Cœlestial Sciences" to the "Student in the Physical and Mathematical Sciences": here was the whole scientific revolution folded into a barely perceptible alteration in one line on a title page.

There seems to be only one logical way to make sense of these confusing observations about the painting in front of us. Collier's painted *Apollo Anglicanus* had to be a carefully planned composite of the title pages of *both* editions of the almanac, twenty years apart. It included the author's name, Saunder without an *s*, which only appeared on the almanacs from 1693 on, and it retained the author's astrological credentials as they had only appeared until 1688. These were two elements that *never* coexisted

on one printed page. In order to paint this image, therefore, Collier must have held in his hand two editions of the almanac and been quite aware of the often subtle differences between them.[3]

Collier actually painted different editions of the *Apollo Anglicanus* in many letter rack paintings. In these other paintings he did not play much with the details of the title page, with one exception: a letter rack painted the previous year, in 1695, with an almanac from 1694 (fig. 0.5). By 1694 the actual publication was already printed with the name "Saunder." At first glance it seems that Collier sidestepped this matter, if he was aware of it at all, by hiding the end of the name with a conveniently placed book strap. But a closer look reveals a small, unmistakable red *s* lurking behind it. Not only was Collier already aware of the change in the author's name, he drew attention to it by painting in a correction, a correction calling attention to itself with its small size and furtive reticence. And then, a year later, he returned to the matter with a vengeance.

III

What does this intricate game mean? Collier's attention to these details is extraordinary, even more so considering that he had only just arrived in England two or three years earlier. So is his manner of drawing attention

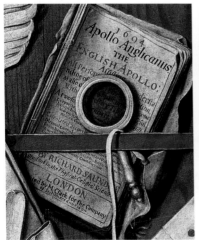

Fig. 0.5: Edward Collier, *Trompe l'Oeil Letter Rack*, 1695, detail. 61 x 48 cm; 24 x 19 in. Courtesy of Sotheby's, London.

to them: blending together two editions of a serial publication that looked almost alike. Real changes had indeed taken place, but they were masked by a faux continuity of appearance, of form. This is what all these variations had in common: the continued publication of the almanac under the name of a long-dead author; the instability of the alleged author's name (dead or alive); the changes in the author's self-description, which encapsulated a reversal of the almanac's position in the world of knowledge. Perhaps Collier also recognized the increasing incongruity between the astrology-driven title of *Apollo Anglicanus* and its anti-astrological stance. In all of these, continuity of form concealed real shifts in production and content. In retrospect such revelations can be dismissed as inescapable and familiar features of mass market society, but in the late seventeenth century every component of this understanding was itself a novelty: mass circulation, serial publications, informational books with a very limited life span, the possibility of form trumping content. These were all new departures that changed the value of print and information. Under these conditions, Collier seems to warn, every aspect of print could prove untrustworthy: if there was a trompe l'oeil here, it was the almanac printers' and compilers', not (only) his.

Yet Collier too played games, introducing into the title page errors of his own. The word "aplication" with a single *p* may have been an innocent mistake. Another error is more elusive and wittier. The word "understanding" on both sides of the magnifying glass is broken with a hyphen, as was not uncommon in title pages of the period. But it also adds an extra letter that should not be there, "und/derstanding," which because of the eye's tendency for continuous reading is quite hard to notice. Is the second *d* likely to have been a mistake, or an eye-fooling game-and-a-wink? And was it a coincidence that this subtle slip, in the middle of a detail-conscious trompe l'oeil painting, happened to occur in the word "understanding"?

Speaking of eye-fooling games and winks, we can now return to the pentimento at the top of the *Apollo Anglicanus*, the "1696" that is painted over in white to become "1676," and take stock of what we already know. Collier laid down the design for the title page of the almanac with extraordinary care and attention to detail. He had, without doubt, both 1676 and 1696 in mind simultaneously, or in any case an earlier and a later edition of this publication. He was purposefully drawing attention to both. And he was able and eager to use visual-and-textual games and riddles, often with considerable subtlety, to make his point. Can the whitewashing of one date for another, therefore, be anything else but a

deliberate superimposition of 1676 and 1696 together in order to signal to the beholder both dates at the same time? (This scenario also explains where the specific year 1676 came from: if Collier was looking back from 1696, this was the easiest alteration to make with semi-transparent white paint.) This device, then, holds the key to the whole construction and is an integral part of Collier's message. *Every aspect of a title page that a reader takes for granted—the author's identity, the author's credentials, the date, the very words on the page—may be corrupted: proceed with extreme caution.* If *pentimento* derives from *repent*, this was anything but a pentimento: Collier was not repenting but admonishing.

At the same time, the painting-over of one date with another is not only a comment on the world of print, it is also a trompe l'oeil, a deception in the visual medium. It is a trompe l'oeil of an error and a correction, an effort to deceive the eye about an effort to deceive the eye. It thus elicits suspicions with regard to the work of the brush on top of those it associates with the work of the printing press. In fact, to make sure viewers didn't miss the point, Collier painted into this canvas a second faux pentimento. It appears in King William's speech directly to the right of the almanac, above the royal arms at the bottom of the pamphlet. A close look at the two crowns reveals the faint letters of the royal monogram, "W" and "R," that are again veiled with semi-transparent white paint as if they too were a mistake: a faux correction consistent with transposing the painting to the year 1676. One can imagine the crescendo of Collier's finger-wagging admonition: *Stay alert! Painters can play games equally as well as printers do. You are on your guard because you know you are observing a trompe l'oeil. You are on your guard because I charged you to be so with my magnifying glass. And still, no matter how closely you look, you will never be certain that what you see is what you get.*

IV

Collier's intricate game here was more than a shrewd comment on the potential for illusionist deception in both print and art. Like the early photographs that attempted to capture movement by exposing one frame to a moving object (say, a galloping horse) several times over, thus creating an impossible spectral image of a simultaneous sequence of different moments, Collier's faux pentimento is twice-exposed to create a spectral snapshot of the passage of time.

The impossible *Apollo Anglicanus* is only one example of Collier's work, extracted from one corner of a single canvas. Within Collier's broader oeuvre, this particular game is part of an abiding preoccupation with the passage of time, set in the context of a specific historical juncture. This context is embodied in the printed and serial form of the almanac. Whatever it is on the almanac's title page that one wants to take for fixed, constant, and trustworthy—as readers expect of publishers—in fact proves to be volatile, unreliable, and in constant motion, masking change through the continuity of form. These concerns with fixity versus volatility, stability versus change, and form versus content are among the most important and surprising aspects of Collier's art: and I believe that they derived from his understanding of the transformations in the printed form during his lifetime. Just as multi-exposure photography evolved as an eye-fooling device to freeze movement through time, so too did Collier's trompe l'oeil letter racks, but in this case in order to capture historical change. What prompted Collier's innovation was his ambition to use his paintings to freeze-frame a revolution. A revolution, moreover, that was itself all about motion. A media revolution.

Print 2.0 c. 1700: A New Media Regime

I

In 1712 Daniel Defoe, the veteran English author, newspaperman, and pamphleteer, made a rather odd statement:

> I might have had one Word here by Way of Reflection upon the happy Times we are just now coming to; Times I remember very well to have seen before, when Printing being not in use, I mean as to News-Papers, State-Tracts, Politicks, &c., Written Scandal shall revive, and the Nation shall swarm with Lampoon, Pasquinade, written Reflections, Characters, Satyrs, and an inconceivable Flood of written News-Letters.[1]

The context was the new tax on newspapers that began on the first of August that year. Defoe feared that the newspaper tax would bring the circulation of printed political information to a halt, thus forcing public debate to rely again on an "inconceivable Flood" of handwritten materials. What was odd was less Defoe's misplaced lack of confidence in the staying power of print, which may in any case have been an exaggeration for rhetorical purposes, than his harking back to former times he remembered so well, "when Printing being not in use." But Defoe was born some two centuries after Gutenberg: surely by the turn of the eighteenth century print was old news?

Well, not if Defoe says it wasn't. Few contemporaries grasped these matters better than Defoe, who himself had made a versatile career off the

printing press. Defoe is thus helpful in establishing a perhaps surprising historical point that is essential for understanding what Collier was doing: print *was* new in the late seventeenth and early eighteenth centuries. Or more precisely, Defoe's and Collier's generation experienced what they themselves took to be a new era in the uses of print. I call this new media regime "Print 2.0" because of suggestive parallels with our own Web 2.0. Like Web 2.0, the late-seventeenth-century media revolution also involved the circulation of much more information much faster and farther than ever before, posing problems and challenges that are surprisingly analogous to today's.

The key to the qualitative difference of Print 2.0 was ephemerality. The era of durable books did not end but was suddenly overshadowed by an explosion of cheap mass print together with the proliferation of news-papers. During the English Civil War in the 1640s, the number of titles published in England more than doubled in comparison to previous decades. After dipping again when the monarchy was restored in the 1660s, it peaked once more in the 1680s and 1690s—to well over twenty thousand titles per decade—and never went down again. The bulk of these thousands upon thousands of new printed publications consisted not of new literary works or philosophical tomes but rather of tracts and pamphlets: cheap publications, typically unbound, hastily produced, dealing with events of the moment, and often responding to one another. In 1642 an early example—a small tract explaining the decision of an Anglican clergyman to deny the sacrament to a man who had insisted on receiving it standing up, in response to the man's own publication defend-ing his refusal to kneel—diagnosed the phenomenon well: "Pamphlets, like wild geese, fly up and downe in flocks about the Countrey. Never was more writing, or lesse matter." (The irony of this judgment opening a second published contribution to the kneeling-down-or-standing-up controversy was apparently lost on its author.) Indeed, that same year saw some two thousand English publications, a crop not matched again until the year 1695. A Frenchman who arrived in 1697 was equally impressed: "England is a country abounding in printed papers which they call pamphlets, wherein every author makes bold to talk very freely upon affairs of state, and to publish all manner of news."[2]

In matter of fact, ephemeral print was not new. Print 2.0 did not depend in the main on new technology, and ephemeral publications had been part of print culture from the very beginning. Counter to popular belief, the first documented product of Gutenberg's printing press was not a heavy Bible but an ephemeral form, an indulgence printed for the

church; and it has been reasonably suggested that the spread of printed indulgences in the second half of the fifteenth century should be seen as the first modern mass media event.[3] Pamphlets played a key role in the Reformation and the religious wars of the sixteenth century, when adversaries sought public legitimation and support, as well as in England during the mid-seventeenth-century Civil War. So it was hardly the case that what Collier and Defoe witnessed in England in the 1690s and early 1700s was without precedent. And yet in significant ways it was a true breakthrough, in terms of the sheer scale, staying power, reach, ubiquity, and consequence of the inundation of the public with a constant stream of cheap printed materials on a wide array of topical subjects. The many contemporaries who commented on this development, like Defoe in his seemingly peculiar reflection in 1712, were less concerned with historical precedent than with the drama of the moment.

The dates of the two peaks in the English production of ephemeral print, 1642 and 1695, were not coincidental. What these two years had in common was the removal, in the midst of a period of great turmoil, of government control of publications through censorship ("the Licensing Act"), temporarily in 1641 and permanently in May 1695. People who could afford the expense could now publish without need of prior approval, and a great many of them did so. The most radical effect of the final lapsing of the Licensing Act was in the periodical press, which had been more vulnerable to government censorship. No fewer than eight new newspapers were launched in London within the first three months after the end of licensing in 1695. There were now more titles, published more frequently, and with a greater number of issues, than ever before. From 1695 newspapers became a permanent, intrinsic, and regular feature of English public life.[4]

At the turn of the eighteenth century, therefore, London was abuzz with the new possibilities—and possible dangers—of an unfettered flood of cheap, ephemeral information pouring from the presses. Whereas the Printing Act of 1662 had tried to limit the number of master printers in all of England to twenty-four, by 1705 there were between sixty-five and seventy printing houses in London alone. Many of them, Defoe reported, were "wholly Employ'd in Printing small Tracts . . . Perhaps not one of those ever wrought a Bound Book." This new economy of information also relied on newly regularized and streamlined postal services. The flames of ephemeral print were fanned by this period's unparalleled political activity, the so-called rage of party. There were more general elections in the two decades following 1695 than in any other comparable period in British

history. King William joined in with an unprecedented blitz of printed propaganda to shore up his legitimacy, although the explosion of print greatly exceeded government influence. It took some fifteen years before the government began to reestablish some order in this new media environment, for instance through efforts to regulate copyright, but also through newspaper taxes like that which worried Defoe so much in 1712. In the period in between, as one student of this period aptly described it, the London world of cheap print experienced a period of "anarchic expansion . . . a veritable Hobbesian state of nature within the trade."[5] It was precisely during this decade and a half that Edward Collier came over from the Netherlands to London with brush in hand. Little did he know that this coincidence was about to lead him into an extraordinary experiment in the painted critique of an emergent information revolution.

II

Once newspapers were taxed, the question of what actually constitutes a newspaper became a pressing one. It depended, as a magazine editor who wished to avoid the tax insisted, on the definition and meaning of *news*:

> The true *Import* and *Meaning* of the Word NEWS is the Return of *Intelligence*, of any Kind, by the Posts *Foreign* or *Domestick*. But all Transactions of a Month's standing, are, long within that Time, recorded in the *Secretary* of *State's Office*, then, by the Law of Nations, become *Memorials*, and all future Recitals of them, fall under the proper, and only, Denomination of HISTORY. All Monthly Collections are bound up annually with proper Indexes; and any *Attempt* to bring such *Collections* within the *Stamp-Revenues*, might as well include *Josephus*, *Rapin's* History, and *Baker's Chronicle*.[6]

The difference between books and printed news could not be clearer. News is ephemeral and depends on the "posts foreign and domestick." It is of the moment, dated and fresh. Once news items stand long enough, they become memorials and join the enduring tomes of Richard Baker's *Chronicle of the Kings of England*, Rapin de Thoyras's *History of England*, or the ancient historical works of Josephus, whose writings on the history of the Jews around the time of Jesus have withstood the test of time for almost two millennia.

So let us take a look at the works of Josephus, the alleged opposite of the time-bound newspaper and the occasional tract, in two paintings (fig. 1.1). "Famous and Memorable," proclaims the title page of the English edition. These are large, heavily bound books (note the golden clasps), sturdy and long lasting, even if well thumbed. The English Josephus was more than ninety years old when it was painted on this canvas; the Dutch one in the middle of the second painting was well over a hundred. Just as the *London Magazine* editor suggested, they could hardly have been further from pamphlets, a description more appropriate for the unbound song and music booklets that in both paintings hang off the edge of the table.

This contrast between different modes of print spoke directly to the larger message of these paintings. Both belong to a particular type called "vanitas," which displays a collection of objects chosen and arranged to remind the viewer, through a familiar grammar of visual signs, of the transience of life and the vacuousness of worldly success. The evocations of worldly riches—a money bag in one, an open treasure box with its jewels uselessly strewn about in the other; the ephemeral music evoked several times over, which is no longer in the air, a realization brought home by the snapped strings of the violins; the sword symbolizing worldly power; the phrase "haec mea voluptas" (this is my delight): the message is nothing if not repetitive. These paintings are all about the passage of time, the un-stoppable tic-toc tic-toc of life that is relentlessly thrust at the viewer from every side—in the hourglasses to the back right, in the pocket watches in the front, and, in the Dutch version, in the celestial globe to the left. These counters of time serve in turn as reminders of the inevitability of death, or memento mori. Lest the point be missed, the artist placed in the English version a skull behind the open book, keeping an eye—or an empty socket—on the beholder. If the overall effect is rather solemn or even glum, this is just as it was intended: the didactic goal of this common genre was to rain on life's parade.

Furthermore, what appears at first glance like chaotic disarray turns out, upon closer look, to be deliberately and carefully laid out; this also helps explain how two paintings separated by more than three decades have so much in common. Note, for example, how many X-patterns are created by various objects: by the Dutch books, by the musical instru-ments in both paintings, by the treasure box and the sword, by the paper objects falling off the tables. These are message-driven compositions in which little is left to chance or to interpretive speculation. They both even include "notes to user," as it were, spelling out that they are in fact vanitas paintings. (It is not unreasonable to wonder, however, whether the artist,

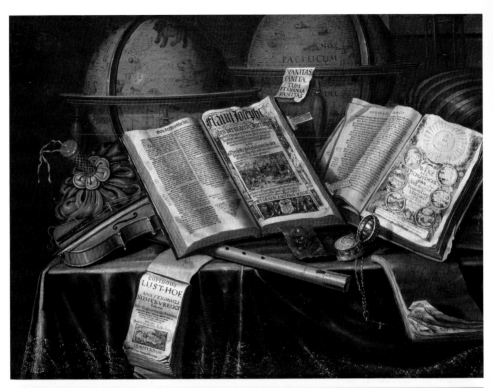

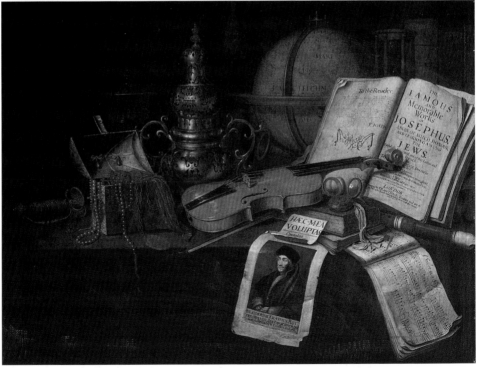

Fig. 1.1: Edward Collier, two vanitas still lifes with the works of Josephus, 1664 and 1696. *Top*: 50.5 x 60 cm. Museum De Lakenhal, Leiden. *Bottom*: 100.3 x 122.6 cm. Photo Collection RKD, The Hague.

in selling to a patron such a lush painting that was itself a valuable posses-
sion, was not somehow undermining his own message.) Finally, it is in
this didactic context that the significance of the books placed so centrally
in the composition should be seen. Offsetting the fleeting evanescence of
human life and desires, the Josephus tomes—enduring classics for over
fifteen hundred years—represent deep history, nothing less than the rise
and fall of whole civilizations.

Both of these painted Josephuses were the work of Edward Collier.
Indeed, for most of his career such vanitas still lifes were Collier's most
distinctive claim to fame. One of them was even in the art collection of
William of Orange at his Het Loo palace.[7] Although Collier had probably
completed the earlier painting of this pair in Haarlem, where he was
trained, he produced most of his vanitas still lifes during his quarter-
century residence in Leiden (1667–1693). Leiden had been home to the
famous professor Justus Lipsius, whose neo-Stoic writings popularized the
didactic message of the vanitas. It was also home to the Netherlands' pre-
mier university, in a century when it is estimated that half the world's books
were published in that part of Europe. It is thus not surprising that in this
Calvinist university town, teeming with learning, students, printing presses,
and libraries, a local specialty emerged among seventeenth-century pain-
ters, such as the better-known Jan Davidsz. de Heem and Gerrit Dou: a
distinctive variant of vanitas still lifes that centered on books and displayed
them as the weighty backdrop to the evanescent vanity of human life.[8] This
was the environment in which Collier cultivated his own skill at the
prominent display of the products of the printing press. His still life com-
positions included variously histories of the world, descriptions of famous
cities, ancient classical writings, foundational texts of the world's monothe-
istic religions, and the like. When in 1693 Collier packed his brushes and
moved to London, he took these skills with him and adapted them to the
local art market, as seen in the English Josephus.

III

Recall now the *Still Life, about 1696* and the letter rack with the 1696/1676
almanac with which this book began. Both Collier trompe l'oeil paintings
were more or less co-temporaneous with his vanitas featuring the Eng-
lish Josephus. And yet they are quite different. They are playful, not sol-
emn, mischievous rather than didactic. They are light, airy, and without

apparent depth. They do not wag their finger at the viewer's foibles but rather invite the viewer to join a game of hide-and-seek. As if Collier intended to render into paint the distinction laid down by the editor of the *London Magazine*, the printed materials on the letter racks were newspapers and pamphlets, not the vanitas's historical memorials of Josephus: Print 2.0 rather than Print 1.0.

The following pages will explore in detail the many ways in which Collier's letter rack paintings were indeed a new departure, and a strikingly innovative one. But it is also important to realize that the letter racks owed much to the earlier, better established tradition of the vanitas still life in which Collier had been trained. This lineage is preserved in the Indianapolis Museum caption that describes the trompe l'oeil as a "still life, about 1696." It is a deliciously apt choice of words, even if unwittingly so: for it was almost precisely at that moment "about 1696," when Collier put his brush to this canvas, that the term *still life* was introduced into the public record of the English language. The innovator was the great poet and playwright John Dryden; the occasion was a translation of a poem on "The Art of Painting" by a French painter, whose 549 elegant Latin hexameters that had taken twenty-five years to compose Dryden summarily rendered into prose. Into this work, which insisted that the perfection of art is in the imitation of nature, Dryden introduced a new description of a particular kind of painting: *still life*. He repeated the term three times, as if to make sure that contemporaries did not fail to notice his linguistic offering.[9]

Dryden's *still life* was itself an adaptation of the Dutch word *stilleven*—"immobile life"—which had been in use since the middle of the seventeenth century. Once again this could not be more appropriate, since the Dutch artists developed this particular pictorial tradition and excelled in it. This remarkable phenomenon, providing the art-cultural framework for Collier's career, merits a moment of consideration. One can say simply, "one of the achievements of the Dutch golden age was exquisite still life painting." Or one can assert more strongly, "still life painting achieved its greatest peak in the seventeenth-century Netherlands." Both statements are true and can be found in many textbook histories of art, but neither captures fully the extraordinary story they try to describe. Here was a society in which suddenly a particular skill developed: the skill among painters to imitate objects so closely and vividly that they produced an illusionary, almost magical, lifelike effect. This skill was not found among the exceptionally talented few but rather shared by a large group of masters. Between them, in multiple artistic centers over a full century, they produced a staggering number of still lifes, perhaps as many as half a

million according to the experts' estimates. This, then, is a story about the qualities of a culture, not about personal genius. And yet in each case it was an extraordinary personal achievement, requiring advanced technical skills and artistic virtuosity.[10]

Then, after a century in which scores of known and less well known painters produced a barrage of lifelike still life illusions representing anything from flowers and shells to domestic interiors to household objects to sumptuous food to letter racks, this collective expertise vanished. It was as if a large group of seventeenth-century still life painters all knew the secret password to an Aladdin's cave rich with technical treasures, but then someone changed the password and no one else could get in. Other artists in other places and periods have since painted highly skilled still lifes, but never so many of them in one place, and never so beguiling in their repeated illusionary effects.

The city of Leiden in the middle of the seventeenth century boasted a skilled group of painters—notably Gerrit Dou and Frans van Mieris—who specialized in particularly careful and realistic paintings in small scale, for which they later came to be known as the *Leidse Fijnschilders* (literally the Leiden fine-painters).[11] Keeping in mind this artistic context in which Collier worked, take a moment to appreciate his skill. The texture of the comb or the leather straps. The tangibility of the feathered quill. The shine of the nails. The illusion of depth even on a virtually flat surface. The distinct separation of the red seal from the letter underneath it. The curling of the printed pages. The absence of brushstrokes, which of course is a "must" for an illusionist painting. The caption is right: Collier certainly knew the password.

In Holland, as I have noted, Collier specialized in still lifes, especially of the vanitas variety. The vanitas message continued into his English letter rack trompe l'oeils as well. The ubiquitous combs, for instance: an unmistakable sign of human vanity. The almanacs, marking the passing of time both as calendars and as annual publications, like a two-dimensional hourglass. More wittily, look again at the red and black sealing wax sticks on either side of the comb in the Indianapolis painting (fig. 0.1, pp. 4–5). Letters were routinely sealed with red wax, but black sealing wax was used only on occasions signaling death and mourning.[12] In Collier's letter rack the black sealing wax, denoting death, is positioned carefully on top of a notepad titled "Memorye," quite literally spelling out the strongest exhortation in the vanitas repertoire: "memento mori."

Collier's letter rack paintings harked back to the vanitas in another crucial way. Like a vanitas still life, the letter rack displays an apparent jumble

of disconnected objects that is in truth orderly and carefully laid out, both in terms of visual geometry and in terms of relationships of meaning. The vanitas paintings repeat again and again certain stock elements—the skull, the hourglass, the musical instruments, etc.—that carried with them well-defined and readily interpretable meanings. The letter rack paintings also included a stock of repeated elements, and likewise they came together with their own set of meanings. In interpreting and deciphering the details of Collier's letter racks, it is important to keep in mind their ancestry in a genre that loaded every element and every detail with an excessive burden of meaning.

And yet, even as the letter rack paintings drew on the visual language of the vanitas still life, Collier was doing something completely different with them. This raises a telling question: why does a mature artist in his fifties, with a well-established strength in a particular genre that he had

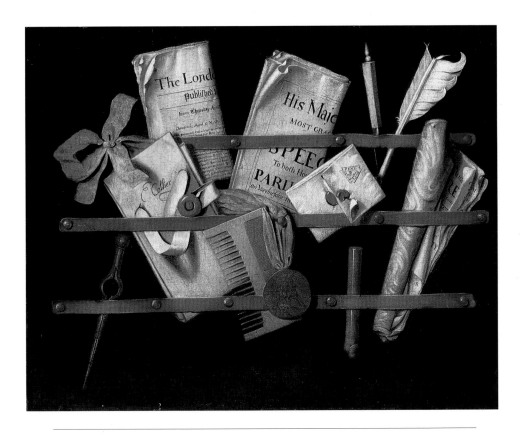

Fig. 1.2: Edward Collier, *Letter Rack with Rolled-Up Pamphlet*. 48 x 61 cm; 19 x 24 in. Courtesy of Sotheby's, London.

honed in scores of paintings for more than thirty years, suddenly change course upon his arrival in a new setting and begin to work intensively within a new and different mode? Demand from a new market—one that was in the process of forming, and that responded well to other still life painters—hardly seems to be a sufficient answer.[13] But Collier's encounter with a brave new print world may well be. His move from Leiden to London in 1693 coincided in both timing and geography with the fast-moving shift from Print 1.0 to Print 2.0. He suddenly found himself in the new media environment of mid-1690s London, with its explosion of cheap ephemeral print and of conversation about the possibilities and challenges of this new information age. Proliferating around him were less tomes like Josephus than pamphlets that could even be rolled up without requiring depth (fig. 1.2). It was in order to comment on this exciting media environment, I want to suggest, that Collier took some elements from the vanitas still life, together with his previous experience in the painting of print, and incorporated them into a distinctive genre of trompe l'oeil still lifes, the letter racks, that proved to be especially suited for what he wanted to say.

CHAPTER TWO

Life Not Still

I

Edward Collier did not invent the letter rack painting upon his arrival in London, however, or indeed at all. That honor goes to one Wallerant Vaillant, a French artist who studied and worked in the Netherlands. In 1658—shortly before Collier's artistic career had begun—Vaillant produced what was probably the first bona fide letter rack trompe l'oeil (fig. 2.1, left), with rectangular and diagonal straps holding partly legible letters, a quill, and a pen knife. Several other painters followed suit, notably the two expert trompe l'oeil illusionists Samuel van Hoogstraten, a student of Rembrandt's who had made his fame in the Holy Roman Emperor's court in Vienna, and the Flemish Cornelius Gijsbrechts, sometime painter to the Danish court. Gijsbrechts, evidently influenced by Vaillant, painted a rich series of letter racks like the one on the right in figure 2.1: large scale, very busy, and best viewed from a certain distance. Van Hoogstraten spent several years in England in the 1660s, during which he experimented with a series of letter racks with horizontal straps that appear surprisingly similar to Collier's (fig. 2.2). Finally, Collier himself had already produced a couple of letter rack paintings while still living in Leiden.[1]

Furthermore, when Van Hoogstraten toward the end of his life wrote the most important seventeenth-century Dutch contribution to the theory of art, he actually made a passing reference to letter rack paintings as a recognizable genre. "A perfect painting," Van Hoogstraten explained, was one that "makes things that do not exist appear to exist, and deceives in a

Fig. 2.1: *Left*: Wallerant Vaillant, *Trompe l'Oeil Letter Rack*, 1658. 51.5 x 40.5 cm. Gemäldegalerie Alte Meister, Staatliche Kunstsammlungen, Dresden. Photo: Bildarchiv Preussischer Kulturbesitz / Art Resource, New York. *Right*: Cornelius Gijsbrechts, *Trompe l'Oeil. Board Partition with Letter Rack and Music Book*, 1668. 123.5 x 107 cm. Statens Museum for Kunst, Copenhagen, © SMK Foto.

permissible, pleasurable, and praiseworthy manner." An illusionist painting, that is. He recommended that apprentice artists practice the skills of illusionist imitation easily and profitably by painting "combs and letters, and delighting in picturing something flat on a flat surface."[2] A letter rack, that is.

The point is not that Collier in London suddenly pulled a brand-new art form out of thin air. Rather, upon arrival in England he turned to a form with which he had already been familiar and singled it out as that best suited for his new needs. In the process he revolutionized the nature of letter rack compositions and pushed them further than anyone before him had done. Beginning to paint letter racks at a furious clip, he also produced a much greater number than any other painter in the history of Western art. How many? This question is not easy to answer, given the relatively low survival rates of paintings that were comparatively cheap and not particularly valued before the twentieth century, and given that most of the extant ones are not in public collections but rather in private hands, traceable only if and when they surface at an art auction or gallery sale. At present I have tracked down close to seventy, which certainly does not include all extant works. It is reasonable to estimate Collier's total output of letter rack paintings in the low hundreds.

The difficulty in amassing this archive is one reason why Collier's letter racks have not been closely studied. Those paintings in public collections—nine in all—are scattered in museums around the globe, mostly smaller regional ones. No collection holds more than a single example, and as far as I know, no two Collier letter racks have ever been exhibited to the public next to each other, or considered together side by side on the printed page. (An exception was a pair of Collier letter racks that hung together on the wall of a Victorian dental surgeon at London's King's College.[3]) Art historians and curators who discuss Collier typically settle for the reproduction of one painting that stands for the whole. But without placing Collier's letter racks side by side, and considering them as parts of a broader project, it is hard to understand what Collier was actually doing in this series of paintings: how he planted in them some of the most curious games in the history of visual art; how they came together to express a self-conscious and shrewd commentary on those revolutionary developments in media and information that were unfolding around him during his sojourn in England; and how his critique of this media moment went far beyond the obvious.

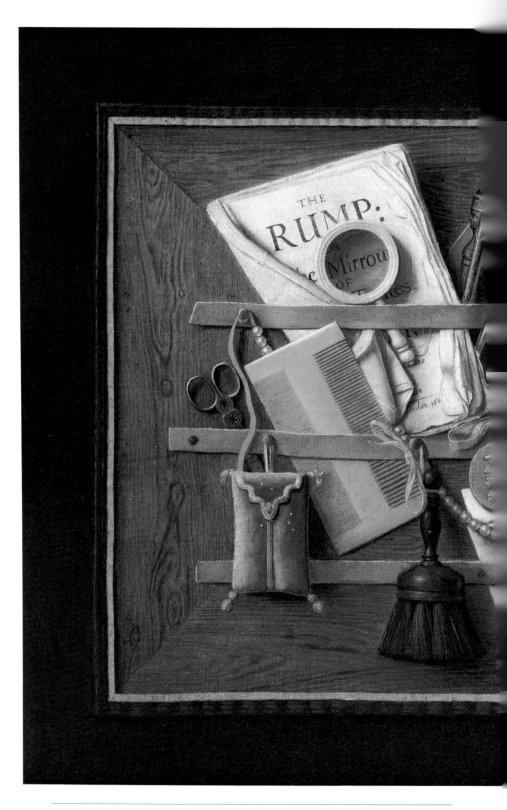

Fig. 2.2: Samuel van Hoogstraten, *Letter Rack with "The Rump,"* c. 1662. 50 x 69 cm.
Reproduced with the kind permission of Mr. & Mrs. Ronald J. Lenney.

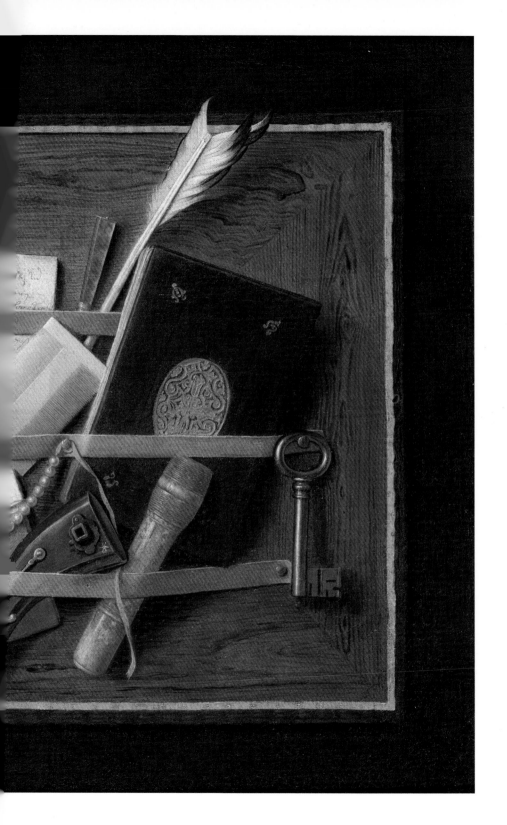

II

What, then, would have been the obvious? The most predictable line for Collier to have followed would have been to join the chorus of chest-beating angst about the consequences of the proliferation of cheap print for the demise of truth, honesty, and gentlemanly exchange. His contemporaries feared campaigns of propaganda, slander, and misrepresentations enabled by the easy availability of cheap print, even as they realized the potential of the immediate access to print in countering such misrepresentations with public statements of their own.[4] An engraving adorning a typically barbed personal-cum-political attack from 1709 titled *Guess att my Meaning* illustrates the basic dynamics of Print 2.0 politics (fig. 2.3). The man at the desk is penning a response to a sermon that presumably attacked him. The exchange, undertaken under the shadow of the axe and to a grotesque drumbeat, is fast paced: a handwritten page is about to turn into a printed pamphlet in immediate response to another pamphlet hot off the presses. The ephemerality of these tracts—the unbound printed one that curls off the edge of the table bearing a surprising resemblance to the handwritten sheet still being created—is underscored by the contrast with the weighty, enduring volumes of the great philosophers frowning upon this transaction from the back wall. The title, referring to a riddle in the caustic verses below, doubles as a general comment about the loss of stable meaning and truth in such a communication environment.

Such dangers, contemporaries warned, lurked behind every shadow of public language. The newspapers, one public figure observed in 1700, are filled with "such designed uncertaintys in them as to give occasion to fill the next newspaper with contradicting the former & making of false news to puzell us." Another in 1716 struck a similar note:

> Our news-papers give us the same facts in such several dresses, that there is not more to be made of what was transacted the last week, than if it had happen'd before the flood . . . In short, the poets first infected the world with their inventions instead of history, and now we have nothing but fictions instead of truth.

The "besotting Intoxication" of "*Verbal* Magick" is so powerful, intoned an anxious clergyman, that "Words are able to persuade Men out of what they *find* and *feel*, to reverse the very Impressions of Sense, and to amuse Men with Fancies and Paradoxes." Such sentiments had been behind the

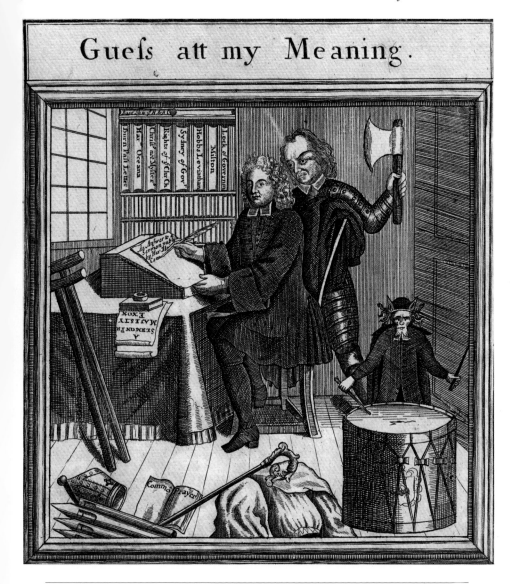

Fig. 2.3: *Guess att my Meaning*, "A Riddle Print," 1709. Houghton Library, Harvard University.

Licensing Act (or, in its full 1662 glory, "An Act for Preventing the Frequent Abuses in Printing Seditious, Treasonable and Unlicensed Books and Pamphlets, and for Regulating of Printing and Printing Presses") and were now exacerbated by its demise. In the words of the notorious censor, licenser, and Tory pamphleteer Sir Roger L'Estrange: "Truth and falsehood have chang'd places . . . Plausible disguises and appearances, have with them the force and value of certain truths and foundations."[5]

Designed uncertainties. Fiction masquerading as truth. Reversing the impressions of the senses. Amusement through fancies and paradoxes. Conjuring verbal magic that confounds disguises and appearances with truths and foundations. Collier's choice of trompe l'oeil as the genre in which to represent the products of this new print environment obviously chimes with these concerns. In a couple of late Dutch-language letter racks Collier included "prints" of Erasmus titled "SCHYN BEDRIEGD" or "Appearance deceives" (fig. 7.3, p. 127). This was a seventeenth-century Dutch subtitle for one of Erasmus's adages, "The Sileni of Alcibiades," describing trick statuettes that when opened displayed an inside quite different from their outside. Erasmus invokes this "amusing deception" as analogy to the uncertainties of linguistic usage: "The meanings of words have to be displaced. The lofty they now call lowly; the bitter is sweet; the precious is worthless; life is called death."[6] Collier's choice of newspaper for the first two trompe l'oeil letter racks we examined seems to confirm that his intent was indeed to warn that things are not what they seem in public communication: the *Flying Post* was a Whig newspaper that sprang up right after the lapsing of the Licensing Act, that is to say precisely the kind of new organ of unregulated partisan "truths" that were such cause for concern in 1696.

And yet this picture of Collier's intentions is insufficient. Although he painted the Whig newspaper in these two instances, and although in a couple of others he included Abel Roper's Tory *Post Boy*, these were the exceptions. Overwhelmingly, Collier's choices of printed materials for his letter racks are striking for how restrained and *nonpartisan* they were. The 1704 letter rack in figure 2.4 brings together the three types of publications that dominate Collier's paintings repetitively and almost exclusively: the *London Gazette*, the *Apollo Anglicanus* almanac, and the royal speech. The *Gazette* was the long-standing official establishment newspaper of record that remained, at least in theory, above the partisan fray and beyond scurrilous politics. It appears in over thirty extant letter rack paintings. Together with the royal speech, and with parliamentary reports that appear in a few other compositions, it belonged more to the category of government publications than to political ones, or perhaps to that of informational publications, which would also include the almanacs. Collier chose to focus on that particular type of printed text whose purpose was to circulate information for public consumption.

That this was not an obvious or inevitable choice becomes clear when compared to those of other artists facing the same range of possibilities. Thus, when Van Hoogstraten painted in London in the 1660s the letter

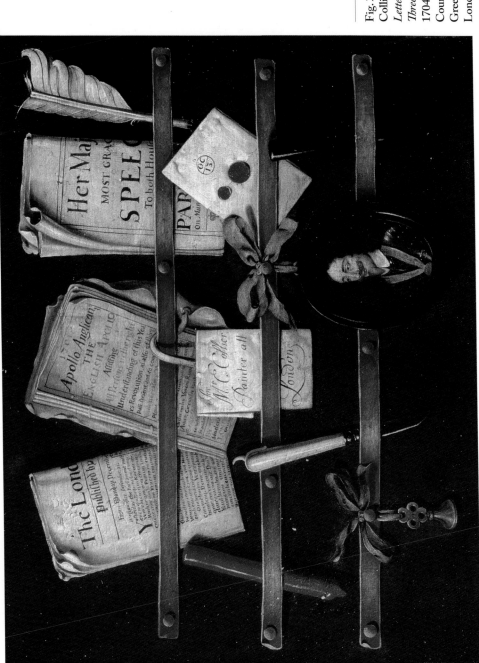

Fig. 2.4: Edward Collier, *Trompe l'Oeil Letter Rack with Three Publications*, 1704: 47 x 59 cm. Courtesy of Richard Green Gallery, London.

 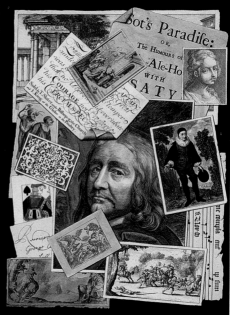

Fig. 2.5: English trompe l'oeil medleys, early eighteenth century. *Left*: Drawing, anonymous, 1703. Christoph Müller's collection, Berlin. *Right*: Etching and engraving by George Bickham, c. 1706. Worcester College Library, Oxford.

rack in figure 2.2 (pp. 34–35), a close precedent to Collier's work, it was the sharp-edged potential of the evolving world of print that especially attracted him. For the crumpled pamphlet that he stuck underneath a magnifying glass and among a wide plethora of objects, he chose a topical commentary on current events: John Tatham's recent political satirical comedy, *The Rump; or, The Mirrour of the Late Times*.[7] Later, in the opening years of the eighteenth century, several so-called medleys hit the streets of London. This new phenomenon was described in one advertisement as "Deceptio Visus," the closest indigenous parallel to Collier's trompe l'oeil paintings, and possibly influenced by him (fig. 2.5). While the drawing on the left is reminiscent of Collier's designs, with an almanac—sometimes, appropriately, called *Ephemeris*—and a newspaper, these medleys sported a more comprehensive array of contemporary printed materials piled on top of one another: in the printed example here on the right, a cheap pamphlet titled *Sot's Paradise*, a music sheet, a trade card, some detached pages from various publications, engraved prints, a few playing cards.[8] The printing presses of the turn of the eighteenth century were churning out

many kinds of printed materials, and these artists—working in multiple media—wanted to display them all.

Collier would have none of that. His letter racks were strictly disciplined. No plays, no political pamphlets, no sermons, no satirical tracts, no ballads. Only dozens upon dozens of informational publications, placed more or less center stage in his compositions. Considering the many other options rolling off the presses in London's bubbling media environment, Collier's restraint was surely the result of disciplined choice and deliberate design. So what was he trying to say?

III

We can begin answering this question with one consistent feature of the printed documents in Collier's letter racks (e.g., figs. 0.1, 0.2, 1.2, 2.4). They are all dated. They virtually always display a notation of time: a year, a day of the month, a day of the week. The time information is often incomplete and not intended to pinpoint specific publications to particular points on a historical timeline. Rather, it ensures the realization that each printed document originated at a particular moment in the present to which it belongs. Furthermore, almanacs, newspapers, and even royal speeches are serial publications. Their dates of issue indicate also their imminent expiration, the sell-by date when they will be rendered redundant by the next installment.

These publications were all vehicles for circulating immediate, time-bound information. None more so than the newspapers, which Collier painted so as to sport conspicuously not one but two dates: one for the newspaper issue, one for the day in which an item of news was reported. Both guaranteed that the contents were fresh, and thus worthy to be news. Literary critic J. Paul Hunter, wishing to explain why the novel emerged as a new genre during this period, has singled out as a key characteristic of the 1690s in England the "fixation with contemporaneity." In this decade, he writes, "the world of print had joined the world of conversation, gossip, and rumor in singular devotion to issues of the moment." The consequence was an urgent desire to create records of the immediate and the transient: these are precisely those time-bound, date-marked publications that crowd Collier's London compositions. Although Hunter seems unaware of Collier's art, it is as if he imagines something like it when he insists that during the 1690s the moment became "in itself a

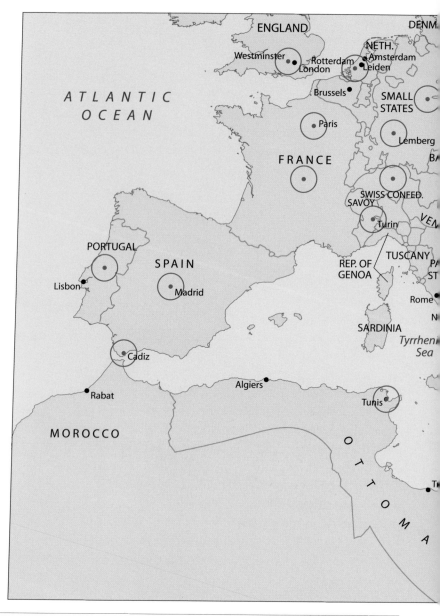

Fig. 2.6: Origins of news items in the newspapers in Edward Collier's letter racks.

kind of art object—to be adored, meditated upon, savored." As a convenient marker of this new departure Hunter offers the first English appearance of the French-derived word *journalist* for someone who writes about daily doings for the public press. It so happens that the first two recorded English usages of *journalist*—in the one case differentiating it

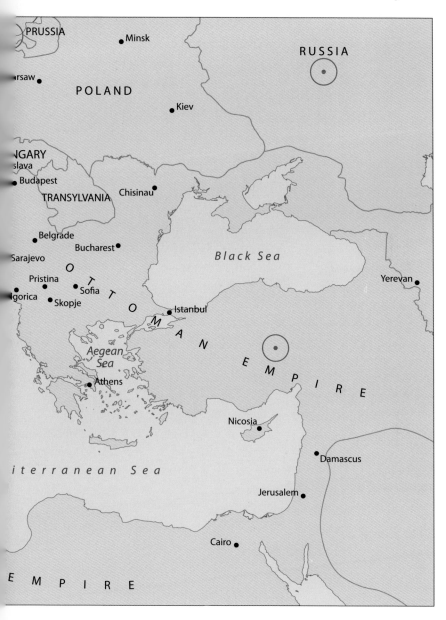

clearly from *historian*—occurred in 1693, the very same year that Collier stepped off the boat.[9]

The news items in Collier's painted newspapers are marked not only with time coordinates but also with a geographic location. If we put together the origins of news in his extant paintings, the result is remarkable (fig. 2.6). News in Collier's letter racks comes from Westminster, Paris,

Turin, Naples, Madrid, Cadiz, Vienna, Danzig, Lemberg, Rotterdam, Germany, France, Switzerland, Portugal, Russia, Turkey, and Tunis (whence the reported item itself, unusually, is legible: "Our Bey broke up last Wee[k] . . . with an army of 30000 . . ."). This wide range of locations is especially meaningful because other elements in Collier's letter racks tend to be repetitive rather than diversified. The geographical spread of the news, therefore, represents a deliberate, even methodical cumulative effort. Gradually, newspaper by painted newspaper, Collier charted the birth of the global information village. This too was a new phenomenon, and Collier was not alone in finding it exciting. "By the help of strange and Universal Intelligence," Daniel Defoe marveled in 1697, "a Merchant sitting at home in his Counting-house, at once converses with all Parts of the known World." Even as Defoe was making this observation in the context of asserting the central role of merchants in an emerging interconnected world economy, Collier was chronicling the very same global network of news circulation in his letter rack series.[10]

Print, however, was not the only medium for the circulation of information. It had a dynamic counterpart in the form of letters. Although letters had been exchanged for thousands of years, this technology of communication was also revolutionized in England in the very same generation, with the introduction of a recognizably modern postal system. The new post was established in response to the same perceived needs of the English merchants that were served also by the newspapers. "Many Letters," explained the Postal Act of 1660, "have been detained long, to the great damage of the Merchants in want of that speedy advice and intelligence." It took until the 1690s for the English experiments in a centralized mechanism for sending letters to mature into a full-fledged postal system. Edward Chamberlayne, whose almost annual editions of *The Present State of England* chronicled England's most promising achievements from 1669 to his death in 1703, began listing the effects of the "prodigious" post office from 1692.[11]

In 1678 another new word appeared on record, this one to describe the distinctive physical sign of the new postal system: *postmark*. In most Collier letter racks, often at the center, there is a folded letter. The letters are clearly and carefully postmarked. Typically the postmarks are round with two letters on top and a number below: in figures 0.1, 0.2 and 2.4, for instance, "NO/23," "NO/26" and "OC/13." These were "Bishop Marks," the earliest type of postmark, named after London's first postmaster, who created them in 1661. Henry Bishop explained his innovation: "A stamp is invented that is putt upon every letter shewing the day of the moneth that every letter comes to this office, so that no letter Carryer may dare to

detayne a letter from post to post; which before was usual."[12] The stamp consisted of the first two letters of the month—*NO*vember, *OC*tober— and the day of the month. Without noting the year, these postmarks were not intended to pinpoint letters to particular moments in time but rather to register the immediacy and speed of their circulation. The postmark on the letter in figure 1.2 (p. 28) is of another type, sometimes called "Dock-wra Stamp" after the London merchant whose private initiative had first introduced it in 1680. It belonged to the London Penny Post, "a modern Contrivance"—according to Defoe—"with the utmost Safety and Dispatch, [through which] Letters are delivered at the remotest Corners of the Town . . . from Four, Five, Six, to Eight Times a Day . . . We see nothing of this at *Paris*, at *Amsterdam*, at *Hamburgh*, or any other City."[13]

In painting these modern postmarks, like the date-marked pamphlets and the twice-dated news, Collier was displaying the signs of rapid movement, dynamic circulation, and precise timing. The letter rack trompe l'oeils may have originated in the tradition of still life, but their details conspired to remind the viewer that within their own sphere of action, life was anything but still.

IV

The products of Print 2.0 and the postmarked letters, then, were central elements in a fast-developing and rapidly moving economy of information in the late seventeenth century, and as such also in Collier's letter racks; but here the similarity between them ends. A closer look reveals that Collier's paintings are concerned less with the similarities between print and writing than with their contrasts.

The letter racks juxtapose writing and print by separating them into distinct registers. Usually—though always with some variations—the top strap in Collier's letter racks holds printed materials, the middle strap handwritten ones, and the bottom strap objects that have a more immediate visual quality, like the colored wax sticks or the textured combs. This spatial division places the letters at the center of the canvas. The central letter is almost always sealed, and often another bears as "address" the signature of the painter.

Collier's letters are folded into tidy rectangles. (Envelopes as we know them were not invented for another century and a half.) Their paper appears thick and durable, disrupted by only the slightest of crumples in

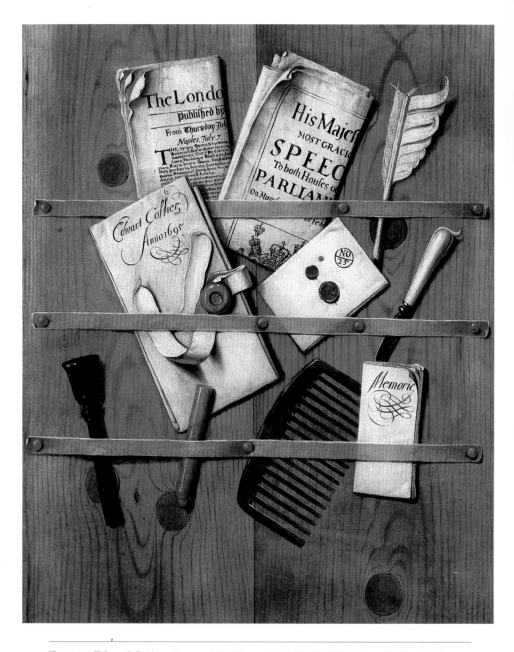

Fig. 2.7: Edward Collier, *Trompe l'Oeil Letter Rack*, 1695. 59.7 x 47 cm; 23.5 x 18.5 in. Reproduced with the kind permission of Frau Dr. Lillemor Herweg-Bengtson.

the corner. It is presumably the same kind of high-grade paper that English lawmakers had in mind when in 1696 they sought more aggressive parliamentary support for the manufacture of "White Writing Paper," formerly imported from Holland and France.[14] The sealed letters on the racks bear neat round seals in striking red, displaying faces. The neatness of the round seal is mirrored in the perfectly rounded postmark. In a 1695 example (fig. 2.7), which extends the trompe l'oeil effect also to the skillfully textured light pine wood boards, the red seal and the document seal on the ornately hand-signed folded vellum deed to its left are nicely echoed in dark, perfectly round knots in the wood. Every aspect of the handwritten documents bespeaks quality, order, and visual satisfaction.

The printed publications are also folded rectangular sheets of paper. But they are far from tidy. Their paper looks darker than the letters and less clean, perhaps spotted: it is evidently of poorer quality.[15] They are unbound. In a couple of letter racks with another informational publication, the *Votes of the House of Commons* (e.g., fig. 6.6, p. 113), the page number "(77)" reveals the pamphlet to be a fragment, not even a whole printed artifact. Most conspicuously, in sharp contrast to the neatly folded letters, Collier painted his pamphlets, booklets, and newspapers as curled, wrinkled, bent out of shape, dog-eared, evidently beginning to crumble. The dog-ears register the many hands that handled them as they circulated widely and quickly, but they are also signs that these publications are already visibly fleeting. Only just off the presses, they are already en route to wrapping fish in the market.[16]

Collier thus captured a key quality of these products of Print 2.0: their instant ephemerality. This is what set them so widely apart from the products of Print 1.0, like the heavy tomes of the fifteen-hundred-year-old Josephus. We begin to see how Collier, even as he stood on the shoulders of the vanitas still life tradition, significantly altered its meaning. Collier's vanitas still lifes, driven by a theological understanding of time, pushed against human perceptions of the moment to insist that human life in its entirety is ephemeral, and thus momentary pleasures must give way to more meaningful things. Against the transience of life, represented by the skull and bones, they placed the enduring heft of human history embodied in books like Josephus. In Collier's letter rack paintings, by contrast, the printed objects are reminders of the instant decay of themselves. The artist succumbed to the secular moment: still life could not be still. In replacing the enduring volumes of Print 1.0 with the ephemeral products of Print 2.0, Collier's trompe l'oeil paintings turned the logic of historical time upside down. We might say that it has become modern.

The Nature of Print

I

If Collier's painted pamphlets and newspapers wear ephemerality on their sleeves, what the letters are wearing on theirs is something else altogether: trust. In several different ways they reassure the viewer that they can be trusted with confidence. The whole arrangement of the letter racks, it seems, was designed for this purpose. Flanked by handwritten and neatly signed documents, or with handwritten addresses on their backs, the letters are a reminder that writing and signing by hand guarantees authenticity. This is even more the case whenever Collier places his own signature on such a letter or on a hand-signed document close by. The letters are surrounded by the personal implements that made them: pen, pen knife, sealing wax, and on some racks the seal itself (on the left of fig. 6.6, for example, p. 113). These belong to a specific person, just like the hair combs, those highly personal tools of body care that differ distinctly from one rack to the next. Finally, the letters are sealed, with the bright red seal often the visual focal point of the whole composition. Like the combs, like the signatures, like the seals, the letters are personalized, individualized, and reliably authenticated.

The printed materials that Collier places next to the letters could hardly be more different. They were impersonal, lacking a clearly identifiable author, and mass-produced. It was precisely during these years that this contrast struck newspaper publishers with particular force, as they scurried to adapt to the lapsing of censorship in 1695. In April 1696 one such

editor admitted defeat as he replaced his former handwritten newsletter with a printed newspaper:

> The Trade of writing News, which has been my profession for several years, being now quite out of doors, I am forced against my own Inclination to appear in Print, to recover if I can my former Customers, and preserve those few I have left, who, as they often told me, will rather read a Printed Paper than a Written Letter.

The editor was resigning himself to a new mass-produced print world, though he did try to preserve something of the former experience with the title of his printed newspaper, the *London News-Letter*. This backward-looking gesture was easily outdone by another editor's response to the transition to print in 1696. Ichabod Dawks's attempt to retain the old feel of his handwritten circulars extended to a specially cast script typeface, one made to Dawks's order so that it would look as if it were still written by hand.[1]

Collier's letters, moreover, protect and shield their contents. Their seals are almost always unbroken, and Collier never allows the content of a letter to be glimpsed. This is quite unlike the earlier generation of letter rack artists, who displayed letters that were open and invitingly legible. For Collier's predecessors, imitating dense, neat handwritings was a particular mark of the illusionist artist's skill. Cornelis Brisé, another midcentury trompe l'oeil artist, known for an illusionist painting of bundled documents pinned to a wooden panel that was hanging in Amsterdam's new Town Hall, was commended in 1665 for having "painted so peerlessly . . . the hand of different people in the writing so well imitated, that all strangers stand in wonderment as if enraptured, if they are mistaken in what they see." The pinnacle of Brisé's illusionism was counterfeiting credible handwritings—which, in turn, raised some doubts about the reliability of handwritten signatures.[2] Vaillant's letter rack of 1658, the harbinger of the genre, uses the contents of the letters through judicious name dropping as an actual or wishful-thinking affirmation of the value of the artist's work (fig. 2.1, left, p. 32: note, for example, the prince on the top right). Even those letters in Vaillant's rack that are still folded and unopened show signs of their scribbled contents through the paper. Collier's letters, by contrast, are squeaky clean. Whereas his printed documents, unbound and without endpapers, proclaim their contents loudly on their title pages, Collier's letters are silent. Characterized by authenticity, reliability, and confidentiality, they are a mode of circulating information that inspires trust.

II

The differences between print and scribal culture that emerged from Collier's paintings are so far more or less what one would expect: they reiterate familiar critiques of the weaknesses of printed documents in comparison to handwritten ones. It is when Collier zeroes in not on the perceived weaknesses of print, but on its alleged strengths, that he becomes most original in his message, and most creative and playful in how he presents this message.

The oft-noted strength of print, its structural advantage as a medium of circulation, lies first and foremost in its capacity for the quick dissemination of information, the standardization of texts, and the fixity of knowledge. Writing at the same time as Collier's decade and a half of letter rack experiments, and a full quarter of a millennium after the introduction of the printing press, the publicist Joseph Addison still found this quality of print remarkable enough to sing its praises:

> The Circumstance which gives Authors an Advantage above all these great Masters [painters, sculptors, architects] is this, that they can multiply their Originals; or rather can make Copies of their Works, to what Number they please, which shall be as valuable as the Originals themselves. This gives a great Author something like a Prospect of Eternity.[3]

Print's advantage was its capacity to replicate identical copies that cannot be told apart from an original. The permanence, stability, and reliability of fully replicable texts provided, in Addison's estimation, "something like" immortality.

Let us look, then, at what Collier did with these vaunted advantages of print. Consider the assemblage of replicable texts produced in multiple copies in figure 3.1. This of course is not how Collier painted them: each is a detail from a unique oil painting, which I here placed together side by side. And yet this composite juxtaposition, simulating as it does the workings of the printing press, is consonant, I believe, with Collier's project. Collier painted the royal speeches, all told, more than *forty times* (and this only in the paintings that survived). This is an astonishing number. I am unaware of any other example of a visual "archive" of a document, let alone a mass-printed one, reproduced in oil on canvas so many times, certainly not before the twentieth century.

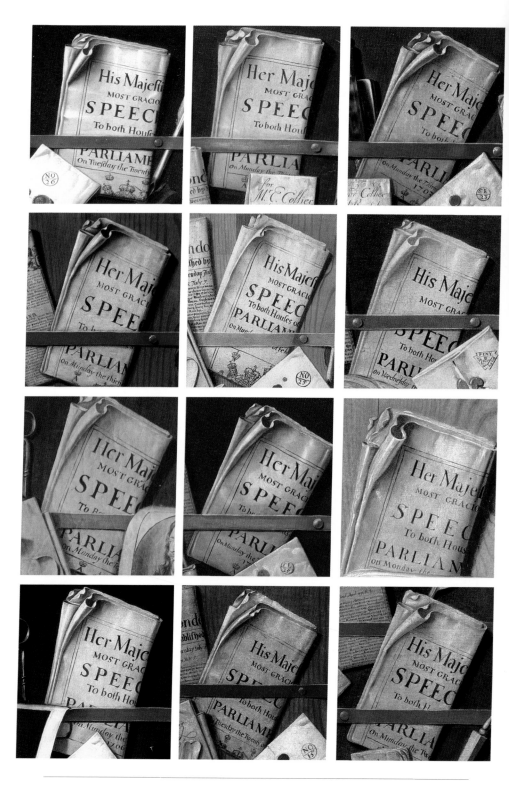

Fig. 3.1: Edward Collier, details of letter rack paintings with royal speeches.

The speeches in this assemblage are not all the same. They are not even by the same monarch. Some are "His Majesty" King William's, others "Her Majesty" Queen Anne's, the two reigns that coincided with Collier's English years. Yet it is easy to miss these differences at first glance. The speech pamphlets are not identical—they also differ in their day of the week, for instance—but they are painted to look alike, as if meant to be mistaken for one another. Remember, these are not real pamphlets but painted trompe l'oeil illusions whose trumpery extends to making them appear rather indistinguishable. I will discuss later the implications of the interchangeability of such public royal pronouncements for Collier's understanding of politics in an age of mass media. But first, how did Collier handle the underpinnings of this interchangeability, that is to say the details of the form of these speeches that print had supposedly rendered stable and replicable?

We can begin with a small detail that early on in my encounter with Collier struck me as a little bit odd. In most of the painted speech pamphlets the day of the week is spelled "Munday," a more archaic form that was still sometimes used in the late seventeenth century. But one or two of the pamphlets actually say "Monday." Was this significant? Perhaps not. A search through the title pages of all royal speech pamphlets that were printed during this period quickly revealed two speeches that were published a year apart, almost identical, but one with "Monday" and one with "Munday." This particular inconsistency, then, could be traced back to the actual paper speeches that Collier reproduced in his canvases. End of story?

Hardly. Take another close look at figure 2.4 (p. 39). In this letter rack, together with a "Monday" royal speech there is a newspaper also dated to a Monday. The two title pages, however, display side by side both variant spellings, "Monday" and "Mun[day]." Given the care with which these letter racks appear to have been arranged and painted, this seems more than coincidence. Furthermore, in the same newspaper the name of the *month* is likewise spelled out on the same (painted) page in two different ways, "Decemb[er]" and "*Desember*," increasing the likelihood of deliberate design. And then one finds the same juxtaposition of the two different ways to spell "Monday" side by side in a second painting, and then a third, and a fourth (fig. 3.2). The one at the top also extends the same pattern once again to the spelling of "December," offering next to it a third variation, "*Desember*."[4]

So this was not a coincidence. Collier had unlimited possibilities for what to paint onto every canvas and onto every "printed" page, and which ones to put next to each other. He wasn't merely copying royal speeches and newspapers into his compositions. He was making choices, and the repeated pattern of these choices reveals them to have been purposeful

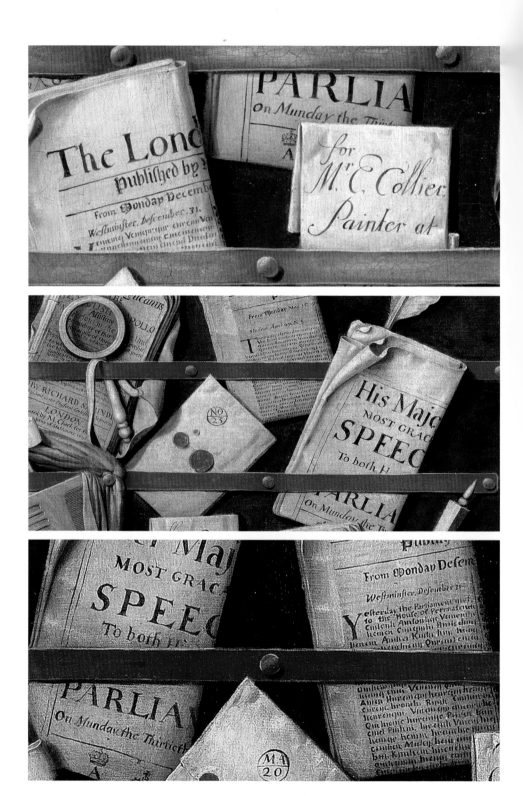

Fig. 3.2: Edward Collier, details of letter rack paintings with Monday/Munday.

ones, presumably intended to call attention to these spelling variants. But why? What could this pattern mean?

Once I became aware of this pattern, I went back to that first Collier painting at the Indianapolis Museum (fig. 0.1, p. 4). What I found there was curious. The speech pamphlet on that letter rack is painted as if spoken on a "Monday," spelled with an *o*. But this *o* is different in shape than any other *o* on the speech's title page, like those in "most" or "both." It is elongated, opened at the top, and with a whiff of a leg to stand on to the right. It is an *o* that also strives to be a *u*, or the other way around: a hybrid. This brings to mind the almanac title page with the complex hybrid 1696/1676 date: could this *o/u* hybrid also be a faux pentimento, almost imperceptibly drawing attention to that duality which it is seemingly trying to hide?

I did find myself looking askance at what I was doing back at the museum and wondering why I was spending so much time on how some artist three hundred years ago had dotted his *i*'s and crossed his *t*'s. I was becoming increasingly mindful, however, that for Collier even the smallest details could be the crux of a carefully laid design.

III

Dotting one's *i*'s is not just a figure of speech. Figure 3.3 shows again five of Collier's speeches. Begin with the two at the top, embedded in two letter racks with an obvious relationship to each other, which strive to appear almost identical—not simply the text but everything about them. The folds of the curling paper at the top. The darker smudge to the left. The precise way in which the overflowing sheet of paper below—also apparently identical—interrupts both speeches beneath the word "Monday." The page layout, including the places where the fold curtails each "printed" line. The shape of the letters (for instance, the forward tilt of the *t* in the word "both"). No other two painted speeches in Collier's letter racks are so remarkably painted to appear so similar, like two prints from the same photographic negative.

At the same time, their virtual sameness invites the beholder to seek the several carefully placed details in which they diverge. The most obvious is "His" versus "Her." Belying their intimate visual synchronicity, these two speeches could not have coexisted at all, belonging as they did to two consecutive reigns. Second: although the word "PARLIAMENT" is written fully in capitals, in the "His" speech on the right the *I* is dotted, conspicuously and gratuitously, contrary to any logic of writing or painting.

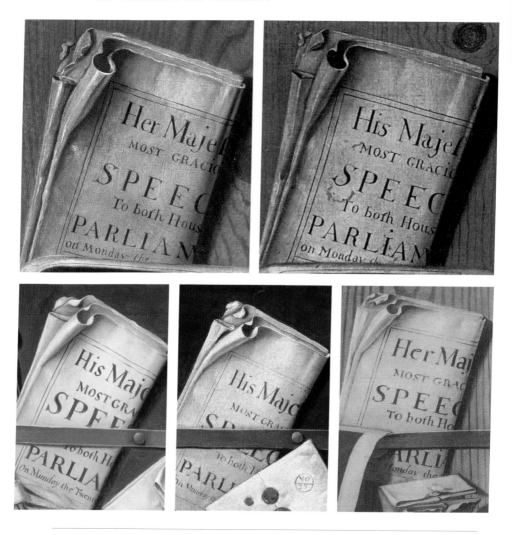

Fig. 3.3: Edward Collier, details of letter rack paintings with *i/j*.

If this were an espionage tale, it could indicate a photographic microdot secreting valuable information. But why should we assume that this oil-paint microdot holds a valuable secret of its own? Because Collier often signals that particular details are purposeful by repeating them again close by on the same canvas. Thus the *I* in the fully capitalized word "GRA-CIOUS" is also unnecessarily dotted, in both paintings. And finally, these dotted *I*'s are echoed in one more difference, in the word "Majesty": the *j*, which is pristine in the "Her" speech on the left, appears in the "His" speech on the right to be overwritten, clumsily but unmistakably, on top of an *i*. Another hybrid.

Keeping this pattern in mind, look now closely at the word "Majesty" in the three speeches below. The one in the middle has a smooth, uninterrupted *j*. But the *j* in those on both sides each has less of a leg to stand on, as if drawing attention to the *j* being superimposed over a thicker *i*. The speech at the bottom right, moreover, also has a dotted capital *I* as another visual cue. Furthermore, the *j*'s in the actual speeches that were Collier's "models" (as in fig. 5.3, p. 92) end with a short thin leg, slanted but uncurved, that is nothing like any of the painted ones. Collier chose to deviate from the originals on this fine point again and again, but in different ways.

Yet these are precisely the kind of small details where an artist may be reasonably expected to display unreflective uniformity, learning the detail one way and then repeating it more or less mechanically thereafter. Divergences like these, therefore, are especially meaningful. For a final illustration of this pattern consider the pair of Collier's still life paintings in figure 3.4, also displaying the royal speech. The paintings seem almost identical, but the enlargements show clearly that they diverge in their renditions of King William's speech. The painting of the left spells "Majesties" with a smooth *j*, just like the original pamphlet. But the painting on the right substitutes for it a clean unadulterated *i*: "Maiesties."

What is this all about? According to the historical linguists, the shift from "Maiesty" to "Majesty" is a notable example of a significant linguistic event, the introduction of the letter *j* to designate a consonant distinct from the vowel *i*. By the beginning of the eighteenth century the development of standardized English spelling was largely complete, at least for printed language. The separation of *i* from *j* based on sound (rather than on position within a word), together with the parallel separation of *u* from *v*, was among the last and most far-reaching changes introduced into this orthographic development. In 1685 the printer Thomas Dawks remarked on the novelty:

> The first Book where I find this distinction of j Consonant and the v Consonant from the i Vowel and u Vowel . . . is [in] 1633. And the first Book, wherein I find it universally observed with us in *England*, in both Capitals & Small Letters, is . . . Printed at *Cambridge*, 1634.[5]

This linguistic reform had been introduced, then, quite recently, and as late as 1700 was not yet fully stabilized. So the play between *i* and *j*, highlighted subtly yet insistently in Collier's paintings of the 1690s and early 1700s, turns out to have been a key linguistic transformation that had been taking place around him—and drawing the attention of

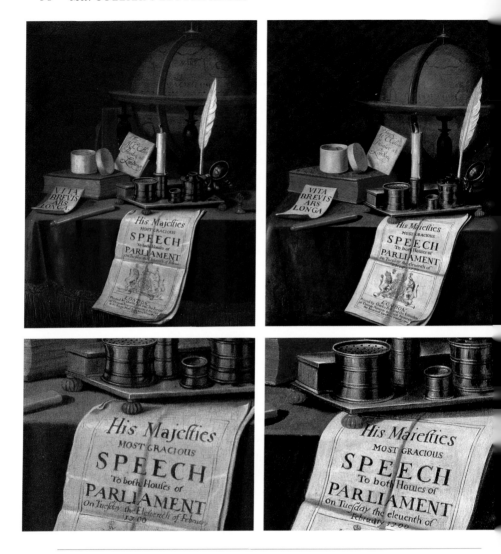

Fig. 3.4: Edward Collier, two still lifes on a desk with King William's speech, and details. *Left*: 73.5 x 62.2 cm. Courtesy of Christie's, London. *Right*: 76.4 x 63.5 cm. Courtesy of Sam Segal, Amsterdam.

contemporaries—right around that time. In fact, Collier also chose to change the word "eleventh" on the actual pamphlet to "eleuenth" in the speech hanging off the tables in figure 3.4: thus, in one painted object, Collier was shining his spotlight on *both* linguistic changes that according to the experts were of the greatest importance during this period.

But to begin appreciating what Collier was doing we need to see the bigger picture. England in the late seventeenth century witnessed

something of a linguistic revolution. People did not suddenly begin speaking or writing a different language, but from around the 1660s a revolutionary idea took hold: that there was one correct way to use the language, and that by comparison earlier forms were misuses or archaic. (It is Dryden, for instance, who is credited with the insistence that a sentence should never end with a preposition.) This was particularly true for spelling. So while this was a period of increased pressures for the standardization of uniform "correct" spelling, at the same time a multiplicity of variant practices was still widespread. Spelling books were therefore in great demand, but the most significant push to standardization came from elsewhere: the printing presses. By the second half of the seventeenth century, printers had largely adopted the modernizing reforms. It thus became their job—and their challenge—to work to stabilize printed spelling and thus to effect in practice that reputed fixity and uniformity of print.[6] The more widespread a printed text, moreover, the greater was its potential impact in habituating the wider public to the new standards. This may help explain why orthographic uniformity was achieved not at the time of Caxton's first English printing press in the fifteenth century but only two centuries later, in the age of Print 2.0.

Few were more aware of this role of the English printing houses than Joseph Moxon. Moxon, a Dutch-trained printer and globe maker, and the only seventeenth-century tradesman to become a member of the Royal Society, was England's foremost authority on the art of printing. In his definitive 1683/84 book on the printing trade Moxon explained that the person who sets the work into type, called the compositor, "should know where the Author has been deficient" and assume responsibility for correcting mistakes. In particular,

> [it is] a task and duty incumbent on the *Compositer* viz. to discern and amend the bad *Spelling* and *Pointing* [punctuation] of his *Copy* . . . It is necessary that a *Compositer* be a good English Schollar at least; and that he know the present traditional *Spelling* of all English Words.[7]

The compositor should know the "present traditional spelling": what a deliciously impossible phrase. The orthographic reform called for fixed spellings that were accepted as traditional, but since they had not yet been stabilized, they were only *presently* traditional. Nothing could capture better the dynamics of this transitional period—the ongoing project of the invention of linguistic tradition—than this unwitting oxymoron. And

nothing could describe better Collier's own project, capturing in his painted renditions of printed materials these same tensions between the dynamic variability of the present and the imagined fixity of print.

IV

It is important to realize that these variations between paintings and within paintings cannot be the result of coincidence or carelessness. Nor can they be the result of the intervening hands of assistants in Collier's workshop, an explanation that art experts often favor to account for variations in the output from the master's easel. How does a Bedouin mark a trail in the desert? He lays three little stones on top of each other. One stone on top of another can be a coincidence, moved by the wind or kicked by a goat, but three must be a deliberate man-made contrivance. In Collier's paintings, the repetition of patterns both within paintings—often reiterated with great care right next to one another—and across several paintings is like the Bedouin's devices squared: Collier piles up more than enough stones to ensure the recognition of intentional design. Were these variations the result of assistants' slips, even more so over a period of fifteen years, they would have displayed a largely random pattern, not a consistent and persistent one.

Another point to keep in mind is that, although there is no evidence of patrons' reactions to Collier's illusionist art, early modern observers may not have found the presence of such games in paintings so puzzling. Playful devices, often in the minutest of details, were part and parcel of the repertoire of at least some artists in this period, and the patient attention to the significance of details in every millimeter of a painting's surface was part and parcel of the viewing habits of at least some viewers. Karel van Mander, author of the most popular seventeenth-century book on Dutch art, recounts several anecdotes about such painterly playfulness and audience participation. Joachim Patinir, for example, made a practice of hiding in his landscapes a tiny figure squatting somewhere with his britches down, inviting the viewer—in Van Mander's words—"to search for this little shitter." The sixteenth-century Dutch artist Pieter Aertsen included in a painting deliberate "mistakes" that held the clue to his pioneering design. Nicolas Poussin in the middle of the seventeenth century placed in painted windows millimeter-wide heads that could not be seen from a normal viewing distance.[8]

Once we have a sense of what Collier was up to, his letter racks suddenly teem with more instances of games following a similar logic. In one case (fig. 3.5), a pair of almost identical letter racks part ways twice with spelling variations: a 1698 pamphlet containing a speech that was delivered on "Fryday" or on "Friday," and two handwritten notepads labeled "Memory" versus "Memorye." Such mnemonic pads appear in over a dozen Collier paintings, some also with a third spelling, "Memorie." This game is again significant: the shift from final *ie* to *y* was another of a handful of meaningful reforms of English spelling in the seventeenth century, leading to standardized modern practice.[9] In another painting (fig. 3.6) Collier played the *i/j* game not only in their hybrid overlaid combination in "Majesty," but also nearby with another word, "July." The painted copy of the *London Gazette* on this letter rack is dated "Monday Iuly . . . ," spelled with an *I*, but the news item comes from "Madrid, July 15." Lest one missed this sleight of hand, the digit *1* sports a tiny dot that endows it with an unmistakable resemblance to an *i*. Even then Collier was not quite done. He added to the same canvas a third game with the word "July," through an unusual choice of postmark for the sealed letter, "IU/25." "IU," an abbreviation for "July," was a vestige in public administrative usage of the days before *i* and *j* were ordered apart; and again Collier painted the *I* in "IU" to look a bit like a *J*. On another occasion he painted this postmark as "IV," making its archaism even more apparent.

In another case, a painting with multiple archaic spellings includes another postmark with "IA/29" for January (fig. 6.6, p. 113). Next to it is the *Votes of the House of Commons* dated "Veneris 19 die . . . ," which designates Friday the nineteenth, as well as a detail of King William's insignia that foregrounds a bold letter "R" for Rex. Three allusions to official administrative uses of terms that retained the primacy of their Latin roots over current English practice were thus piled on top of each other in one crowded segment of one canvas. Collier, it seems, chose this particular painting to point to yet another source of variability in contemporary documents: leftovers from Latin. This same painting also crowds together four different types of abbreviations in superscript form, conventions that create another kind of discrepancy between the typography on the page and the actual words it represents. Recall also the Penny Post postmarks that appear in several letter racks (e.g., fig. 1.2, p. 28). Was Collier attracted to this forward-looking administrative instrument of efficient circulation because of the ironic archaism in its orthography, "Peny Post Payd"?

And why did Collier single out in another letter rack the word "Tuesday," repeated twice, but not in order to point out spelling variation (fig. 0.2, pp. 10–11)? It takes a moment to notice that this particular speech day is

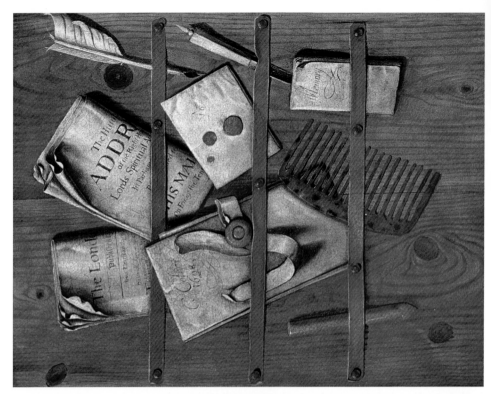

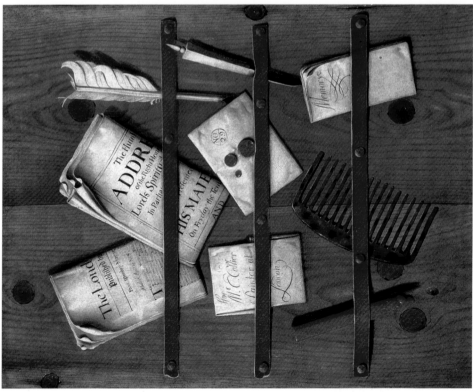

Fig. 3.5: Edward Collier, two letter racks with *Humble Address*, 1698. *Left*: 58.8 x 46.2 cm. Tate, London / Art Resource, New York. *Right*: 60.5 x 47.5 cm. Courtesy of Rafael Valls.

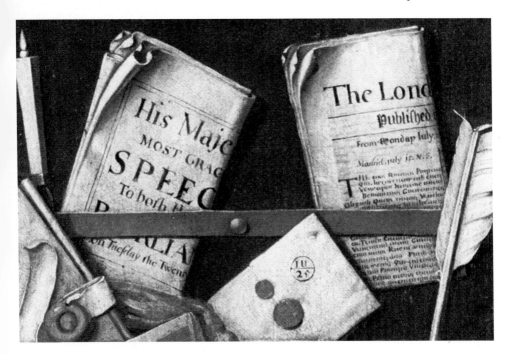

Fig. 3.6: Edward Collier, *Trompe l'Oeil Letter Rack with "July" Games*, detail. 47 x 60 cm. Courtesy of Christie's, London.

painted as if printed half in roman font and half in italics: "Tue*sday*." It is as if Collier tried to capture the moment when a printer is "out of sorts," which is the printing jargon for running out of a particular typeface mid-printing (and reputedly though perhaps apocryphally the origin of the phrase "being out of sorts"). Fonts are yet another factor in the variability in print. The painted print works in Collier's letter racks sport numerous kinds of letterings. In the newspaper and pamphlet in the Indianapolis letter rack, for example, every single line is different from every other, with its own font, size, or capitalization. Together they offer a visual mélange of perhaps as many as ten different typographical ways to place a word on the printed page—and this without adding color, as does the wildly diverse title page of the *Apollo Anglicanus*. (Moxon insisted that a printer worth his mettle should have at his disposal complete sets of some eight to ten different typefaces.) Collier contrasts this variability of print forms sharply with the handwritten documents on the letter rack, which display one stable, consistent, unvarying hand. Unlike the earlier letter rack artists Vaillant and Gijsbrechts, who had reveled in their ability to reproduce multiple handwritings, Collier reveled instead in his ability to capture the multifarious appearances of print.

$$\mathrm{V}$$

Daniel Defoe was always interested in the nature of print. In a work with a seemingly unpromising title for this purpose, *The History of the Devil*, Defoe recounts the story of John Faustus, Gutenberg's supposed collaborator on his printing press, who brought to Paris the first printed books but sold them as hand-copied manuscripts. But when the famous doctors of the faculty of Paris

> observ'd the exact Agreement of every Book, one with another, that every Line stood in the same Place, every Page a like Number of Lines, every Line a like Number of Words; if a Word was mis-spelt in one, it was mis-spelt also in all, nay, that if there was a Blot in one, it was alike in all;

they then believed that Faustus, who in truth was but a "meer Printer," must have been a witch using the devil's magic to create these identical books.[10]

Defoe's blending of Gutenberg's one-time partner Johann Fust with the necromancer "Doctor" Johann Georg Faust notwithstanding, his anecdote nicely blends together the myth and the realities of print: on the one hand, the image of the press as capable of such a faithful replication of appearances that it seems unnatural to those unfamiliar with its origins; on the other, the fact that the actual production of a printed text is likely to involve mistakes, blots, and misspellings that are then reproduced with every copy. The story also blends two layers of time: the origin of print as recounted a quarter of a millennium later, Print 1.0 seen from the perspective of Print 2.0.

As we have already seen, there was much preoccupation during Defoe's lifetime—and Collier's—with both the promise and the limitations of print, a preoccupation catalyzed by the explosion of cheap ephemeral publications, rapidly produced and widely circulated. Thus against Addison's marveling in 1711 at the endless replicability of print that confers on authors "something like" immortality, one can set another prominent contemporary writer, Jonathan Swift, appealing in 1704 to "Prince Posterity" to forestall the unfortunate fate that befalls "the Writings of our Age":

> that of several Thousands [publications] produced yearly from this renowned City, before the next Revolution of the Sun, there is not

one to be heard of: Unhappy Infants, many of them barbarously destroyed, before they have so much as learnt their *Mother-Tongue* to beg for Pity.

The specter of instant ephemerality and transience within the throngs of a print overload was traumatic enough for Swift to revisit it in three detailed visions in his publications that year.[11] And again: on the one hand, one writer in 1694 extolled the advantages of print—advantages that "if not self-evident, yet need no Proof"—whereby "the Text is hereby better preserved entire, and is not so liable to be corrupted," which is particularly important "in Mathematicks, where the Alteration of a Letter, or a Cypher, may make a Demonstration unintelligible." On the other hand, some authors were so concerned with the authenticity and accuracy of their work in an age of cheap, often piratical reproductions that they fantasized about authenticating by hand every single "authorized" copy. In 1716 the first European book on the history of proof corrections made explicit what many had suspected, that the seventeenth century had actually witnessed a decline in publication standards.[12]

Collier arrived in London straight into the middle of this conversation, and evidently became very much interested in both sides of the issue. The information explosion of the late seventeenth century profoundly shaped his work: never before had he registered contemporary historical developments in his paintings in this way. Collier now gave pride of place in his compositions to chronicling, charting, and characterizing this new environment. He engaged with it most prominently in his letter rack trompe l'oeil paintings, a genre that he had experimented with a couple of times before but now resorted to again and again as singularly suitable for what he wanted to do. The still lifes that Collier painted in London also took a new turn in comparison to his earlier Dutch ones, routinely including the same pamphlets and newspapers that filled his letter racks. Collier's paintings from his English period manifested great enthusiasm for the new waves of change. In his portrayals of the products of cheap print he captured key distinctive qualities of the emergent Print 2.0: the dynamism of fast circulation, the preoccupation with the moment, the instant ephemerality of publications just off the presses, the seriality of mass-produced pamphlets, the global network that undergirded a new economy of news. Print was on the move, and Collier was moving with it.

At the same time, however, Collier was keenly attuned to the limitations and fault lines of this brave new world of cheap print. This chapter began by considering the kinds of trust that can be put in letters but not

in print. Print, by contrast, could reputedly be trusted to do other things: to produce fixed, reliable, and endlessly reproducible copies of an original. Only it could not be trusted to do these things without fault. For Collier it was precisely the places where the drive for stabilization and fixity ran up against the sheer multiplicity, variability, and dynamism of Print 2.0 that were of greatest interest and that led him to lay on canvas the most elaborate games. Deliberately placing side by side the variations on "Monday/Munday," "Friday/Fryday," or "December/Desember/Descember," thereby highlighting the mutability of spelling in a period of increasing investment in its standardization. Carefully overlaying *i*'s and *j*'s so as to focus attention on the last great effort to eliminate disorder in English orthography, an effort that was still ongoing at the time of Collier's painting. Packing into the corner of one canvas multiple linguistic variations derived from bureaucratic uses of Latin. Painstakingly constructing an illusionist almanac so as to expose the hazards in trusting key pieces of information on the title page of this annually published serial: the author's name, the author's credentials, the continuity of contents, or the date of publication. Any single one of those devices by itself would be a rather unusual thing to discover in an early modern painting. But here was an artist who could not stop, who uncovered more and more instances where print multiplied variations rather than eliminated them—not only in cheap commercial publishing, like the almanac, but also in official publications, like the royal speeches, where one might expect better quality controls—and who then subtly but insistently inserted them into a large number of paintings. Each single example is small, even fussy. But taken together they are quite an extraordinary statement of a rather unusual individual.

Marking Time

I

Collier, then, is emerging as an individual with an unusual eye for details and unusual playfulness, even an unusual sense of humor. In England these traits served him well in a new project that became central to his art, marking a sharp break from his past practice. Yet if this is the kind of person he was, surely there had been signs of these qualities earlier, during Collier's three-decade career in the Netherlands?

One possible place to look is Collier's painted music notebooks with legible, well-informed musical notations. Uniquely for the period Collier repeated notations for the same melodies in multiple paintings, and a closer reading of those may well reveal similar textual predilections.[1] More immediately striking, however, is another playful pattern in Collier's Dutch-era paintings. I have been referring to our painter unproblematically as "Edward Collier." But this goes against Collier's own practice. Collier had a bewildering assortment of ways to leave his mark on his paintings. They are variously signed as Collier (first datable occurrence in 1662), Kollier (1662), Kolier (1663), Colyer (1675), Collijer (1678), Colier (1680), Colijer (1684), Coljer (1692), Coleijer (undated), and Collyer (undated). His Christian name he varied as well, choosing between Edwaert, Edwart, Eduwart, Edwaerd, Edwaerdt, and, of course Edward, as well as the Latin forms Edwardus and Eduwaerdus. In the early modern period, of course, signature variations were common. Shakespeare, for example, signed his name in six different ways, Sir Walter Raleigh in five. When Collier's own name or those of his family surface

in archival documents, their spellings vary almost as wildly as his list of painting signatures. In a quarter of a century of the Leiden Reformed Church records, for instance, Collier appears variously as Eduaert Colier, Eduwaert Colier, Eduard Colier, Eduard Colyer, and Edward Colijer. And yet Collier's Dutch canvases carried carefully painted signatures, not handwritten scribbles on documents produced by different scribes, and these signatures vary in a methodical and insistent manner. It is their range and variety, exceeding by far that of other painters of the Dutch golden age, that indicate a move from unselfconscious casualness to meaningful intent.

Given Collier's later attraction to the instability of language and the variability of spelling, it seems reasonable to interpret this earlier practice along similar lines, as a playful response to the orthographic variability of contemporary scribal practices. Remember that this was a painter with a natural inclination to repetitiveness more than to variation in his work. So whenever Collier chose to vary a certain detail repeatedly, this choice was likely to be a deliberate one. A revealing detail in one of Collier's earliest paintings, a vanitas at the Metropolitan Museum of Art in New York, lends support to this conclusion (fig. 4.1). In the corner of a large and busy still life Collier placed an almanac with his signature as a styl-ized square monogram above the "1662" date on the almanac flyleaf: "E C." But right next to the almanac is a signet ring, which in simple unadorned (and unreversed) lettering bears the monogram "E K": a playful comment on the multiplicity of forms Collier's name could take.[2] It was a device that foreshadowed the visual juxtapositions of "Monday/ Munday" and the like several decades later. Furthermore, next to the almanac and the ring with the two monograms lies a conspicuous neck-lace, or in French—a language our illusionist used self-referentially in at least one letter rack—a *collier*.

The most conclusive evidence, however, arrives later. Once Collier came to England, the games with his signatures suddenly stopped. In one of the most distinctive changes in Collier's work from his Dutch to his English period, every painting of his from 1695 onward that I have seen, of whatever genre, is signed only with the name Collier. He also stuck to the first name Edward, with only a couple of exceptions in Dutch and French. Nothing can indicate more clearly that Collier's wildly varying signatures up through 1693 had been intentional. In England, where his attention moved away from the variability of scribal culture toward that of print, and where he repeatedly positioned hand-written documents and especially signatures as the trustworthy counter-parts to printed documents, his painted signature, typically introduced

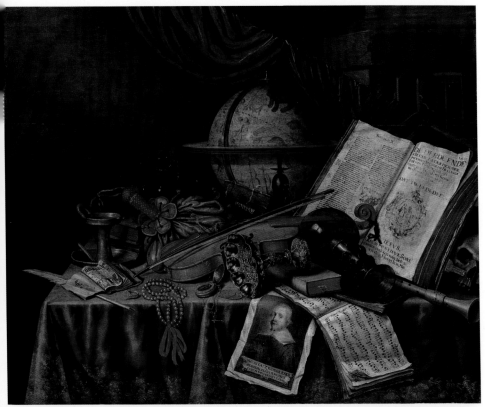

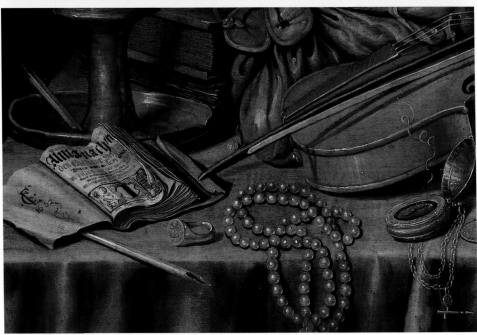

Fig. 4.1: Edward Collier, *Vanitas Still Life*, 1662, Metropolitan Museum of Art, and detail. Oil on wood. 94 x 112.1 cm; 37 x 44⅛ in. Purchase, 1871 (71.19). Photo: The Metropolitan Museum of Art / Art Resource, New York.

in imitation handwriting on sealed letters and documents, was suddenly and invariably stable.

<div align="center">

II

</div>

Collier was surely aware of and attentive to such signs of change over time. The marking of time is one of the most significant aspects of his work throughout his career, displaying both continuities and radical change between his Dutch years and the letter rack paintings in England. On the one hand, the letter racks frequently reiterated the preoccupation of the vanitas paintings with the passing of time: not only the memory notepads, the almanacs, and the occasional black memento mori objects, but also dangling pocket watches, musical notes or instruments, or portraits of King Charles I, whose reversal of fortune served as a mnemonic equivalent to the painting of a tossed-off crown. On the other hand, the letter racks embodied that fixation with contemporaneity and obsession with the moment that characterized their own historical context, which they displayed through the transferal of ephemerality from human life, measured against the gravity of history and of the printed annals of civilization, to the printed objects themselves.

Several of Collier's letter racks harbor a particular game with the marking of time that is unusually complex and revealing. This game fuses together Collier's long-standing interest in the passage of time, his newly found interest in the preoccupation with the moment, and his never-ending fascination with places in which documents fail to convey information with the certitude one might expect. It was a game, moreover, for which the perspective of a foreigner recently arrived from the Continent was a distinct advantage.

To see this game we can begin again with an almanac, the *Apollo Anglicanus* for 1701, placed under the top strap of a letter rack painting side by side with the queen's speech (fig. 4.2). But this can be seen as an unlikely, even incongruous, combination. Queen Anne acceded to the throne in 1702. She became queen on 8 March, the day that King William died, supposedly from the complications from a riding accident two weeks earlier. The new queen gave her first speech to Parliament on 11 March 1702, and her second on Monday, 30 March—which is the speech that Collier painted into this letter rack. But why pair it with an almanac from 1701, when King William had still been on the throne? Of course, it is

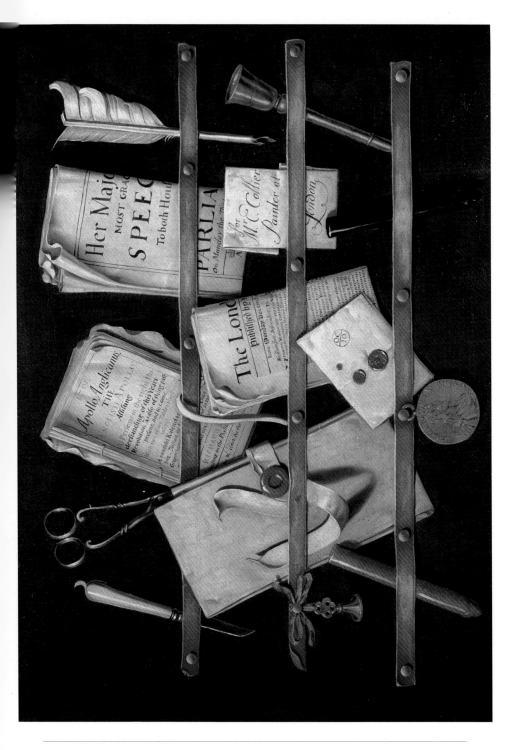

Fig. 4.2: Edward Collier, *Trompe l'Oeil Letter Rack with Writing Materials*, 1701/2. 51.5 x 63.7 cm. Victoria & Albert Museum, London / The Bridgeman Art Library.

not impossible that Collier might have simply cobbled together some recent publications on his shelf. But given that he almost never mixed different years in his letter racks, given that the change of monarch made the leap from 1701 to 1702 more significant than any other that Collier experienced during his sojourn in England, and given his usual attention to detail, especially when it came to royalty and to the marking of time, this combination is rather puzzling.

Collier actually placed the key to this puzzle close by and in plain sight. The almanac title page is painted legibly, with considerable detail. It explains that the purpose of the almanac is to assist people "in the right Understanding of this Years Revolution," and that it does so with the aid of "A twofold Kalendar . . ./ viz. Julian or . . ./ Gregorian." This is what was on Collier's mind: English dates in this period were ambiguous, out of sync with the rest of Europe. The European calendars had been reformed to match more accurately the actual length of a year's revolution of the earth around the sun, but the English one had not. As a consequence the calendar used on the Continent—called the Gregorian calendar—was eleven days ahead of the Julian calendar that the English followed. Additionally, the new year in England started not on 1 January but on 25 March, the spring equinox and the day of the Annunciation, known as Lady Day. For almost three months England and the Continent were in different years. Imagine the resulting complications in sending letters across borders, say, or receiving news, or making business arrangements between both sides of the Channel. The confusion was kept partially at bay by referring to English dates as "Old Style" and Continental ones as "New Style." Not until half a century later, in 1752, were the calendars finally aligned.

So when exactly did William die and Anne become queen of England? According to the authoritative *Dictionary of National Biography*, on 8 March 1702. That would mean that according to our calendar—the Gregorian calendar, New Style—this was really 19 March. But if one prefers, plausibly, to mark the date according to the time-keeping habits prevalent in England at the time, Old Style, it would be 8 March, but 1701, not 1702. (Anne's first speech to Parliament was dated 11 March 1701, and her second, three weeks later, 30 March 1702.) In short, by no calendar did William die and Anne ascend to the throne on the date assigned to these events in most reference works. (Even this apparent clarity is overstated: in Scotland from 1600 the New Year was marked on 1 January while the calendar remained Julian, so by Scottish dating the *DNB is* correct.) This messiness was nothing new. King William himself

had once lost a carefully constructed symbolic advantage during the buildup to the Glorious Revolution to the subtleties of calendrical ambiguity. The Dutch prince had scheduled his landing in England in autumn 1688 for 14 November, his birthday, a coincidence that was supposed to impress upon his future subjects the providential nature of his mission. The symbolism was, however, lost on the English, for whom it was only 4 November.[3]

Here, then, is the most important event in England in the early years of the eighteenth century, and yet it cannot be assigned a precise date without an elaborate explanation. Can there be a greater instability in basic information that one expects to be rock-solid reliable? Small wonder that Collier was drawn to this problem, which is the most likely explanation for the quirks of this letter rack. The 1701 almanac next to the queen's 1702 speech signals both possible dates of the monarchical change. The deliberateness of this juxtaposition is affirmed by the almanac title page close by, on which Collier spelled out with meticulous care the duality of the two different calendars. As a final touch Collier may have added another subtle indication of the calendrical matters on his mind. The date on the news in the *London Gazette* is 31 December, the last day of the year. But only if one followed the Gregorian calendar; otherwise it was just an ordinary day. Coincidence? After all, this same newspaper was a careful contrivance that Collier also used strategically to plant spelling variants of Monday and December. As it happens, it was a fake contrivance, which Collier could not have simply copied from a printed newspaper: 31 December 1701 was a Wednesday in England and a Saturday in Europe, but nowhere was it a Monday.

There is another Collier painting that revisits this calendrical confusion with its own twist (fig. 4.3). Of some dozen extant letter racks with the *Apollo Anglicanus*, this is the only other that spells out legibly the "twofold Kalendar. viz. Julia[n] or English [and] Gregorian or fore[ign]." And sure enough, like the previous example, this one also couples the explicitly highlighted doubleness of calendars with a double dating on the canvas, a discrepancy between the date of the almanac and that of the queen's speech. In this case, while the speech is the same "Munday the thirtieth," it sports a different year: 1703. But like the faux pentimento on another almanac, here too the illusionist painter made sure to provide visual clues that the dating had been tampered with, as if added by hand to the wrong place on the title page. The date "1703"—in form and placement unparalleled in any of Collier's forty-plus painted speeches—thus draws attention to the fact that it is wrong. Once again Collier engages in a double act of deception and exposure. With one hand he points to distinctions that

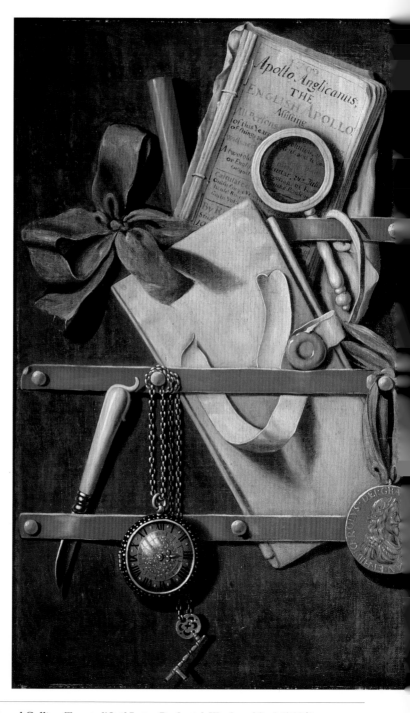

Fig. 4.3: Edward Collier, *Trompe l'Oeil Letter Rack with Watch and Seal*, 1702/3.
50 x 65.5 cm; 19¹¹⁄₁₆ x 25¹³⁄₁₆ in. Museum De Lakenhal, Leiden.

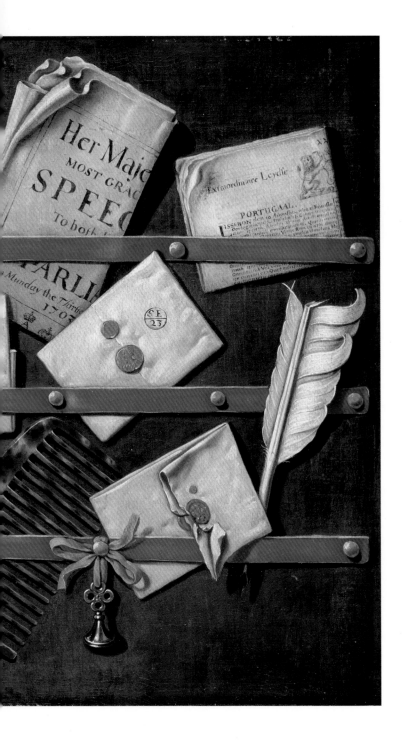

would allow us to tell good information from bad. With the other hand he reminds us that in calendrical matters, as in so many others, the "good" information that is seemingly trustworthy is ultimately just as suspect.

Collier also registered the divergence of the calendars in several painted newspapers by adding the letters "N. S."—New Style—next to the dates of international news (e.g., fig. 3.6, p. 63). I found seven examples, all concentrated in the last years of William's reign: four with news from Madrid and three from Danzig. The fact that no other European city appears three or four times in Collier's extant letter racks may suggest that he picked these cities deliberately. Could it be that Collier was purposefully associating "N. S." with locations in Spain and Poland, two Catholic countries that were the first in Europe to accept Pope Gregory XIII's calendrical reform in October 1582? That Collier painted all these "N. S."–dated news items during William's final years on the throne is also significant, because the years 1699 and 1700 witnessed the most sustained (if unsuccessful) efforts to reform the English calendar between the sixteenth and the mid-eighteenth centuries. Public awareness of the issue was raised by the imminent change of the gap between the English and Continental calendars from ten to eleven days, which was to take effect in 1700. During the same period the usage of "N. S." for calendrical New Style became current. The first instances recorded in the *Oxford English Dictionary* are from 1698 and 1709, but the *London Gazette* had actually begun introducing this abbreviation for foreign dates a few years earlier, and as regular practice from about 1695. Once again Collier did not let a recent change in printed language go unnoticed. Even better for his linguistic-cum-painterly predilections, it was an innovation that bespoke a major instability in contemporary documentary culture and yet could be signaled by two innocuous letters on a painted newspaper page.

Finally, Collier may have taken advantage of one more incongruous consequence of the mess with the Julian and Gregorian calendars: the possibility that a news report of an event on the Continent could appear in an English newspaper published, ostensibly, before the event had ever taken place. Was this what was going on in this painted *London Gazette* (fig. 4.4)? The news report is from "Naples, July 7" but the *Gazette* is dated "Thursday July 2." Or was the paper folded, and it was really July twenty-something? Considering the care with which this detail-conscious illusionist manipulated visual cues, this ambiguity is likely to have been the effect he wished to create, thus encouraging the viewer to ponder how odd the calendrical discrepancy really was. And what month was better suited

Fig. 4.4: Edward Collier, detail of *Trompe l'Oeil Letter Rack with Penner*, 1696 (fig. 6.5). Private collection, Houston, Texas.

to nudge the viewer in this direction than that named after the Roman emperor responsible for the calendar still in use in England, *July*?

III

These calendrical complications were especially meaningful. They did not only join those other fault lines in the broad circulation of information that Collier collected and laid down in such playful ways. They were about the passage of time, about how time is marked and counted and kept track of. In fact, slippages in the marking of time have been with us all along. Surprisingly often Collier chose to showcase instances of variation and instability through their occurrences in notations of time: days (Monday, Tuesday, Friday), months (July, December), and years (1676/1696, 1701/1702). For Collier the record of the passing of time mattered.

The types of printed materials that Collier chose for his letter racks, similarly, were not only mass-produced information publications but also devices for marking time, not merely in the sense that the almanac is a calendar, but in the broader sense that they were all serial publications.

The success of both almanac and newspaper—their very identity—relies on their regularity, which primes their audience to await their next issue. They must continue to come out like clockwork. Each one clocks time with its own unit of measurement: the newspapers mark days and weeks; the almanacs mark years. (The extant letter racks with the *Apollo Anglicanus* register virtually every year since Collier arrived in England, as if he were using the painted almanacs to mark his own time in London year by year.) The monarchical speeches were also serial in their own way, marking royal time that in pre-modern annals was the most basic measure of human history.

Seriality holds important lessons for understanding the new media age. Serial publications must not only keep appearing regularly, they must also keep regular appearance. Like the minutes on the pocket watch that are indistinguishable other than by their enumeration, so the issues of the almanac or the newspaper, or the royal speeches, appear the same. For a serial publication predictability is everything: the reader is conditioned to expect the same familiar package issue after issue after issue. Regardless of the amount of news, the newspaper will always be four pages of two columns each, and regardless of content, every news item will be processed into the form of a paragraph.[4] In a serial, form precedes and structures content.

Nowhere was this more apparent than in Collier's game with the hybrid 1696/1676 title page of the *Apollo Anglicanus* with which this book began. The almanac kept its appearance year after year. When its editor had died, his "authorship" continued unabated, until years later he was replaced on the title page by another with a virtually undetectable alteration in his name. When a royal decree emptied the almanac of astrological content, this shift from celestial to modern science was contained in an unobtrusive change to the editor's credentials. When the printer died and his widow took on the almanac, that change too was contained in the alteration of a single initial. Three significant changes occurred between the editions of 1676 and 1696, and yet they appeared so similar that they presented Collier with an opportunity he could not resist. He created a trompe l'oeil almanac, a non-existing mirage, that was no less true than any of the "real" ones. No matter what historical changes took place, insofar as the printed almanacs were concerned, *plus ça change . . .* This is the nature of serial publications: their continuity of form masks the inevitable changes produced by the passage of time. Time's marks become invisible. It suddenly turns out that movement and circulation and ephemerality notwithstanding, in the age of mechanical reproduction life stood still after all.

IV

Before proceeding further, allow me a perhaps heretical digression.

This chapter considers Collier's investment in the passing of time. Here, as elsewhere, his modus operandi is a clever double act of exposure and deception. As in some of the best whodunit plots, Collier is a master sleuth who is also the perp. But then what is *my* role in this? Sleuth or perp? After all, time is my métier too, not just his. I am a historian. My own modus operandi is to contextualize, to explain what is visible by setting it in the specific historical context of the time from which it originated. I rely on sequences (this happened after that) and on simultaneities (that happened while something else was going on), both of which lead fairly readily—sometimes too readily—to a link and an explanation. But as I sit now at my desk rereading the last few pages, I have a flash of doubt. What have I just done?

On the one hand, I am solving a puzzle using the protocols of my craft as historian. Take for instance the example of the hybrid *Apollo Anglicanus*. I produced documents (the title pages of two almanacs), collected historical information from credible sources (biographical data for the authors Richard Saunders and Richard Saunder, scholarly discussion of James II's injunction against astrology), and employed this information to construct a sequence of events together with a plausible map of causes and explanations. I made assertions with varying, well-calibrated degrees of certitude: from the claim that without doubt Collier had had in front of him two almanacs when he painted this picture, through claims that I deduced therefrom and considered plausible regarding the design of the pentimento, to more speculative claims about his intent.

In executing these protocols I thoroughly ignored Collier's admonitions. Where he raised the possibility that authors are not necessarily who they claim to be, I treated it as a curiosity. Where he showed that publication dates could be tampered with, I trusted them. Where he drew attention to the unreliability of authors' proclaimed credentials, I historicized this observation so that it could not impact the credentials of any author *I* cite. Where he insisted that every kind of information is suspect, I brushed it off. This, after all, is my craft: his is creating illusions; mine is sifting historical truth from untruth. I trust my ability to discern in the overwhelming majority of cases a deception from a reliable source, and to identify and quarantine those few in which I cannot. So as interested as I am in what I take to be Collier's message, about the unstable and illusory

nature of representations, as a historical artifact, it does not stop me as I try to stabilize them and affirm their precise meaning. It is true that every time I think I am done, new slippages open up. But I remain convinced that just one more step and all would be solved, and I know that I will continue to dig until I get there.

Collier must have known this about me too. He knew that whoever would attempt to follow his devices in all their intricate twists would profess an abiding belief in the truth value and stabilizing power of details. And yet Collier is an illusionist, an artist who like a magician performs the protocols of his art by anticipating, controlling, and molding the responses of his audience. Suddenly I have a whiff of realization (or is it paranoia?) that everything that Collier had done in this series of paintings—the insistent repetitiveness, the minuteness of the details, the coded connections, the multiple layers, the private jokes—was but a series of snares, nesting like Russian dolls one inside the other, waiting for a prey of a particular kind: *me*. I look back at that same complex example of the *Apollo Anglicanus*: the trompe l'oeil, the printed almanac, the magnifying glass, the dropped letters, the pentimento. Even as I was becoming increasingly pleased with the ingenuity it took to penetrate Collier's games one after another, I was really only following the illusionist's visible actions on stage while the magic trick itself was taking place elsewhere, all according to the illusionist's plan. I was doing Collier's bidding, puppet at the end of his string. He *wanted* me to figure the puzzle piece by minute piece, and the further I proceed the more I become entangled in his real game, lured by my trust in the historical method to a sense of false confidence, not unlike that of viewers who trust the powers of their eyes to see through the artist's illusionism. In this battle of minds I lost. Collier's illusion depended on—required—a spectator who is also a historian, a sleuth who'd also become the victim. It wasn't I who exposed Collier: it was Collier who exposed me.

This may well be the greatest game that the illusionist played with time. For me, it is also a moment of nagging self-doubt. But I know that in a few minutes I will resume the digging and the historical analysis as if nothing had happened. I cannot curb my own instincts any more than the illusionist can curb his.

Even if I am Collier's perfect prey, however, surely I am not the only one. Why, then, did Collier's puzzle wait for three centuries? The answer to this question also has to do with the passing of time.

We do not know what Collier's patrons made of his art during his lifetime. There are no records of trompe l'oeil paintings sold or viewed during his years in England, and only several instances of vanitas sales.[5] Collier paintings have continued to show up in occasional sales and auctions ever since. I am not the first to try to track him. There were several efforts in previous generations to follow Collier's tracks, efforts that failed.

First was Johann Wolfgang von Goethe. The interest of the great German writer in Collier emerged not as part of his literary pursuits but because of eight large crates that had been sent at the beginning of the nineteenth century to his patron, the Archduke Karl Augustus of Saxe-Weimar, containing the many parts of an intricate eight-foot model of Amsterdam's Town Hall in the late seventeenth century. When Goethe took charge of the model's restoration in 1820, he discovered the name of a painter, "E. Collier," on several small but exquisite panels in the miniature model.[6] As much as he tried to pry information about Collier from the art experts—entreating his friend art historian Johann Heinrich Meyer, who in turn consulted with the painter and scholar Henry Fuseli—Goethe came up with nothing. The century that had passed since Collier's time apparently erased him from memory or record.

Half a century later took place the most sustained effort to track Collier down, in the pages of the English magazine *Notes and Queries*. Described on its title page as "A Medium of Inter-Communication for Literary Men, Artists, Antiquaries, Genealogists, etc.," *Notes and Queries* served as the Victorian precursor to an Internet forum. In 1861 the editors received a letter titled "Old Picture" from one John Corner in Ruswarp, a village in North Yorkshire. Corner asked for information from readers about "a curious picture of merit" that was in his possession, "about 200 years old," which appeared unsigned:

> The background of the picture represents a panel, to which is nailed three red leather straps, running across. In the top one is a knife, pair of scissors, a folded copy of a paper, supposed to be *The London Gazette*. Another folded paper or parchment inscribed as "His Majesty's Most Gracious Speech to Parliament on Tuesday," and also a swan quill.

And so it continued, strap by carefully described strap, all the way to the memory notepad at the bottom.

The readers of the magazine quickly rose to the challenge. The first response came two weeks later from "C. O. B.," who owned two such paintings, including one quite similar to Corner's but "with the following exceptions," which he proceeded to describe in detail. One of C. O. B.'s

paintings was unsigned, while the other included a letter directed " 'For Edward _____ , London' (the strap covering the surname)": so he too knew not the name of the artist. Two more weeks passed and a third correspondent, "SENEX," finally identified the painter as Edward Collier and noted the location of three more of his works, all still lifes. The fourth and final contribution to this thread brought to the readers' attention two more Collier letter racks, one "in the possession of a gentleman at Lea. The other is in an upper room of the Jerusalem Tavern, St. John Square, Smithfield."[7]

With the aid of their connoisseurs' magazine—a better means than was available to Goethe—these Victorians managed within the space of some two months to report eight Collier paintings, all located in more or less modest settings. Still the thread dried up, without enough information to keep going. Fifteen years later the Rev. Richard Hooper of Didcot, a regular *Notes and Queries* correspondent, sent a similar inquiry about two Collier paintings that adorned his Upton Rectory: a vanitas still life with "His Majesty's Most Gracious Speech" of 1697, which reputedly had belonged to Charles Lamb, and a letter rack with "Her Majesty's Most Gracious Speech" of 1702. Although Hooper assured the readers that Collier's paintings were "curious and interesting . . . singularly striking," this time around there was no response at all. Even with two paintings Hooper had very little to go on, other than didactic condescension: "From the misspelling in some of the titles and open pages of the book, and in the royal speeches, Mr. Collier must have either been very illiterate or a foreigner."[8] The puzzle was as safe as ever.

In the late twentieth century, Alfred Frankenstein, a scholar, connoisseur, and art critic for the *San Francisco Chronicle* for almost half a century, came closest than anyone before. Frankenstein encountered a rich Collier letter rack while preparing a private collection of trompe l'oeil paintings for an exhibition. It so happened that Frankenstein was one of the world's foremost authorities on trompe l'oeil art, with particular expertise in the revival of painted letter racks and similar illusionist works in nineteenth-century America. And yet it was Collier's letter rack, not an American revival, that Frankenstein chose to single out from almost a hundred works of art. Collier, Frankenstein declared with all the authority of the seasoned expert, "was one of the most brilliantly inventive still life painters who ever lived." Yes! But Frankenstein immediately followed this promising statement with a shrug: "yet he has never been studied and even the dates of his birth and death are unknown." Even for Frankenstein, whose own hunt for hidden American trompe l'oeil artists was

described as a "Holmesian" masterpiece of detection, Collier remained "somewhat mysterious."[9]

There is a simple reason why I can take you now further than these former fellow travelers, and it brings us back to the effects of time (and timing). Collier's paintings, the key pieces in the puzzle, dispersed as soon as he sold them. They were not seen together during his lifetime, let alone later, scattered as they were across the globe, often in relatively inaccessible places. What allowed me to locate a sufficient number of them and to place them side by side was the dense network of Internet communications and electronic databases for which we use the shorthand Web 2.0. Had I seen that first trompe l'oeil letter rack in the Indianapolis Museum twenty years ago, say, before these new media were available, I doubt that I could have done much more than Goethe, the correspondents of *Notes and Queries*, or Frankenstein. What a curious triumph over time this is on the part of the illusionist: there is something satisfying but also uncanny in the fact that Collier's insights into the new possibilities of his turn-of-the-eighteenth-century revolutionary media moment, those that he coded into small details in multiple canvases, can only be appreciated through the new possibilities opened up by our own turn-of-the-twenty-first-century sequel.

Monarchy in the Age of Mechanical Reproduction

I

If Collier's choices of serial publications underscored how in the age of mass media form trumps content, this was never more significant than in the case of the royal speeches to Parliament, those that he painted to all look alike, regardless of which speech or occasion or even monarch they represented. The pair of painted title pages at the top of figure 3.3, for example (p. 56), manifests a deliberate effort to reproduce speeches identical almost to the last detail, but one from "His Majesty" and the other from "Her Majesty." Although the change in monarchs was one of the most meaningful historical events during Collier's stay in England, with these two speeches he tried his utmost to present the change as virtually undetectable. The copies of the *London Gazette* placed directly to the left of both pamphlets reinforce the effect. In both paintings the *Gazette* displays royal proclamations, likewise visually interchangeable though one is "by the King" and the other "by the Queen." This was the fate of politics in the new media age. With the same packaging all speeches were interchangeable, even those of a king and a queen who everyone knew represented two remote poles on the political spectrum, and who for many years did not even speak to each other.

At the same time, this was a comment not only on what befell politics in a new print world but also on what befell *royalty*. As political documents these speeches had an exceptional status: they were public royal pronunciations at a time when monarchy still had a special—indeed divine—aura. Or at least made claims to one.

Royalty was a major preoccupation for Collier. It is everywhere in his letter racks, most commonly in the speeches to Parliament, which in post-1688 England were a particularly apt representation of the power of the monarch within the revolutionary settlement. But royalty is also present in occasional monarchical proclamations in the *London Gazette*, in the faces on the seals on letters, and in the words so prominent on every painted copy of the *Gazette*, "Published by [authority]" (or the variant "Publish'd by": Collier simply couldn't help himself). Collier never actually painted enough of the newspaper to get in the word "authority." As long as everyone knew what was missing, this was a more effective evocation of the present-absent royal oversight than spelling it out.

Images of royalty are also present in many letter racks directly, in the form of coins, medals, and miniatures (fig. 5.1). And yet even those are not direct images of the sovereign. Collier did not paint royal portraits, only objects that represented royal portraits: repetitive objects, objects that like the printed speeches were generic and mass-produced.

Despite all being mass-produced, medals, miniature portraits, and speeches—the three main types of objects that introduce the sovereigns into Collier's letter racks—belong to quite different media. Medals are sanctioned by authority, minted by privilege, and impervious to time. When Joseph Addison published a book on "the usefulness of ancient medals," Alexander Pope added to it a verse prologue in which he admired the quality of the medal:

> The Medal, faithful to its charge of fame,
> Thro' climes and ages bears each form and name:
> In one short view, subjected to our eye,
> Gods, Emp'rors, Heroes, Sages, Beauties lie.[1]

Medals inspire confidence and awe. They are faithful, enduring, long-term memorials to the greatness of the face's value.

The case of the miniature portraits is more complex. Royal portraits were an important vehicle of regal authority and what has been described as "supra-personal aura." Louis Marin, the foremost expert on this question, reads Hyacinthe Rigaud's ceremonial portrait of Louis XIV painted in 1701—precisely when Collier was busy with his letter racks—as an exemplary display of the divine glory of the king's body, which sets the absolute monarch apart from mere mortals. The only real audience for this portrait is the king alone; everyone else is simply the object of the painted king's gaze, not the other way around. As a midcentury Spanish writer

recorded his encounter with a Velázquez portrait of Philip IV, the king appeared "full of grace, august in his countenance . . . I was overcome with such respect, I knelt down and lowered my eyes."[2] The royal portraits that achieved such effects were large, regal, majestic, quite unlike those that Collier included as objects in his paintings. His are readily multiplied, publicly available, miniature representations of the regal portrait. Indeed, he chose rather cheap ones in comparison to more upscale miniatures in gold frames or lockets. Collier's painted miniatures are still memorials to the king with his distinctive features (the hair, the moustache and goatee, the armor, the medallion of the Order of the Garter) and thus easily recognizable for contemporaries and near-contemporaries. Unlike the coins and medals that carry a caption for distant posterity, the miniature portraits do not, and thus rely on prior familiarity. At the same time, these are not so much portraits of a king in the sense evoked by Marin as they are signs, echoes, almost cartoons, of such a portrait, placed among the mundane materiality of combs, pens, or letters. They have lost the aura but kept the memory, if for a shorter term.

Finally, in the speeches, two further qualities of the representation of the royal image are lost. Collier's painted speech pamphlets are no longer distinct: no medallion or moustache sets one monarch apart from another. And they are ephemeral: dog-eared, crumpled, decaying from their very entry into the public domain. This form of royal embodiment in cheap print possesses no aura, loses its distinctiveness, and lacks durability. This is the sobering fate of monarchy in the age of mechanical, printed, reproducibility.

<div align="center">II</div>

The desacralization of the monarchy was a sea-change on the path from early modern Europe to modernity. In absolutist France, the challenge to Rigaud's majestic portrait was embodied perhaps most evocatively by the painter Antoine Watteau in his last masterpiece, *L'Enseigne de Gersaint* (1721). The three-meter-wide painting, designed as a shop sign for the art dealer Gersaint, shows a floor-to-ceiling display of multiple artworks for sale. Among them, off-center to the left, is a portrait of the deceased Louis XIV—obviously by Rigaud—in the process of being packed sideways in a crate, no differently than a landscape, a classical scene, or the nude nymphs inspected by the clients on the right. Perhaps a vanitas

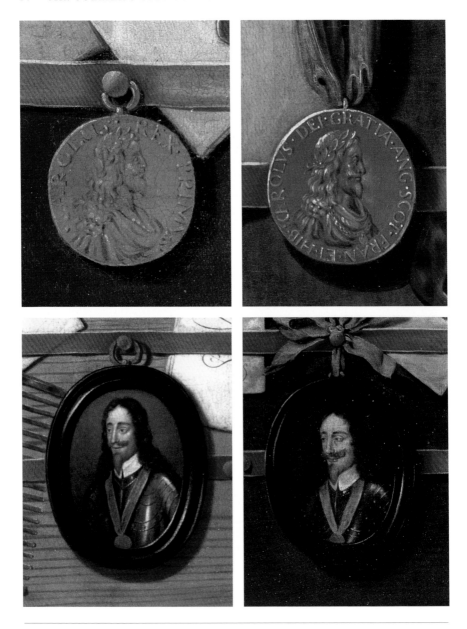

Fig. 5.1: Edward Collier, details of letter rack paintings: royal medals and miniature portraits.

gesture, but surely one that radically debased the king's standing. One scholar has called this a "post-absolutist" painting, though it was created decades before absolutism was in fact over.[3]

In Britain, which had only recently banished the specter of absolutism together with James II, Collier was already producing paintings with a similar

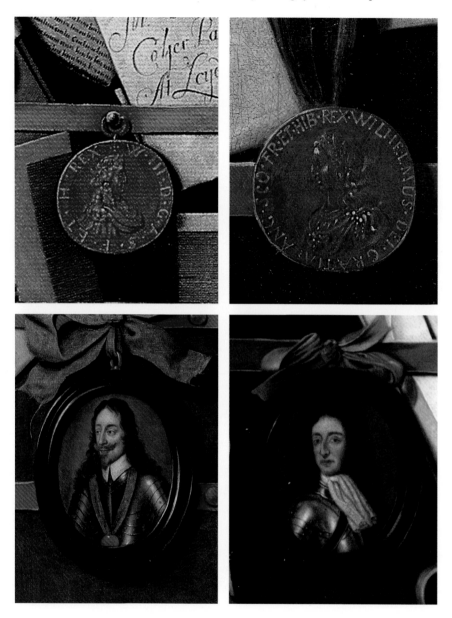

point twenty years before Watteau. Figure 5.2 shows a pair of royal portraits by Collier, of William and Mary, or more precisely, a pair of royal images based on portraits. The trompe l'oeil paintings show prints of both monarchs nailed to wooden boards. The prints are coming off the boards and curling up, presumably (at least for William) from having lost a nail. Just like Watteau's Louis XIV, here were the king and queen partly bundled up and

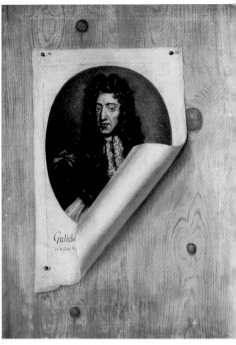

Fig. 5.2: Edward Collier, a pair of trompe l'oeils of engraved portraits of William and Mary pinned to boards. Each 59 x 43 cm; 23 x 17 in. Photo Collection RKD, The Hague.

not particularly regal. There is another such painting of a print of Queen Anne, curled up as well as torn, which is unsigned but likely also to be Collier's. These paintings, it should be noted, stand out in Collier's work. Collier painted at least two dozen trompe l'oeil portraits in the form of prints attached to a wooden board. Many repeated Collier's favorite characters, Erasmus and Charles I. Others were of lesser figures, mostly dead—like poets Abraham Cowley and Samuel Butler or painters Anthony van Dyck and Hans Holbein—but also living, like the dissenting minister Samuel Slater, whom Collier painted as a print-on-board in 1695, a decade before his death. Virtually none of these prints-on-boards display so prominently signs of neglect and decay like the curled-up and torn monarchs of Collier's own time.

Of course, Collier had a long history of displaying the signs of monarchy after their regalness had worn off, in the form of crowns and scepters strewn about in his vanitas compositions. The theme was a traditional one:

sic transit gloria mundi, even of monarchs. But although the immediate meaning of Collier's curled-up portraits is similar, their effect, like that of Watteau's king-in-a-box, is quite different. Without the vanitas context, they simply brought the monarchs down to earth. This was not a moralizing vanitas belittling kings in the name of a higher, even sacred, purpose: it was rather a desacralized image of kingship.

III

Collier's two insistent preoccupations, the status of royalty and the irregularities of print, came together in one extraordinary detail in his letter racks. It was the realization of this detail, representing a consequential blunder and demonstrating the keenest of observations and a dogged determination, that convinced me early on that Collier was a singular individual on a singular mission.

This detail is part of a significant feature of the painted speech pamphlets that has so far escaped our attention: the royal arms and monograms. Or, more correctly, the royal cyphers, which are the initials of the king or queen—"W" or "A"—and an "R" for Rex or Regina, typically surmounted by crowns. When painting King William's speeches, Collier for the most part left out his arms and monogram, though occasionally one can find the crowned "W" and "R" (fig. 3.1, middle of second row, p. 52). But in Collier's renditions of Queen Anne's speeches the crowned "A" is everywhere and all too conspicuous. Sometimes, it seems, to an exaggerated degree: could it really have been the case that the queen's monogram appeared so far to the side of the pamphlet as portrayed in the letter rack in figure 5.3 (bottom right)? To answer this question I went back to the original title page of the Queen Anne speech that Collier painted here and many other times, which she delivered soon after ascending to the throne, on "Munday the Thirtieth Day of March, 1702" (fig. 5.3, top right). And then came the surprise: the royal monogram was not there.

This was indeed peculiar. The cyphers represented the monarch. They were the closest one could get in print to a royal seal of authenticity and personalized signature similar to that of a handwritten letter. Royal insignia are of considerable importance: there was (and still is) a distinct profession, the herald painter, dedicated to presenting them properly. So what happened here? The "Printers to the Queen"—as they proudly

Fig. 5.3: Title pages of King William and Queen Anne's speeches to Parliament, next to one of Edward Collier's. 1696 and 1704: reproduced by permission of The Huntington Library, San Marino, California. 1702: Houghton Library, Harvard University.

announced themselves on the title page of every royal pamphlet—printed the speech without their queen's monogram. To add insult to injury, they left behind the crowns under which the former king's "W" and "R" used to be (fig. 5.3, top left), and under which the present queen's "A" and "R" should have been, floating purposelessly midpage.

This omission was not a momentary lapse. A survey of the official publications of the queen's printers reveals that it was repeated in every pamphlet of every speech of Queen Anne's for more than two years, as well as in other royal proclamations.[4] On one occasion matters got even worse: for Anne's speech of 27 February 1702/3 the sloppy printers to the queen actually reused the royal arms with the monogram of the now-quite-dead King William. This particular embarrassment was apparently noticed, because the printers also produced a second version of the 27 February speech without this mistake. But it was not until April 1704 that the queen's printers finally corrected their repeated omission and restored the queen's cyphers to her speech's title page, in a new design that was less conspicuously placed and without the crowns (fig. 5.3, bottom left).[5]

Collier was aware of this continuing gaffe from the very beginning. There is simply no other possible explanation for his insistence on painting the title page of Queen Anne's 1702 speech again and again while adding a crowned "A" in the most eye-catching manner. He was not merely aware; he was evidently interested in this significant letter-size mistake to the point of responding to it with an emphatic correction in a repetitive series of paintings. Subsequently, when in 1704 the queen's printers finally caught on, Collier was familiar with this newly corrected design as well, as can be seen in the pair of still lifes in figure 5.4. On the right is the queen's speech of 1702 with Collier's own design for her cyphers, while in the painting on the left he faithfully reproduced a 1706 speech in the official version with the inconspicuous uncrowned ones. But in his letter racks even after 1704 Collier continued to paint the same older speech with the same attention-grabbing self-designed "A" as before, as in the example from the same year, 1706, on the left of the second row in figure 3.1 (p. 52).

Collier planted this device in eleven of his fourteen surviving letter racks that are clearly datable to the reign of Queen Anne. Of all his games and tricks, it is the most tenacious, at times requiring him to forgo the visual logic of the painted title page. It is not hard to understand why. This typo was perfect fodder for Collier's preoccupation with the fault lines of the ephemeral, rapidly turned around, widely circulated products of Print 2.0,

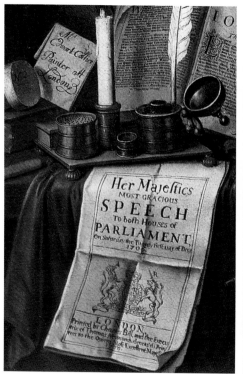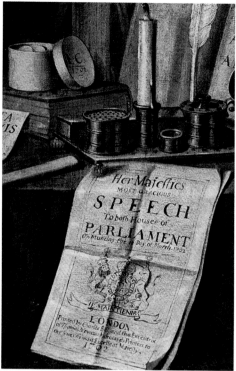

Fig. 5.4: Edward Collier, details of two still lifes with the queen's speeches, 1702 and 1706. *Left*: Courtesy of Christie's, London. *Right*: Photo Collection RKD, The Hague.

as well as for his interest in the consequences of these qualities of cheap print for royal authority. It was the best single example for Collier's critique of media in the new information age: a king-size typo.

<div align="center">

IV

</div>

The "archive" Collier left behind, we need to remind ourselves, was not one of pamphlets and documents but of paintings. Doesn't the medium matter? The discussion thus far may well have underestimated the power of the medium of painting to offset the mass media effects of print.

On the one hand, prints like those of William and Mary painted by Collier were the mass-circulation products of the age of mechanical reproduction, hot off the presses, cheapened, desacralized, and aura-deflated. Even more so in the example in figure 5.5, because of the credit line that

Fig. 5.5: Edward Collier, *Trompe l'Oeil with Print of Charles I after Van Dyck*. 34 x 28 cm; 13.5 x 11 in. Courtesy of Rafael Valls.

Collier added to Charles I's "print": "A. Van Dyck. Eqúes pinxit. E. Collier. Fecit." The original behind this series of representations went back to Charles I's court painter Anthony van Dyck, whose twelve-foot equestrian portrait of Charles in armor is indeed very similar to this print. The chain of transmission originated, then, with a commanding majestic portrait, unique and aura-laden, much like Rigaud's Louis XIV, before it was cropped, reduced, and rendered for mass circulation. The desacralization of the monarch went hand in hand with the deflation of the work of art, and Collier, it seems, wanted viewers to know this.[6]

Furthermore, although prints had been around for a long time, this particular period saw new trends in their production and circulation that reinforced this effect. Historians of the print medium note the shift from the fifteenth and sixteenth centuries, in which prints of invention—that is to say, original art—were as important as prints of reproduction, to the seventeenth and eighteenth centuries, in which prints became devoted overwhelmingly to informational and other reproductive uses. This shift, which according to the experts was first noticed by a self-aware contemporary in 1681, was in many ways a visual-print parallel to Print 2.0.[7] More distinctively, what gave Collier's painted prints an even fresher modern quality was that they were *mezzotints*: a technique recently invented and imported from the Netherlands that from the 1680s took hold in England with such enthusiasm that it soon came to be known as *la manière anglaise*. The mezzotint was the first tonal method that allowed the reproduction of half-tones without visible lines or dots, and thus made possible supposedly unmediated reproductions of oil paintings. Like photography in the nineteenth century, mezzotinting was seen to circumscribe further the role of the artist—the engraver—in an increasingly mechanical production of copies.[8]

But these are the prints. Collier's paintings in which they are embedded, by contrast, are unique creations in oil on canvas: a completely different medium with a completely different effect. One could even say that the contrast between the reproducible print and the unique canvas is the very nub of such a composition. If the printing press and the mezzotinting technique worked to undermine authenticity and singularity, the oil painter worked to restore them. In the case of the mezzotint he did so literally, by returning the image that had been removed from oil painting to print back again to oil. In his

Fig. 5.6: Edward Collier, trompe l'oeils of prints of Charles I and Erasmus pinned to boards. Charles portraits courtesy of: © The Berger Collection at the Denver Art Museum, USA / The Bridgeman Art Library; Photo Collection RKD, The Hague; Rafael Valls. Erasmus portraits courtesy of: Fresno Metropolitan Museum of Art and Science; SØR Rusche; Sotheby's.

trompe l'oeil painting of Charles I, then, Collier appears to resist the effects of print circulation: he extracts the representation of the monarch from the domain of mass production and endows it again with the aura of art.[9]

Yet Collier did not leave matters so simply. A painting like this one of Charles I indeed draws attention to the difference between the trompe l'oeil oil-on-canvas and the print represented therein. But what if we have a whole series? Collier in fact repeated the paintings of iconic figures such as Charles I or Erasmus many times (fig. 5.6). The effect suddenly seems reversed. Rather than allow his oil paintings the uniqueness of art, Collier turned his art itself into a serial mass-produced form.

If Collier was indeed experimenting with serial production in art, surely nothing constitutes a better demonstration of this than the dozens upon dozens of letter racks, paintings so similar and yet distinguished from one another through a disciplined play with details. By repeating every element so many times Collier transformed those very details that were supposed to confer individuality on a particular canvas—a dated pamphlet, a specific newspaper issue, a postmarked letter, a comb—into the markers of the seriality of the whole group, analogous to the seriality of the products of mass print.

This proposition may seem overstretched. In what sense did the letter racks constitute a series? Each painting, after all, was painted and bought as an autonomous stand-alone work, and had to wait three hundred years to be seen as part of a group. Furthermore, the repetition of elements over and over was standard procedure for lesser artists in this period, who specialized in multiple arrangements of bunches of flowers, say, or of fish on a table. Such practice was dictated by the exigencies of an increasingly difficult art market and was more a commentary on the declining fortunes of artists than on the declining aura of art. Collier's letter racks, arguably, did not have meaning as a series before I created it.

Perhaps. And yet I think Collier himself may well have conceived of the letter racks as a series. Their seriality suggests a distinct shift in his understanding of his own art as he moved from the established art world of the Netherlands, in which his production of similar yet not serial paintings had been in line with the artistic practices of the Dutch golden age, to England, where he found a new environment that elicited from him a different practice altogether. Furthermore I believe Collier may have left a sign that he conceived of the letter rack paintings in this way.

The sign is in the postmarks that are found on so many of Collier's sealed letters, the Bishop Marks in the form of a divided circle with the day of the month and the two first letters of its name. All told, there are

39 legible postmarks in the paintings I have seen, not counting the differently shaped Penny Post postmarks. Their spread is not random. Every month is represented in at least one or two of Collier's postmarks: "IA," "FE," "MA," "AP," and so forth. But one month stands out as far more popular than any other, providing almost half of all painted marks (18 out of 39): the month of November, or "NO" for short. When set side by side, as in figure 5.7, these stamped letters suddenly suggest another signification: no. 15, no. 16, no. 23, no. 25, no. 26, no. 29 . . . So: given that "NO" appears much more frequently than any other month; given that it is concentrated particularly during Collier's earlier years in London, in 15 of the 23 painted postmarks extant from the reign of King William; given that "NO" is combined with a spread of different numbers for days of the month (so not marking someone's birthday, say); given that the usage of "no." for enumeration appears in English from the second half of the seventeenth century, and that Collier actually included it as such in several vanitas paintings on the caps of boxes of seals (as in fig. 5.4, left, p. 94); and given Collier's attraction to the meanings of letters, numbers, and abbreviations, not least in bureaucratic usages, and all the more so if recently introduced; given all these, is it farfetched to understand these particular postmarks to be also a device, developed during Collier's experimentation with this genre in his early London years, for enumerating the letter rack paintings as parts of a series? Is it farfetched to suppose that "no. 24" is still out there?

Serial production, to be sure, is not quite the same thing as mass production. In a series every element is similar to the others in most things but different in some meaningful detail, a detail that safeguards its individuality within the series. Each letter rack is not quite like any other. In the group of Collier's Erasmus portraits, although they all appear to draw on the same identifiable engraving that itself drew on a Holbein painting, Erasmus's faces actually differ considerably in age and expression.[10] So we can still see this series as resisting the logic of mass production, not unlike printed texts that are allegedly identical yet differ in their spelling or appearance. And yet the seriality itself is meaningful, signaling that not only monarchy lost its aura in this first age of mechanical reproduction. Long before Walter Benjamin, Collier appears to have already been playing with the idea that in an age of mass production the reproducibility of print as well as of the painted canvas significantly compromised the uniqueness of art.

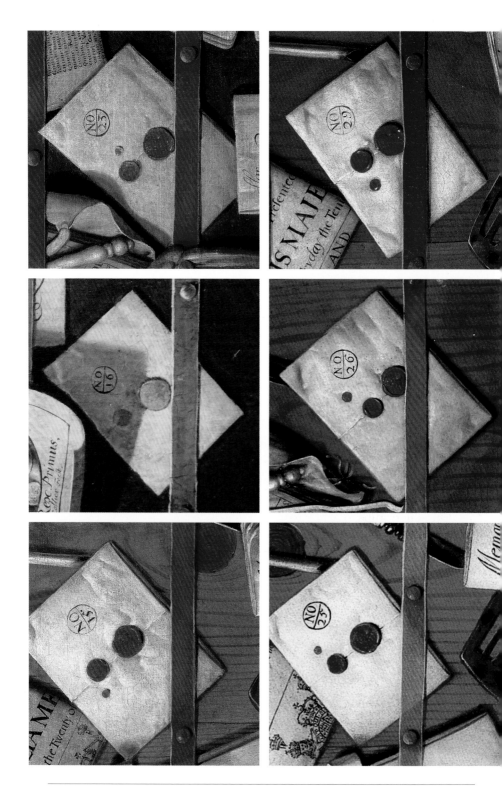

Fig. 5.7: Edward Collier, details of letter rack paintings: letters with November postmarks.

Eye Con

I

Collier's letter rack paintings, I have suggested, are meaningful in the context of a late-seventeenth-century media revolution that he encountered upon his arrival in England. His paintings are also related to early modern developments in visual culture: the proliferation of royal imagery, new use patterns for prints, and the late-seventeenth-century development of mezzotints. One further development in visual culture is key to understanding what Collier was doing and why in this particular form: the development of trompe l'oeil painting itself.

Although trompe l'oeil as a painterly technique has a long history, going back to deceptive frescoes in Roman Pompeii or in Renaissance churches, the practice of taking eye-deceiving art off walls and ceilings (or other surfaces, like a painted insect that can appear to sit, in fact, on top of an artwork) and onto movable paintings was largely a mid-seventeenth-century innovation. In fact, its arrival in a bona fide painting was announced with some pomp on a particular day, 6 August 1651. Samuel van Hoogstraten, then an ambitious young pupil of Rembrandt's, arrived at the court of the Holy Roman Emperor Ferdinand III to seek patronage. Of the three paintings he brought with him, one in particular drew everyone's attention, a still life that perpetrated illusionist trickery on the viewer. As the story was recounted many years later by one of Van Hoogstraten's students, the emperor "looked at it for a long time and, finding himself still deceived, he said, 'This is the first painter who has deceived me.' And

he went on to say that as a punishment for that deception he should not get the picture back."[1] In return for the trompe l'oeil painting Van Hoogstraten received a special imperial medallion on a heavy gold chain, which he proceeded thereafter to insert into as many of his paintings as he could get away with.

Good story. It would be more believable if it did not happen again. To the very same emperor. In the very same year.

The competing tale was told by the painter and art theorist Joachim Von Sandrart. A minor German prince wanted to curry favor with Emperor Ferdinand III, so he sent him as a diplomatic gift two paintings by the Alsatian-born and Flemish-trained artist Sebastian Stoskopff. One of them was a trompe l'oeil: a painting of a board to which was affixed the "engraving" of *The Triumph of Galatea*, itself created by Michel Dorigny after a painting by Simon Vouet (fig. 6.1). Von Sandrart, Stoskopff's student, was charged with delivering the gift. He remembered distinctly how he held up the work for the emperor, who promptly reached out to remove the print by hand, laughed at the artful deception, and—again—added the painting to his gallery in Prague.[2] The year was 1651. So either the story was recycled and retold multiple times by pupils of different masters, each appropriating it for their own, or else this was one unusually gullible emperor.

The very origin of the trompe l'oeil genre is thus mired in illusionist uncertainty, though it is Stoskopff's *Galatea*, which survived in the imperial collection, that is often proclaimed as the first freestanding trompe l'oeil painting of the seventeenth century. Regardless, it was more or less from that moment on that Netherlandish artists and a smattering of others (French, German, Italian, Spanish) started painting trompe l'oeils that could fit onto rectangular panels and canvases: faux cupboard doors, faux cabinets, faux windows, faux niches, faux bookshelves, faux boards with things hanging on them—be they game, engravings, or musical instruments. With the trompe l'oeils emerged a new audience willing to be delighted by being fooled, like the famous London diarist Samuel Pepys, who became a devoted fan of Van Hoogstraten when his peregrinations had taken him to England. Pepys recorded on one occasion seeing "several things painted upon a deal Board, which board is so well painted that in my whole life I never was so pleased or surprised with any picture, and so troubled that so good pictures should be painted upon a piece of bad deale." Of course Pepys immediately realized his mistake: "even after I knew it was not board, but only the picture of a board, I could not remove my fancy."[3] And if that subterfuge was clever, it could still be outdone. One of the most striking experiments of the seventeenth century came

Fig. 6.1: Sebastian Stoskopff, *Trompe l'Oeil: The Triumph of Galatea*, 1651. 65 x 54 cm.
Kunsthistorisches Museum, Gemäldegalerie, Vienna.

from the brush of Cornelius Gijsbrechts, illusionist extraordinaire, who
produced a startlingly modern-looking faux backside of the painting itself
(fig. 6.2). The ingenuity of these designs was driven by the realization that
the repertoire of objects that are square, flat, and more or less the size of a
painting (for a trompe l'oeil to fool anyone, of course, it has to portray

Fig. 6.2: Cornelius Gijsbrechts, *Trompe l'Oeil: The Reverse of a Framed Painting*. 66.4 x 87 cm. Statens Museum for Kunst, Copenhagen, © SMK Foto.

things in actual size) is in truth quite limited. It is even more limited if the artist wished to use the framing device to include a variety of smaller objects, like a two-dimensional still life table. For that, no device was more suitable than a faux letter rack.

II

But why the sudden fascination of easel painters, as distinct from house decorators, with eye-fooling paintings at this time?

As scholars often point out, Dutch painters of the golden age were unusually preoccupied with verisimilitude and with quasi-scientific ways of achieving it. The two places in Europe that were most invested in the scientific exploration of vision, leading to the development of new

optical technologies such as the microscope or an improved camera ob-
scura, were the Netherlands and England: the two poles of Collier's
career. It has become a point of much debate whether and to what extent
artists like Vermeer, Dou, or Van Hoogstraten used optical devices to
aid their painting, but there is no doubt that trends in optical science
and in art, especially still life painting, went hand in hand. That Dou
used magnifying glasses is a documented fact. Samuel van Hoogstraten
conducted optical experiments with his pupils in his studio and even
recorded one of them—the "dance of the shadows"—in an evocative
print. The long-standing interest of the Habsburg court in experimental
arts and sciences, not least astronomy and optics, was what had drawn
Van Hoogstraten to seek the patronage of Emperor Ferdinand III in
1651 and kept him busy in Vienna through the first half of the 1650s. In
1662 Van Hoogstraten moved to London, where he found himself once
again in an environment favorable to experimental arts and sciences,
manifested in the recently established Royal Society. The London scien-
tific community became keenly interested in his illusionist art, and it
was here that he developed his series of letter rack paintings. Van Hoog-
straten reported proudly on his inclusion in these circles through the
invitation of Thomas Povey, merchant and colonial administrator, in
whose house he was wined and dined lavishly, along with other mem-
bers of the Royal Society. In return Van Hoogstraten painted for his
host one of the most remarkable achievements of illusionist painting:
the almost nine-foot-high canvas *Perspective from a Threshold* that cre-
ated behind a closet door the illusion of a corridor with a series of open
doorways where in fact, as Pepys delightedly reported, "there is nothing
but only a plain picture hung upon the wall."[4]

The scientific exploration of optics led to a paradox that was captured
well by trompe l'oeil art. On the one hand, this was the heyday of Euro-
pean confidence in empirical observation, striving to stretch the powers of
optical science to their limits. On the other hand, there was a growing
realization and attention precisely to these limits, to the places where even
the eye could falter. "It doth happen often to me," admitted the master
microscopist Antoni van Leeuwenhoek in 1699,

that People looking through a Magnifying-glass, do say now I see
this, and then that, and when I give them better Instructions, they
saw themselves mistaken in their opinion, and what is more, even he
that is very well used to looking through Magnifying-glasses may be
misled by giving too sudden a Judgment, of what he doth see.[5]

A magnifying glass, warned the scientific expert, does not make the eye foolproof. This is precisely the same warning that the illusionist expert Collier appeared to issue at almost precisely the same time, when he placed his own magnifying glass on top of the impossible 1696/1676 almanac title page. Collier magnified here, so to speak, the doubt that inheres in every trompe l'oeil as it suspends its viewers between the conviction that they see through the contrivance and the doubt that they are being fooled. A trompe l'oeil by its nature constantly affirms that every supposedly certain truth claim harbors its opposite, and vice versa.[6]

There appears to be only one surviving account of a seventeenth-century patron purchasing a trompe l'oeil letter rack: a painting of "several letters, pens, penknives, Spanish wax attached to some cords nailed to a board, with a half-pulled curtain." The artist who offered this illusionist letter rack for fifty ecus was almost certainly Cornelius Gijsbrechts. What makes this a telling transaction is that the buyer came right from the midst of the scientific microscopists' milieu. He was the French diplomat Balthasar de Monconys, a scientific traveler and avid aficionado of microscopes and lenses, and now also of letter rack paintings. The year was 1664, precisely when Van Hoogstraten was producing his own letter racks in London.[7] Indeed, Monconys would probably have also liked the Van Hoogstraten letter rack in figure 2.2 (pp. 34–35). Its main theme, after all, is optics, with its magnifying glass on top of the printed play *The Rump*, which in turn draws attention to the word "Mirrour," an optical metaphor. And at the middle of the composition is a medal that is itself an optical gimmick: a trick double-sided medal that when looked at upside down turns a dignified man into a fool.

III

The debt that Collier's letter racks owed to Van Hoogstraten's is unmistakable: the three wide horizontal straps of red leather; the selection of objects—pen and pen knife, scissors and combs, and especially those magnifying glasses overlaying the printed pamphlets. Indeed, they are so similar that when Van Hoogstraten's *Rump* painting surfaced in a Sotheby's auction in New York in 1991 it was offered and sold as a Collier, before the experts corrected its identification.[8]

The *Rump* painting was auctioned together with a second letter rack also identified as a Collier, which was likewise reidentified later by the

same expert as Van Hoogstraten's (fig. 6.3, top). This second painting, which was evidently of lesser quality, has since disappeared. It presented a curious problem. On the one hand, it certainly looks much like Van Hoogstraten's *Rump* and shares with it the prominent display of Van Hoogstraten's imperial medallion, which was the basis for its corrected attribution. On the other hand, I was certain I could see the letters "EC/2" in place of the familiar postmark on the sealed letter, and needless to say, there is no month that begins with "EC." So was this painting despite everything a Collier? And yet it did not really look like the other Collier letter racks. Furthermore, what about the medallion? There is one other early Collier letter rack, signed and dated 1684, with a similar medallion.[9] So what was Collier doing with Van Hoogstraten's cherished badge of honor?

I found the solution much later, in a privately owned and heretofore unknown Van Hoogstraten painting that only surfaced in 2005 (fig. 6.3, bottom). Here was the missing link. The two letter racks are strikingly similar in their busy arrangement of multiple objects as well as in their details. Evidently, the enigmatic half-Collier-half-Van-Hoogstraten painting that disappeared in New York in 1991 was Collier's copy of Van Hoogstraten's earlier one of 1663, imitating its design so closely that the result was deliberately confusing. But where Van Hoogstraten placed the Bishop Mark "FE/2"—a particularly interesting detail, since this type of postmark had only been introduced a couple of years before Van Hoogstraten reproduced it—Collier placed instead his initials, "EC/2." The other early Collier letter rack dated 1684, likewise sporting Van Hoogstraten's imperial medallion, was also a loose copy of the same 1663 painting, as attested to by two distinctive interlocking rings at the bottom left of both original and copy. I was as certain as one could be that these were Collier's earliest, tentative steps into the letter rack genre, an experiment in reproducing the illusionist composition of his elder.

IV

Collier's copy of Van Hoogstraten's letter rack also replaced the latter's self-portrait with another. Given the quality of the copy, it is unclear whether the grim-looking man in the octagonal frame was Collier himself. But I knew one other such painting into which Collier inserted himself through a miniature self-portrait, the Glasgow letter rack with the almost

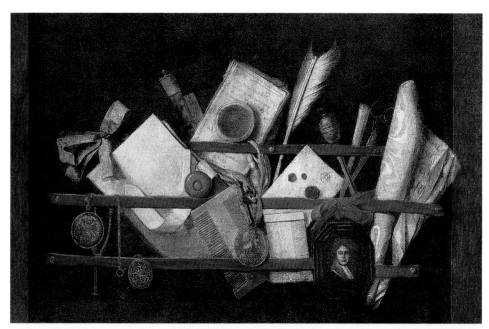

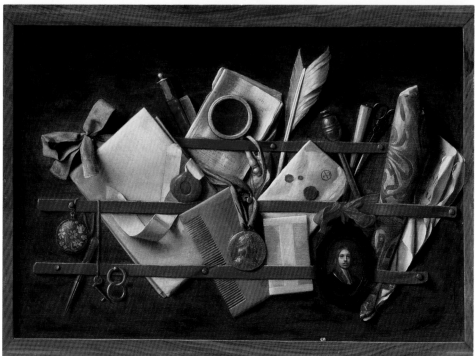

Fig. 6.3: *Top:* Edward Collier, *Letter Rack with Portrait in Octagonal Frame*, 1683–84. 44.5 x 66 cm. Courtesy of Sotheby's, New York. *Bottom:* Samuel van Hoogstraten, *Letter Rack with Self-Portrait in Octagonal Frame*, 1663. 44.7 x 60.7 cm. Private collection, Paris.

impossibly deceptive *Apollo Anglicanus* (fig. 0.2, pp. 10–11). The positioning of Collier's self-portrait, and indeed the composition of the Glasgow letter rack more broadly, obviously hark back to Van Hoogstraten's earlier model. Yet Collier's self-representation plays a weightier role. For Van Hoogstraten the portrait complements other forms of self-representation in the painting: his name on the almanac, his imperial medallion. For Collier in the Glasgow painting the self-portrait stands all alone. Unlike his other letter racks, this one includes no handwriting or signature. The portrait itself thus becomes the signature, and the face the guarantor of authenticity. This effect is reinforced by the other two circular objects aligned with Collier's miniature: the seal on the letter under the middle strap, stamped with a clear face—its own sign of authenticity—that echoes Collier's; and the magnifying glass under the top strap, drawing attention to the deceptive almanac with its elaborate cautionary note about the unreliability of printed authorship. Trompe l'oeil or not, pentimento or not, the message seems to be that ultimately it is only the unmediated visual representation—the portrait is not even accompanied by a name—that one can trust.

Or can one? Collier's insistent illusionism once more gets in the way and sets his self-portrait apart from the earlier model he had seen in Van Hoogstraten's composition.

Although unnamed, it is easy to recognize Collier in the miniature portrait hanging from the Glasgow letter rack. The figure bears an unmistakable similarity to other Collier self-portraits (fig. 6.4): a 1684 painting of Collier in his studio, and a "print" titled "EDUWARDUS COLLIER" in a 1687 vanitas still life. The long, slightly arched eyebrows, the aquiline nose, the straight, sharply delineated lips, the unobtrusively cross-eyed look, and the dimple on the left chin, together with the posture, the wig, the velvet coat, and the cravat, leave little doubt that all three, as well as a fourth that will be discussed later (fig. 11.3, p. 194), were drawn after the same original.

But something is not quite right. Collier was in his midfifties when he painted the Glasgow letter rack with the hanging miniature portrait. This is surely not the age of the man looking out from the oval frame. He appears perhaps a tad older in the middle self-portrait than in the one on the left, which preceded it by twelve years. But this earlier portrait of 1684 also does not seem to represent a man in his early forties, a discrepancy that others have noted before.[10] Collier painted himself frozen in time, a ghost of his own past, an illusion of a young man. The self-portrait in the trompe l'oeil was him and not him at the same time.

Such a practice was unusual. The several self-portraits of Van Hoogstraten show him clearly aging from one to the next. Rembrandt, his teacher, had left

Fig. 6.4: Edward Collier, three self-portraits (details). *Left:* From *Self-Portrait with Vanitas*, 1684, courtesy of Johnny van Haeften. *Center:* Detail of *Trompe l'Oeil Letter Rack*, c. 1696 (fig. 0.2). *Right:* From *Still Life with Bust*, courtesy of Noortman Gallery.

behind an unparalleled series of self-portraits that wallowed in the details of aging. One possible precedent for Collier's age-defying self-representation may be found in his own town of Leiden a generation earlier. In 1651 the artist David Bailly, then sixty-seven years old, painted a vanitas self-portrait that showed him as a young man holding a smaller portrait of himself as an older man. Some have found this so peculiar that they doubt the identification of the young man as Bailly's younger self.[11] But whether or not this reading of Bailly's painting is correct, and whether or not Collier was aware of Bailly's painting, for an artist so preoccupied with the passage of time the series of frozen self-representations in figure 6.4 was surely not a coincidence. And for an illusionist so preoccupied with the deceptiveness of representation, the "signing" of a letter rack with a self-portrait decades out of date may well have been a comment about the limits of authenticity and trust even in the unmediated visual medium. While Collier's right hand was working to expose misrepresentations and deceptions, his left was multiplying new and ever more intricate ones.

The hanging miniature portraits of the two artists thus reveal their different stakes in their illusionist art. Van Hoogstraten, when push came to shove, subjected the potential for visual deception in his trompe l'oeil to

the requirements of authenticity in his self-presentation. Collier, conversely, subjected the authenticity of his self-presentation to his exploration of the limits of empirical observation. Van Hoogstraten's choice was in line with his general practice of packing letter rack paintings with self-referential objects. The more his trompe l'oeils turned into carefully contrived ego trips focused on his own self—that is to say, the more he invested them with claims to authenticity—the less effective they could remain as warnings that things are not really what they seem.[12] Collier, indebted as he was to Van Hoogstraten for the letter rack trompe l'oeil composition that served him so well in questioning the reliability of the medium of print, also pushed it further in calling into question the reliability of the visual medium itself.

How far he was willing to go is evident in one letter rack with a startling twist, one in which Collier all of a sudden broke the rules of illusionist painting and mischievously gave the game away. At first glance this 1696 trompe l'oeil looks like so many others, but a closer look at the bottom strap reveals something puzzling (fig. 6.5). The painted seam between the two wooden "boards" that together constitute this "rack"

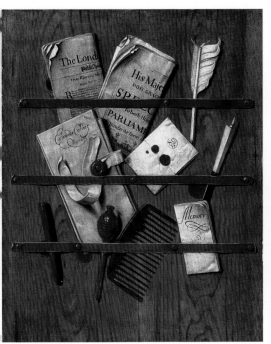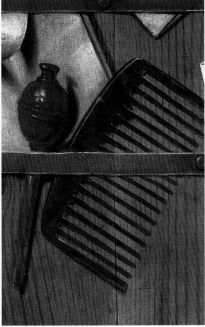

Fig. 6.5: Edward Collier, *Trompe l'Oeil Letter Rack with Penner*, 1696, and detail. 62.6 x 50.7 cm; 24⅞ x 20 in. Private collection, Houston, Texas.

actually goes *over* the strap. The same seam also climbs over the comb teeth and reveals itself unmistakably to be a black painted line. Whereas above the strap the teeth of the comb have the three-dimensional texture familiar from so many other Collier paintings, below it they suddenly give way to thin smears of paint that seem like they are bleeding into the wood. Further to the left, the penner, consisting of a wooden handle and a bulbous top for ink, follows a similar pattern. Whereas the wood at the top is painted substantially and with a light-reflecting shine, the bottom—the "leg"—appears to lose its substance below the strap, becoming transparent and increasingly indistinguishable from the wooden board, whose grain lines crawl over the penner rather than disappear beneath it.

How can we make sense of this section of this painting? The proximity of the same "mistake" in the penner, the comb, and the seam overlaying the strap suggests that it is intentional. A careful examination with an ultraviolet lamp confirmed that it was not the false step of a hasty restorer but part of the original design. The fine handling of the penner's glass-like effect on the wood makes it less likely that this section of the canvas was the work of an assistant less skilled in illusionist technique, though this possibility cannot be completely ruled out. But keeping in mind the multiple ways in which Collier manipulated visual effects, it seems to me more likely that this too was one of his games, an extraordinary move that undermined the trompe l'oeil effect itself and thus exposed its underpinnings as an eye-manipulating painterly skill. Things are truly not what they seem. Even a trompe l'oeil painting cannot be trusted to remain one.

VI

Finally, a playful coda to Collier's relationship to Van Hoogstraten. Recall the trick two-faced medal in Van Hoogstraten's *Rump* trompe l'oeil, which shows a dignified visage right way up but a fool when the painting is turned upside down. In one letter rack Collier played such a game as well, though in his own manner. The game is subtle: the present owner of the painting had it on her wall for thirty years and never realized there was a trick there.

This particular painting (fig. 6.6) is unique in being connected to a specific figure and a specific event. The letter at the center is addressed to "Dr. Mountague the Deane of Durham." This was John Mountagu, fourth son of the first Earl of Sandwich, who became dean of Durham on 19

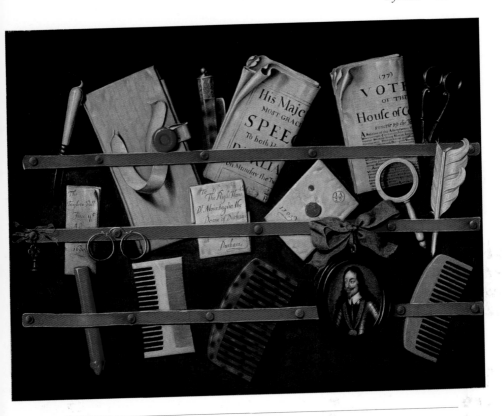

Fig. 6.6: Edward Collier, *Trompe l'Oeil Letter Rack with Letter to the Dean of Durham*, 1700. 55.9 x 73 cm; 22 x 28.75 in. Private collection.

January 1699/1700. The date on the second letter to the right—the only such date to appear on any of Collier's sealed letters—is 1700. The painting thus marks this important moment in John Mountagu's career, and may well have been commissioned to commemorate it.

The number "1700" is "written" rather awkwardly. The reason for this becomes evident when one turns the painting upside down: the year, together with the flourish right after it, suddenly turns into letters. Letters spelling "E COLl." Collier added an upside-down signature to his right-side-up monogram on the right-most comb below.

Collier's game is actually more complex still. There is another curious element here, a group of incongruously placed dots and lines around the other date on the painting, in the "Taylors Bill" to the left. (This bill is puzzling in itself. My best guess is that it may refer to the person who commissioned the painting in honor of Dean Mountagu, a man whose name might have been William Taylor, and indeed there was a William

Fig. 6.7: Edward Collier, *Trompe l'Oeil Letter Rack with Letter to the Dean of Durham*, 1700 (fig. 6.6, detail). The 1984 black-and-white photograph is reproduced courtesy of Christie's, London; the ultraviolet light photograph is reproduced courtesy of the Detroit Institute of Arts.

Taylor who graduated St. John's College in Cambridge in the year 1690, when Mountagu held a position there.) The dots and squiggles around the number "1690" have no business being there. This, in any case, was the opinion of a recent restorer who summarily removed what appeared to him to be the most gratuitous one. In figure 6.7 this segment of the painting is repeated three times: the black-and-white photograph at the top was taken in 1984, before the restoration; the middle one is the state of the painting today; and the bottom one is photographed with ultraviolet light, which is used to reveal restorations. In 1984 there were two dots next to "1690": one above the digit *1*, the other between the *1* and the *6*. Today the latter dot is gone. The UV photograph shows clearly that it had been there before but then was removed. Why is this significant? Because the "1,690" with the dot and the flourish right after it, turned upside down, appears to spell "Colÿe," complete with a Dutch *ÿ*. Once again Collier accentuated a hard-to-find contrivance by repeating it twice, on the two dates in this letter rack.

There is even a bit more. The UV photograph reveals one more dot that has been removed in an earlier restoration, above the digit *1* in "1700" on the right, which matches precisely a dot above the *1* in "1690" on the left. When looked at upside down, both dots seem to become the conventional periods marking the abbreviated form of Collier's two differently spelled names. The plausibility of this reading increases when one notes that this painting, unique among Collier's letter racks, also incorporates into these two handwritten documents no fewer than four more types of abbreviations, displaying the various conventions that mark them as such, from superscripts to colons—and periods.

While following the example of Van Hoogstraten's two-sided reversible medal, Collier replaced the dualism of the pictorial representation of faces with his own interest in the representation and manipulation of letters, numbers, and dates. And not just any letters, but two different spellings of his own name, an old interest of his that he had set aside since arriving in England. He also infused this interest into the painted spelling of "Mountague," which was not quite the "Mountagu" that the dean (or "Deane") of Durham had used himself, nor the more common "Montagu" that became the preferred spelling for the rest of the dean's family. Even in this almost invisible trick Collier nudged the emphasis from the visual toward the linguistic, putting the upside-down device in service of his persistent—not to say obsessive—preoccupations.

A Man with an Impossible Temper

I

Reuniting Van Hoogstraten's 1663 painting with the copies that Collier made of it revealed something further. I was virtually certain I knew where Collier's encounter with Van Hoogstraten's painting had taken place. As it happens, of all the letter rack paintings in this book there is only one for which we have an identifiable near-contemporary description. In April 1730 the engraver and connoisseur George Vertue noted a letter rack trompe l'oeil at a sale in Covent Garden, signed "S. V. Hoogstraten" and dated 1663:

> a still life painting. against a walnut tree board. papers (stuck between) pens penknife. an Almanack. 1663 gold medal. hanging & the pic-ture of the Author a black ebony fram[e] his hair long & reddish.[1]

Vertue added a small hand drawing of Van Hoogstraten's portrait in an octagonal double frame and concluded that "its apparent it was done by him in England that year." It is also apparent that Vertue saw the same painting that Collier had copied. So if Van Hoogstraten painted it in England in or around 1663, and it was sold in London in 1730, it is likely that the painting remained in England throughout this time. Collier therefore must have seen it in England. Since one of his copies is dated 1684, Collier must have visited England before or around 1684, a decade or more before his move to London.

Suddenly many things fell into place. A self-portrait from 1683 with an English royal reference. A painting dated 1684 with a partially visible title

page of a book in English, not Dutch, as far as I know the earliest English printed work in a Collier still life. Another painting from 1684 combining a Dutch book and an English-language-and-topic print.[2] And most reassuringly, a puzzling coincidence with the work of a London-based house painter named Robert Robinson, who was also a pioneer of English mezzotinting. A mezzotint of Robinson's published before 1688 and probably after 1685, a vanitas still life on a table, displays an unusual baroque candlestick with a dolphin base and wide basin. A very similar arrangement, with the same candlestick, appears in a Collier painting of 1669, when Robinson had been eighteen years old and before mezzotinting arrived in England (fig. 7.1). In another undated Collier vanitas the same candlestick stands on a table next to an open book, a skull, and a shell with bubbles. That Robinson had seen Collier's work—these paintings, or another quite like them—seems highly likely (unless both drew on a third common source).[3] Collier's stay in London in the early 1680s seems the most likely opportunity for such an encounter to have taken place.

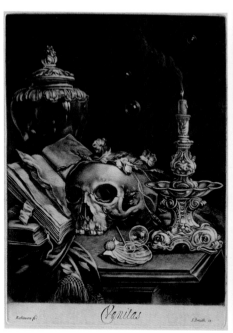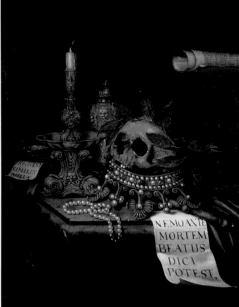

Fig. 7.1 Two vanitas compositions. *Right:* Edward Collier, *Vanitas Still Life with Skull and Candlestick*, 1669. 77 x 63.5 cm. Photo Collection RKD, The Hague. *Left:* Robert Robinson, *Vanitas Still Life*, c. 1685–88. Mezzotint with burin work, ii/ii. Plate: 24.5 x 18 cm; 9⅝ x 7¹/₁₆ in. Sheet: 29.1 x 21.5 cm; 11⁷/₁₆ x 8⁷/₁₆ in. Sterling and Francine Clark Art Institute, Williamstown, Massachusetts, 1999.38.1. Image © Sterling and Francine Clark Art Institute, Williamstown, Massachusetts, (photo by Michael Agee).

I could now see more clearly the road leading to Collier's departure for London in 1693. An earlier visit allowed him to establish connections and to develop a feel for the English art scene. He may have also begun to cultivate his own English market. When "a vanity by *Collier*" was included in a May 1691 London sale by the well-known auctioneer John Bullord, Collier's was one of the several dozen names that Bullord listed in the announcement for the sale, indicating a certain expectation of name recognition.[4] Furthermore, this earlier visit to England helps situate Collier's next two extant letter racks, both dated 1692, after an eight-year hiatus in this genre. It would appear that toward 1693 Collier was preparing for his move, stocking up on canvases that matched expectations he had earlier formed of the English market, not least the English taste for trompe l'oeil paintings. The letter racks of 1692 match in arrangement and content Samuel van Hoogstraten's earlier forerunner of the genre that Collier had encountered in England, where Van Hoogstraten's trompe l'oeils had evidently been popular. In the example in figure 7.2 the similarity extends to the placement of the woman's miniature portrait. Although the 1692 racks include English printed materials, in preparation for their future clientele, they are different from those that followed Collier's arrival in London, when he was to adapt the genre to what he would then wish to say about this vibrant print world. The 1692 paintings have none of the later textual games and are signed in variant spellings—Edwart Colyer or Coljer—typical of his Dutch-period paintings but not of his English-period ones. In another marked difference, the painting in figure 7.2 displays in lieu of postmark the same self-referential "EC/2" of the earlier imitation of Van Hoogstraten. Once Collier became interested in the circulation of letters and information, he restored the actual Bishop Marks with actual months' names and turned them into an element in his own design and purpose.[5]

II

The circumstances surrounding Collier's encounter with Van Hoogstraten's letter rack revealed even more. I could actually pinpoint precisely when Collier left Leiden and crossed the Channel, and I knew why. Collier traveled to England because he was driven out by his wife.

Fig. 7.2 (following page): Edward Collier, *Trompe l'Oeil Letter Rack with a Woman's Portrait*, 1692. 53.2 x 64.8 cm; 21 x 25.5 in. Courtesy of the Witt Library, The Courtauld Institute of Art, London.

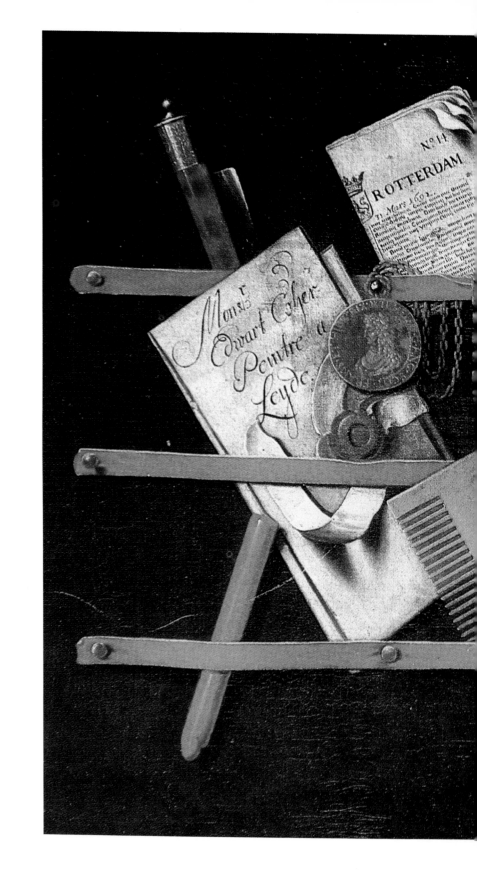

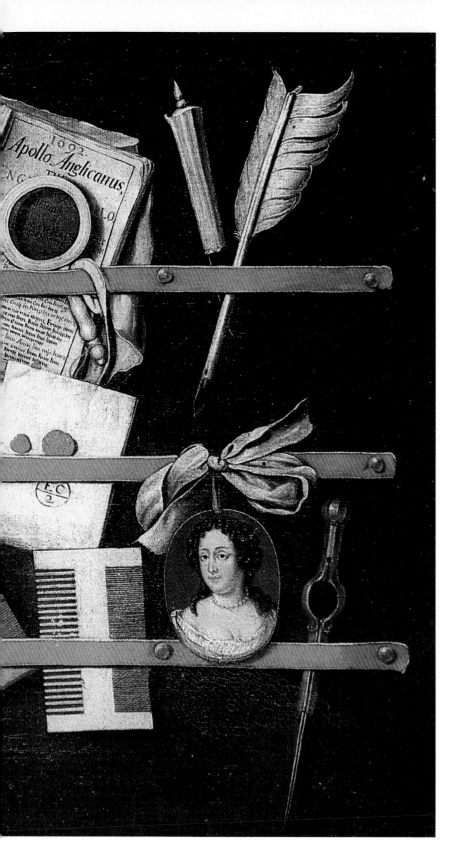

It may seem strange that so little of Collier's life has surfaced thus far. Of Collier's English period, other than the revealing group of paintings, we have frustratingly few documentary traces. I am unable at present to tell you where in London Collier lived, who noticed or bought his unusual trompe l'oeil compositions, or where and when he died, if he died in London at all. The records of St. James's Church in Piccadilly include the burial of one Edward Collier on 9 September 1708, which may or may not be the painter.[6]

Collier's life in Leiden, on the other hand, can be reconstructed in some detail through a rich archival record. Some traces are rather random, like a portrait commission that Collier undertook on 9 April 1670 for a Leiden baker in exchange for a regular supply of hot pies through the end of the following February, though excluding wedding supplies should Collier marry during this period.[7] And marry during this period he did: the first of four marriage attempts before the marital crisis that drove him to England in the early 1680s.

Collier's first marriage took place in November 1670, when he was a bachelor of about thirty. His wife, a widow named Maria Francois, died within two or three years. He became engaged again in 1674, as a widower, to a woman who was, again, a widow. In 1677 Collier married a "young spinster," but she too died shortly thereafter. He became engaged for the fourth time in 1681, to yet another widow. Her name was Anna du Bois, and she was to become his wife of many years and mother of his children.

Two observations about Collier's marital efforts can be made in relation to his art. First, within a decade he saw two wives die and was engaged to marry three women who had all previously lost at least one husband. The arithmetic is sobering: the road to Collier's final marriage was strewn with the corpses of five dead spouses. Such an abundance of mortality was not uncommon, of course, in a period in which the average life expectancy was around twenty-five. Most of the dead, however, were the young, which probably makes the demise of five nubile adults in rapid succession, even in the late seventeenth century, a somewhat higher than ordinary rate of extinction. But be that as it may, Collier's experience of the immediate, relentless presence of death should be kept in view next to his vanitas paintings. Their memento mori were not simply reminders of mortality for people who otherwise would muddle through their daily routines blithely unaware, but rather moral exhortations about how to behave when living with a specter that was ever present in people's lives.

The second possible connection between Collier's marital life and his art is different. What happened on 11 May 1674 cannot be so easily catalogued among the eventualities that late-seventeenth-century Europeans learned to expect—at time with the didactic aid of paintings such as Collier's—as an inevitable part of pre-modern life. A week earlier Collier had registered his betrothal to the widow Maria de Pijper, in anticipation of his second marriage. Collier had four marriage partners but was widowed only twice. Thus one partner remains unaccounted for: Pijper. With hindsight, the first sign of trouble might have flashed when Pijper did not appear in person for the registration of the betrothal, as was customary, though the church clerk noted that "adequate attestation has been handed over on her behalf." The following week, however, "a certain missive from the Commissioners of Marital Affairs of The Hague" was entered into record "at the groom's request." It related "that Maria de Pijper had a preceding promise of marriage to a certain Pompeus de Bije."[8] With a dry note at the margin of the church register, the betrothal was annulled. By the skin of his teeth, Collier was saved from becoming the victim of a fraudulent misrepresentation. So if Collier's repeated brushes with premature death plausibly informed his interest in the skulls and hourglasses of vanitas paintings, might the close shave in Maria de Pijper's act of deceit and misrepresentation have fed into his future passion for perpetrating and exposing misrepresentations in his trompe l'oeil art?

In real life too, when it came to false representation, Collier was not only victim but also perpetrator. Only weeks before his almost-marriage to a woman promised to another, Collier had been in court because of a false promise of his own. In November 1673 Collier had signed a notarized agreement with a woman named Gerritje Jans. Croesdonck who was in the final stages of pregnancy. Collier admitted to having a four-month relationship with the woman, although not to fathering the baby, and agreed to pay a one-time sum in acknowledgment of this fact. When a son was born in December, far from denying him, Collier gave him his name: the illegitimate baby was baptized as Evert, son of Evert Colier. But by the middle of the following February the woman had taken Collier to court, claiming that he had seduced her with flattering words and repeated promises of marriage. She demanded that Collier marry her or pay a much higher sum than originally agreed: for her defloration, for delivery costs, and as weekly alimony.[9]

The sequence of events is telling. On 1 November 1672 Collier and his first wife, the latter being "sick of body," drew up a will. On 9 March 1673 his wife was still alive but "bedridden," as attested in a new last will and

testament signed jointly at her bedside.[10] But in the same month, at the latest, Collier was already bedding someone else and making promises of marriage that he did not intend to keep. Small wonder he refused a formal admission of paternity to the child baptized on 20 December, since this would have constituted an admission of an adulterous attachment when his wife was dying. In February and March 1674 Collier was in court dealing with the fallout from his misrepresentations, but less than two months later he was already declaring a new engagement. The quick succession of these events was little short of breathless. But then Collier was keenly alert to the urgent passing of time and the fleeting nature of man's life, even if this was not exactly the moral that Collier's vanitas still lifes with their emptying hourglasses and ticking pocket watches were designed to instill.

So, arriving at Collier's final marriage, why did he travel to London in the early 1680s? This time the tables were turned: Collier was the cuckold, not the rake. At least, that is what he appeared to believe. By the time we learn of the affair, on 24 March 1682, Collier was busy in front of a notary formally retracting the "slanderous" accusations he had made against his lodger, a theology student by the name of Jacobus Sappius, for having held criminal conversation—or an adulterous relationship—with Collier's wife, Anna du Bois. Retracted or not, the accusations refused to die down. Two weeks later Collier's wife requested a separation of room and board, citing great misunderstandings and discords with her painter husband. Once again events moved at breakneck pace. Edward and Anna had registered their marriage at the end of November 1681, two months after the burial of Collier's previous wife; by the end of the year they had made a joint will and taken a full inventory of his possessions (which included thirty-one unframed paintings and twenty-six framed). Less than three months later accusations of infidelity were made and the marriage bed broken up.[11]

Matters between the estranged newlyweds were apparently so bad that a respectable relative of the wife intervened in the role of mediator and protector. It was the husband of Anna's sister Eva, a preacher by the name of Jacobus Boerhave or Boerhaave. His identity is significant for understanding Collier's environment and connections. Boerhaave's son from his first wife and Collier's nephew by this marriage, Herman, then a teenager, was to become one of the Netherlands' most famous scholars, a professor of botany, medicine, and chemistry at the University of Leiden.

Collier, in fact, was further embedded in the scientific milieu of late-seventeenth-century Leiden. The witness on Collier's behalf at his betrothal with Anna was one Dr. David Stam, who at long last provided

one thread tying the contents of Collier's paintings to his personal life. Collier's four-strap letter rack with Dutch materials, including the print of Erasmus titled "SCHYN BEDRIEGD" (fig. 7.3), displays next to it, unusually, a medical book. Enough of the title page is visible to see that it was printed in Amsterdam by its author, one "[Da]vid Stam, M. Dr." The same man.

So who was he? David Stam was a Leiden apothecary and chemist who had arrived from the German town Wesel in 1657. He had worked in the private laboratory of the illustrious Leiden physician Franciscus dele Boë Sylvius, also known as a first-class art collector, and gave private chemistry training to the young Herman Boerhaave. Sylvius, in turn, had been a close confidant or blood relative of another apothecary by the name of Jacob de Bois, who is likely to have been related to Eva du Bois, Herman Boerhaave's stepmother, and to Anna du Bois, Collier's future bride.[12] All this was very helpful in reconstructing the network that surrounded Collier in Leiden, people with interests not only in art but also in science. But the best surprise was still to come. In 1667 David Stam married Maria, one of the two daughters of the deceased Leiden theologian and professor of Greek Lambertus Barlaeus. The two daughters lived together in a house on Leiden's prestigious Rapenburg canal that had been left to them by their father. Once Stam married Maria he moved in with her, and they occupied the southern side of the house. Maria's older sister Johanna, living in the other half of the house, had married the previous year. Her husband was a wine merchant named Johannes Colier. He was brother to the painter Edward Collier.[13]

This painting, then, was connected to Collier's family. David Stam and Collier's brother were married to two sisters and lived in the same building. Their relationship continued: when Stam became a burger of Leiden in 1671 he brought Johannes Colier the wine merchant as his witness. Edward Collier, who had trained as a painter in Haarlem, is first recorded in Leiden in 1667, the year following his brother's marriage.[14] Did he arrive to join his brother, now a family man? Did he perhaps live with him for a while in the house on the Rapenburg? Regardless, Collier had obviously established a long-term relationship with Stam, not only enlisting him as witness upon his marriage in 1681 but also painting his book into this particularly fine letter rack many years later. Stam is very likely to

Fig. 7.3 (following page): Edward Collier, *Trompe l'Oeil of Framed Four-Strap Letter Rack with Medical Book*, 1703. 67 x 84.7 cm; 26¼ x 33¼ in. Courtesy of Richard Green Gallery, London.

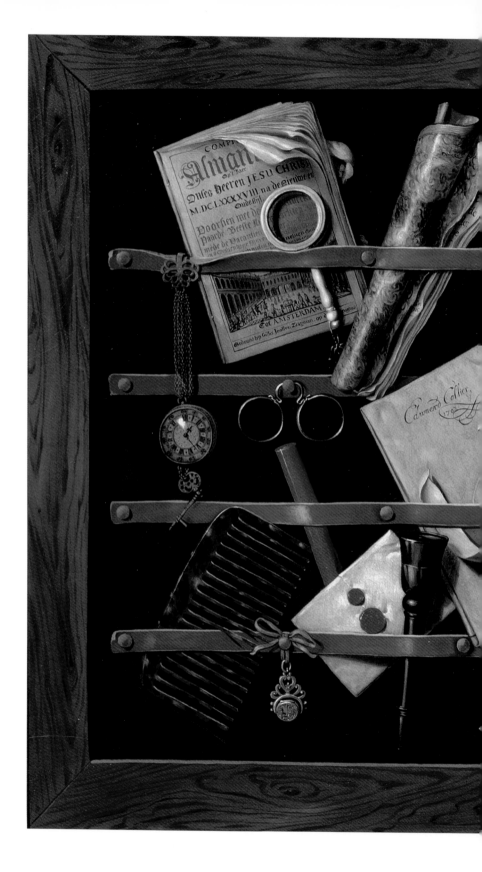

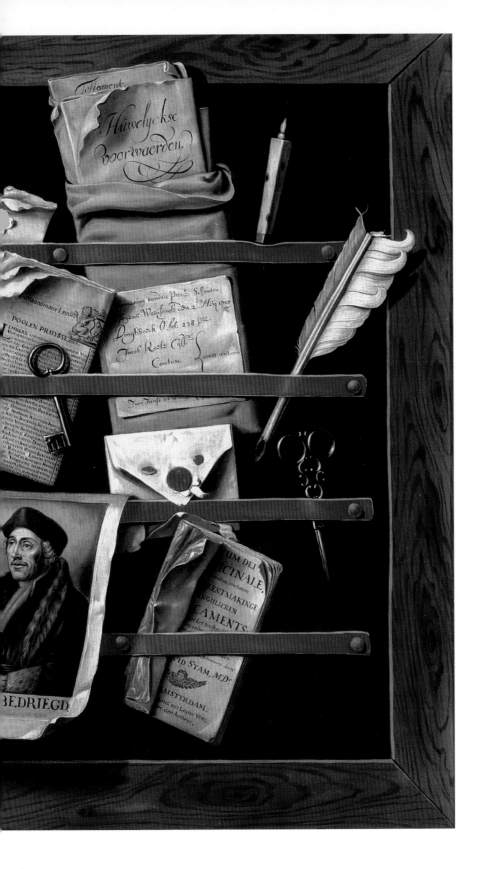

have known Jacob de Bois, fellow apothecary, from Sylvius's laboratory. In 1673 Eva du Bois, almost certainly a relative of Jacob, married the widowed Jacobus Boerhaave and became Herman's stepmother; and in 1681 the other sister, Anna, married the widowed Edward Collier, a mutual commitment witnessed by Stam, who later became Herman's chemistry tutor. Edward and Anna's marriage ceremony was removed by special permission to Voorhout, a village near Leiden where Jacobus Boerhaave was the presiding minister.[15] Given how closely interconnected they were, one can only imagine the consternation of the Boerhaave, Stam, du Bois, and Johannes Colier families when Edward and Anna's union unraveled so ignominiously so fast.

In truth, the situation was even worse. The grievance that exploded Collier's marriage was not just about sex but also about religion. What the theology student Jacobus Sappius was doing with Anna du Bois, as the Leiden church council learned when they investigated the matter, was holding private prayer sessions together, perhaps behind closed bedroom doors. Anna was already suspect in the eyes of the council, having earlier invited a well-known member of the Nadere Reformatie movement, the Dutch equivalent of the godly Puritans, to hold private religious services in her house with up to twenty or thirty people. So if Collier had to retract accusations of adultery—a not implausible conclusion for him to have drawn from this intimacy—Sappius also had some explaining to do. It was true, Sappius told the church elders, that he had held such private services, but not in Anna's bedroom; rather, in her sister's quarters with more people present. It was true that he called Edward Collier, with whom he was lodging at the time, "*onwedergeboorne*," or unreborn, and he would do so again, but he never said that twenty righteous men could not be found in the city of Leiden. While he considered the general level of religious practice in Leiden mediocre, he did not speak disdainfully of the leaders of the church.[16]

This was the tense set of relationships at close quarters in early April 1682. Whether because of the apparent religious incompatibility of the godly Anna and the "unreborn" Edward, or because of the collapse of marital trust in the face of mutually exclusive intimacies, the level of discord was such that Anna requested a formal separation. The painter, it was reported, had rented a house in Bredestraat for 170 florins, but his estranged wife refused to move there. Her brother-in-law, Jacobus Boerhaave, therefore promised to pay the rent himself, and thus to protect the painter from the danger of the house remaining vacant. (Boerhaave also promised not to allow student renters into the house: some things never change.)[17]

But why did the house remain vacant? Where was Edward Collier? The next thing we know is that in September 1682 the church council reprimanded Collier because "he dared to attend the *Avondmaal*," or communion, which apparently he had been told not to do. The council declared this behavior "unbecoming" and warned him not to show up again without permission. And indeed he did not, for quite a while. When the question of admitting Collier to communion was brought to the council again just before Christmas 1683, one of the church elders declared that "he had not heard anything from him in the past year." But now Collier was back. He reemerged in Leiden on 3 December 1683 in an arbitration to determine his payments for the delivery costs, baby clothes, and upkeep of yet another baby whom he had fathered out of wedlock.[18] There may well have been another reason in fall 1682 for Collier to leave town.

Finally this tale wraps back to the beginning of this chapter. The most plausible narrative that takes all these fragments into account is that Collier had escaped both family disputes and communal indignation by taking off around late 1682 for England, where he remained for perhaps as long as a year. While in England he encountered Van Hoogstraten's painting and spent some time copying it so meticulously. It was there and then that his letter rack trompe l'oeil painting career began.

III

This tale of matrimonial mayhem, sexual indiscretion, and religious heterodoxy, surprisingly, has a happy ending. Once Collier returned to Leiden in winter 1683, both he and Anna came back to the church council: Edward asking to be readmitted to communion, Anna requesting a testimonial of her good standing in the church that she could take, as was customary, to the new community outside Leiden where she was now living. The council, however, refused to grant either request until the couple reconciled, a powerful form of communal social pressure. Over the next few months the church elders tried to mediate. Collier, one reported, was open to reconciliation. Another told the council that while he heard that Collier's behavior had improved, he also talked to Anna, who said that "it was impossible to live with a man of such temper (*humeur*)."[19] None of this was very auspicious, even setting aside Collier's new illegitimate child.

But then the winds changed. The first indication is perhaps a painted one. In 1684 Collier painted a self-portrait holding a sketch of a woman

and a music book on a table with an identifiable love song. Musicologist Debra Pring has suggestively linked this love song—and thus the woman's sketch—to the name Anna, through the Dutch word from its title that Collier leaves visible, "Tanneken." Whether this was a sign of longing and reconciliation or not, on 5 April 1686 Edward and Anna were announced by the Leiden church council as fully reconciled, and thus deserving of testimonials as members in good standing. A week later the couple left Leiden for Amsterdam, where within four months they buried their firstborn.[20]

By 1691 Edward Collier and Anna du Bois were back in Leiden baptizing a healthy son by the name of "Joan," or John, with Jacobus Boerhaave's widow as a witness. A couple of years later the Leiden church records show the couple leaving together for a new life in England: "Eduard Coljer and his wife Anna du Bois of the Lange brugge [long bridge]. To London on May 2nd 1693." Subsequently, on 30 July 1695, the English secretary of state issued official travel passes to Holland—a customary procedure in a world before passports—to "Johanna du Bois and John and Alida Colier, her children." Although the woman is named "Johanna," not Anna, there is little doubt that this is Collier's (at long last stabilized) family, since both children are named in other documents: John in his baptism record of 1691, and Alida in the will of her cousin Joris, son of Edward's brother Johannes, thirty years later.[21]

As it happens, this travel pass is the only clear archival trace of Collier's decade and a half in England. This contrasts sharply with the rich web of documentary footprints he had left behind in the Netherlands, including even rare verbatim evaluations of Collier from people who knew him well. For Sappius, his lodger and perhaps competitor for his wife's attention, he was "*onwedergeboorne*," unreborn. And for his wife, estranged yet hoping for the reconciliation that eventually would come to pass, he was a man with an impossible temper.

Tom, Dick, and Henry

I

Henry Howell came as a surprise. I was already knee-deep in Collieriana, fairly confident that I knew what one could expect to find in letter rack paintings, but this I did not see coming. Fred Meijer, the still life curator of the Netherlands Institute for Art History, reproduced in a recent publication a Collier letter rack, and next to it a copy or imitation of Collier from 1702, signed by "an obscure London painter" named Henry Howell (fig. 8.1).[1]

At first glance the similarity to Collier's racks is striking. Collier's typical elements are all here: the quill and pen knife, the royal speech, the *London Gazette*, the postmarked sealed letter, the sealing wax, the miniature of Charles I, and the folded letter on which appears the signature "For Henry Howell Painter at London" in precisely the same manner as Collier's. On the other hand, certain details stand out as different from Collier's practice. The straps, for instance, appear quite tattered, as if made of cloth rather than Collier's leather ones, though not less skillfully painted. Charles I's face appears more like a caricature. And perhaps most significantly, the lettering on the printed documents is painted as more obviously hand-drawn than press-printed. Note for instance the unequal sizes of the two *E*'s in "SPEECH" and the differently shaped *A*'s in "PARLIA[MENT]."

At the same time, Howell repeated two minor details that are distinctive signs of Collier's idiosyncratic compositions: the placing of "Monday" next to "Munday," together with "Des . . ." as a spelling variant for December; and Collier's self-designed crowned "A" monogram on the queen's speech

pamphlet. These indicate a considerable intimacy with Collier's games. So was Howell perhaps an apprentice, or a friend?

Or was this painting, regardless of its signature, the work of Collier himself? However thrilled I had been with Collier's efforts to undermine the usually unreflecting confidence in the authorial claims of a printed title page, I found it difficult to disregard the straightforward testimony of the signature on a painting. Would Collier play the same kind of game with an artifact in his own medium? If his letter racks expressed a critique not just of print but also of art, would not such an identity-switching trick in a painting be the ultimate test for the illusionist painter? But if so, why the alteration of some details? And why the name Henry Howell?

It thus became imperative to find out whether there was an actual historical figure behind the name Henry Howell. There was. A painter, as advertised. And yet he was an elusive figure to track down, because Howell was not an easel painter. Having been apprenticed to an arms painter, Henry

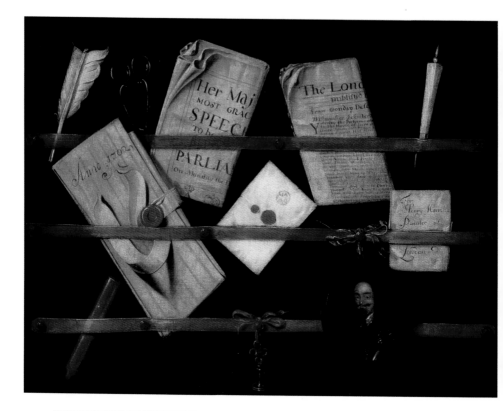

Fig. 8.1: *Trompe l'Oeil Letter Rack with Signature of Henry Howell*, 1702. 61 x 73.7 cm. Courtesy of Sotheby's, New York.

Howell was admitted in 1669 as freeman to the Worshipful Company of Painter-Stainers, a London livery company. The painters in this guild made a living by applying color to solid materials like stone or wood, painting walls and ceilings or signs and coaches. The stainers did the same on woven materials. They were highly skilled, but typically they did not paint canvases, with a few exceptions. A trial deposition reveals that Howell kept a shop in Russell Street near Covent Garden, where he "publicly set out signs and tokens of arms, escutcheons and banners, as was usually done by persons of his trade in and about London." Among the Painter-Stainers Howell rose to some prominence. In 1693, the year that Collier arrived in London, he was Warden; and in 1698/9, shortly before this letter rack was painted, he was elected Master of the Painter-Stainers.[2] Howell, in short, was no illusionist trick but a well-regarded professional in the painting craft.

But did Henry Howell paint this 1702 letter rack? I was about to move on when I suddenly saw the initials. Or did I? The more I stared at them, the more I was convinced they were there. On the folded document pouch in the middle-left of the painting, below the date "Anno 1702" (fig. 8.2, left)—that is, precisely where one would expect to find a signature—there is an ornate curved line. Or rather two lines, one echoed nicely by the ribbon right below. If one looks at these two curved lines from right to left, as if in mirror image, they seem to spell "E C."

At first I was rather skeptical. But then I remembered the Collier vanitas at the Metropolitan Museum where Collier had placed his two monograms, "E C" and "E K," next to a *collier*, or necklace (see fig. 4.1, p. 69, and fig. 8.2, right). But did I really get the full extent of Collier's playfulness in the corner of the table on this canvas? On the flyleaf of the

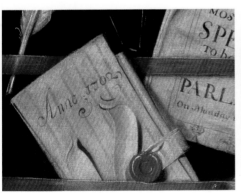

Fig. 8.2: Details of *Trompe l'Oeil Letter Rack with Signature of Henry Howell*, 1702 (fig. 8.1) and Edward Collier, *Vanitas Still Life*, 1662, Metropolitan Museum of Art, New York (fig. 4.1).

almanac, beneath the square letters "E C" and the date "1662," there is an ornate curved line balancing the block-print geometry of the monogram above it. Does this line not also delineate a large curled cursive *& above a smaller *c*? Placed next to the Howell letter rack, both curved lines seem quite similar. Moreover, in the Metropolitan vanitas Collier made sure the viewer didn't miss the significance of this ornamented line: in his usual tactic, he repeated it again. Look in figure 4.1 (bottom) to the right, at the broken violin string, which is rather unnaturally bent: the line it delineates is a precise echo of the ornament on the almanac flyleaf. The flourish on the almanac did have a meaning: it was sneakily hiding a third Collier monogram. And if so, then perhaps this was also the case in the Howell painting.

I remained uncertain. Then I realized I had already encountered evidence that the Howell painting with its authorship puzzles was not the only one.

II

Several months earlier, as I was telling a friend about Collier's trompe l'oeil paintings, she unexpectedly said: "I know these paintings, I have one on a cover of a book at home." But no way was the letter rack painting on the cover of the English edition of Michael McKeon's history of the novel a Collier (fig. 8.3). First of all, the cover identified the painter as one Thomas Warrender. Second, the letter rack held publications of kinds that Collier never painted: playing cards and Scottish political pamphlets. Furthermore, a quick search revealed that Warrender is a known figure in the history of Scottish art, often used by experts as an example of what early-eighteenth-century artists north of the border were capable of. The date on the pamphlet at the top right, 1708, did not preclude Collier's involvement but was something of a stretch, since his last dated painting is from 1707. I thus quickly concluded that this painting was an imitation by a Scotsman who apparently used the conventions of the genre to further causes he was interested in—especially those involving religious politics in Edinburgh, his home town—while remaining uninterested in the finer points of what Collier's letter racks were all about.

But after my encounter with Henry Howell I went back for a second look. The center of the letter rack is dominated by two handwritten documents that highlight Warrender's status as burgess and guild brother in Haddington (his birth town) and Edinburgh (his home town). But Warrender's name in these two documents of considerable personal importance is

spelled differently: "Warrender" in one, "Warrander" in the other. This rang familiar. I also learned that *The Danger of Popery Discovered* had in fact been published in 1705, so its date in the painting was tampered with.

More significant was what I then learned about the identity of Thomas Warrender. Warrender was a painter known for architectural decorative work: imitation marbling and garlands of fruits and flowers on the bedchamber walls at Hamilton Palace (1696), a "fyne landscape work of walnut tree collour in oyll and the styles Japand" in the countess's bedchamber at Hopetoun, and the like. He also painted the Order of the Thistle on the Marquess of Annandale's coach, and in 1704 he painted and gilded twenty-eight batons that belonged to the constable of Edinburgh. A versatile craftsman. But there is not a single canvas painting on Warrender's record other than this letter rack, which a recent reference work on Scottish art describes as "extraordinarily accomplished." This expert calls the painting a "mystery." Another has admitted that this unique flash of talent in a medium unfamiliar to the artist is "difficult to believe."[3] Moreover, how likely was it to find *two* craftsmen painters with no record of easel painting who left as their only surviving works close imitations of Edward Collier's letter racks?

Armed with this conviction, I turned back to the painting itself to look for Collier's mark, his monogram. I was optimistic that I would find one, but I was wrong. There were two.

The first hides in the one place on the canvas that draws attention to itself as a monogram: the beautifully placed *W* on the printed *Solemne League and Covenant* in the middle of the top strap (fig. 8.4), which also doubles as Warrender's initial. Immediately to the right of the ornate square are two letters vertically huddled together and separated from the rest by a conspicuous bold typeface: *E* (the letter following the *W* to spell "WE") and *K* (from "Knights"). "E K," Collier's alternate monogram. The second set of initials turned out to be only a couple of inches away from the first. And like the Metropolitan vanitas, it offers close by the alternative spelling. The letter *E* is hidden in a whitewashed "pentimento"—a device Collier used elsewhere—right in front of the *C* in *Covenant*: "E C."

It remained the case that this letter rack did not look quite like one of Collier's, and that it had some features I could not explain. And yet looking at two examples made the existence of a pattern seem more likely than when I had

Fig. 8.3 (following page): Thomas Warrender, *Still Life*, c. 1708. 60.5 x 73.5 cm. National Gallery of Scotland, Edinburgh.

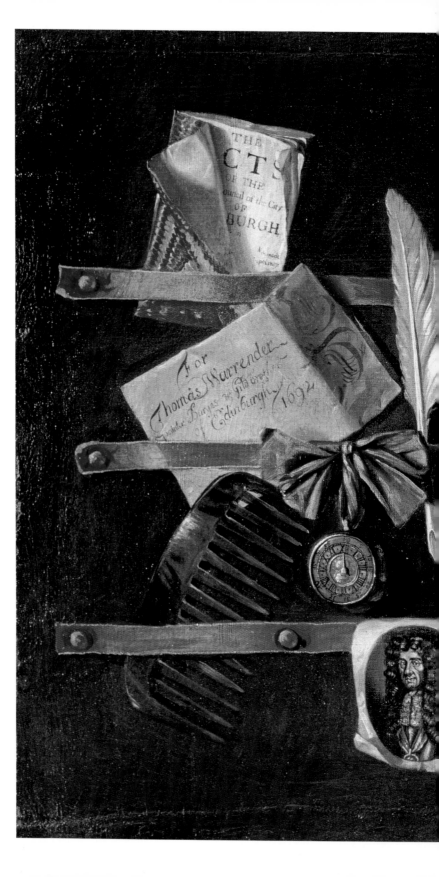

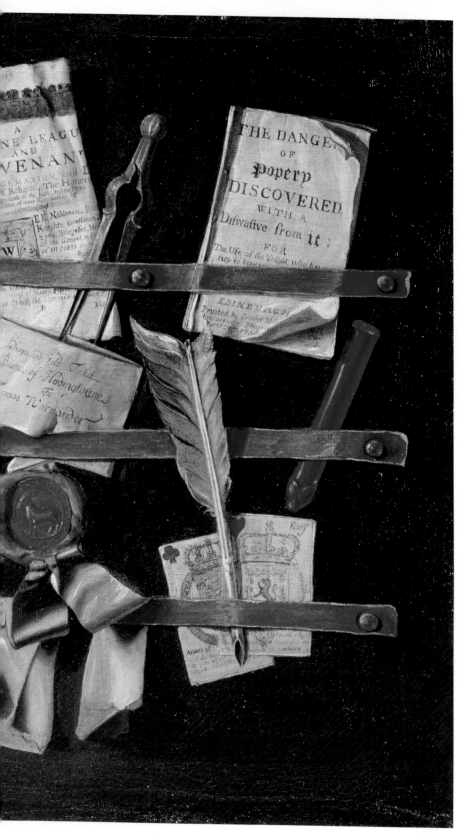

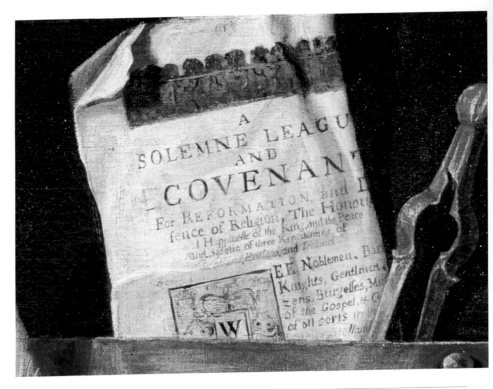

Fig. 8.4: Detail of Thomas Warrender, *Still Life* (fig. 8.3).

only one. Since these two emerged in completely serendipitous circumstances, could one expect more to emerge from a more deliberate search?

III

Fourteen. This is the number of confirmed "Collier" paintings signed with the names of others that I have so far been able to track down. And there are five or six additional possible ones for which the information or reproduction is not good enough to be certain. These paintings cannot be searched for systematically and are quite difficult to find. Typically they make a flash-in-the-pan appearance in an auction, often a minor auction with a low-quality catalogue entry since they are taken to be minor works by unknown artists, and disappear again. I am convinced there are many more extant ones of which I am unaware, perhaps as many again as those I have found. Taken together, this group of paintings is unusual in the extreme.

How and why were these paintings produced, and what *could* such a peculiar pattern mean? I will first put in front of you what I have found, and then turn to possible explanations of this further twist in the story. Since the figure at the center of this new mystery is the same Edward Collier, keep in mind that this was a man with a proven record of unusual game playing, relentless illusionist tendencies, and an appreciation for the hidden telltale detail.

The pattern is consistent and unmistakable. Fourteen paintings, each carrying a different name as signature. They are overwhelmingly more like Howell's than Warrender's in terms of how closely they replicate and imitate Collier's designs, using the same objects and devices in the same compositions. In six cases a Collier-signed painting can be matched with the painting signed in the name of another as its near-twin in a deliberate pair. Nine of the fourteen examples are letter rack paintings; the other five are vanitas arrangements with books and globes. Twelve of them carry their respective "signatures" in Collier's most typical fashion, through the device of an addressed folded letter (see fig. 8.5). The two earliest painted examples of Collier signing his own name with this device are from 1693, immediately upon his arrival in London. The Collier-looking-yet-signed-by-others paintings all appear to correspond to Collier's British period, incorporating British materials and signatures. (I will mention later a possible precedent from Collier's years in Leiden.) And in virtually every case in which I have been able to see the painting or obtain a good enough reproduction of it, I found Collier's monogram, inserted in a different manner every time, and almost always hidden in sneakily clever ways. In a couple of cases a whiff of doubt remains. But with so many examples, doubts about details in individual paintings pale next to the overall pattern.

Recall the two royal speeches that were deliberately painted as identical as possible, but one with "His Majesty" and the other with "Her Majesty." Figure 8.6 shows in full the two letter racks that "hold" them. They are obviously very closely interdependent. There are also some obvious differences: the sizes and orientation of the canvases, the odd angle of the *Gazette* in the painting on the left, its much more elaborate hand seal, and the large-size overflowing print of Neptune. Then of course there is the difference in the signed letters, placed in identical positions beneath the tip of a stick of red wax: the one addressed to "Mr. Edward Collier Painter at London," the other to "Mr. Willi[am] Brasier Painter at London."

A second example of such deliberately matching near-twin letter racks takes us back to a painting we already examined for Collier's invocation

Fig. 8.5: Details of Collier-like paintings: "signatures" in the form of addressed folded letters, stuck in a letter rack or perched on a table behind an inkpot. At the top are two examples carrying the name of Collier himself, one on a table in Dutch, one from a letter rack in English.

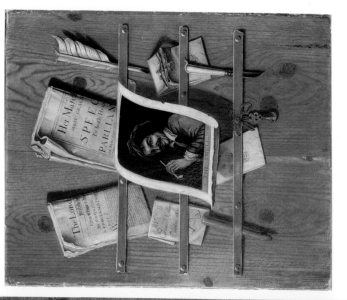

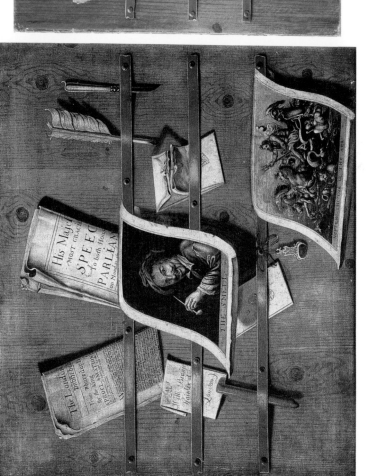

Fig. 8.6: *Right:* Edward Collier, *Letter Rack with "Smell" Print*, 24⅝ x 20½ in. Sarah Campbell Blaffer Foundation, Houston. *Left: Trompe l'Oeil Letter Rack with "Smell" Print and Signature of William Brasier.* 63.5 x 76.5 cm; 25 x 30 in. Courtesy of Sotheby's, London.

of the two calendars, the Gregorian and the Julian, next to two inconsistent dates, 1702 and 1703. This preoccupation with doubleness is compounded when this painting is placed next to its veritable doppelgänger, carrying the impossibly out-of-order date of 1731, as in figure 8.7. The top one is signed by Collier. The bottom one is signed with the usual device of an addressed letter in the name of "C. Seymoor" of Twickenham. The name is actually Seymour; it also appears a second time, in faint letters spelling "Charles Seym . . ." just visible "through" the parchment of the folded deed immediately to the left. (The writing is not reversed, however, as it should be.) At the same time, while duplicating both the layout and the details of the Collier-signed painting—for instance, the news item on the Dutch newspaper—the Seymour letter rack also includes textual and visual variations, most obviously the turning ninety degrees sideways of the letter bearing Seymoor's "signature."

The manner in which Collier's monogram is insinuated into this painting is one of my favorite examples of this practice, subtle and witty. One detail that differs unnecessarily between the two near-twin paintings is the wind-up key of the pocket watch, though both watches are themselves identical. Collier in fact painted the watch and key in several other letter racks, and the top of the key (called the bow) always looks like that on the left in figure 8.8: round, smooth, and symmetrical. In the Seymour painting, by contrast, it is replaced by a somewhat stretched oval with various metal ornamentations (fig. 8.8, right). Recall now one final time the almanac in the corner of the table in the Metropolitan Museum vanitas, in which Collier placed his "E C" in block letters right above the date "1662" (fig. 8.2, right, p. 133). The metalwork oval of the key bow in the Seymour painting conjoins not one but two "E C" monograms: an E within a C facing an upside-down C within an E. Herein lies the key.

In passing, consider another remarkable aspect of this story. The Metropolitan vanitas seems to provide a key—now in the sense of a map key—to the variety of hidden Collier monograms in three different paintings sporting the signatures of others: Howell, Warrender, Seymour. But Collier painted this vanitas still life in 1662, probably in Haarlem during his apprenticeship, and decades before the move to London. What kind of steadfastness is revealed in a line connecting a solution to a puzzle with the puzzle itself across a full forty years?

With these possible hidden monograms in the Seymour painting in mind, take another look at the William Brasier painting. Like the Seymour watch key that stands out as different from all others, so does the

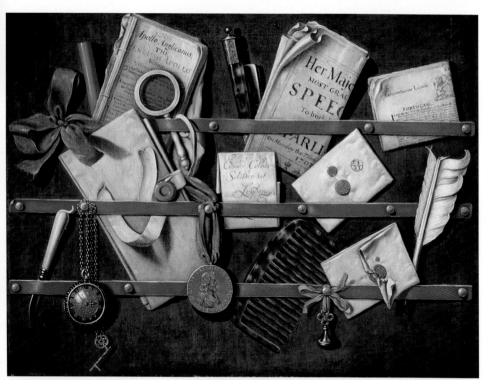

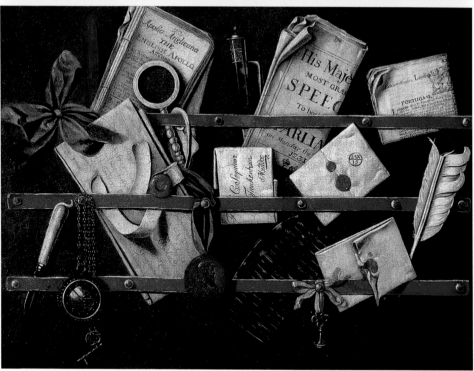

Fig. 8.7: *Top:* Edward Collier, *Trompe l'Oeil Letter Rack with Watch and Seal,* 1702/3. 50 x 65.5 cm; 19¹¹⁄₁₆ x 25¹³⁄₁₆ in. Museum De Lakenhal, Leiden. *Bottom:* *Trompe l'Oeil Letter Rack with Watch and Seal with Signature of Charles Seymour.* 62 x 74 cm; 24.5 x 29.5 in. Courtesy of Sotheby's, London.

Fig. 8.8: Details of Collier and Seymour letter racks with watch and seal (fig. 8.7).

hanging seal in the Brasier letter rack, which is ornate, elaborate, and unlike any of the dozen other such seals in Collier's letter racks. I have little doubt that Collier's monogram is hidden in the handle of this seal, though I admit I find this example less satisfying. One can make out the *E* in the indentation at the top of the handle, and a *C* turned sideways at the bottom, but the separation between them leaves me wondering whether I am missing something, or whether this device in the Brasier painting is simply less successful.

IV

If I had believed at some point that Collier turned to trompe l'oeil as the appropriate genre for deceptions and illusions, I was only to be surprised yet again. Collier did not play by the rules, even those I took to be his

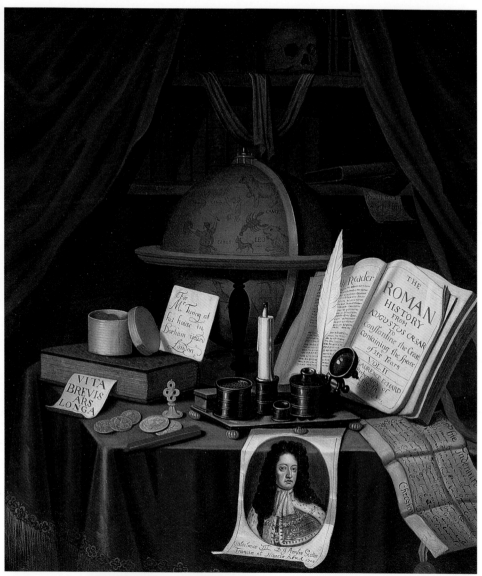

Fig. 8.9: *Vanitas Still Life with Signature of Mr. Turing*, 1700, and detail. 75 x 64.1 cm; 29½ x 25¼ in. Private collection.

own. Similar subterfuges, it turned out, appear also in several vanitas paintings.

In the example in figure 8.9, every element is familiar from many other Collier still lifes. Especially distinctive are the unusual inkstand and the box of red wafer seals on top of the book with its cap open. The letter bearing the signature, perched between the box of seals and the celestial globe, reads: "For/ Mr Turing at/ his house in/ Dorham ÿeard/ London." It is an odd way to spell Durham Yard, with a whiff of Dutchness, signaled by the usage of ÿ. Now shift your eyes to the Roman history volume behind the inkstand, written by Laurence Echard, the prebendary of Lincoln, enlarged below. It may be surprising to the prelate, but not to the connoisseur of Collier's antics, to find that "Prebendarÿ" is also spelled with the Dutch dotted y. Twice gratuitously in one painting, a painting in English, not Dutch, is surely a signal. And where is Collier's monogram? Look at the prebendary's name, which is spelled in letters of varying sizes, increasing further to the right: "ECHARD." The first two letters, separated from the others by their smaller size and lighter shade of red, and mirrored so precisely at the end of the gently sloping "LAURENCE," are of course "E C."[4]

There is actually more going on in this carefully painted title page (for enlargement see fig. 10.1, p. 168). The lines are arranged to correspond to each other, for instance the ÿ beneath the author's name placed so that the two dots point symmetrically to the mirror images "CE" and "EC," or the words "Constantine" and "Containing" that are aligned and delineated so as to echo each other (not at all like the actual book). These two lines continue as visual echoes of each other, most markedly in the similarly placed "the," but then the upper line includes an obvious mistake: "Creat" rather than "Great." The echo in the "e S" below raises the possibility that this is a deliberate substitution of C for G, introducing another "e C" into the composition. Right above there is another "E S" in "CÆSAR," increasing the likelihood that both are intended together to draw attention to the "E C" in between. The "e s" and "e c" in these three lines are aligned vertically, and the continuation of the same vertical axis takes us back to the "EC" in "ECHARD." Finally, once the eye has noticed all this it also discovers that the same vertical line ends at the bottom of the page in the *k* in "Hodgkin," which is preceded by an unexplained empty space. The details here are small and dark, and only an enlargement with enhanced contrast reveals in full the bottom line. The *k* is larger than the other letters, like a capital letter, and is followed by a clear dot, like that of an initial. And sure enough, a few letters to the left, the *o* in Hodgkin's name is topped with a little

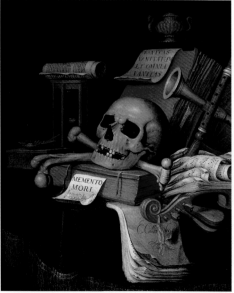

Fig. 8.10: *Left: Vanitas Still Life with Signature of R. Chandles*, 1695. 73 x 61 cm; 28¾ x 24 in. *Right:* Edward Collier, *Vanitas Still Life.* 76.5 x 62.5 cm; 30⅛ x 24⅝ in. Both courtesy of Christie's, London.

curved line that turns it into a cursive capital *&*, and it too is followed by an unmistakable dot: "E. (. . .) K."

Moving on, the two vanitas still lifes in figure 8.10 are very similar, in content as well as in size. The one on the right is signed by Collier on the cover of the music book flowing off the table. The one on the left bears a different name, this time in a piece of paper sticking out of the standing book: R. Chandles (easily mistaken for Chandler, as indeed it was auctioned). There are differences between the two paintings. For instance, the Chandles vanitas has a pedestal with a flowery design where the Collier one has a cloth-covered table; but then the same flowery design reappears in the Collier painting as the ornament on the "memento mori" sheet. Rather than simple imitation, these two canvases are playfully in dialogue with each other. With that in mind, look at the parallel gray-blue music notebooks overhanging from the table/pedestal. One is inscribed "E. Collier fecit" in lightly elaborated italics; the other bears the date "1695"—the other half of a signature, if you will—and the words "Memento Mori," also in signature-style curved italics. Does this mutually reinforcing give-and-take between the two notebooks provide the correct context within which to consider the rather strongly painted line

Fig. 8.11: Details of vanitas still lifes signed by R. Chandles (fig. 8.10) and William Palmer (fig. 8.12).

at the top of the notebook in the Chandles vanitas, that suddenly appears, perhaps, to delineate a large, confident, cursive *E* and a smaller, shyer *c* (fig. 8.11, left)?

I am not sure of this last monogram apparition, but the relationship of the Chandles painting to the Collier one is clear and does not depend on ghostly monograms. And yet how many ghosts doth a bona fide apparition make? In the middle of figure 8.11 the "R. Chandles" signature appears upside down. Note the excessive flourishes at the top of the *Ch* that appear to come together in delineating "E c" yet again. The *E* is even marked out with a conspicuous black dot that has no business being there, as if to signify a period following an initial. Now compare it also to the signature of "William Palmer" on another such painting (fig. 8.11, right). The word "Painter" ends in a rather out-of-place, elaborately curved line, one that resembles nothing as much as a reversed cursive *E*, and one that again encircles a clear black dot that appears to signify an initial. The oddly free-floating ornament right below, above "Froom," further seems to harbor a distinct mirror-image small *c* in bold black. And if this mirror image "E c" seems a mirage, note its close echo in the seal box cap, in the ".3" and the flourish beneath it. Coincidence?

V

The Palmer signature belongs to a painting that is one of a group of four, a group that was particularly difficult yet rewarding to reunite (fig. 8.12). The four canvases are almost identical, which in turn draws attention to their few, deliberate differences.

The painting on the top right was published half a century ago by a Swedish scholar, John Bernström. The letter on the table appeared to him to identify the artist: "To C.ˢ Field Painter at Trowbridge Wilts" (detail in fig. 8.13).[5] Bernström recognized that the painting was "directly inspired" by Collier, though he also believed that Field's still life influenced Collier's later works. Knowing less than we do about Collier's predilections, Bernström did not include in his list of Collier/Field parallels the peculiar variant spelling, on the painted title page of the open book, of Montaigne as "Montagne." Instead Bernström took this apparent mistake as a sign of Charles Field's ignorance, not surprising for a painter from a small town in Wiltshire. It did not, however, seem to puzzle the Swede that this painter in a small town in Wiltshire had gotten his hands on a seventeenth-century Dutch edition of Montaigne to begin with.

Bernström was not aware of the existence of the other three paintings, so he could not know that in two painted versions of Montaigne's Dutch edition the author's name is spelled correctly, and in the other two in the variant that he considered incorrect. Nor did he know the game of "spotting the differences to find the monogram." In the case of the Field painting this takes us to the caps of the boxes of wafer seals to the left of the letters bearing the signatures (compare fig. 8.5, top right and left, p. 140). The caps have numbers on their insides, indicating different seal sizes. The seal box cap in the Collier version displays a simple "No. 5." But its counterpart in the Field painting stands out as overly ornate, with a ".3" in the equally placed "No. 3" easily recognizable as a mirror-image *Ɛ.*, together with a mirror-image *C* in the curved line below. This curved ornate line, once again, loops around a conspicuously painted black dot that has no business being there, other than as a period to accompany the second initial in "E. C." Several Collier vanitas paintings with the same inkwell, book, and seal box arrangement are signed by Collier in initials precisely in this same spot on the open seal box cap, reinforcing this reading of the signs in the Field painting (see fig. 5.4, right, p. 94, and two examples in fig. 11.6, p. 201).

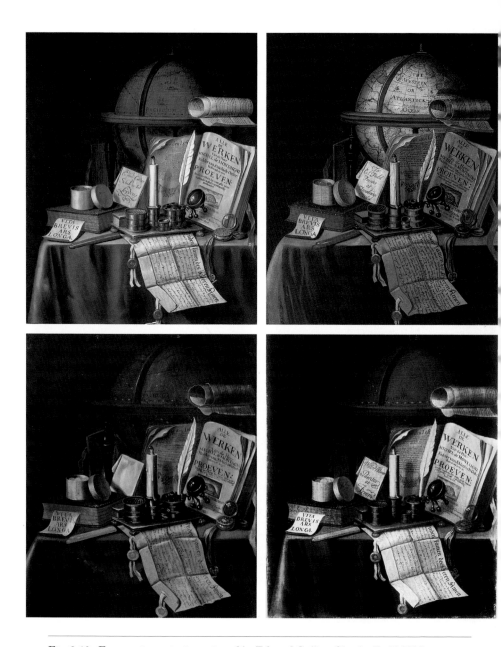

Fig. 8.12: Four vanitas paintings, signed by Edward Collier, Charles Field, William Palmer, and a blank. Measurements: Collier, 80 x 64.5 cm; 31.5 x 25.375 in.; Field, 83.3 x 69.2 cm; 32¾ x 27¼ in.; blank, 75 x 62.5 cm; Palmer, no information. Courtesy of Christie's, London (Collier, Field) and Photo Collection RKD, The Hague (Palmer, blank).

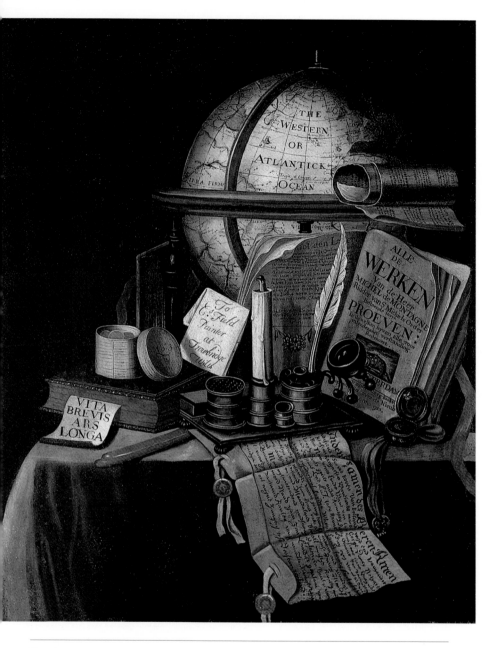

Fig. 8.13: *Vanitas Still Life with Works of Montaigne and Signature of Charles Field.*
83.3 x 69.2 cm., 32¾ x 27¼ in. Courtesy of Christie's, London.

There is more going on in the Field painting. The ".3" on the seal box is echoed in the initial of Field's name on the signed letter, which leads one to notice that this initial, a "C." for "C[harle]s," commences rather too abruptly in the middle of an overly long curve at the top, as if it were perhaps meant to delineate an E. Was this letter tampered with, or was it another faux pentimento that deliberately fused Collier's two initials? Furthermore, isn't there yet a third echo of Collier's dotted initials in the date of Montaigne's book, which ends with "53.", which is as fairly accurate a repetition of reversed "E c" as digits allow, and which is painted together with yet another unnecessary yet prominently displayed black dot?

Perhaps. But this out-of-place date "1753" leads me to conclude the discussion of this painting with a short speculative digression, not about identity games but rather about the trajectory of world history at the turn of the eighteenth century. If the Field painting is contemporaneous with Collier, then 1753 must be some playful gesture toward a distant future. But why? The Montaigne in the Collier-signed version of this painting is dated 1674. (The other two bear no dates.) This is also rather curious. 1674 is *almost* correct, but in fact Jan Hendrick Glazemaker's Dutch edition of Montaigne was published in 1672, with further reissues in 1680 and 1692. So why the slight shift? What marked the year 1674 was the end of the third Anglo-Dutch war, the last in a series of seventeenth-century tussles between the world's two largest naval powers over who ruled the waves. The Anglo-Dutch connection is indeed quite prominent in this group of paintings. Although they belong to Collier's English period, they display a Dutch book, and the version signed in Collier's own name has his signature in Dutch and places him in Leiden. Why?

The answer to this geographical question may lie in the paintings' geographical aids, namely their globes. For there is one more difference between the two paintings. The globe in the Collier-signed painting is in Latin and shows the Pacific Ocean; the Field-signed painting has an English-language globe foregrounding "The Western or Atlantick Ocean." Together these two paintings may be drawing attention to the history of England and Holland, the two successive arenas of Collier's career, in relation to each other. The globe in the "English" one shows the Atlantic Ocean, central to British imperial designs; the globe in the "Dutch" one, in Latin, is centered on the Pacific Ocean, central to the Dutch empire. And what made these two turn-of-the-eighteenth-century snapshots into a narrative is the fact that the Dutch composition was associated with the past—specifically with the year 1674, which with hindsight could be seen to have marked the erosion of Dutch glory—whereas the English one was

placed deep in the future. The Dutch globe is even in the shade, while the English one is bright and shining. Here in a nutshell was not only Collier's personal biography but also the history of European expansion from the seventeenth to the eighteenth century, as the baton was passed during Collier's lifetime from one global empire to another.

VI

The geography in these particular paintings is local as well as global. In their signature letters, Charles Field is described as a "Painter at Trowbridge Wilts[hire]," and William Palmer as "Painter at Froom." Trowbridge was a modest town in Wiltshire, some 110 miles west of London. Froom, or Frome, was a modest town in Somerset, some 110 miles west of London. But the distance between Trowbridge and Frome themselves is less than ten miles. These two nearly identical paintings, then, sport names of painters in towns that in turn-of-the-eighteenth-century terms were worlds apart from London, geographically and culturally, but that were quite close to each other, almost neighbors. Such a geographic pattern was probably not a coincidence.

A second geographic pattern then emerged, with greater significance. Recall the Warrender painting, and its group of Edinburgh-related objects unparalleled elsewhere. When I shared my thoughts about this painting with the curator responsible for it at the National Gallery of Scotland, her main objection was geographical. Edinburgh was a considerable distance from London, and one not too easily traveled at the beginning of the eighteenth century: did I have any evidence to show some connection between these two distant locations that could account for whatever I was proposing?

Two serendipitous findings provided an answer. The first comes from a Scottish wedding in 1890, of one Marie Louise Isobel Norie. The wedding guests were handed a souvenir pamphlet about the Norie family, which included a description of a "clever work" in the family's possession:

> It is on canvas, and represents some boarding of a wainscoted room, to which three leather straps are horizontally attached with tacks at intervals, into which are thrust a pair of compasses, a pair of horn eye-glasses, a long quill pen, an ink eraser, a stick of wax, copies of the *Edinburgh Courant*, the *Caledonian Mercury*, and of "*The Gentle*

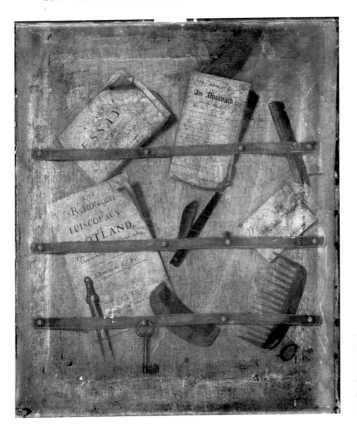

Fig. 8.14: *Trompe l'Oeil
Letter Rack with Signature
of Kenneth Smith,* 1705–6.
62 x 51.5 cm. Courtesy of
Shapes Auctions, Edinburgh.

Shepherd, a Scots Poem, by Allan Ramsay," open at the title-page, and
much thumbed,—and lastly, two letters, one with the seal outwards
and the other addressed to "Mr Jas. Norie, Painter, Edinburgh". . . .
Attached by a bow of ribbon to the lowest strap is an ivory, or biscuit
relief miniature of Charles the First in an oval black wood frame.[6]

Without doubt, here was another letter rack painting, now apparently
lost, that closely resembled the Warrender one and that included similar
Scottish materials. It also included a letter addressed in a manner now all
too familiar to one James Norie of Edinburgh.

Fig. 8.15: *Top: Trompe l'Oeil Letter Rack with Signature of Henry Howell,* 1702. 61 x 73.7 cm.
Courtesy of Sotheby's, New York. *Bottom:* Edward Collier, *Still Life with a Portrait of King
Charles I,* 1702. 44 x 55 cm. Gift of Abraham M. Adler, New York, through the America-
Israel Cultural Foundation B70.0158. Photo © The Israel Museum, Jerusalem, by Elie
Posner.

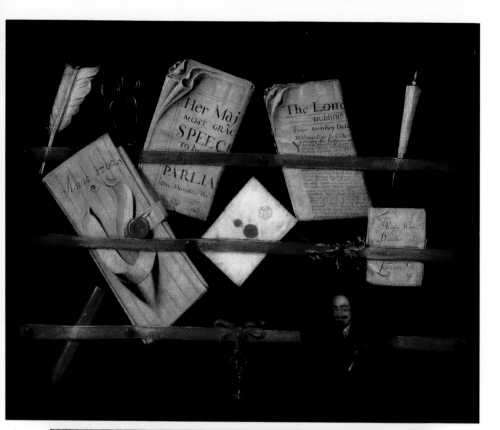

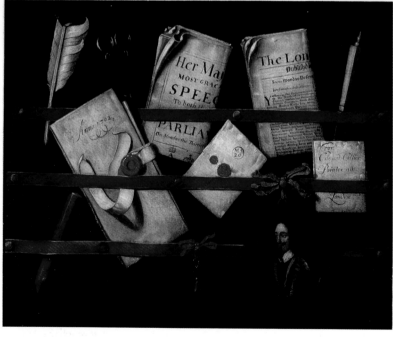

Second was the appearance of a heretofore unrecorded painting in an Edinburgh auction just as I began writing this book. It was in bad condition, dirty, and difficult to discern, but clearly a three-strap letter rack painting with Scottish pamphlets and a Scottish almanac dated to 1706 (fig. 8.14, p. 152). It too had a folded letter addressed in barely legible letters "to M?? . . . / Kenneth Smith . . . / Painter/ [Edin]burgh?."

I now had an answer to the curator's question. Here were three paintings with unmistakable and repeated characteristics that all proclaimed an association with Edinburgh: another geographic concentration, like that in the West Country.[7] Whatever explanation could be proposed for this series of Collier-like paintings, it had to be able to accommodate such clusters in a broad and unexpected geographic spread.

VII

I began the hunt for the Collier-like paintings signed by others with Henry Howell. Before moving on toward an explanation, let me close the circle by going back to Howell's letter rack. Or more precisely, to its long-lost twin, which, as it happened, had been hiding unrecorded in the cellars of the Israel Museum in Jerusalem, half a mile from where I grew up. It is one of the last Collier paintings I have found, and it provided a valuable missing link and confirmation.

It is obvious that Howell's painting and this one are closely interdependent (fig. 8.15). Their similarity extends, as in the case of Seymour and his doppelgänger, even to the details of the unusually legible news item in the *London Gazette* ("Yesterday the Parliament met . . . / to the House of Peers . . ."), as well as to the spelling of "Desember." And yet there are also differences, some obvious, some more subtle. Various details, especially of execution (lettering, the straps, etc.), are not the same. The two canvases differ considerably in size and are differently proportioned. One painting of course carries the signature of Henry Howell, the other of Edward Collier. And most satisfying: where the Howell painting has that broken curved line just below "Anno 1702" that I suspected to harbor Collier's monogram, the Collier-signed painting has merely a continuous looping line, an innocent flourish.

The Collier Club?

I

There is one further pattern in this group of Collier-looking paintings that turns it from simply a playful game or idiosyncratic practice to a historical episode begging for an explanation. The significance—and enigma—of these obscure canvases lies above all in the identities of the individuals in whose names they claim to have been painted. These individuals (as far as I can ascertain, since their archival traces are often difficult to find) were all house painters or skilled craftsmen otherwise engaged in painting and decorative work that placed them just outside the circles of easel painters. Although here and there the details are sketchy, the overall pattern is strikingly consistent. Just who were these people? And what can answers to this question tell us about the broader purpose and meaning of Collier's work?

Henry Howell was a prominent figure in the Worshipful Company of Painter-Stainers in London. Richard Chandles was also a guild member. He is recorded as a painter-stainer as well as herald painter in Shrewsbury, some 160 miles northwest of London. He was one of a thriving family of house painters in that town, several of whom belonged to the guild. Several Chandleses were apprenticed in London, among them Richard's son and Richard's brother Charles. The latter subsequently settled in London and was actively involved in the affairs of the Painter-Stainers Company, on one occasion joining efforts with Henry Howell to mediate a conflict between the painter-stainers and the herald painters. The British Library has a manuscript of arms and pedigrees of Shropshire families boasting an unusually ornate title page, with a hand-drawn book plate and inscription:

"Richard Chandles/ His Book/ 1695"—precisely the same year as the Collier-twin vanitas painting with the name "R. Chandles" protruding from a book.[1]

One more name may have also belonged to the circles of the London Painter-Stainers. Another typical Collier-like letter rack painting, complete with His Majesty's speech, the *Gazette*, Charles I's miniature portrait, a sealed letter, a hanging seal, and a comb, is signed with the usual letter, addressed "To/ Van Dyck mock/ Painter att/ London" (fig. 8.5, bottom left, p. 140). Note the unusual phrase "mock painter." Who was he? Not the famous Anthony van Dyck or van Dyke, deceased half a century before His Majesty gave any speeches. Perhaps he was one George Vandike, from a well-known family in Lewes (Sussex), who entered into an apprenticeship in the Painter-Stainers Company in London in 1668. His subsequent whereabouts are unknown, though he may have moved back to Lewes, where a presumably younger George Van Dyke was active in various civic roles in the early decades of the eighteenth century.[2]

If this last identification is plausible but not 100 percent foolproof, such is not the case with the Scottish group. The letter rack trompe l'oeil bearing the name of the Edinburgh house painter Thomas Warrender dates to 1705–8. Precisely during the same period, the historical documents also record the activities of Kenneth Smith, whose name appears on the 1706 letter rack painting with a selection of Scottish pamphlets. Smith was an Englishman who came to Edinburgh around 1700, when he was "commissionat [*sic*] by some noblemen and others to bring home some pictures and frames for staircases chambers and closets," upon which he petitioned to sell the remainder by public auction. In 1705, while he was decorating Melville House, it is recorded that "The Dean of Gild and his Council are to admit Kenneth Smith, painter, burgess, and gildbrother gratis, for good services done by him to the town." In 1707—a year in which he was lining pictures and copying portraits of Queen Mary for the Duchess of Buccleuch—Kenneth Smith was naturalized in Scotland. The act of naturalization described him as a "limner," a term that had been used in the sixteenth century for artists painting in watercolor on vellum, but that by the late seventeenth century was employed more loosely for various painterly occupations below the top of the professional hierarchy, such as miniature painters, decorative painters, copiers, and portraitists.[3]

This leaves one more Scotsman unaccounted for: James Norie, whose own letter rack painting is lost but was recorded for posterity in his descendant's wedding souvenir. Norie too was a house painter. He established the most successful decorative painting business in Scotland in the

eighteenth century, the Norie firm, whose services extended from painting gutters and skirting boards through decorating with Italianate landscapes to imitation marbling. Born in Morayshire in 1684, Norie was of a younger generation. The most important archival nugget for the present investigation is a bond dated 2 February 1707 for a debt owed by an architect to Thomas Warrender, painter, which lists the witness as "James Norie, servant to the sd Thomas Warrander." Right around the time that the letter rack paintings with the names of both house painters were produced, then, the young Norie was in fact working for and probably training with the well-established Warrender.[4]

Three other names in this group of paintings lend themselves to indubitable identification. One appears in a standard-issue letter rack painting with a rather poorly executed king's speech and a "memorie" notepad, as well as a letter addressed "for/ Mr. F. Peterson/ Painter att/ London" (fig. 8.5, bottom, second from right, p. 140). Otto Fredrik Peterson was a Swedish-born goldsmith turned enamellist who arrived in London in the early 1690s, just like Collier, and specialized there in miniature portraits.[5] A second appears in a standard-issue vanitas still life with the queen's speech, of which several almost identical variations exist (fig. 9.1). The speech, oddly, is dated 1709. The other oddity is Collier's monogram, found here in the same location as several others on the cap of the seal box, but in this case not hidden but rather emblazoned in huge letters. The folded letter, perched in its usual place, reads: "For/ Mr. Ritts/ Painter at/ Cambridge." In 1743 the antiquary William Cole visited the church of St. Mary the Less in Cambridge and noted as follows:

> Over the door of the screen pretty high hang the Arms of the present Royal Family neatly painted, and was the gift of Mr. Valentine Ritz, a German painter, who had lived in this parish near 50 years, and is now very old: he was formerly no indifferent copier, but now past his work.

German-born Valentine Ritz—the spelling variation of his name is of course of a piece with the rest—resided from the late 1690s in Cambridge, where he painted churches, walls, coats of arms, and also some portraits, including one of Newton, which may have been copies.[6]

The third individual who can be identified with virtual certainty is Mr. Turing of Durham Yard. In the second half of 1701—precisely the year noted on the painting with Turing's name and address—a new ratepayer by the name of John Turing moved into Durham Yard. He paid at a rate

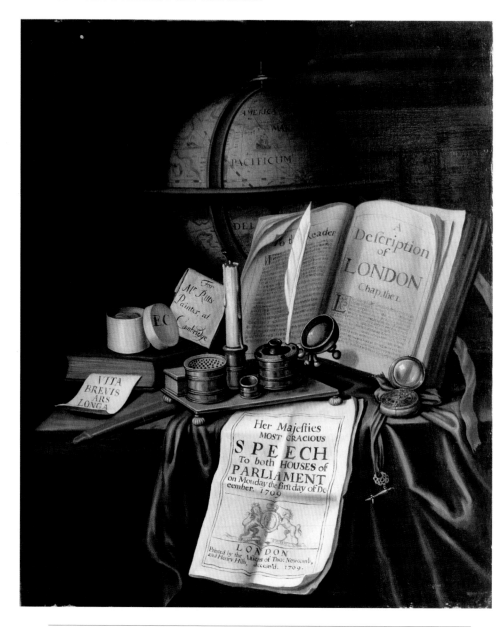

Fig. 9.1: *Vanitas Still Life with Signature of Valentine Ritz*. 76 x 63 cm. Courtesy of Sala Parés, Barcelona.

of £1 per annum, which marked him as fairly solidly prosperous by the standards of the street. The fact that Turing was an Aberdeenshire name quite uncommon south of the border made his identification as the man in the painting all the more likely. And then came the clincher: John Turing continued to pay the rates in Durham Yard through 1709/10, and in the

record of his very last payment his occupation is stated next to his name: *limner*.[7] John Turing, in short, fit the pattern to a *T*.

There was a second man named Turing in this neighborhood during the very same years. His name was William Turing, he had Scottish connections, and he was a cabinet maker and japanner as well as screen maker and looking-glass maker, living in a variety of locations within a stone's throw of Durham Yard. The close proximity of addresses, the rarity of their family name—John and William were the only two Turings listed for the whole large parish of St. Martin in the Fields—and the affinity of their occupations suggest a likely family relationship. Perhaps they were brothers or cousins: when William baptized twins in February 1700 (Old Style), he named them William and John.[8] This is worth mentioning because of a detail in the inventory of the property left by William Turing upon his death in 1730. After listing the various tools and materials in Turing's warehouse and shop related to his trade, the inventory moves to his rooms, where it lists "one drawing table . . . a Book with some drawings Ten instruments for drawing" and "two Brushes twenty Seven Prints and Drawings in black and Guilt frames."[9] Was William Turing an amateur artist, sharing with his putative brother/cousin a private interest in painting or drawing? Or perhaps these signs of painting activity *were* his relative's?

Either way, nine individuals so far can be identified as house painters and decorators or otherwise employed in applied visual arts other than easel painting. A few more cases require speculating with less than perfect information. Who, for instance, was William Brasier? Although I could not find a painter by this not uncommon name, it does match a skilled professional whose work involved both careful draftsmanship and decorative drawing. This William Brasier was a surveyor and map maker, several of whose hand-colored and decorated maps from the early decades of the eighteenth century have survived, including some of London parishes. While I cannot be sure that he was the man described in the letter rack as a "painter at London," surveyors are known to have been sometimes members of the Painter-Stainers Company.[10] Another name appears on a now-lost letter rack painting that surfaced only in a grainy photograph in *Country Life* in 1948—a virtual twin to the one carrying the name of Otto Peterson. It was signed, reportedly, by "C. Knight." If the name on this rack was actually "E. Knight" (we saw before a similar confusion of *C* and *E*) then this might have been Eloas Knight, a minor artist, flower painter, and perhaps scene designer active c. 1700, who later illustrated George Farquhar's plays.[11] This Knight would again fit the emerging pattern quite well.

Finally, two other names, William Palmer and Charles Field, appear on two almost identical Collier-twin vanitas still lifes as painters from Frome

and Trowbridge. Sure enough, both names turn up as the local house painters in these respective West Country towns. And yet in this double instance I encountered a wrinkle. Neither identifiable house painter could be firmly placed in the correct period. Frome's records flag one multi-generation family, the Palmers, who between 1785 and 1852 supplied the town with at least five house painters, including one named William, but the records do not reach back as far as the early eighteenth century. As for Charles Field, the traceable house painter in Trowbridge with this name married in the 1740s, worked on various house decorating projects in the area from the 1750s through the 1770s, and died in the early 1780s.[12]

So perhaps these are mid-eighteenth-century copies of an earlier Collier painting? This is not impossible. It would also account for the 1753 date on the one signed by Field. There is one example of precisely this: a Collier-looking painting carrying the date 1755, painted by an artist named Samuel Goodwin, who himself is also known from another trompe l'oeil of a dead bird after a hunt dated with certainty to 1749. The details reveal Goodwin's painting without a doubt to be a later copy, or a later alteration of an earlier canvas: the royal speech bears the name of a printer that only began printing such speeches in 1712, after Collier's death; the composition includes the works of Alexander Pope, published only from 1717; and Goodwin's name is signed next to Collier's full name, departing from the practice of all the examples from Collier's lifetime.[13] This is precisely the point: a painter working much later could imitate Collier but could hardly be expected to get right all the small details. The Palmer and Field examples, by contrast, reproduce even the most quirky details of this group of paintings: the naming of house painters from two close-by towns; the penchant for name-spelling variations between pairs of paintings ("Montaigne" and "Montagne"); and the hiding of Edward Collier's initials in both paintings in two different ways that match perfectly the other examples. That these were simply later copies that happened to get all these details right seems improbable.

It could also be the case that the historical records I have been able to find are incomplete, and that both Palmer and Field came from families of local house painters going further back in time. This is a not unlikely proposition, since such professions often ran in families for generations, like the Palmers of Frome or the Chandleses of Shrewsbury. Yet this explanation leaves the "1753" date on the works of Montaigne in the painting carrying the name of Charles Field, who was active in Trowbridge at precisely that time, as a rather peculiar coincidence. So perhaps the best explanation is a combination of both alternatives: namely, that these

paintings indeed originated like the others during Collier's lifetime, but that one or both of them were subsequently altered for future family members, retouching a date here or a first name there. The trace of such an alteration may be evident, say, in the ambiguous *E/C* as Field's initial. Whether this suggestion is plausible or not depends on the answer to a more basic and pressing question: taking this group of fourteen paintings together, paintings that fall into a consistent and surprising pattern, what possible narrative can make sense of all this?

II

The first thing to point out is that a scenario in which Collier was *not* himself involved intimately with these paintings-signed-by-others is rather improbable. Unless, of course, we posit the existence of a sizable group of fans, coming from professional circles with especial appreciation for Collier's skills, who followed this relatively minor artist around and copied his work with the aid of a list of guidelines that ensured the repetitive adherence to certain rules. A Collier Club.

This fantasy aside, the next plausible assumption is that Collier painted these canvases himself: hence their close and often intimate relationship to his signed work. Perhaps these paintings were an outcome of a market transaction, a service that Collier offered in his atelier to choice patrons and fellow masters of the brush. *Boost your record: take home a painting painted by you.* A decorator who wanted to start up a business could obtain a canvas to put on his wall as advertisement and proof of credentials. Or perhaps this was Collier's idea of a gift to students or collaborators. Either way, in this scenario Collier would paint a composition with his own favorite elements and games, and while signing it in the name of the client or colleague he would also implant his monogram. Sometimes, presumably, Collier would also add certain touches specifically at the patron's request: a print of Neptune here, a pair of playing cards there. Hence the particular details in some of these paintings that are quite unlike Collier's own and not repeated elsewhere. Such paintings therefore were not intended for the open market but rather as presents or trophies for the people signed on them, like the one bearing the name of James Norie that was still a prized possession of the Norie family almost two centuries after its creation.

If these paintings were some kind of professional-courtesy-cum-service that Collier offered to house painters and decorators, this can account also

for their geographical pattern. Three letter rack paintings appeared simultaneously in Edinburgh, in this scenario, when Collier traveled to Scotland and catered to a local group of house painters. This group then asked for certain variations on his usual designs to suit their own local political and personal interests. The paintings from the West Country may offer a further insight into Collier's actual practice. Figure 8.12 (p. 150) shows a fourth near-identical canvas next to those signed with the names Collier, Palmer, and Field, carrying a "signature" letter that appears *blank*. I am saying this cautiously: only a photograph survives of this no longer traceable painting, which over a period of three centuries may have been tampered with, allowed to deteriorate, or restored badly. But if this painting does carry a blank letter where the others are signed, then perhaps it is a template. The book's title page likewise seems to have been done by a less skillful hand, perhaps added to the blank template.[14] We can imagine, then, Collier traveling to the West Country with several pre-prepared canvases of a very similar design, using his own name as example on one of them, filling some others while he was there with the names of local house painters, and having a blank one left over.

However unusual, this is a plausible picture. I believe it is not too far from the truth. But it is not yet complete: what actually happened with these paintings must have been, at least in some cases, even more complex.

There are certain quandaries that the speculative narrative I just offered does not resolve. If Collier produced copies of his own paintings that he "signed" with the names of house painters and decorators, why did he introduce deliberate yet minor changes, altering the angle of a newspaper, say, or the uniformity of painted letters in print? Was it simply the case that Collier did not invest as much effort in "copies" as he did in his self-signed "originals"? Or that he deliberately maintained the copies that others would pass off as their own work at a lower level of technical skill than those bearing his own name? Perhaps, sometimes. But in fact the quality of execution of the "faux non-Collier" paintings varies considerably, from those that are not inferior to Collier's other work, like Warrender's, to some that are obviously executed at a lower standard. In some cases—say, the letter rack straps in the Howell trompe l'oeil versus its Collier-signed twin—the differences reflect aesthetic preferences but not gradations of skill. It is as if they were simply executed by different hands. Such examples can be readily multiplied. In the signatures of the Charles Field and its near-identical Collier (fig. 8.5, top left and right, p. 140) the "handwriting" is not the same. The *w* in "Edward" has pointed legs, but those in the *w* in "Trowbridge" are rounded. The *e*'s in the Collier are squatter and fuller in

comparison to the slimmer, more vertical ones in the Field painting. Such a comparative exercise is hardly foolproof. Although Collier's typical w is pointed in dozens of paintings, one can also find an incontrovertible signature by his hand with a w that is rounded (on the rack in fig. 7.3, p. 126). Many of those paintings have also undergone restorations that were sometimes less than satisfactory. But with all the caveats, these two paintings do appear to indicate that they were not "signed"—and in some other fine details not painted—by the same hand.[15]

So maybe they weren't. Here, then, is a more elaborate scenario that seems to me to explain as much of the evidence as possible.

As I suggested before, I have little doubt that Collier was involved in the production of these paintings, and that he was responsible for the repetition of Collieresque elements as well as for his hidden monograms. But I do not think these were his responsibility alone: I'm imagining these paintings as *collaborations*. Suppose that the service that Collier offered second- and third-tier painters and decorators was not simply to provide them with a painting in their name but, at least in some cases, to give them a training session in which teacher and student produced a painting together. After all, house painters were more likely to actually need trompe l'oeil skills on the job than easel painters. It is also clear that Collier was well connected to this milieu, perhaps going back to a relationship with Robert Robinson in the 1680s. So Collier would let it be known that he taught naturalist and illusionist painting skills, as he had learned them from the Dutch masters, to British painters who were interested. Their training, perhaps sometimes in group sessions (recall the Edinburgh trio), would culminate in producing together a Collier painting, but not fully Collier. Some of them would have little independent input into the design or the execution and would walk away simply with a Collier-copy painting bearing their name, as I suggested. But others, more mature and confident—like Warrender, who was by the early 1700s a well-established painter in his own right—would contribute more: some would do this well, adding perhaps elements of their own, others less so. Such a scenario explains the wide spectrum in terms of quality of execution among the "faux non-Colliers." It explains the localized variations in style in those cases where we have near-identical pairs of paintings, as well as variations in the quality of execution even on the same canvas. In the case of Howell's letter rack and its "twin," for instance, the line with the hidden "E C" beneath the date on the folded document in the Howell-signed painting is actually better executed than the counterpart plain line in the Collier-signed one, which makes

sense if the two painters swapped roles for this particular detail with which Collier ghost-signed the Howell canvas.

Such a scenario also makes it more plausible to envisage such a painter continuing to tinker with *his* painting once he took it home. Perhaps Collier actually encouraged his student-collaborators to do so. One of them might have introduced, say, something as odd as the monogram in Valentine Ritz's still life with the queen's speech (fig. 9.1, p. 160). The placing of the "E C" on the cap of the seal box is precisely that which Collier had used, quite subtly, in other paintings, some signed by him, some by others. But the black, schematic, in-your-face appearance of the monogram in this painting is anything but. Was this a change introduced by Ritz? Perhaps to commemorate Collier, who died right around this time (recall the odd date on this painting, 1709, that may also be an alteration[16]), or simply to complete a painting that Collier's death or departure left unfinished? Similarly, did the more mature James Norie in the 1720s—precisely at a time when we know he experimented with a few paintings on canvas—"update" a newspaper and a pamphlet relating to a personal friend in his own letter rack composition?[17] And did the mid-eighteenth-century Charles Field alter a painting that had been in the family, changing a date, and perhaps an initial?

There are many assumptions and leaps in this story, and yet it seems to be the best explanation of the available facts. But this is hardly the end of the matter: my account so far suggests how these paintings came about but does not yet explain *why*. It is in the answer to this question that this story becomes more significant. The relationships between Collier and the decorative painters, the painting of these canvases on behalf of craftsmen who never made anything like them, the signing of these paintings boldly in their names but only surreptitiously in his: these were all loaded gestures, political ones. The stakes in this unusual episode, I want to suggest, go to the heart of the politics of professionalization in the arts.

Death of the Author?

I

I'd like to begin laying out the political stakes in Collier's pas de deux with the house painters and decorators by revisiting two seemingly unrelated painted objects that already crossed our path and that landed, prematurely, in the "cases solved" column.

The first is in the painting signed in the name of Mr. Turing (fig. 8.9, p. 145), with its intricate games with "E C" and "E K" in the title page of the open book, the second volume of a work on Roman history by Laurence Echard. But is Echard really the author? What is in fact written in the "credits" section of the painted title page is somewhat confusing: "LAURENCE ECHARD/ Prebendarÿ of/ Lincoln/ by T. Hodgkin." So is it Echard, or Hodgkin, or both? To answer this question we need the book's actual title page (fig. 10.1). It says: "By LAURENCE ECHARD, A. M. Prebendary of *Lincoln*," and further below: "London, Printed by *T. Hodgkin*, for *M. Gillyflower* . . ." and a host of other booksellers. Hodgkin was *the printer*. When Collier painted this same book on another occasion into a less elaborate still life he took out the printer's line altogether, leaving only Echard's name, the author.[1] In the title page in the Turing painting, by contrast—a title page constructed, as we have seen, with great care—Collier not only included Hodgkin's name but withheld the word "Printed" that precedes it, even though the corresponding space on the painted page is clearly visible and empty. At the same time he also placed the opened cap of the inkwell so as to cover the word "By" in front of Echard's name. The combined effect of these two choices is to obscure or reduce the difference

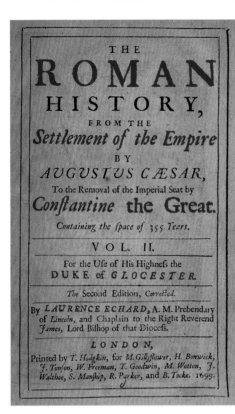

Fig. 10.1: Detail of *Vanitas Still Life with Signature of Mr. Turing*, 1700 (fig. 8.9); with Laurence Echard, *Roman History*, vol. 2 (London, 1699), title page. Courtesy of the Trustees of the Boston Public Library/Rare Books.

between author and printer. The painted book sports what appear to be dual, two-tiered authorship credits, coyly suggesting that the craftsman's responsibility for the printed object is of the same kind, even if not the same degree, as the author's. And this in a painting in which the painterly authorship itself is dual, double-tiered, coyly fudged (with the signs hidden right in the middle of Echard's and Hodgkin's names), and also involving two individuals with related vocations and a professional skill differential.

The second element I would like to revisit is the book of medicine signed "[Da]vid Stam, M. Dr." that Collier painted into an elaborate letter rack next to Erasmus's "appearance deceives" (fig. 10.2), an unusual touch that was presumably related to Stam's identity as Collier's relative and longtime acquaintance. But the book is actually a much more elaborate feat of illusionism. To begin with, Stam never wrote such a book. David Stam has one publication to his credit, a 1693 edition of an earlier Italian

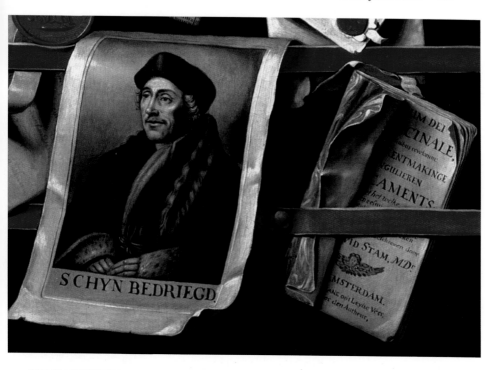

Fig. 10.2: Detail of Edward Collier, *Trompe l'Oeil of Framed Four-Strap Letter Rack with Medical Book*, 1703 (fig. 7.3).

chemistry work to which he added his own recipes, but there is no record that he ever published anything else. To the contrary we have the testimony of William Burton, MD, a mid-eighteenth-century biographer of Stam's student Boerhaave, who commended Stam for having been one of those learned people "who are unwilling to load the world with books, [but] are greater adepts than others, who have printed chemical treatises with pompous titles." Stam was not one who "conceals any material part of his knowledge," as the people whom he taught chemistry in his shop could attest, but he did not engage in vanity publications.[2]

There is more. It is not even clear that Stam really had a medical degree. Stam studied medicine at the University of Leiden for several years, and used the title "M. Dr." on numerous occasions, but is absent from the well-preserved lists of Leiden's medical faculty graduations, and there is no evidence that he received this degree elsewhere. When Sylvius, the famous physician in whose laboratory Stam had worked, attests in writing that "Stam has lived as a medical student more than eight years, during which time he exercised other students well in chemical operations," this reads like a rather roundabout way of giving Stam the testimonial he had asked

for without actually calling him a doctor.[3] Burton, himself also a medical doctor, refers to Stam as "Mr.," not "Dr." In short, as far as the evidence allows, even if Stam the apothecary had considerable medical knowledge, it appears that his medical degree was made up. So Collier, it seems, painted a book that did not exist in the name of a professional who claimed credentials he did not in fact possess. Small wonder that the artist placed the book right next to Erasmus's "SCHYN BEDRIEGD."

And yet what could "SCHYN BEDRIEGD" here mean? It is questionable whether Collier was simply drawing attention to a fake doctor and a fake book; after all, Stam was family and friend. Perhaps, rather, he was boosting or correcting the résumé of a man with the medical know-how but without the full appreciation he deserved. *Appearance deceives: David Stam may not have the veneer of professional credentials, but he is as knowledgeable as any physician.* In the early modern medical pecking order the apothecaries were actually not too far below the physicians. They prepared medications but were not supposed to prescribe for or treat patients. In practice these lines, even as they were insisted upon by the professional establishment, were often hair-thin.

Herein lies the connection to the house painters. The apothecary was to the physician what the house painter was to the easel painter. The guild structure that enshrined and reinforced these professional hierarchies was undergoing much flux in the seventeenth century, often accompanied by tensions between the professional elites, medical or painterly, and those just below them, breathing down their necks by offering very similar services. The history of the St. Lucas guilds in seventeenth-century Holland—the guilds that provided a common roof for house painters, tapestry weavers, jewelers, paint makers, and sometimes even apothecaries—is peppered with efforts on the part of the panel painters, the *fijnschilders*, to separate themselves from the painter-decorators, or *kladschilders*. Sometimes the pressures worked the other way around, as when the Leiden *kladschilders* petitioned successfully to reduce their guild dues because of their considerably lower earning power in comparison to the panel painters, and to prevent the latter from sending their apprentices to perform tasks that were the domain of the house painters. In London the painter-stainers refused on one occasion to allow the "Picture Makers"—the easel painters, who were sometimes treated as part of the collective and sometimes not— use of their hall for the purpose of "drawing to the life."[4]

And what is the connection to Echard and Hodgkin? During the late seventeenth and early eighteenth centuries the modern notion of the quintessentially unique role of the author, so different from that of other print

workers, was still in the process of being hammered out. For an earlier way of thinking we can turn again to the leading late-seventeenth-century authority in the field, Joseph Moxon, whose confidence in the role of the compositor in the print shop to mold the text—for meaning, not merely for form—was unflinching:

> It is necessary the *Compositers* Judgment should know where the Author has been deficient, that so his care may not suffer such Work to go out of his Hands as may bring Scandal upon himself, and Scandal and prejudice upon the *Master Printer.*[5]

Yes, the author had the primary responsibility for the text. But read through an early modern rather than a modern eye, it is evident that Moxon's view of textual production was a *collaborative* one, in which print workers also played their second-tier yet qualitatively similar part; much like the implication of Collier's title page of Echard's and Hodgkin's Roman history volume.

The process through which these professional hierarchies in the production of texts became stabilized was again fraught with tension. In 1713 a Scotsman prefaced an Edinburgh translation of a French tract on the art of printing by drawing a sharp contrast with former times. Before, he wrote, printers were distinguished by "the Marks of Honor paid them, whilst alive; nay, and the Monuments rais'd to preserve their Memories after Death . . . Whereas now, we are scarcely class'd or esteem'd above the lower Forms of Mechanicks."[6] The sense of loss—loss of status, of appreciation, of proximity to the author—is immediate and personal.

Like the printers, like the apothecaries, the house painters and decorators too saw their professional status and pride threatened by increasing professionalization and the ever more rigid hierarchies it entailed. Was an accomplished house painter so much less skilled, or deserving of respect, than an easel painter? In the early 1700s—around the time when we know Collier was in Edinburgh—a group of house painters, including Thomas Warrender and two of his pupils, James Norie and another Scottish house painter and herald painter named Roderick Chalmers, joined the Edinburgh trade guild, a multi-craft organization similar to the Dutch ones. In 1720 Chalmers was asked to paint the guild house's chimneypiece: he chose to depict a collective portrait of the various crafts represented in the guild (fig. 10.3). In Chalmers's painting the tradesmen are all wearing their working gear, caps and leather aprons, standing or sitting on three-legged stools, and engaged in their respective trades. The one striking exception is

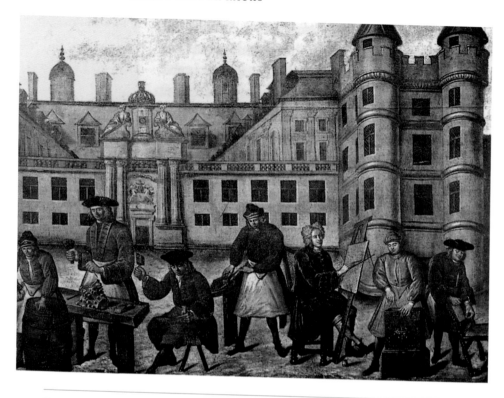

Fig. 10.3: Roderick Chalmers, *The Edinburgh Trades of Holyrood,* 1721 (detail).
Courtesy of the Witt Library, The Courtauld Institute of Art, London.

the painter. Although the stock-in-trade of painters like Warrender, Norie, or Chalmers was house painting, Chalmers depicted the painter sitting on a carved high-back chair next to an easel, dressed in his best velvet coat and wig like a gentleman, painting a panel picture.[7] This was the painter-decorators' ambition or unrequited fantasy.

James Norie, unusually, had actually acted on this ambition. As an established house decorator later in his life he also painted some land-scape canvases. But a younger member of Chalmers's family, writing about Norie many years later, tells us the truth: "The natural genius of Mr. Norie for landscape, entitles him to a place among our Scots painters. [But:] His occupation as a housepainter employed him so much, that he had no time left to improve his natural talents." A modern historian is harsher: "Norie's work, in fact, reveals the status of landscape painting at this time, to harmonise the overall effect of certain rooms, to function, in other words, as 'up-market wallpaper' in relation to a generalised decorative scheme. Cultural workers like Norie were in no position to assert their own autonomy

as 'fine artists' during this period."[8] The distinction in the professional hierarchy was difficult to overcome.

This is the context, I wish to suggest, for understanding Collier's gesture when he invited house painters, decorators, and other painters of relatively lowly status to collaborate with him on paintings in their names. Together they were enacting the same wishful thinking or unrealizable fantasy that Chalmers indulged in when he portrayed the house painter as a genteel canvas artist, or that the middle-aged Norie engaged in when he aspired for his "natural genius" to earn him a place among Scottish painters. Together they shored up the house painters' résumé and their pride. Just think of the two documents most conspicuous in Thomas Warrender's letter rack: his guild memberships. Together, most importantly, they engaged in a defiant political act. Collier's repeated practice of painting canvases with and for the house painters was a gesture of resistance to the pressures of hierarchical specialization. The phrase "mock painter" in Van Dyck's painting might also have been an ironic dab at this hierarchization. It was the same kind of gesture as when Collier endowed the apothecary David Stam with a medical degree and a medical book, and when he forced Laurence Echard to share his title page credits with Hodgkin the printer. Here was a man who was happy to call every house painter a "painter" in precisely the same manner that he described himself.

II

Why did Collier care? What drew this recent arrival from Holland to the house painters and decorators?

It is likely that Collier's lot as a painter was not an easy one. Collier arrived a generation too late, just missing the golden age of the Dutch still life and hoping to make a living when the genre and the market were in steep decline. The number of artists active in the Netherlands in 1700 was a quarter of what it had been around 1650. As a still life artist Collier was also, so to speak, a genre too low. This too was in part a question of timing. At midcentury art theorists had not yet adhered to strict "high" and "low" distinctions between genres of painting. Oddly, it was Samuel van Hoogstraten—himself an accomplished still life illusionist—who introduced in his art theory book of 1678 such a strict hierarchy, placing still life artists at the very bottom, those who are merely the "common soldiers in the army of art." (One could imagine he was talking about *kladschilders*.) Van Hoogstraten insisted that

"by no means may a few flowers, fruits, or other still lifes, whatever name we give them and no matter how pleasingly they are painted, be ranked higher than the first degree of works of art, though they be rendered . . . even as deceivingly lifelike as Zeuxis and Parrhasios."[9] Zeuxis and Parrhasios were the two master illusionist artists of antiquity. Now, three years after the death of Gerrit Dou and three years before the death of Frans van Mieris, each of whom had been acclaimed as the Dutch Parrhasios, Van Hoogstraten declared that even Parrhasios himself could not elevate an illusionist still life to the rank of high art. Collier simply missed the boat.

Or more likely, this is why Collier caught the boat. His move to England followed the dramatic shift in the European art market, in which demand in Holland plummeted but that in England was rising fast. London had seen a handful of art auctions per year before the late 1680s, but after the Glorious Revolution their number exploded: 28 in 1689, 48 in 1690, 76 in 1691, and 64 in 1692, just as Collier was preparing for his move. But there was a price to be paid for this. The Netherlands had experienced many decades of unprecedented artistic effervescence. In 1685 William Aglionby, an Englishman with a long-standing interest in Dutch matters, proclaimed with envy: "the *Dutch* in the midst of their *Boggs* and ill *Air*, have their *Houses* full of *Pictures*, from the *Highest* to the *Lowest*." The English, on the other hand, have "a Notion of *Painters* little nobler than of *Joyners* and *Car-penters*, or any other *Mechanick*, thinking that their Art is nothing but the daubing a few *Colours* upon a Cloth."[10] In England all painters were treated like decorators. So while it is true that things were changing fast, it is also plausible that a painter moving to London in the 1690s—an accomplished but not world-class painter, and one with a predilection for illusionist art that could easily be looked down upon as a kind of novelty—would find it hard to gain the same public respect that his teachers had had in Holland during its golden age.

Paintings in the 1690s, moreover, were cheap. This was the express rationale professed by one avid art buyer during this decade, Robert Kerr, the fourth Earl and later first Marquess of Lothian. In London in the mid-1690s Kerr found himself purchasing paintings time and again for himself, for his wife, and for his daughter, "knowing no ornaments Cheaper, and more modish." "I have bought some pictur for my selfe," he wrote to his wife on one occasion, "which will serve instead of hangins in Lynd rooms and much cheaper." If the art Kerr wanted could not be found in London, or not cheaply enough, he would have it "fraught from Holland, where I intend to Looke after, if I can gett non heer." "My picturs, I confess," he informed a friend, "are now Lesse worth, since I cannot gett

an stair case to hang them up in, but they have coast but very inconsiderably," whereas "slight hangings" would cost "more than them all."[11] Kerr seems to embody the undiscerning patron that provoked Aglionby's exasperation, seeking good deals for ornamental decoration "rather than the choice acquisitions of a connoisseur" (thus the assessment of the modern historian of the Lothian collection). This remained true even if somewhat later in the decade he was pleased to report to his wife the purchase of a choice still life, "a pictur of Shells you will ad meere." The Earl of Lothian's purchasing habits are significant not only because such information is rare, but because one of his regular suppliers of paintings was Collier himself. The Lothian collection included as many as five Collier canvases (or more), one of which was dated 1695, and at least six by Collier's compatriot in London and fellow still life painter Pieter van Roestraten, who was probably responsible for Lady Lothian's admirable seashell composition. Such a concentration was most likely accumulated by the fourth earl himself, until his death in 1703. While being the only British patron of Collier's that can be identified with reasonable certainty during the artist's lifetime, Lothian, perhaps because of a taste developed during his education in Leiden in the 1650s, restricted himself to traditional still lifes, and does not appear to have sought attractive bargains in Collier's more avant-garde trompe l'oeils.[12]

In truth, therefore, Collier may have had trouble making a decent living from his easel painting alone, in Leiden or in London. Other painters of similar standing certainly had their difficulties, like the still life and trompe l'oeil artist Cornelis Brisé, who supplemented his income by moonlighting as custodian of the Amsterdam theater. In Leiden there are fragments of evidence that Collier undertook *kladschilder* commissions as well: the panels for the model of the Amsterdam Town Hall that were to puzzle Goethe; an elaborate coat of arms for the 1676 Leiden funeral of an Englishman named James Primrose, for which Collier was paid eighteen guilders. In England—where the art auction market slowed down after the feverish mid-1690s, and where the kind of paintings Collier painted sold for modest sums—no such evidence has come to light. And yet the connoisseur, critic, and collector Edward Croft-Murray, author of the most detailed study of house decorating in Britain, included Collier in his catalogue of house painters even though he never encountered a wall painted by him, simply because his profile fit those artists at that point in time who could and would have needed to diversify their practice.[13]

It is likely, in sum, that Collier's circumstances brought him quite close to the house painters and decorators. He shared with them the difficulties

of making a living, a precariousness of status within the professional establishment, and, one may assume, some resentment. It is thus not too surprising to find him mobilizing his specific talent and his penchant for playing games on canvas in order to allow those house painters, and others similarly under-appreciated in the professional pecking order, gestures of defiance against the system.

<div style="text-align:center">III</div>

Although the relationship of the Worshipful Company of Painter-Stainers to foreigners was often vexed, as was also their relationship to easel painters, some individuals from both groups were allowed to become members.[14] The records of the company, however, do not mention that Collier was among them. The main evidence of Collier's close association with the guild thus remains the group of paintings that he produced in collaboration with some of its members. Perhaps his initial entry into these circles was facilitated by his likely early association with Robert Robinson, an active member of the London company who also worked in mezzotints, including the one from the 1680s with a distinctive design borrowed from Collier. Collier, in turn, may have collaborated with Robinson on one of his Collier-like canvases.[15] These London connections may have also led him to others elsewhere. Perhaps he knew Kenneth Smith, limner and frame maker, before the latter moved from England to Edinburgh around 1700. Smith, like Warrender, was also associated with the House of Lothian, with which Collier was connected as an important source of patronage.[16]

It is still possible, however, that Collier was a member of the Company of Painter-Stainers after all. A tantalizing snippet of information places Collier in close proximity to the company and possibly in it. On 24 June 1710 a visitor arrived at the Painter-Stainers Hall. The Frankfurter Zacharias Conrad von Uffenbach did not like London very much—he found the grime that covered everything disgusting—but was keen on recording curios of all sorts. One of them he found there, in the company's hall:

> In the corner was also a small oblong piece on canvas . . . There is a board represented on it, on which are two portraits half rolled up, painted incomparably naturally as copper pieces [engravings]. At the

bottom is written the name: Taverner. I cannot say whether it should mean the owner or the painter of this piece, or the bookseller from Paris who has many copper [engravings] produced, . . . and that it is only placed there in order to make it more believable that these are really engravings.[17]

What Von Uffenbach saw was of course a trompe l'oeil painting of two prints attached to a board. In 1908 this canvas was still in place, and described in an inventory as "A Representation of partially rolled engravings; one a Portrait of Charles II." The inventory confidently attributed the painting to the eighteenth-century artist William Taverner, who in 1710 was a young lad of seven years. "Taverner" may in fact have been his grandfather, the portrait painter Jeremiah Taverner, whose now lost portrait of Daniel Defoe survives in an engraving by a Dutch artist. Von Uffenbach probably conjectured correctly that Taverner's name on the painted prints was part of the deception. Another fact to keep in mind is that a major project for the company in the early eighteenth century was to replace pictures destroyed when the hall burned down in the fire of 1666, for which artwork was contributed by several artists.[18] So, a trompe l'oeil of signed prints-on-board, pre-1710 but probably not much earlier; prints that are depicted partly rolled up, much like those of William and Mary that we have seen; one print being a portrait of the Stuart king— surely these are rather strong grounds to suspect a lost Collier painting.[19] But if so, this is as close as we are likely to get to capturing Collier as he enters the Hall of the Company of the Painter-Stainers. Perhaps he was presenting his "proof" piece in order to become a member, just like Pieter van Roestraten, whose proof piece is on record but whose membership in the company is not.[20]

IV

This chapter began with a painted title page that challenged the presumption of unique and univocal authorship. Echard the writer and Hodgkin the printer sharing the glory of the published Roman history was an instance in which Collier appears to offer the possibility of authorship as more fluid and collaborative. The same possibility was raised in Collier-looking canvases that concealed more than one artistic creator, or in Collier-signed trompe l'oeils of prints by other artists and

engravers: the possibility, we might say, that the medium exceeds the individual creator.

On the one hand, this is a pre-modern notion of authorship harking back to the practices of artisanal and craft production, and as such fitting well with the challenges posed in this series of paintings to the professional status pyramid. But on the other hand, this notion of authorship was also forward looking. It is probably not a coincidence that all the publications that were stock items in Collier's letter racks did not have clearly identifiable authors: the almanacs supposedly signed by a long-dead man, the newspapers that are not signed at all, and the royal speeches that had been delivered orally by the monarchs but rendered into print by anonymous others. Like "publications" in the present-day Web 2.0, they hinted at a kind of authorship that is fluid and collaborative, and that allows knowledge to be collectively improved, amended, updated.

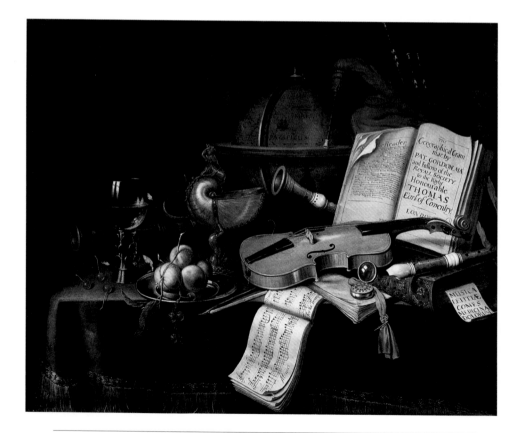

Fig. 10.4: Edward Collier, *Vanitas Still Life with Gordon's Grammar*, c. 1700. 97 x 123 cm. Photo Collection RKD, The Hague.

It is thus fitting to end this chapter with one more painted book title page that raises precisely this possibility: a complement to Echard/Hodgkin's Roman history. The book in Collier's vanitas still life in figure 10.4, unusually combining title and dedication on one page, is Patrick Gordon's *Geographical Grammar*. The date of the book is obscured, but it must be the second edition of 1699 rather than the first one of 1693 or the third of 1702, because Gordon was described as Fellow of the Royal Society only from the second edition, whereas from the third edition the dedication shifted to the Archbishop of Canterbury. In the actual 1699 volume the dedication reads as follows: "To The Right Honourable THOMAS Lord Viscount Deerhurst, Eldest Son and *Heir Apparent* of The Right Honourable THOMAS Earl of COVENTRY" (emphasis added). Why "Heir Apparent"? In 1699 the father of Thomas Lord Viscount Deerhurst, the fifth Earl of Coventry, who was also named Thomas, died. But Gordon's book, published that year, was obviously printed before Coventry's eldest son assumed his title. In Collier's painted version of the dedication, however, the edition is the same edition, the dedicatee is the same dedicatee, but he is described simply as "THOMAS *Earl of Coventry.*" The painting updated his title: in between book and painting Thomas had become the Earl of Coventry, so the painter intervened in the book page and inserted the up-to-date information. Precisely the kind of thing that can be done with fluid authorship in interactive media.

Which Revolution? or,
The Memory of Mr. Lory

I

One "faux non-Collier" painting stands out from the others and takes the meaning of Collier's work in a completely different direction. This is the letter rack signed in the name of "C: Seymoor. Twickenham Middx" and monogrammed in the pocket watch key handle. Charles Seymoor, or more commonly Seymour, was hardly an aspiring painter or decorator, nor a figure of obscurity. He was actually one of the more powerful men in the land: the sixth Duke of Somerset, the master of the horse in Queen Anne's court, a man who married the richest heiress in England (and with her took possession of Syon House bordering on the parish of Twickenham). What was someone like him doing in the "signature" of a Collier letter rack? The answer will lead the discussion from Collier's position in the politics of hierarchy in the artistic establishment to his position in the heated context of national politics, a matter that has been hovering over Collier's work—replete as it is with political pointers—from the very beginning.

Several details in the Seymour painting, parting ways with its Collier-signed near-twin, are unusual (fig. 8.7, p. 143). The king's speech bears an impossible date, "1731." The postmark on the sealed letter is a peculiar three-lettered "IAN" rather than the correct "IA," derived from "Ianuarius." The almanac is titled, oddly, "Apollo Anglicana" rather than *Apollo Anglicanus*. Singular deviations from Collier's standard fare, they are unexpected, even jarring, and in the case of the latter rather comical. What could they mean?

The character of the real Charles Seymour may be the beginning of an explanation. Seymour's reputation was as a man "in whom the pride of birth and rank amounted almost to a disease." Seymour, one earl observed, "was a man of vast pride, and having had a very low education, shewed it in a very indecent manner." Another found him to be "a False mean-spirited Knave, at the same time he was a pretender to the greatest Courage and Steadiness." His self-aggrandizing behavior—for instance, ordering his servants to clear the roads of people when his carriage passed by, lest a common person see him—earned him the nickname "the Proud Duke."[1] Was Collier aware of Seymour's reputation? After all, the two apparent blunders in the Seymour trompe l'oeil have something in common: the substitution of "IAN" for "IA" and the rechristening of *Apollo Anglicanus* as "Apollo Anglicana" both revealed an ignorance in the proper public uses of that *sine qua non* of the educated gentleman, Latin. Was Collier—who was always attentive to the inroads of Latin into English usage, and who liked to repeat a subtle point more than once—mocking the pretentiousness of this high aristocrat with a lowly education and a famously inflated sense of self-worth?

Perhaps. Or perhaps the painting harbors a private joke not understood in the twenty-first century. But that this painting has a pointed edge unlike any others is confirmed by a startling detail. It involves only one letter, in fact not even a full letter, and yet it spells something of a political bombshell.

This detail is in the royal speech (fig. 11.1). The speeches in the near-identical paintings differ in three places: "His" versus "Her," 1703 versus 1731, and the royal monogram. That in the Collier-signed painting, on the right in figure 11.1, displays as usual a conspicuous crowned "A" for Queen Anne. But what is the monogram in the Seymour painting on the left? Not an "A," which in any case would not make much sense with "His Majesty." Is it the letter "G," which would actually fit the date 1731, but which would mean that someone altered this painting after the Hanoverian Georges ascended to the throne, from 1714? The visual proportions of the monogram seem to rule out this possibility, as do George II's speeches with uncrowned monograms that looked nothing like this. No, this crowned cypher has to be a "C."

This is surprising. "C" could stand for none other than Charles, either the first or the second Charles Stuart. Yet the most significant political development of the age was the ousting of the Stuarts in the Glorious Revolution, replacing them with William and Mary, and then Queen Anne. The Jacobites, who wished for a Stuart comeback—James II and his descendants were in France hoping to reverse the tide—were preparing for what would become a full-blown rebellion in 1715. This book began with the question of whether Collier was a crypto-Jacobite. And here was

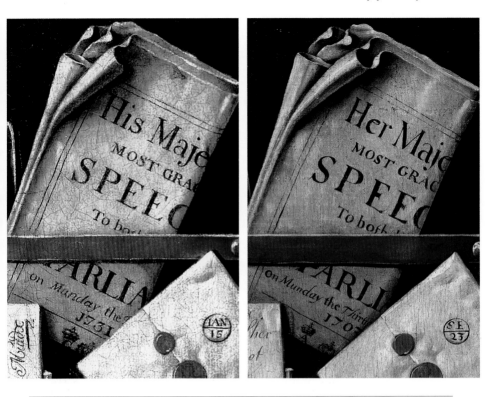

Fig. 11.1: Details of letter racks signed by Edward Collier and Charles Seymour (fig. 8.7): the royal speeches.

a royal pamphlet with a date set in the future next to a crowned monogram from the past, that of the Stuart kings. Was this the smoking gun?

The painting, however, takes pains to associate its contents not with Collier, who knew his official Latin, but with Charles Seymour. Seymour's politics were in fact quite complex. He had held posts for the Stuart King James II but forfeited them when he refused to meet the papal ambassador on his behalf. He joined William III at the 1688 revolution but voted against the notion that James had abdicated his throne and thus against the offer of the supposedly vacant crown to William and Mary. When Princess Anne found herself on the opposition side against William and Mary, he stuck by her, and even offered her shelter in Syon House when she was driven out of court. Seymour's political fortunes continued to rise and fall with Anne's, until she became queen in 1702 and rewarded him with a post in her household. And yet in Parliament he often chose to vote with the Whigs against Anne's Tory supporters. "This noble lord," opined the first Earl of Hardwicke, "was so humoursome, proud, and capricious,

that he was rather a ministry spoiler than a ministry maker." Rumors of Seymour's political gaffes began early in Anne's reign; in 1704 he broke ranks with the queen one time too many and almost lost his post.[2]

Collier often positioned himself as a partisan and defender of Queen Anne. Just think of his proactive insistence on restoring her crowned monograms to the speeches from which they were left out. Perhaps that explains why he might enlist his skill with detail to direct a painted jab against the Proud Duke's pretentiousness and politics, the latter mocked through the semi-hidden Stuart "C." But at the same time, Collier had also himself inserted the visage of Charles I and Charles II prominently into many of his canvases, even as William and Anne appeared in them regularly as well. So here again was the political problem that hangs over Collier's whole oeuvre: what can be made of his seemingly contradictory political colors? For a long time Collier's politics baffled me, until I realized my mistake. I was interpreting his politics as I would those of an Englishman, but the only way they could really make sense was to trace them back to his roots in the Netherlands.

II

On 29 June 1649 a regal procession had left the town of Breda in Brabant, the southern region of the United Provinces of the Netherlands. Breda was a fortified frontier town, not very prosperous or noteworthy, though enjoying a certain reputation for its beer. The procession that day was an unusual sight. Two royal personages, a prince and a king, were leaving Breda en route to Flanders, accompanied by a large contingent of horse riders.[3] The prince was William II of Orange, the direct ruler of Breda as well as the "stadtholder"— a term that signified his leadership of the seven provinces of the Dutch Republic. The king was Charles II of the House of Stuart, William's brother-in-law, on whom monarchy had been violently thrust only a few months earlier when English rebels had executed his father, Charles I. Charles II's status as a legitimate monarch in exile was still shaky, and William had carefully orchestrated a fête and this procession to shore up his public standing.

The crowd that gathered to watch the royal procession must have included many or even most of the inhabitants of this medium-size town, all in all less than ten thousand strong. About half of the people in Breda were the families of soldiers, stationed there ever since the celebrated siege in 1637 in which the former stadtholder, Frederik Hendrik, William II's father, had

liberated this prize possession of the House of Orange from Spanish occupation. The Breda garrison included hundreds of Englishmen and Scotsmen, members of the highly respected Anglo-Dutch Brigade that had had a long-standing association with the Orange stadtholders. Throughout Europe during the Thirty Years' War (1618–48), huge numbers of soldiers from England and Scotland had sought military glory in fighting in the anti-Habsburg armies.[4] For those in the Netherlands, this military service was joined with a more personal defense of their own royal family, since the Habsburg Empire had attacked Bohemia, whose queen, now living in The Hague, was Elizabeth Stuart, sister of Charles I. Many of these soldiers then settled down and married into Dutch society. In Breda, as many as half the women in town married soldiers, and about half the Anglo-Scottish soldiers—in 1638 six English and five Scottish companies had been reported there—married local women.[5] Most of them probably came out that day in 1649 together with their families to support the new Stuart monarch as he departed their town in the company of their own ruler, Prince William, toward Flanders, making his way to his mother's place of exile in France.

One of the children in the crowd that day may well have been Edward Collier, though his friends probably knew him by a slightly different name. That Collier came from Breda was recorded when he signed up in Leiden to be married.[6] Collier also registered his relationship to the city in several vanitas paintings that include a book opened to a description of the town of Breda. (In other paintings he included volumes with similar descriptions of Haarlem, Leiden, and London, thus charting the geographic arc of his life.) Little more was known about Collier's origins. Since his earliest paintings date to the beginning of the 1660s, art historians and auctioneers, unable to locate his actual family origin or birth record, have assumed that he was born circa 1640. Collier would have been as young as seven or as old as nine or ten by 1649, certainly old enough to understand and young enough to be impressionable.

The more I searched for traces of Collier's origins, the more one name kept popping up: Joris Collier, a.k.a. Colier, Coljer, Collijer, Collyer, Kollyer, or Qualier. These spelling variations are all found in the Breda archives, where Joris appeared regularly from 1639 onward: to baptize several children with his wife, Aeltien Engelberts (Engels, Engelborghs); to rent, buy, and then sell at a loss a house named "the Little Fox"; to give money as poor relief or to lend money to another soldier; and finally to be listed in the capacity of the dead spouse at his wife's remarriage in 1659. Military sources further reveal that Joris Coljer had belonged to the Halberdier regiment of Frederik Hendrik's army and suffered injury while

building fortifications during the Breda siege. (The siege works, involving damming the moat and mining the walls, took place under heavy fire and resulted in numerous casualties.) As compensation Joris was given in 1638 a reserve position in a stationary company of soldiers: this seems to have been the moment when he settled in Breda.[7]

Given the perfect timing, was Joris Collier Edward's father? The first child whom Joris baptized in Breda, a boy, was registered on 7 November 1639 as "Joan"; presumably John, Johan, or Johannes. Recall that Edward's brother whom we met in Leiden was named Johannes Colier. But if Edward was indeed "Joan's" brother, why wasn't his own baptism registered in those Breda church records that list four other siblings at mostly regular intervals? The more I weighed this objection, the more convinced I became that I was barking up the wrong tree.

There was another possibility, another family of Colliers, or, as they mostly preferred to spell it, Colyears. They were a family of Scottish-Dutch soldiers, beginning with James Colyear (or Colyer) who had come from County Fife to the Netherlands in the early seventeenth century to join the Scottish regiments in the Anglo-Dutch Brigade. The family's original surname was in fact Robertson. Genealogists are unsure how they became "Robertson alias Colyear," but this is how they appear in many Dutch documents. They were quite prominent. James's son David Colyear moved in 1625 from his service as the chamberlain to the Prince of Orange to a commission in a Scottish regiment in his army. David's son Justinus Colyear became the Dutch ambassador in Constantinople. Another branch of the family went back to Britain, some when Charles II was restored and some with William III, and were bestowed with titles. While in the Netherlands, at least some of the Robertson-alias-Colyears were stationed or living in Brabant. And on one occasion we can place a Scottish Colyear right in Breda: "Davit Alicxsander Robbertson dictus Colier," another son of David son of James, who in 1656 married Johanna (or Jean) Murray, daughter of an English lieutenant colonel, in Breda, where he was stationed at the time.[8]

Was *this* Collier's family? The Scottish connection was promising, given the keen interest of this English-speaking Dutch artist in matters across the Channel. But the well-connected Robertson-alias-Colyear family seemed a tad too prominent for Edward, and although their genealogical records are quite detailed, there was no mention of him. So while I had managed to locate *two* Collier families more or less in the right place more or less at the right time—and Collier was a rather uncommon name—both appeared to be dead ends.

And then I found the connection. It was buried in the Dutch National Archives in The Hague, in a wad of documents relating to the English

Church in Breda, in the form of a 1655 letter from the English community in Breda signed by some twenty-five of its members.[9] Among the signatures, written prominently in a confident hand, appears "George Robertson dijt Collÿer." So the Robertson-alias-Colyear clan had a branch in Breda, a member of the English Church, and his name was George, which is of course Joris. The two Collier families were in fact one and the same, and present in Breda precisely at the right time.[10] It now seemed likely that Edward Collier, brother to Johannes, was son to this Joris/George, a scion of the Robertson-alias-Colyears, and thus himself the offspring of one of those Scottish-Dutch marriages that were so common in Brabant garrison towns.

But where was Edward's own baptism record? A second trawl through the Breda records at last unearthed a baptism on 26 January 1642, in the Big Church in Breda, of a boy named Evert, child of Joses Calier and Elsken Engelberts. Very close, yet not a single name was 100 percent correct. We have seen that Evert could be Edward. But was "Calier" Collier? "Joses" Joris? "Elsken Engelberts" Aeltien Engelberts? Those multiple scribal spelling variations that were to become such an intriguing aspect of Collier's art made it rather difficult to verify his own historical record. Circumstantial evidence helped. Joris's wife, Aeltien, gave birth to a new child with almost mathematical precision every two years. But counting all the children baptized as Colliers from 1639 to 1650, there was one "double" gap between November 1639 and January 1644. The regularity of the family's history suggests a possible additional birth in between, in or around December 1641. Evert Calier was baptized in January 1642.[11]

Armed with this information, another search through the records from Collier's adulthood yielded further corroboration. Margarita Colier from Breda, without doubt Joris Collier's daughter, witnessed in Leiden in 1668 the baptism of Johannes Colier's firstborn and then married in a village close by. The mother, "Aeltie Engelberts," surfaced in Leiden a year later as a witness for the baptism of Johannes's younger son, together with David Stam. And most significantly, on the occasion of Edward's first betrothal, in 1670 to Maria Francois, "Aeltien Engelberts, widow of Joris Coljer, living in Breda" visited a local notary to declare "that Mr. Eduard Coljer, her son at Leiden has, with her total consent and pleasure, liaised himself with a promise of marriage to Miss Maria Francois, also living at Leiden." The actual purpose of Aeltien's notarial visit was to put on record her son's promise to her of a portion of his estate in case he died childless and before his new wife.[12]

Once all these family connections fell into place, they shed light on one other document, from Collier's years in London, that proved to be baffling, revealing, and humorous in equal measure. While in England, as

mentioned before, Collier surfaced indirectly in the historical record through an official travel pass to Holland issued in 1695 for "Johanna du Bois and John and Alida Colier, her children." Another travel pass, dated 22 May 1697, was issued "for Joris Engelbregts, Anna du Bois his wife, Johanna Tilburg his cousin, with two children to Holland."[13] The name of the mother of the two children is correct, but only now could I decipher the name of the father. Joris was the name of Edward Collier's father, Engelbregts the maiden name of his mother. There could be only one explanation. In his art Collier played games of every nature imaginable with names and documents. Here we seem to get a whiff of Collier's idiosyncratic, illusionist sense of humor when applied not to canvas but to real-life red tape.

III

Now that I have reconstructed Collier's family history and background, we can begin to consider how the experience of growing up in the Anglo-Scottish-Dutch community in Breda in the 1640s and 1650s might have shaped the political meanings of his work.

The presence of English and Scottish military men in Breda was pervasive. They mingled with the Dutch inhabitants; they lodged in their houses; they frequently established families with them. The Anglo-Scottish military men, moreover, were instrumental in the establishment soon after Breda's liberation of an active English Reformed Church. This church quickly developed into the most royalist and Anglican church in the Netherlands, and one with strong Scottish Presbyterian connections.[14]

The English Reformed Church owed its continued vitality, at least in part, to the most prominent English connection of mid-seventeenth-century Breda: the private residence of a prominent member of the Stuart family. This was Mary Stuart (1631–60) the Princess Royal, daughter of King Charles I, who at age ten had been married off to the teenage son of the Dutch stadtholder, the future William II of Orange. By the late 1640s, the young Mary Stuart came to wield considerable personal influence in Breda. No major decision in the English Church was undertaken without her approval. It was a request for approval of a new pastor, sent by the elders and members of the English Reformed Church to Mary Stuart in 1655, that was signed by George Robertson dijt Collÿer.

The years of civil unrest in England, especially following Charles I's execution in 1649, intensified Breda's English and Stuart connections. The

town, whose population was no more than four thousand people without counting the soldiers, became a haven for numerous English royalists and their families who were forced into exile in large numbers in the 1640s and 1650s and who thus sought throughout Europe sympathetic expatriates. As a royalist and Stuart center in the Netherlands, Breda was second only to The Hague. Breda was the town charged by William with the regal support of Charles II once the execution of his father had made him king, and that to which the young and embattled Stuart royal headed to regroup while visiting his sister Mary; hence the parade of June 1649. Subsequently the town remained central to the European circuit of the Stuarts during the interregnum, including James, brother of Charles II and Mary. It came to be associated with two of the most significant documents involving Charles II during his years of exile: early on, the ignominious Treaty of Breda in which Charles gave in to the Scottish Presbyterians and signed on to their Solemn League and Covenant in return for their recognition of him as king, an agreement that was scuttled by bad faith from all sides; and a decade later the glorious Declaration of Breda, with which Charles received the news of his imminent restoration to the crown in England by pardoning his enemies and declaring his restoration the act of God, not man.[15]

Teeming with Englishmen and Scotsmen of all walks of life, Breda was a town in which it was very easy to grow up a fervent partisan of the House of Stuart, or at least to develop a familiarity with and interest in their affairs. The mixing of the local Anglo-Scottish community with those recently arrived made the events in Britain all the more relevant. Whether through the experiences of daily encounters up close, or through the more distant observation of the high and mighty like that summer parade in 1649, there were not many other places on the European continent in which a young man of modest background, growing up at the time of the English Civil War, could have become as routinely exposed to the English language, English and Scottish culture, English and Scottish politics, and English and Scottish nostalgia as in the medium-size southern Dutch town of Breda.

IV

In the early 1660s, when Edward Collier was an apprentice in Haarlem, he experimented with several different types of paintings, some of them among the more adventurous of his career. The unsigned trompe l'oeil from 1663 in figure 11.2 may be one of them. Portraying a glass cabinet

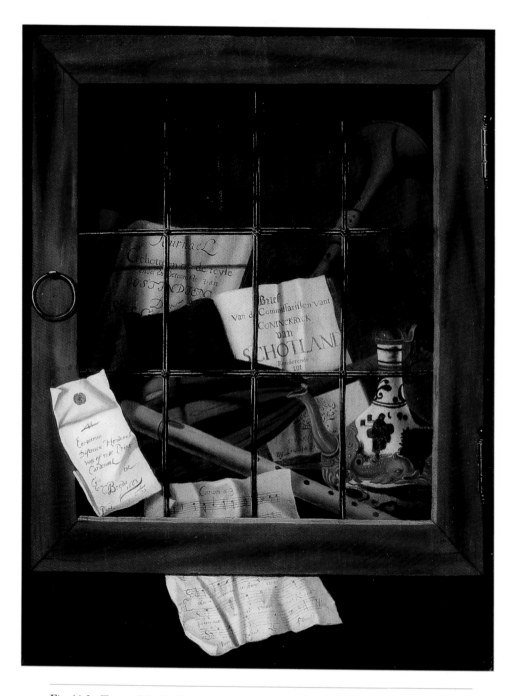

Fig. 11.2: *Trompe l'Oeil Still Life behind Glass Door*, 1663. Oil on panel. 72.4 x 55.3 cm;
28½ x 21¾ in. Photo Collection RKD, The Hague.

door or window with books and objects behind it, it is dominated by the word "SCHOTLAND" from a 1649 pamphlet in Dutch about Scottish reactions to the trial and execution of Charles I.[16] To the left, reaching toward the viewer, is a letter offering a signature that resembles nothing more than "E C Breda." (The *℮* consists of the beginnings of "Cito Cito," an early notation for express postal delivery, an issue that will remain of continuing interest for Collier.) Elsewhere in the painting one can spot as many as five or six possible "E C" combinations, some more tentative than others, raising the possibility that this canvas served also as an experiment with monograms, much like the vanitas of the previous year at the Metropolitan Museum.[17] The appearance of these letters in a trompe l'oeil that combines Stuart fortunes, Scottish interest, Dutchness, and the city of Breda seems to indicate an early expression from Collier's brush of the dual-focused identity forged in this environment.

Yet I also had my doubts, since Collier—unlike Gijsbrechts, for example—has no known trompe l'oeil cabinet doors to his name, and because I could not explain the monogram on the letter, "P S." What finally convinced me, and made the question more significant, was the "SCHOTLAND" pamphlet, which in its English title reads: *A Letter from the Commissioners of the Kingdom of Scotland Residing Here at London . . . Concerning the Present Proceedings in this Kingdome, against Religion, the King, and Government.* The first among the Scottish commissioners who signed this document, insisting on Covenanting principles and protesting Charles's trial and execution, was the third Earl of Lothian. This was William Kerr, father of the fourth earl, Robert, who would become a patron of Collier's at the end of the century. Was this a coincidence? Why was this composition centered on an unbound pamphlet of eight leaves that was printed a decade and a half earlier? Was there an early connection between Collier and the Earls of Lothian, adding a personal layer to his interest in Stuart politics?

Serendipity provided the answer. Searching for the Robertson-alias-Colyear family in Holland, I came across one Captain William Kerr who in the 1650s was the financial agent and solicitor for the regiment of "David Robbertson dict Coljer." During this period Robert and William Kerr, sons of the third Earl of Lothian, were teenagers at the University of Leiden. An exhibition catalogue dedicated to the foreign education of the two young men confirmed that they frequently visited "Captain Kerr a kinsman of their father, who was in the Dutch service." So far so good: here was a member of the Kerr family, "a very good friend"

of young Robert and his brother, in proximity to a member of the Robertson-alias-Colyear family. The Colliers and the Kerrs knew each other when Edward was still a child.[18]

There was more. With Captain Kerr the two young Scottish noblemen in Leiden also often visited "their father's uncle, Major Murray," who also helped them financially on several occasions.[19] As it happens, we already encountered Major Murray in these Scots Brigade circles: Alexander Murray, another family relative of the Major, whose daughter Johanna married in 1656 in Breda "Davit Alicxsander Robbertson dictus Colier." Through this marriage, then, Edward Collier and the Earls of Lothian were family!

One further step. When Joris Collier, Edward's father, was given a reserve position that allowed him to settle in Breda in 1638, he was placed in "the company of captain Alaste Moro." The military records yield only one name for which "Alaste Moro" could be a scribal variation: Alexander Murray. If so, then Murray was not only father-in-law to a Robertson-alias-Colyear, he was also the military commander of Edward Collier's father. The Colier-Murray wedding in 1656 may well have counted among its guests the fourteen-year-old Edward as an invitee on behalf of both sides.[20]

It therefore makes sense that the Earls of Lothian surface throughout Collier's career. Collier may well have met his kinsmen the Kerr family during his childhood in the English community in Breda, including the future fourth earl and his brother when they visited their relatives, and perhaps even William Kerr, the third earl, when he came in 1650 as part of the Scottish delegation to negotiate the Treaty of Breda with Charles II. As a budding artist Collier most likely painted this trompe l'oeil cabinet door with a translation into Dutch of a political intervention that was written by the same William Kerr shortly before his mission to Breda. Subsequently, when Collier moved to England as a mature artist, the fourth earl, now a bargain-hunting art collector, purchased several pieces of Collier's work (some perhaps when he was still in Leiden) and became for Collier something of a patron. Finally, it may be through the Lothian family that Collier was introduced to the Edinburgh house painters (the records link both Warrender and Smith to the family) with whom he collaborated on letter rack paintings that included documents related to the same religious-political matters. The most pertinent example is the *Solemne League and Covenant* in the trompe l'oeil signed by Warrender, the very document that had inspired William Kerr's pamphlet and his actions in Breda in 1650.

There are other signs that Collier continued to care about royal politics in England long before he moved there. The most significant is embedded in a self-portrait that he painted in 1683 (fig. 11.3). At first glance the self-portrait seems fairly conventional, showing Collier in a typical pose of an artist engaged in his craft, wielding his palette and brushes as he re-creates his model on the canvas in front of him. The painting on which he is putting the final touches is a vanitas centered on books and replete with the standard elements of the genre: globe, hourglass, musical instruments, skull. These were a genre and a composition with which Collier worked often and with which he obviously wanted to associate himself in his self-portrait, as if establishing his trademark.

The composition of the self-portrait, however, is misleading. Is Collier looking at his book of sketches, signed on the back "E. Colyer Anno 1683," or is the book actually the model for his painting, leaning on a skull that is the model for the skull in the vanitas on his easel? The "model" skull, similar as it is to that in the painting-within-the-painting and positioned just like it, is at the same time completely out of the artist's field of vision and thus an impossible model. Furthermore, in the painting-within-the-painting the smaller book on the table appears to leap off the canvas into the plane of the easel and the artist. Is this a straightforward still life, then, or an illusionist composition? All the more so given that Collier represented himself again not as a man over forty but as a young man, a ghost of times past? Even as the self-portrait misleads as to Collier's physical appearance, it is thus true to the duality of Collier's artistic persona, part vanitas still life painter, part playful illusionist.

This genuineness of self-representation adds meaning to a key detail in this painting. The right side of the composition displays Collier's professional belongings: models in two and three dimensions, drawings and sculptures, an illustrated volume that is perhaps an emblem book, a wall map, a sketch of a woman (who actually appears in another of Collier's still lifes). The objects appear to have just emerged from the large chest to the right, the capacious keeper of the accessories to Collier's artistic identity. The chest is lined with red straps, and decorated with geometrical designs that are most pronounced on the lid but in fact continue in a quasi-illusionist fashion onto the inner sides of the chest. In the middle of this pattern is a coat of arms, and therein lies the punch line. The insignia is the British Royal Arms as they existed between 1603 and 1688, those

Fig. 11.3: Edward Collier, *Self-Portrait in Artist's Studio*, 1683. 44.4 x 52.8 cm; 17½ x 20¾ in. © National Portrait Gallery, London.

designating Charles I and Charles II. Collier painted his personal/professional chest with the arms of the restored House of Stuart.[21]

However inconspicuously placed, this carefully executed detail is significant. Its Englishness in a portrait from 1683 is probably related to the fact that Collier was almost certainly in England during this year. And yet this fact of geography is not sufficient to account for such a deliberate and elaborate choice. Edward Collier was a Dutch artist, painting in the tradition of Dutch art that he had learned as an apprentice in Haarlem. He had lived for more than fifteen years in Leiden and was about to return there for another decade. But here, in a self-portrait displaying those elements that presumably represented him best, he chose to include the royal arms of a foreign royal family. Well, not quite foreign, if one was a product of that particular mid-seventeenth-century Breda blend of Dutchness and Englishness, crystallized around the House of Stuart.

Months after inspecting Collier's self-portrait I came across a photograph of this painting taken before it was bought and restored by the National Portrait Gallery. It was not the same: the writing on Collier's book in the painting's present state, "E. Colyer Anno 1683," appeared to have formerly been "E. Colyea . . . Anno 1683." An examination of the painting under a microscope confirmed traces of an *a* in "Colyea[r]."[22] This almost invisible signature variant, unparalleled in any known Collier painting—which may explain why the restorers chose to "correct" it—was an unexpected confirmation of how I understood this painting. Collier chose for the self-portrait the spelling of his name used by the Scottish Robertson-alias-Colyear clan, thus affirming his own part-British roots right next to his homage to the British royal family.

VI

So Collier's self-portrait shows his attachment to the House of Stuart to have been up close and personal. There is actually one more unrecorded Collier painting in private hands, from 1684, that achieves the same again, this time by inserting into a beautifully executed vanitas composition, next to a Dutch book, two portraits (fig. 11.4). One, hanging off the table, is a mezzotint of "Maria Dutchesse of Jorck," or Mary of Modena, the wife of James the Duke of York, Charles II's brother and heir. The print itself was created after a portrait by Peter Lely by the Dutch engraver Gerard Valck, who had spent several years in London in the 1670s and continued to

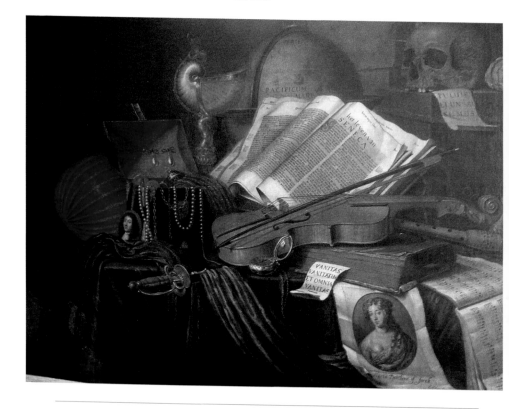

Fig. 11.4: Edward Collier, *Vanitas with Portrait of Mary of Modena*, probably 1684. 35½ x 46¾ in. Private collection.

produce prints for the English market—like this one, with its English title—until 1684. The other portrait, a small oval miniature of an unnamed man, is the personal touch: a juxtaposition with another self-portrait of the same year (fig. 6.4, left, p. 110) reveals it to represent Collier himself.[23]

There may have also been a more immediate imperative for displaying allegiance to the House of Stuart at this particular moment. The year 1683 was the year of the Rye House Plot, a failed conspiracy to assassinate both Charles II and his brother James. It is possible that the painting of the Stuart royal arms, and perhaps also that of the Duchess of York, were triggered by this event, an expression of loyalty and support in the face of a threatening close call. Indeed Collier might have done this a second time. In the 1690s, the first royal speech he painted into a letter rack (as far as I know) was one delivered by William III on 24 February 1695/1696 (fig. 2.7, p. 46). It was a formative moment in William's reign, the so-called Assassination Plot Speech, in which the king dramatically announced his eleventh-hour escape from a plot to kill him. The revelation shocked the nation and

unleashed an unprecedented wave of loyalty to the hitherto unpopular William.[24] Later Collier would paint different speeches so similarly as to neutralize the significance of their contents. But here was the very first one he ever chose to paint, and thus presumably a meaningful choice. Like the inclusion of the Stuart royal arms in his self-portrait of 1683, here was perhaps a second case in which Collier was doing his artistic bit to express support for the monarch of Britain when under a perceived, dramatic, threat.

There would be little remarkable in expressing allegiance to the Stuart king in the early 1680s and to the Orange king in the mid-1690s. Most people conformed to the change brought about in the Glorious Revolution. But Collier continued to insert the Stuarts into his paintings throughout his English period, as well as King William and then Queen Anne. Sometimes he was cheeky enough to force Charles I to share the same canvas with those very monarchs who brought his son's rule to an end (for examples, see figs. 4.3, pp. 74–75, and 6.6, p. 113). A particularly good example is the letter rack in figure 11.5, in which the speech of Queen Anne, complete with her insistent cypher, is next to an unusual overflowing painted "print" of Carolus Rex Primus, carrying a Collier signature distinct from that for the whole painting. The medal below is probably King William's, which would make this an unusual composition with *three* monarchs cohabiting side by side.

We thus circle back to the original question: what was the political meaning of Collier's repeated mixing of Stuarts and Oranges in his English painting career? After all, as one noted historian once put it, Charles I was "the hinge on which the century swung": if one endorsed the "cult of King Charles the Martyr" following his execution in 1649, it was rather difficult to support the deposition of his son in 1688. William did try, for instance by continuing the national days of fasting on the anniversary of Charles's execution on January 30. But his limited success can be gauged from a note that was affixed to the church door at Whitehall on 30 January 1696:

> What, Fast and Pray,
> For the Horrid Murder of the Day.
> And at the same time drive ye Son away.
>
> . . .
>
> Go ask your Learned Bishops, and your Dean,
> What these strange Contradictions mean.[25]

Collier enacted in his paintings precisely what this church door poet saw as "strange Contradictions," and yet, as I finally understood, it was not contradictory at all. The solution to this puzzle lies, once more, in Breda.

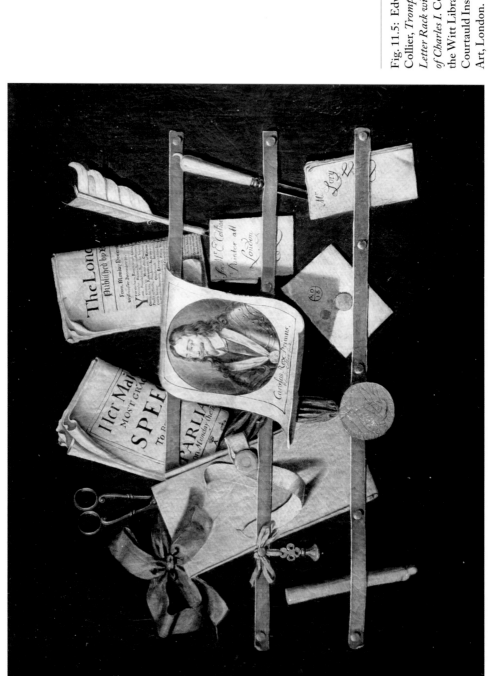

Fig. 11.5: Edward Collier, *Trompe l'Oeil Letter Rack with Print of Charles I*. Courtesy of the Witt Library, The Courtauld Institute of Art, London.

The political amalgam that Collier imbibed during his Breda childhood was not simply one of Anglo and Dutch affiliations. It was also specifically, and quite personally, Stuart and Orange. Few places could serve as stronger reminders of how the houses of Stuart and Orange were in fact joined at the hip. Breda was the personal duchy of the Princess of Orange, but also the most Stuart of Dutch cities (similarly to The Hague, but more intimately so). When Mary the Princess Royal married William II, the beginning of the Anglo-Dutch alliance between the relatively-minor-but-upwardly-mobile House of Orange and the mighty-but-fallen-on-hard-times House of Stuart, she had her private residence in Breda. Following the execution of Charles I, as we have seen, Breda played a key role in the Orange support for Charles II.

Furthermore, it was in Breda that the subsequent issue of the Stuart line was conceived, substantially if not quite literally. This is how it all came about. Charles II was followed to Breda by his younger brother James. While in Mary Stuart's court James became enamored with one of her maids of honor, whom he seduced in 1659 with a promise of marriage and then impregnated. The young woman's name was Anne Hyde: she was the daughter of Sir Edward Hyde, one of Charles II's closest advisers and the future Earl of Clarendon. Hyde was a leading royalist exile who was involved in most of the episodes mentioned before, from the travel arrangements of the newly crowned Charles in June 1649 to the drafting of the Declaration of Breda in 1660. In between Hyde crisscrossed Europe with Charles or in his service, while leaving his wife, children, and father-in-law in Breda, where they had been accommodated with the help of the Princess Royal herself ("Out of her own princely nature and inclination," Hyde recorded later).[26] Their close relationship led in 1654 to Hyde's daughter Anne joining Mary's court, where she met James Stuart. Their liaison flourished just before Charles II regained the English throne, and thus it was generally assumed that the now prince and heir to the throne would not honor his promise to a commoner, pregnant or not. In what became the Restoration's earliest scandal, however, James insisted on marrying his commoner lover, ignoring protestations even from her own father. Although that love child died, Lady Anne Hyde eventually gave birth to two daughters who survived to adulthood: Mary, who was to marry William III and assume the English throne after 1688, and Anne, who was to become queen of England after the deaths of Mary and William. The post-1688 arrangements and the future of the English monarchy for almost three decades were determined through a union made in Breda.

VII

Did Edward Collier know or care about any of this? I believe so. Consider his curious attraction to Queen Anne, her court, and her royal standing. He demonstrated this interest many times: in his insistence on restoring Anne's forgotten crowned monogram to her speeches in Parliament; in several paintings in which he included next to her speeches also her royal proclamations in the press; in the canvas with the unusual commentary on Charles Seymour, a politician whose career was closely associated with the queen; and once with what may well be the most gratuitous sleight of hand in Collier's work. This particular trick appears in a pair of seemingly identical vanitas paintings with Queen Anne's 1702 speech in the foreground (fig. 11.6). Even with both side by side it takes a while to notice the anomaly, slyly painted in so as to be missed and then to surprise. Where the top speech has the words "most gracious," like every other royal speech ever published or ever painted, the one below suddenly has a deceptively similar yet inexplicably different wording: "*Monarchical.*"[27]

Collier's seemingly excessive preoccupation with Queen Anne begins to make sense when we consider that the queen's mother had been an English-speaking youngster with him in his own home town of several thousand people in the southern Netherlands. Collier in fact left an unusual and eloquent testimony to his personal attachment to these Breda connections. It is a unique detail in the painting we have just looked at, with Queen Anne's monogrammed speech and the attention-grabbing print of Charles I, underscored with Collier's personal touch in the form of a second signature (fig. 11.5, p. 198). Look now at the "Memory" notepad, similar to those that appear in some fifteen other letter rack paintings, typically in the same bottom-right position. We have grown accustomed to expect variations in spelling on the notepad: "Memorie," "Memorye," "Memory." But this particular case had metamorphosed, through the playful substitution of two middle letters, into something else altogether: "*Mr. Lory.*" A name. Who was Mr. Lory? Friend? Patron who commissioned the painting? Benefactor to whom Collier wanted to pay homage? Someone from Collier's past, who thus occupied the place of "Memory"?

To this question there is a virtually certain answer. Mr. Lory's name may ring a bell for connoisseurs of late-seventeenth-century English politics, in the form, say, of a scornful ballad sometimes attributed to Dryden, titled "Lamentable Lory." But long before Lory became important enough to have ballads penned about him he had already crossed paths with the present story. For this we need to go back to the Hyde family. When the

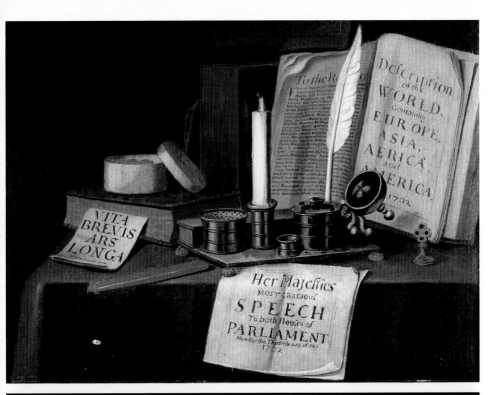

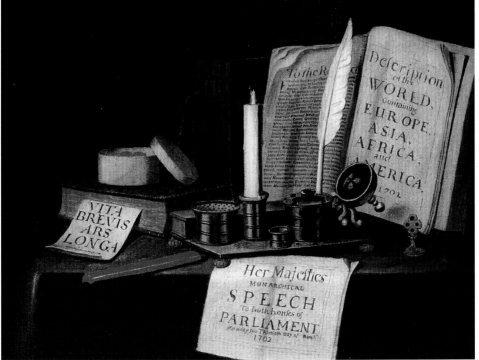

Fig. 11.6: Edward Collier, two still lifes on a desk with the queen's speech, 1702. *Top:* 54.5 x 63.5 cm; 21½ x 25 in. The Bridgeman Art Library. *Bottom:* 54.5 x 63.5 cm; 21½ x 25 in. Photo Collection RKD, The Hague.

Hydes, like other royalists in exile in the 1650s, found themselves in dire straits, Mary Stuart used her influence in Breda to arrange lodgings for Hyde's wife and her "two or three fine sons" (thus the letter of recommendation sent at the princess's behest) in a former convent that was being used by a school. The eldest child was in fact a daughter, Anne Hyde, who presently joined the Princess Royal's retinue. The two "fine sons" that followed were Henry, the future second Earl of Clarendon, and Laurence, the future first Earl of Rochester. Laurence, baptized in 1642, was precisely Edward Collier's age. He arrived in Breda at age eleven and lived there until his eighteenth year.[28] His nickname was "Lory."

The subtle incorporation of Mr. Lory into the memory notepad is most unusual. It gains further meaning from the repetitive and even formulaic nature of Collier's other compositions with memory pads, from which this painting alone deviates. The only comparable case is the letter rack that uniquely includes the medical book by David Stam, who turned out to be Collier's relative and close acquaintance. We cannot know whether Laurence Hyde had a personal acquaintance and shared childhood memories with the young Collier, or whether the painter was simply paying homage to a figure associated with his childhood environment. After all, Hyde was a well-known public figure. Collier could have encountered his name again in Holland when Charles II sent him there on a sensitive diplomatic mission in 1677–78, or later in England, where he had risen to become a prominent Tory politician during the reigns of both his nieces, especially Queen Anne's. Including Hyde in a painting that highlights the affinity between Anne and perhaps William to the early Stuarts thus makes sense on its own terms. And yet such a purely political reading does not take into account the personal touches: Collier's flagging of his personal involvement through a rare second signature on Charles I's print; and especially Mr. Lory's unique placement in the painting as a substitute for "memory." It seems to me that this unusual detail must be considered together with the affinities between Collier and Mr. Lory: two sexagenarians in early 1700s England who half a century earlier had been teenagers of the same age affiliated at the same time with the same expatriate English community and church in the same medium-size Dutch town.

Keeping in mind this expatriate community, as well as Mr. Lory's identity, consider finally the possible political message of this painting with its particular combination of figures. Historians have spilled much ink over the English Glorious Revolution being in matter of fact not all that glorious, if "glorious" was meant to imply smooth and bloodless.

Some have suggested that it was also not all that English, given the Dutch invasion that made it possible.[29] When viewed from the perspective of mid-seventeenth-century Protestant Breda, however, with its mixed Anglo-Scottish-Dutch community, and where the then-exiled Stuarts and their loyalists were so intimately intertwined with the House of Orange on a political as well as a personal level, the so-called Glorious Revolution was hardly a revolution at all.

Collier's seeming "strange Contradictions," as his canvases mingled Charles I and II with William and Anne (but skipping over the "Papist" James II), suggest therefore an original and eye-opening perspective on the political reconfiguration of 1688. From Collier's specifically off-center Dutch point of view—one that distinguished him from his English neighbors—the Stuarts and the Oranges were so intertwined that their affinities greatly exceeded their differences, and thus Charles I could cohabit with Anne, and Collier could equally affirm his allegiance to Charles II or King William when they faced conspiratorial dangers.

In a period of deep-running and all-consuming political partisanship, this was a position that rejected the immediate meaning of politics as Collier's contemporaries were likely to understand it. (The distinctiveness of Collier's political choices stands out when contrasted with the two canvases that he painted together with his Edinburgh collaborators Thomas Warrender and Kenneth Smith. Whether because of the wishes of the Scottish house painters, or because of Collier's own rather different relationship to Scottish politics, stemming perhaps from his half-Scottish descent or from his relationship to the Marquess of Lothian, the choices of materials in these paintings were markedly of the partisan, controversial variety that Collier avoided in England.) At the same time Collier's position was one that enabled him to move beyond the political revolution to another, the media revolution that was simultaneously changing the very nature of politics. Rather than partisan pamphlets and newspapers, Collier chose official ones. In those royal speeches that Collier painted deliberately to appear indistinguishable, even in the case of monarchs so far apart in their politics, lies a more profound and more enduring observation about the nature of politics than any comment on the specific political configuration of the day.

Ending the discussion of the political meanings of Collier's work on such a theoretical note, however, misses part of his message. As demonstrated

Fig. 11.7 (following page): Edward Collier, *Trompe l'Oeil Letter Rack with Dutch and English Materials*, 1701. 46 x 59 cm; 18 ⅛ x 23 ¼ in. Private collection.

so well by Mr. Lory, for Collier the political was intertwined with the personal. This was particularly evident in a group of letter racks from about 1701 that combined Dutch and English materials. These paintings, often signed in Dutch as a painter in Leiden, have been taken simply as evidence that Collier moved back to Holland at some point before his death. But although he is recorded in Leiden in January 1706 and may well have been there at his wife's deathbed in 1704, there are also many paintings that he obviously painted in Britain—including Edinburgh—between 1705 and 1707.[30] From 1706 there are at least a dozen trompe l'oeil letter racks and prints-tacked-to-board with cartoon-like "prints" of the five senses: these alternate erratically between Dutch and English, and their signatures between London and Leiden, all in one year. Rather than recording Collier's physical movements, it seems more plausible to interpret these alternating Dutch/English references and locations as acknowledgments of precisely this mutual mirroring of the personal and the political. Consider the details of the mixed-language letter rack in figure 11.7: the prominently displayed Amsterdam newspaper that features news from England, but in Dutch; the signature in the form of a letter addressed in Dutch to Edward Collier, painter in Leiden, paired with a handwritten memory book, but this one in English, as well as with another letter with an English postmark; and at the bottom center the medallion of William III, the Dutch prince of England (identified in neutral Latin). Dutchness and Englishness are inseparably braided together, both publicly—the newspaper, the king—and privately, in the painter's personal documents.[31] Rather than trying to establish a physical address, this painting offers a parallel between the transnational nature of public events and that of the artist's own biography. Like William, like Collier.

One final piece is out of place in this picture of Collier's political messages. It circles back to one more revolution, a revolution that did not happen: the return of the Stuarts, signaled in the monogram "C" on "His Majesty's" speech in the letter rack signed in the name of Charles Seymour. If the Glorious Revolution, when seen from the perspective of a half-Scotsman-half-Dutchman who grew up in Breda during the interregnum, was hardly a revolution at all, then how can I interpret this surreptitious Stuart royal cypher as a political barb directed at Seymour?

Fig. 11.8: Edward Collier, *Single-Strap Letter Rack with Print of Charles II.* 68 x 56 cm; 26 x 22 in. Courtesy of Christie's, London.

The answer, as often in Collier's work, lies in the passing of time. The Stuart kings belonged to the past. A glorious past perhaps, but a distinctly passé one. Collier devoted an unusual almost-letter-rack painting to Charles II (fig. 11.8). Its main theme is precisely the pastness of its subject: Charles II's old-fashioned garb; the primitive form of the letter rack

with its simply nailed single strap; and above all the *London Gazette* and the royal speech, so different in appearance from the dozens of examples in Collier's usual compositions. The paper that is unevenly cut but does not crumple into dog ears; the browner, fuzzier print; the more-newspaper-like shape of the royal pamphlet; the different font with its roundly shaped letters; and the spelling, for instance the *v* instead of *u* in "graciovs" and "[H]ovses." Collier was well aware of changes in design and harnessed these changes to represent the passing of time. (He actually exaggerated those differences: printed speeches from the time of Charles II did not in fact sport *v*'s instead of *u*'s.) Without familiarity with Collier's other paintings it is hard even to recognize the pamphlet on the right as a royal speech, not least since the word "SPEECH" itself is reduced simply to Collier's "E C" monogram. The understanding of this painting depends on a comparison with others, a comparison that reveals how every aspect of this letter rack bespeaks its archaic, even antiquated nature.[32]

Nostalgia for the Charleses, then, belonged in the past. But the crowned "C" monogram at the bottom of the painted speech in Seymour's rack located the same nostalgia emphatically in the future. This was the significance of the peculiar imaginary dating of the "C" speech to 1731. It was that wishful reversal of the flow of time that endowed this particular invocation of Charles Stuart, elsewhere welcome in Collier's work, with the frisson of sedition.

Collier underscored the risqué potential of this political fantasy by carefully placing the monogram as if hiding something, an effort at concealment that ends up calling attention to itself. He may have also planted a subtle hint that this political fantasy was just that, an impossible fantasy. Look carefully at the upper edges of the quasi-twin speeches in the "Seymour" painting and its Collier-signed double (fig. 11.1, p. 183). Was Collier intimating that a Stuart future was as illusionist as the Escher-like upper edge of the "C" speech pamphlet, impossibly tapering off rather than folding and wrapping around as it does correctly in the other painting and in every other folded speech Collier ever painted? That the Jacobite fantasy was like a trompe l'oeil within a trompe l'oeil?

A Signature Gone Wild

I

Collier was not the only illusionist painter of his time. Several others have appeared in these pages, most of them predecessors who had influenced his work. This chapter introduces another illusionist artist, a contemporary of Collier's by the name of Willem van Nijmegen, about whom precious little is known. I have managed to track down only six surviving canvases by his hand, all in private collections. Taken together, they are perhaps the most elaborate running commentary on the meaning and practice of illusionist painting from the early modern period. They are also, as far as I am aware, completely unknown, having escaped the notice of scholars and curators for over three hundred years. Yet my goal is not simply to place next to Collier another painter with the same background and the same professional predilections, nor merely to add to the knowledge of trompe l'oeil during this period. Van Nijmegen's career offers a surprising link—speculative, bewildering, and yet begging to be made—right back to Collier himself.

The six paintings are all trompe l'oeil canvases of the print-tacked-to-a-board variety. In the generation following Sebastian Stoskopff's genre-setting *The Triumph of Galatea*, the two main illusionist artists experimenting with this device, whose work has survived, were Collier and Van Nijmegen.[1] Four of Van Nijmegen's paintings (fig. 12.1) are relatively simple designs: light pine boards to each of which four nails pin a monochrome "print." One is an image and description of the Bastille, drawing on a print by the French king's official draftsman, Israël Silvestre.

Fig. 12.1: Willem van Nijmegen, four trompe l'oeil paintings. *Clockwise from top left:* 32.5 x 33.5 cm; Rafael Valls. 43.8 x 35.9 cm; Christie's, London. 31 x 27.5 cm; Galerie Fischer Auktionen, Luzern. 36.5 x 41 cm; private collection, Paris.

Two are based on prints of self-portrait paintings by Rembrandt (one print by Van Vliet, another by Rembrandt himself). The fourth reproduces a Jan Lievens etching of an old man together with the artist's signature "I. L."[2] The remaining two are at least twice as large and much more elaborate (figs. 12.2, 12.3). One shows a richly executed colored portrait

Fig. 12.2: Willem van Nijmegen, *Trompe l'Oeil of an Engraved Portrait of Hendrick Goltzius Pinned to a Board*, 1675. 87.6 x 76.6 cm; 34½ x 30¼ in. Photo Collection RKD, The Hague.

of the late-sixteenth-century artist Hendrick Goltzius, surrounded by details about his life and career, based on a print by Jacob Matham, his stepson. The other is an unusual large-scale trompe l'oeil combination of three items "attached" to the board and executed with great care. At the top are "glued" (not nailed) two late-sixteenth-century "prints" of classical

Fig. 12.3: Willem van Nijmegen, *Trompe l'Oeil with a Challenge and Prints of Harpocrates and Chilon Pinned to a Board*, 1688, and detail. 91 x 114 cm, 35¾ x 45 in. Courtesy of Elidor Invest SA.

figures derived from Goltzius: Harpocrates, an incarnation of the Egyptian Horus, who in the Greco-Roman world came to represent the imperative to be silent (hence the finger to the lips); and Chilon, the Spartan sage famous for his saying "Know thyself" (hence the mirror). Beneath, as if pinned with a single nail and partly covering the prints, is a "document" of some three hundred words. Three of the six paintings are signed with the name Willem van Nymegen, two others with curious variants, and one not at all. Four carry dates between 1675 and 1688.

The most conspicuous thread running through all six paintings, rendering them into a group commentary on illusionist practice, is the poetry. *Beeldgedicht*, or painting poetry, was something of a fashion during this period, beginning with the Netherlands' most important poet of the seventeenth century, Joost van den Vondel. Of hundreds of known examples, however, only a small number address still lifes—portraits were much more popular—and only a few of those address trompe l'oeils. Vondel himself penned in 1657 the most famous poem of this kind in admiration of Cornelis Brisé's painting at the Amsterdam treasury:

> Some cry: the art of printing and the art of writing shall
> degenerate (*verwilderen*: turn wild, go astray)
> Now that Holland forbids us the use of French paper.
> Dismiss your concerns, says Amstel's Treasury:
> BRIZE supplies paper when he paints.
> Examine that picture. What does one see up there?
> Papers, certificates, and letters—or do appearances
> deceive our eyes.[3]

Against the concern about a recent prohibition of importing the higher-quality French paper, Vondel asserted the illusionist success of Brisé's "paper." Now compare Vondel's last two lines to those painted at the bottom of Van Nijmegen's Goltzius painting:

> *Hier tart de kunst natuur. wat kunst? zy schÿnt ver wildert.*
> *Dit's druk en teken kunst, En schrÿf kunst, maar geschildert.*
> Here art challenges nature. What art? It seems to have
> gone astray.
> This is printing and drawing, and writing, but painted.

The lines are not the same as Vondel's, but similar. In addition to the wording, the cadence and structure are repeated: short sentence, question about the

nature of art, and second-line response that goes "*X*, and *Y*, and *Z*, but really something else." Did these lines, though once or twice removed, still reveal Vondel's imprint?

This painted couplet, however, like the poetry in several other Van Nijmegen paintings, is clearly attributed to "I./J. Vollenhove(n)." The pieces all fell into place when I learned that preacher-cum-poet Joannes Vollenhove was a follower and close imitator of Vondel, who even referred to Vollenhove as his son. Vollenhove wrote no fewer than seven poems on trompe l'oeil art—a unique cluster, virtually unknown—under the title "To a Painting Consisting of Prints Nailed to Wood," and one of these poems corresponded quite closely to these two lines in Van Nijmegen's painting. The other lines in this set of paintings are also traceable in all cases but one to Vollenhove's group of trompe l'oeil poems.[4] The poems expand the same basic theme:

> The eye of clever carpenters
> Thinks it sees wood and nails here.
> A printer is no less impressed
> By the page that looks like it was printed by him.
> Print makers and draftsmen look at it
> As the kind of work that they do.
> And there is many a painter that when he sees it
> He does not even recognize his own oil paint.
> Art lovers decide, whether this artistry
> Doesn't deserve praise and favor.[5]

This was the unique skill of the illusionist. The carpenter, the printer, the print maker, the draftsman all admire how well their own arts are imitated while not really there. The painter, conversely, is deceived into *not* recognizing his art even as it is so well practiced.

Vollenhove's verses were such a marked feature of Van Nijmegen's trompe l'oeil paintings that one of them turned up in an eighteenth-century inventory simply as "een Vollenhove."[6] This was actually quite unusual. Poetry praising artworks was common, but not so seventeenth-century artworks quoting such poetry back. One known example comes again from a pas de deux between Brisé and Vondel, in which Brisé inserted into a vanitas painting a poem that Vondel had written about another unknown painting of his.[7] Van Hoogstraten also included in one self-referential letter rack a handwritten poem, allegedly by an Austrian nobleman, praising his art. But Van Nijmegen's painted poetry consisted

of verses that were not specifically about himself and were thus less an ego trip than a celebration of his chosen genre, trompe l'oeil.

II

The appreciation for illusionist art in Van Nijmegen's paintings extends well beyond poetry. The two large canvases both celebrate Goltzius, who, while not quite a trompe l'oeil artist, was singled out in Karel van Mander's popular *Schilder-Boeck* (1604) as the father of Dutch illusionism. On one occasion, for instance, Goltzius circulated plates of his own that imitated Albrecht Dürer and Lucas van Leyden, after "aging them as if they had been in circulation for many years," and fooled many into thinking it was the best work they had seen from the earlier masters. Van Mander introduced a special term to describe Goltzius's genius to "refashion himself into any shape of rendering": *teyckenconst* (literally, the art of inscribing). *Teyckenconst* was nothing less than a new approach to draftsmanship, based on imitation—on the model of reproductive engraving—and a blurring of the boundaries between painting, engraving, and drawing. It had made Goltzius in Van Mander's eyes as prominent in northern art as Michelangelo had been in Italy. Van Nijmegen's two paintings, underscoring their trompe l'oeil prints of or by Goltzius with the words "teken kunst" from Vollenhove's couplet, pay homage to this original "prince of *teyckenaers* [draftsmen]."[8]

Another form of appreciation is in the smaller trompe l'oeil board with Van Vliet's 1634 print of Rembrandt's self-portrait as a young man. Here, above Van Nijmegen's signature and Vollenhove's two poetry lines (lines slightly altered to reinforce their emphasis on illusionism), and just below Rembrandt's visage, are written in much bigger letters the words "Alter Parasius," "another [or the second] Parrhasios." This title invokes the founding myth of trompe l'oeil art, the competition described by Pliny between Zeuxis and Parrhasios. Despite an auspicious beginning in successfully deceiving birds who came to peck at his painted grapes, Zeuxis was nevertheless bested by Parrhasios, who painted a curtain so skillfully into his own creation that Zeuxis himself was deceived into trying to lift it off so as to see the supposed painting beneath. In seventeenth-century Holland the story of Zeuxis and Parrhasios circulated often. Gerrit Dou, Frans van Mieris, and Samuel van Hoogstraten were each referred to at some point as the Dutch Parrhasios. Many paintings

from this period, like Gijsbrechts' trompe l'oeil in figure 2.1 on the right (p. 32), include an apparently movable curtain gesturing to Parrhasios's illusionist feat. A late-eighteenth-century art auction included an example from the brush of Rembrandt's student Ferdinand Bol, now lost, that represented in this role Willem van Nijmegen himself. Standing in front of a balustrade on which some of his drawings were hanging, the illusionist painter held a palette in his right hand and with his left hand pulled open a curtain.[9]

Van Nijmegen thus mobilized poetry, portraiture, copies of old master prints, classical allusions, and the aura of his most illustrious predecessors in a multimedia effort to promote the estimation of illusionist art. The most revealing commentary on the practice of trompe l'oeil in this group of paintings, however, and really anywhere in the Dutch golden age, is the long prose "document" at the bottom of Van Nijmegen's largest canvas, a text rendered so meticulously that virtually every one of its almost three hundred words can be read (fig. 12.3, bottom, p. 212). Containing the artist's heartfelt appeal and manifesto, it displays quite a different side of the illusionist's pride, one less self-assured and more defiant, even petulant.

The "document" begins with the affirmation that the two classical figures hovering above it are literally looking over it, "defending the art of the person Willem van Nymegen, who is slandered and doubted, about his [artistic] manner, as if it were a copy of a print, not a work of art in oil."[10] Without preliminaries the beholder is thrust into the middle of the fight. Were it to be so, the author—as he describes himself—blusters on, surely the accusers would be right to consider him incompetent and worse. "But being conscious himself that the opposite is the case," the author/artist retorts with a challenge to his opponents. Should they succeed in proving their case against him, "he offers this piece"—that is, the very painting in which his challenge is embedded—"and ten gold ducats." But if they do not succeed, "the undersigned . . . advises these Batavians to shut up" and not to despise something of which they cannot produce a better example. The author/artist knows there is much inferior work out there: "As concerns pasting up prints and tearing the paper off, the author is familiar enough with that, offering such rags as if they were real art, and considers them mere hirelings." But his own work, while never before auctioned or exhibited, would be recognized by the cognoscenti as of a different caliber altogether, of the kind that Vollenhove praised with his couplet. (The author/artist leaves it ambiguous whether Vollenhove's lines were written specifically about his own paintings or about paintings *like* his own.) And finally, in order to remove any doubt, "it is the author's intention . . . to

lend his name truthfully. Willem van Nymegen fecit et pinxit [made and painted (it)]."

What an embattled cry for appreciation of illusionist art! One made more poignant by letting through a sense of vulnerability and defensiveness. We have already seen that still life was held by this point—at least by theorists and cognoscenti, if not by a ready public of consumers—to be a form of art lower than other genres of painting. But here illusionism was in danger of falling even lower, dismissed as mere copying, piggybacking on others' artistic success. The author/painter's offended exasperation is unmistakable. Do the critics not realize how difficult this is? Imitating well print and writing and engraving in oil paints is a work of skill and originality; and what better way to make the point—no less defiantly than the text itself—than through an exquisite illusionist oil painting combining engraved "prints" with a handwritten "document." Let anyone put forth a better example if he can.

It is now clear why this painting is signed twice, and with such pomp. In addition to the written challenge issued by "the undersigned" that ends with a full sentence drawing attention to the act of its signing, the Harpocrates "print" is also marked prominently and centrally: "Willem van Nymegen fecit et pinxit A° 1688." Some might think that this image was the creation of the painter Hendrick Goltzius or of the engraver Jan Muller. But the two signatures on two distinct levels of the painting's composition declaim as loudly as they can that both levels, the "prints" that give the illusion of being by another, and the manifesto subsuming the prints into one unified whole and giving the illusion of not being painted at all, are the author/painter's original art. The composition may suggest an author, a signed document, a challenge, a print derived from an earlier old master work, or a wooden "piece," but ultimately there is but one artwork here demanding appreciation from the discerning beholder: an oil painting on canvas.

Not all the Van Nijmegen paintings are signed so unambiguously. The trompe l'oeil with the Jan Lievens print is signed "Johan van Nymeg," a hybrid of the poet (unnamed in this case) and the painter. In the case of the Goltzius portrait, next to the same Vollenhove lines that are also included in Van Nijmegen's signed manifesto appears the enigmatic combination

"Willem van den Burgh." Even if its precise meaning remains obscure, a playful signature by another late-seventeenth-century illusionist painter is hardly a surprise.

Yet this particular case may elevate the signature games to a new level altogether. Look closely at the two lines of text below Goltzius's portrait (fig. 12.4). In the lower line of Vollenhove's couplet, right in the middle, three words appear quite odd. The poetry is written in controlled, measured, square block letters, as if printed. But the words "En schrÿf kunst" are bigger, more conspicuous, more attention grabbing than the rest. Their behavior is well described by Vollenhove's own phrase, "schÿnt ver wildert": they have gone astray, wild. Instead of uniform block letters these three words, seemingly without rhyme or reason, sport elongated, elaborate, playfully ornamented letters in italics. More than anything, they behave like *a signature*. This is precisely what an early modern signature looked like: italics—the proper form for signing since the sixteenth century—topped with additional calligraphic curling and twirling, the cursive flourishes, or "paraphs," that constituted the telltale distinction of an individualized signing hand.[11] As a signature, moreover, this italicized

Fig. 12.4: Detail of Willem van Nijmegen, *Trompe l'Oeil of an Engraved Portrait of Hendrick Goltzius Pinned to a Board* (fig. 12.2).

"insert" at the center of the bottom line chimes visually with, and is in turn echoed by, the other two personal names in italics flanking it to the right and the left: the poet's and the painter's.

Whose signature, then? I hear you laugh. The most telling letter in this wannabe signature is the cursive *ℰ* in "En," meaning "and." It is the second "en" in this line, which underscores how incongruous is the sudden capital- ization of the *ℰ* in this conjunction. On the other side the enlarged flourish of the k in the cursive "kunst" stands out, again in marked contrast to the earlier "kunst" in the same line. In between lies "schrÿf," which as part of "schrÿfkunst" means "writing," but that alone can simply mean "write" in the first person. "*I, E K, write.*" Not simply a monogram, but one embedded in a declarative statement! And the true ingenuity of this signing device, if indeed it is one, is that the effect is achieved without disrupting the flow of the poetry, simply by altering the visual appearance of a few letters.

"*I, E K, write.*" Could this really be the familiar mark of Edward Col- lier, in yet another trompe l'oeil painting from the second half of the sev- enteenth century, or has it become so familiar that I have come to see it at the bottom of every coffee cup?

Some circumstantial evidence could perhaps be taken to point in this direction. I did not put too much weight on the spelling variations of names in this painting. "Goltius" rather than "Goltzius" is indeed un- common, but in fact goes back to Jacob Matham's original print. Yet it is notable that the painter retained this spelling as he moved the name to the oval at the top and incorporated it into a longer biographical description. The second spelling variant in the same oval, "Haerlem" rather than "Haarlem," was the painter's alone. More significant may be the fact that the painter took some liberties with the poetry beneath the portrait. These are the lines that Vollenhove the preacher-poet had actually penned:

> *Hier tart de kunst natuur. wat kunst? zy schynt verwildert,*
> *Die teffens maalkunst, druk en schryf– en snykunst schildert.*
> Here art challenges nature. What art? It seems to have
> gone astray.
> These [things] represent at the same time painting, print,
> writing, and engraving.

In the painting, however, the second line is altered, thus:

> *Dit 's druk en teken kunst, En schrÿf kunst, maar geschildert.*
> This is printing and drawing, and writing, but painted.

The change of wording allowed the painter to introduce the *teyckenconst* associated with Goltzius. At the same time, this modification is also what opened the door for the possibility of insinuating "E schrÿf K" into the line.

So were these Collier's fingerprints? *Could* they have been Collier's fingerprints? I needed to know more about Willem van Nijmegen before I could even speculate on how to place Collier within a brushstroke of this painting.

Here are the basic facts. Van Nijmegen was a few years older than Collier, having been born in 1636 to a family of painters. As a professional he moved around, joining painters' guilds in The Hague in 1675, in Delft in 1684, and in Haarlem in 1691, where he died in 1698. Two of his brothers, Jan and Elias, lived for some time in Leiden and were members of its own painters' guild, recorded respectively in 1673 and 1689. From 1690 on Jan actually held central positions in the Leiden guild as warden and then dean.[12] Collier of course was a member of the same guild following his move from Haarlem in 1667. At midcentury Leiden was a town of around seventy thousand people, with fifty-five master painters and further twenty-two guild-registered *kladschilders*; these numbers are small enough to allow us to assume it not unlikely that Collier knew the Van Nijmegen brothers, at least the one who was so actively involved in guild affairs over many years. As it happens, this brother is also the one for whom we have evidence of a close connection to Willem: when Jan van Nijmegen's first wife died in 1684 in Leiden, Willem, "his brother in The Hague," was designated guardian of his four children and was then witness to his second marriage.[13]

Of course none of this means that Collier and Willem van Nijmegen knew each other. But then they were not merely two people who happened to share a profession. They shared much more: both were trompe l'oeil painters specializing in illusions of paper. As such they belonged to quite a small group, and one that was getting smaller, as most of its notable members were dead by the 1670s.[14] Aside from a few examples by Cornelis Biltius in the 1680s, Collier and Van Nijmegen may well have been the only two artists of the next generation in the Netherlands whose surviving work demonstrates continuous interest in paper-focused illusionism. They had a lot to talk about.

Further digging provided some more circumstantial evidence nudging Collier and Van Nijmegen closer to each other. First, we can actually place Willem himself, not only his brothers, in the city of Leiden. During recent restoration work in the Pieterskirk, Leiden's oldest church, the decoration

of the wooden vaults in the churchwarden's room was uncovered and cleaned. In the folds of a handsome banner with the name of one of the church wardens, the restorers found the signature "W. v. Nymegen 1691."[15] So Willem may have paid guild dues elsewhere, but he was also invited to undertake a job in Leiden, perhaps through the intervention of his brothers or other local connections, when Collier was there.

Second: consider what job this was—painting a ceiling. There is also a surviving Van Nijmegen ceiling in the castle of Amerongen, dating to 1685. In fact, Van Nijmegen's reputation, like that of his other brush-wielding family members, was not primarily as an easel artist but as a house (and occasionally carriage) painter and decorator. In particular he was known as a *marmerschilder*, or painter of marbling. When the Swedish architect Nicodemus Tessin the Younger traveled in Holland in the late 1680s, he singled out Van Nijmegen for having produced the best marbling in house decorations he had ever seen, executed so well that Tessin—an architect—could not tell it apart from the real thing that was right next to it.[16] Van Nijmegen, in short, was a house decorator with a particular penchant for trompe l'oeil and an ability to extend his illusionism to canvas. Given what we know about Collier's interest in and connections with house painters, sometimes with easel aspirations and often with illusionist tendencies (imitation marbling was also in the repertoire of Thomas Warrender and James Norie), it is hard to imagine a more likely figure for Collier to pair up with.

Third: a hundred years after these events, in 1781, the grandson of Willem's brother Elias, Gerard van Nijmegen, traveled through William III's former hunting lodge in Dieren, where he saw a painting signed by Willem van Nijmegen, dedicated to William III, and dated "December A° 1680." Gerard described the painting, mimicking views outside the house, as a *schijnbedrieger*, or "deceiver of appearances"—the Dutch term for a trompe l'oeil painting—like others of his great-uncle's that he had seen before. "It was drawn so elaborately with a brush that one could believe that it was an engraved print, the wide paper margin of which had been fastened to the chimneypiece with four seals in red wax (*vier zegels in roodlak*)."[17] The illusionist print was "attached" not with faux nails, like the Van Nijmegen paintings that survived, but with faux wax seals. Red wax seals—often four, sometimes six—were a distinctive and ubiquitous feature of Collier's trompe l'oeil prints-on-boards, and could thus be a sign of a link.

Fourth: another possible link between the two trompe l'oeil artists may have been through the third man, the preacher-poet Joannes Vollenhove. Vollenhove, whose name completes the triangular ensemble of apparent

signatures at the bottom of the Goltzius portrait, was unusually central to Van Nijmegen's paintings. In one case the painter used an apparently unpublished poem of Vollenhove's, indicating perhaps a personal connection. It is also possible tentatively to connect the dots between Vollenhove and Collier. Vollenhove lived in The Hague with no apparent direct connections to Leiden or to Collier, though his nephew was a medical doctor in Leiden and his best friend a professor there. The trail gets warmer with Joannes's brother Bernardus Vollenhove of Zwolle, who was himself both poet and painter. In 1670 Bernardus married Elisabeth Braam, a woman who had more business in Leiden than the two brothers. Their wedding record lists as Elisabeth's witnesses "her friend" Nicolaas van Persijn, an important civic figure in Rijnsburg, a village northwest of Leiden, and her brother Willem Braam, who was a barrister in that village. Herein lies the connection: the former was almost certainly the same Heer van Persijn, and the latter plausibly the same Heer Bramst, who two years earlier had also witnessed together the baptism of Joris, son of Johannes Colier, brother of Edward Collier.[18] Of course this is not conclusive proof that Johannes Vollenhove and Edward Collier knew each other, but it stands to reason that their brothers did. When we add to the mix the common theme in Vollenhove's poetry and Collier's art, such a connection between them—within this rather small world—seems quite likely.

Finally: when Van Nijmegen's trompe l'oeil derived from Jan Lievens was sold in Paris in 2002, the French auction cataloguer, obviously not knowing Dutch, reproduced the painted text beneath the portrait thus: "Bedroop penf Ec . . ." The second word is in fact "penseel," but the French cataloguer had a point: what is actually painted is "PensEel," with an additional line, like a superscript *c*, above the final *e*. Not knowing what *should* be written, the cataloguer saw an "Ec" inserted into this word; an insertion that involves, once again, an *E* capitalized without any reason, here in an unlikely position in the middle of a word. The result certainly resembles several instances of Collier's monograms.

In sum, the more likely an acquaintance between the two artists became, the easier it was to speculate on a pattern much like that with which I was already familiar from Collier's English years. In Van Nijmegen Collier may have found a house painter much to his liking, with a shared interest in illusionist painting, especially of paper. Their relationship may have involved collaborative works in which Collier cleverly planted his monograms, a practice that he was going to repeat later with many other house painters and decorators.[19] It now also appeared meaningful that the two paintings in which I suspected hidden Collier monograms were precisely

the two that Van Nijmegen signed not straightforwardly with his full name, but rather with coy or playful variants. However unexpectedly, everything seemed to fall into place.

IV

There is, however, a fly in the ointment. The same lines with those three words that go wild in italics, those which I have alleged to encrypt Collier's signature, appear also in Van Nijmegen's largest painting, embedded in the long document defending trompe l'oeil. In this case the two lines are written throughout in italics rather than square letters, and still the words "En schrýf kunst" break rank with their sisters with precisely the same cursive, signature-like appearance as in the Goltzius portrait. This painting, however, declares itself to be the work of Van Nijmegen, who signed it twice.

There seem to be three ways to resolve this difficulty. One is to conclude that I am wrong about the Goltzius painting, and that Willem van Nijmegen had his own reasons for painting those three words, twice over, in a peculiar way that we do not understand, bearing a mere coincidental resemblance to Collier's familiar antics. The second is to allow that Collier may have been involved in the creation of the earlier Goltzius painting, but to assume that Van Nijmegen subsequently copied these two lines by himself into his later, more mature work. The flaw in this scenario is that the idiosyncratic form of the three "wild" words is retained in the later painting even as the general appearance of the two poetry lines is significantly altered. The third possibility is to bring Collier into the vicinity of this later painting as well. After all, these two paintings do stand out from the other Van Nijmegen canvases that have survived. They are significantly bigger and more intricate. Despite more than a decade between them (the Goltzius portrait is dated 1675; the three-part composition is from 1688), they are evidently related to each other, both being forms of homage to Goltzius that repeat the same lines by Vollenhove, with the same visual emphasis on those three words.

The counter-arguments to this third possibility are weighty. The three-part painting is unambiguously signed by an artist with other uncontested canvases to his name. It marshals an animated personal manifesto that trumpets from the rooftops his professional identity and pride. It issues a detailed challenge in his explicit name, and it dwells on the very act of his signing the

painting with self-conscious relish. All I could offer to counter all this was three painted words that have inexplicably, once again, gone berserk.

There was one more thing, however, that could possibly be of some help: a comparison of the painted versions of the Chilon and Harpocrates "prints" to Jan Muller's original late-sixteenth-century engravings. So here they are (fig. 12.5). The imitation of these rather unusual classical figures is excellent, though the painted versions are slightly less grotesque than the original engravings. Several alterations in the trompe l'oeil version adapt it to the conditions of its making. Thus the painter removed from the bottom of the ovals the attributions "Joan Muller fecit" and "Harman Muller excudebat" (Harman Muller—Jan's father—printed). He also removed the original dates from the top of the ovals, replacing them with symmetrically placed and executed geometrical ornamentations. At the same time, he added the new Van Nijmegen signature and date, much bigger and more conspicuous, in the empty off-center space in the Harpocrates print. And this, other than two small mistakes in copying the Latin, seems to be it. A dead end.

But no, there is one other small change. The words below the image of Harpocrates in the painting, but not in the original print, end with a ":•••" followed by another floral ornamentation. The placement of this ornamentation is oddly asymmetrical: it is balanced neither by another at the beginning of the phrase nor by a similar one under Chilon. Note, however, that the three words under Chilon *are* followed by an identical ":•••": a repetition that draws attention to the absence of the floral ornamentation, and thus to the deliberateness of including this design, an element out of place, in the painted Harpocrates print. Was this change too, then, like the others, related to assertions and erasures of authorship? For the connoisseur of Collier's games with his monograms, from the early vanitas at the Metropolitan Museum to the letter rack signed by Henry Howell, this out-of-place floral squiggle may appear like a familiar device to hide— rather openly—an "E C." Could it be that Edward Collier added his sign here too, characteristically concealing it while at the same time planting subtle signposts to draw attention to it if anyone cared to look?

Van Nijmegen's story thus leads to a curious place. Admittedly speculative, it is possible that the large three-part Van Nijmegen painting is marked with *two* hidden Collier monograms: an "E C" in the floral ornamentation beneath Harpocrates to the right, and the familiar counterpart "E K" in the Vollenhove lines in the "written" manifesto. The double repetition makes compositional sense: one set of initials to balance Willem van Nijmegen's signature on the same side of the same Harpocrates

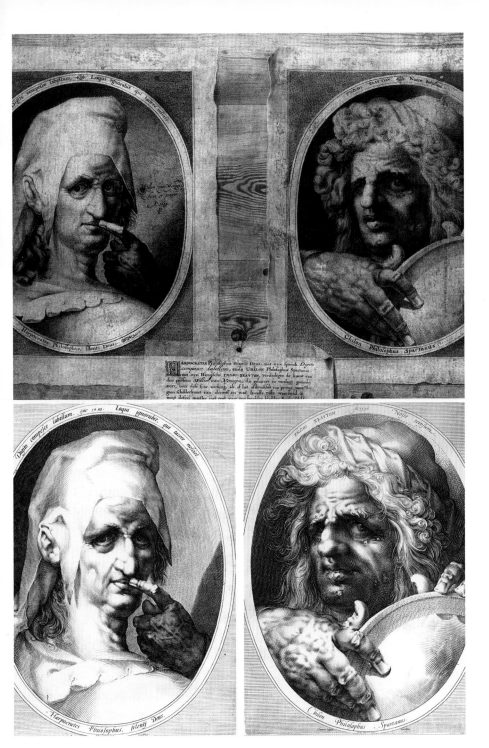

Fig. 12.5: *Top*: Detail of Willem van Nijmegen, *Trompe l'Oeil of an Engraved Portrait of Hendrick Goltzius Pinned to a Board* (fig. 12.2). *Bottom*: Two engravings by Jan Harmensz. Muller. *Harpocrates, Philosopher*, 1593. 48.2 x 37.3 cm. *Chilon, Philosopher of Sparta*, 1596. 48 x 36.3 cm. 2009 Museum Associates / [Los Angeles County Museum of Art / Art Resource, NY.

print, and one, using the berserk-italics device that had also appeared in the Goltzius portrait, just above Willem van Nijmegen's second signature at the bottom. On the one hand, Collier's possible involvement in the production of two elaborate large-scale illusionist paintings of a house painter and *marmerschilder* with a long-standing interest in trompe l'oeil should not strike us as too surprising. But on the other hand, the implications of this particular episode are quite unexpected. The most heartfelt, emotional, personal eruption of an impugned illusionist may turn out, if these conjectures are correct, to be an illusion, an act of dissimulation, even as the text promises that "the author's intention" is "to lend his name truthfully." Never trust a magician who tells you he's about to shuffle the cards, or break the egg, or sign truthfully.

Much here remains obscure. Did Collier and Van Nijmegen have a working relationship of many years, and what was its nature? Was Van Nijmegen's reputation actually challenged, and was it this challenge that brought Collier to collaborate with him again in defense of a favorite art form? Or was the whole story laid down in this canvas a case of false advertising, a radical device to trumpet the genre of trompe l'oeil? Perhaps I should post a challenge myself: this book and ten ducats to the person who comes up with the best narrative for stringing together all the pieces of this puzzle.

One final reflection. Who wrote this most evocative early modern plea in defense of illusionist art? If the production of this painting was indeed a collaboration, was this the case also for the penning of the text, which drew in part on an earlier putative collaboration between the two artists? If we follow this conjectural string of deductions and speculations all the way through, it is possible that Collier himself participated in the writing of this almost-three-hundred-word-long manifesto about trompe l'oeil painting. The resistance of this manifesto to the hierarchization of different painterly genres that elevated "high" productions over others equally skilled is quite in line with Collier's message a few years later, in that series of paintings signed in the names of house painters and other artists who found themselves in a relatively lowly place in a calcifying professional pecking order. Do we hear here, then, a whisper of Collier's own voice, refracted through several echo chambers as one might expect from an artful illusionist?

Epilogue

I

In the papers of the American artist John Haberle, who died in 1933, was found a newspaper clipping published in New York around 1900. The reporter had visited an unnamed painter in his studio, where he saw

> an ordinary drawing board, eloquent of long and hard usage. There were pencil sketches on it. Three or four cancelled stamps were stuck here and there, and a photograph of an actress, such as is given away with a package of cigarettes, ornamented a corner of the board. Someone had cut his initials into it, and the knife had not been very sharp, and someone else had struck a match across it.

The artist told the reporter he proposed to paint an exact copy of that drawing board, and when he had finished he was going to paint the things on the other side. The writer then turned the board around and discovered that it was no drawing board at all, but a painting.

This latter-day Parrhasios was probably Haberle himself. Haberle and several other late-nineteenth-century American painters—notably John Frederick Peto and William Harnett—were together responsible for the most significant revival of the trompe l'oeil letter rack. The lines of transmission from seventeenth-century Europe to late-nineteenth-century North America are not fully clear. But we know that artists such as the Frenchman Gabriel Gresly and the Italian Benedetto Sartori continued to experiment with similar compositions in the eighteenth

century and beyond, at times including unmistakable visual quotations from their forebears, and, perhaps more to the point, that in the early 1790s an English letter-rack-trompe-l'oeil artist named Samuel Lewis emigrated from London to Philadelphia, where his future career as one of the foremost mapmakers of the early American republic did not put an end to his illusionist work.[1]

But it may be that the most illustrious American trace of this late-seventeenth-century episode in European art is to be found elsewhere, lying—like its own protagonist—hidden in plain sight.[2] It begins with a short description evoking a typical Dutch still life: "a large writing-table . . . upon which lay confusedly, some miscellaneous letters and other papers, with one or two musical instruments and a few books." The assortment of books, musical instruments, letters, and papers creates a recognizable effect, one characteristic of many of Collier's vanitas still lifes.

As it happens, however, this description does not refer to a seventeenth-century painting. It instead describes the desk of the French Minister D—— who had stolen a compromising letter from the royal apartments in Edgar Allan Poe's 1844 short story "The Purloined Letter." What interests me here is the famous climax of the story that immediately follows the still-life-like description of D——'s desk. At this point Dupin, Poe's Sherlock Holmesian prototype with a brilliant ability to think outside the box, discovers the missing letter that had eluded the police prefect for many months:

At length my eyes, in going the circuit of the room, fell upon a trumpery filigree card-rack of pasteboard, that hung dangling by a dirty blue ribbon, from a little brass knob just beneath the middle of the mantel-piece. In this rack, which had three or four compartments, were five or six visiting cards and a solitary letter. This last was much soiled and crumpled . . . It had a large black seal, bearing the D—— cipher *very* conspicuously, and was addressed, in a diminutive female hand, to D——, the minister, himself. It was thrust carelessly, and even, as it seemed, contemptuously, into one of the uppermost divisions of the rack.

No sooner had I glanced at this letter, than I concluded it to be that of which I was in search. To be sure, it was, to all appearance, radically different from the one of which the Prefect had read us so minute a description. Here the seal was large and black, with the D—— cipher; there it was small and red, with the ducal arms of the S—— family. Here, the address, to the Minister, was diminutive and feminine; there the superscription, to a certain royal personage, was markedly bold and

decided; the size alone formed a point of correspondence. But, then, the *radicalness* of these differences, which was excessive; the dirt; the soiled and torn condition of the paper, so inconsistent with the *true* methodical habits of D——, and so suggestive of a design to delude the beholder into an idea of the worthlessness of the document; these things, together with the hyper-obtrusive situation of this document, full in the view of every visitor, . . . were strongly corroborative of suspicion, in one who came with the intention to suspect.[3]

Note the carefully unfolding details. A hanging card rack or letter rack with several divisions one above another. A smallish number of documents sticking out. A letter tucked into it seemingly carelessly, but in fact with precise care and aforethought. A letter sporting only the name of its addressee, who is the owner of the rack. An invitation to compare different letters. An evaluation of authenticity through seals and handwriting. A red seal and a black seal. A deliberate representation of paper as worn and crumpled. An apparent messiness masking a master-designer with true methodical habits. A subsequent substitution of a facsimile for the real letter, "imitat[ed] . . . very readily," including the seal. Even a suggestion of "a design to delude the beholder" through appearances, a deception fully successful before the arrival of Poe's hero. And all this immediately following what can easily be seen as a verbal gesture to the early modern still life. Did Poe register here—in this object that was, in his words, a work of "trumpery"!—the memory of the trompe l'oeil letter rack paintings of the seventeenth century? If not, then the multiple affinities between this nineteenth-century text and a unique genre of almost two centuries earlier were truly uncanny.

Let us assume for the sake of argument that Poe's story does bear traces of the still life tradition in which Collier took part, and that Poe picked up on the letter rack's potential for deception in this famous forerunner of modern detective fiction. Poe may have seen letter rack paintings as a child in Britain, where he had spent several years in Scotland and in London—two locations where running into a Collier painting was possible. As a writer, he certainly expressed interest in how such still life interiors were represented. A couple of years before describing D——'s desk and letter rack, he had commended Dickens for "his powers of *imitation* . . . the *faithful* depicting of what is called still-life." Poe was also interested in the actual material culture of interior design, as he indicated in his "Philosophy of Furniture" essay of 1840.[4] The study in "The Purloined Letter" could thus well have drawn its inspiration and model both

from actual interiors with desks and letter racks and from earlier visual and verbal representations of such interiors.

II

This sounds not unlike how still life painters work. Collier too had drawn both on previous representations of still lifes or letter racks and on actual material objects, which he arranged before him according to the best practice of still life painting.

There is only one problem with this picture, a historical problem that I left for the very last moment because, in truth, I hesitate to bring it up. As far as can be ascertained, it seems that in seventeenth-century Europe—unlike in Poe's nineteenth century—letter racks did not exist. Such a statement, I hasten to add, greatly exceeds my own expertise. It derives from the combined efforts of two more qualified experts: a curious curator who raised the question while researching an extensive trompe l'oeil exhibition in the National Gallery of Art in Washington in 2002–3, and the leading authority on the historical accuracy of paintings of Dutch interiors, who tried to answer it, and who has remained alert to the question ever since.

The latter, C. Willemijn Fock, has spent decades examining the veracity of Dutch interior paintings. In quite a number of details, she finds, these paintings parted with reality or embellished it for artistic purposes: impossible ceilings, unlikely interior spatial arrangements, black-and-white marble floors that were in fact extremely rare, Turkish rugs depicted on floors when in fact their use was apparently limited to table covers. With regard to seventeenth-century letter racks, Fock's conclusion is that despite our considerable and detailed knowledge of Dutch interiors, their existence cannot be confirmed. It is confirmed neither through the survival of any such artifacts, nor through any listing in thousands of extant inventories, nor through any visual (or textual) representation of interiors, especially those of scholars' studies or offices.[5]

Nevertheless, given the difficulty of arguing from negative evidence, the National Gallery exhibition catalogue leaves the matter with the cautious suggestion that perhaps letter racks did after all appear in some seventeenth- or early-eighteenth-century households, but because of their low value they left no trace. It is thus left to me to observe, first, that it is curious that every other object in the still life letter racks is known to

us in multiple examples, all but the letter racks themselves. Second, that there are in fact Dutch paintings from this same period depicting letters and papers on walls, such as Adriaen van Ostade's paintings of lawyers in their studies from the 1670s and 1680s, Egbert van Heemskerck's *Fransz Hercules and His Family* of 1669, Heyman Dullaert's *Physician in His Study* of c. 1670, Frans van Mieris the Younger's *Apothecary* of 1714, or Brisé's 1656 trompe l'oeil for the Amsterdam treasury; but that in each and every case they depict these letters and documents affixed to the wall simply with a hook or on a string.[6] This is the case, moreover, in a culture that represented the details of interiors more lovingly and more frequently than ever before. By contrast, in the nineteenth century we do find next to the letter rack paintings like Peto's and Harnett's also representations of actual letter racks on walls—for instance in Ernest Meissonier's *The Philosopher* (1872), which influenced Harnett directly.[7] Third, in the one contemporary account we have of someone actually purchasing a letter rack painting—the Frenchman Balthasar de Monconys during his travels in 1664—not only did Monconys not have a name for the object in the Gijsbrechts painting he bought, but he described it as if it did not have any function familiar to him. Likewise, when Van Hoogstraten described a letter rack painting in his treatise on art, he also did not name it. Finally, it is telling that even as we deal with images that are all about deception and illusion, in a genre that trumpets the warning "Do not trust to appearances," we still feel such a strong urge to anchor what we see in the tangible real, in something "true."

So it may be the case that the letter racks that constitute the very defining feature of these trompe l'oeil paintings were themselves an illusion. A rather befitting ending to this book. And one perhaps more plausible than first meets the eye. After all, recall the needs of the seventeenth-century trompe l'oeil painters as they transferred the skills of illusionist painting from architectural decoration to framed canvases. Searching as they did for two-dimensional rectangular objects that could be mobilized for the purpose of presenting a life-size flat illusion of still life—a window, a shelf, a cabinet, a closet door, a board to pin something on—their options were quite limited, and all the more so if the illusion was intended to replicate the effect of a miscellany of objects central to the Dutch still life tradition, or the clutter of a desk. Put this way, something like a letter rack becomes almost a necessity for the visual rhetoric of the trompe l'oeil. Was it the case, then, that the first European letter racks—as objects— were actually put together with straps and nails and boards by a small coterie of illusionist artists?

I have come across one piece of counter-evidence. It is a painting now lost that was recorded a generation ago by the Italian scholar Alberto Veca. It shows the interior of a room not unlike Poe's minister's, with a desk piled with heavily bound books, miscellaneous papers, and a hanging portrait of Melanchthon; and next to the portrait, on the wall, partly hidden by a curtain, a one-strap letter rack. The rack has on it two letters: one addressed to "Phillipp Melancthon," the other with a broken seal. So is this the elusive visual proof that letter racks existed as actual furniture in actual rooms? Maybe not. Even without paying attention to the unusual spelling of "Phillipp Melancthon," the experienced Veca was confident that he had spotted two letters insinuated into a document at the bottom of this painting: "E C."[8]

Notes

ABBREVIATIONS

DNB	*Dictionary of National Biography*
EEBO	Early English Books Online
NA	Notarial Archief
NH	Nederlands Hervormd
OED	*Oxford English Dictionary*
RAL	Regionaal Archief Leiden
RKD	Rijksbureau voor Kunsthistorische Documentatie / Netherlands Institute for Art History

INTRODUCTION

1. B. Capp, *Astrology and the Popular Press: English Almanacs, 1500–1800* (London, 1979), 242, 329, 378. W. E. Burns, "Astrology and Politics in Seventeenth-Century England: King James II and the Almanac Men," *Seventeenth Century* 20, no. 2 (2005): 243. When I communicated my skepticism to Bernard Capp, a former colleague and the world's greatest expert on British almanacs, he kindly assured me of his unwavering confidence that this story needs no modification.

2. Burns, "Astrology and Politics," 242–53. Capp, *Astrology and the Popular Press*, 117, 239.

3. One more detail that Collier took from the later edition was the printer's name. The 1676 issue had been printed by Andrew Clark, but by 1696 the name at the bottom of the title page—as in Collier's image—was that of his widow, M[ary] Clark. In another painting (fig. 4.2, p. 71), Collier included a 1701 edition of the *Apollo Anglicanus* in which he chose to leave the printer's name M. Clark, as in 1696, though by the 1701 edition the almanac's title page already announced a different printer by the name of J. Wilde.

CHAPTER ONE

1. *A Review of the State of the British Nation* 8 (8 May 1712), fac. ed., ed. A. W. Secord (New York: 1938), bk. 21, 708. Cf. H. Love, *The Culture and Commerce of Texts: Scribal Publication in Seventeenth-Century England* (Amherst, 1993), 3.

2. Roger Cocks, *An Answer to a Book Set Forth by Sir Edward Peyton . . .* (London, 1642), 1; cf. L. Morrissey, *The Constitution of Literature* (Stanford, 2008), 26. *M. Misson's Memoirs and Observations in His Travels over England . . . Translated by Mr. Ozell* (London, 1719), 203 (Henri Misson traveled in 1697).

3. F. Eisermann, "The Indulgence as a Media Event: Developments in Communication Through Broadsides in the Fifteenth Century," in *Promissory Notes on the Treasury of Merits: Indulgences in Late Medieval Europe*, ed. R. N. Swanson (Leiden, 2006), 309–30; and his unpublished "Medium of the Masses? On Press Runs and Audiences of Fifteenth-Century Broadsides." I am grateful to Falk Eisermann for sharing his work and knowledge with me.

4. R. B. Walker, "The Newspaper Press in the Reign of William III," *Historical Journal* 17 (1974): 691–709. M. Knights, *Representation and Misrepresentation in Later Stuart Britain: Partisanship and Political Culture* (Oxford, 2005).

5. *A Review of the State of the British Nation* 8 (29 April 1712): 670. P. McDowell, *The Women of Grub Street: Press, Politics and Gender in the London Literary Marketplace, 1678–1730* (Oxford, 1998), 28–29. See also G. S. de Krey, *A Fractured Society: The Politics of London in the First Age of Party, 1688–1715* (Oxford, 1985), 213–22.

6. *London Magazine; or, Gentleman's Monthly Intelligencer* 2 (May 1733): 263.

7. K. Jonckheere, *The Auction of King William's Paintings (1713)* (Amsterdam, 2008), 307, lot 220. Besides still lifes and trompe l'oeil paintings, Collier also produced the occasional portrait, history, or genre piece: together they constitute less than 10 percent of his surviving works.

8. J. Becker, "Das Buch im Stilleben—Das Stilleben im Buch," in *Stilleben in Europa*, ed. U. Bersmeier (Münster and Baden-Baden, 1979–80), 448–78. E. Gemar-Koeltzsch, *Luca Bild-Lexicon: Holländische Stillebenmaler im 17. Jahrhundert*, 3 vols. (Lingen, 1995), 1:86–87. A. Chong and W. Kloek, *Still Life Paintings from the Netherlands, 1550–1720* (Zwolle, [c. 1999]), 166, 168, 180. W. A. Liedtke, *Dutch Paintings in the Metropolitan Museum of Art* (New York, 2007), 1:130. In Haarlem Collier may have studied with Pieter Claesz and/or Vincent Laurensz. van den Vinne: cf. *The Hoogsteder Exhibition of Music and Painting in the Golden Age* (The Hague, [1994]), 178–81, and *The Dictionary of Art* (Grove), ed. J. Turner (New York, 1996), 7:568.

9. *De Arte Graphica. The Art of Painting, by C. A. Du Fresnoy . . . Translated into English . . . by Mr. Dryden . . .* (London, 1695). Scholars sometimes date the first appearance of *still life* to W. Aglionby, *Painting Illustrated in Three Dialogues* (London, 1686), but the phrase there describes "inanimate objects" that can appear on any canvas, not a particular genre of paintings. In auction records the term *still life* was already in use in the early 1690s.

10. These paragraphs are indebted to W. Kloek, "The Magic of Still Life," in Chong and Kloek, *Still Life Paintings from the Netherlands, 1550–1720*. For the estimated number of still lifes see M. Westermann, ed., *Art and Home: Dutch Interiors in the Age of Rembrandt* (Zwolle, 2001), 21.

11. E. J. Sluijter et al., *Leidse Fijnschilders: Van Gerrit Dou tot Frans van Mieris de Jonge, 1630–1760* (Zwolle and Leiden, [1988]). P. H. Smith, *The Body of the Artisan: Art and Experience in the Scientific Revolution* (Chicago, 2004), 205–10.

12. Cf. Caspar Netscher's painting *The Letter with the Black Seal* (1665) and its discussion in P. C. Sutton et al., *Love Letters: Dutch Genre Paintings in the Age of Vermeer* (London, 2003), 111–12.

13. Although there is evidence that English art patrons enjoyed optically clever paintings, this fact by itself is hardly sufficient to account for Collier's massive change of direction. Only one extant Collier letter rack painting can clearly be attributed to a specific commission. Other émigré Dutch painters appear to have done well in England with their stock-in-trade still lifes, like Pieter van Roestraten, whose paintings often resemble Collier's. Collier himself did not stop producing vanitas still lifes upon arrival in London, but they now took second place to his trompe l'oeil paintings.

CHAPTER TWO

1. Other Netherlandish contemporaries of Collier who had tried their hand at letter rack paintings included Cornelis van der Meulen, Cornelis Biltius, and the Swedish artist of Dutch origin Johan Klopper. Variants of the genre, typically more loosely arranged with a greater variety of objects, appeared around the same time in France, Spain, and Germany, by such artists as Jean-François de la Motte, Marcos Correa, and Domenico Remps. There is also a single known errant precursor to these seventeenth-century developments, a late-fifteenth-century painting of a window frame with a single strap across it holding some letters, from the brush of the Venetian artist Vittore Carpaccio; which goes to show that there are never really true beginnings.

2. Samuel van Hoogstraten, *Inleyding tot de hooge schoole der schilderkonst: anders de zichtbaere werelt* (Introduction to the Academy of Painting; or, The Visible World) (Rotterdam, 1678); cited and translated in C. Brusati, "Honorable Deceptions and Dubious Distinctions: Self-Imagery in Trompe-l'Oeil," in O. Koester, ed., *Illusions: Gijsbrechts, Royal Master of Deception* (Copenhagen, 1999), 52, and in C. Brusati, *Artifice and Illusion: The Art and Writing of Samuel van Hoogstraten* (Chicago, 1995), 159.

3. Catalogue of Bonhams Auctions sale 10195, 9 July 2003, lots 53 and 54, provenance from Samuel James Augustus Salter (1825–1897).

4. M. Knights, *Representation and Misrepresentation in Later Stuart Britain: Partisanship and Political Culture* (Oxford, 2005). See also S. N. Zwicker, "Language as Disguise: Politics and Poetry in the Later Seventeenth Century," *Annals of Scholarship* 1, no. 3 (1980): 47–67; and B. Dooley, *The Social History of Skepticism: Experience and Doubt in Early Modern Culture* (Baltimore, 1999).

5. Richard Gorges to Christopher Hatton, 7 March 1699/1700; quoted in L. K. Davison, "Public Policy in an Age of Economic Expansion: The Search for Commercial Accountability in England, 1690–1750" (PhD thesis, Harvard University, 1990), 128. *The History of Associations*, (1716), 1–2; and Roger L'Estrange, *The Observator in Dialogue. The Third Volume* (1687); cited in Knights, *Representation and Misrepresentation in Later Stuart Britain*, 216–17, 207, respectively. Robert

South, "The Fatal Imposture, and Force of Words: Set Forth in a Sermon. Preached . . . May the 9th, 1686," *Twelve Sermons Preached upon Several Occasions*, 4th ed. (London, 1718), 2:341.

6. Cf. *Catalogue of the Erasmus Collection in the City Library of Rotterdam* (Westport, CT, 1990), 224. Thomas More, *Utopia; with Erasmus's The Sileni of Alcibiades*, ed. D. Wootton (Indianapolis, 1999), 169, 178; and cf. introduction, 24–25.

7. Cf. A. Chong and W. Kloek, *Still Life Paintings from the Netherlands, 1550–1720* (Zwolle, [c. 1999]), 224–26. Another Van Hoogstraten painting from 1663 includes a contemporary play from the London social scene: Brusati, *Artifice and Illusion*, 363, checklist no. 85.

8. T. Clayton, *The English Print, 1688–1832* (New Haven, 1997), 2–6, with two examples by George Bickham the Elder, c. 1706. A third similar design, also from 1706, can be found in the Witt Library, British Still Lifes folder; and another from 1704, by Bernard Lens, at the British Museum (Sloane, Misc. Pic. 26). Three further examples are kept at the Library of Congress, two of which are dated 1706, including *Great Britain's Post Master*, in which the newspaper, grotesque print, and portrait of Charles I once again bring to mind Collier's compositions. A 1706 medley by John Sturt, including also a ballad broadsheet and a map, is discussed in M. Hallett, *The Spectacle of Difference: Graphic Satire in the Age of Hogarth* (New Haven, 1999), 38–39. Together with the 1703 drawing published here for the first time, this is a curious concentration of compositions piling up all manner of unbound printed materials into a new genre dated to those very years in which Collier was making his mark in London.

9. J. Paul Hunter, *Before Novels: The Cultural Contexts of Eighteenth-Century English Fiction* (New York, 1990), 167–72. Thomas Brown, "The Life of His Present Majesty King William the Third," in Louis Aubery du Maurier, *The Lives of All the Princes of Orange* . . . (London, 1693), 235–36 (and cf. *OED* and *EEBO*).

10. Daniel Defoe, *An Essay upon Projects* (London, 1697), 8. It is curious that Collier's global news network in the letter rack paintings I have seen did not extend to any parts of the British or Dutch empires in the Western Hemisphere, though globes and maps in Collier's other still life paintings often focused on those more exotic parts of the world.

11. K. Dierks, *In My Power: Letter Writing and Communications in Early America* (Philadelphia, 2009). For Edward Chamberlayne, compare *Angliae Notitia; or, The Present State of England* (1669), 43 (which was repeated without alteration until 1687) with *Angliae Notitia; or, The Present State of England* (1692), 33–34.

12. R. C. Alcock and F. C. Holland, *British Postmarks: A Short History and Guide* (Cheltenham, 1960), 14. F. George Kay, *Royal Mail: The Story of the Posts in England* . . . (London, 1951), 29–30. See also www.earsathome.com.

13. Daniel Defoe, *A Tour thro' the Whole Island of Great Britain* (London, 1724), 2:136–37.

14. Dierks, *In My Power*, 35–36.

15. These canvases differ greatly in their state of preservation and restoration: the contrast of hues of white and brown between writing and print within each canvas is thus often more revealing than comparison across different paintings.

16. The first recorded usage of this phrase for distinguishing ephemeral publications from durable books itself apparently goes back to this moment at the beginning of the eighteenth century, in a comment on an "ingenious device" that accelerated printing: "I wish that the result were only to supply learned men with books," wrote the Italian physician Bernardino Ramazzini, "and not fishmongers with paper to wrap up their mackerel." B. Ramazzini, *Diseases of Printers (De Morbis Typographorum)*, trans. W. Cave Wright (Birmingham, Eng., 1989), unpaginated. Excerpted from *De Morbis Artificum Diatriba*, 2nd ed. (1713; 1st ed., 1700); the first English edition appeared in 1705. The image of fish wrapped in book pages can be found earlier—in Montaigne, say, and even in the Roman poet Catullus—but for a book not worth the paper on which it is written, not for an ephemeral publication.

CHAPTER THREE

1. *London News-Letter, with Foreign and Domestic Occurrences*, 19 April 1696, 1. S. Morison, *Ichabod Dawks and His "News-Letter"* (Cambridge, Eng., 1931). H. Love, *The Culture and Commerce of Texts* (Amherst, 1993), 11.

2. Tobias van Domselaer, 1665; quoted in A. Chong and W. Kloek, *Still Life Paintings from the Netherlands, 1550–1720* (Zwolle, [c. 1999]), 230, and cf. 69. The *Encyclopédie* at midcentury made this link between handwriting and illusionist painting explicit: "Handwriting is nothing more than a painting, which is to say an imitation of traits and characters. A great painter in this genre can imitate others so well, that he can dupe the most discerning critics." Cited in J. S. Ravel, *The Would-Be Commoner: A Tale of Deception, Murder, and Justice in Seventeenth-Century France* (Boston, 2008), 168–69.

3. *Spectator* 166 (10 September 1711).

4. The italics are in the painted documents.

5. Quoted in V. Salmon, "The Spelling and Punctuation of Shakespeare's Time," in *William Shakespeare: The Complete Works. Original Spelling Edition*, ed. S. Wells and G. Taylor (Oxford, 1986), xlv. And cf. D. G. Scragg, *A History of English Spelling* (Manchester, 1974), 80–81. C. Barber, *Early Modern English* (Edinburgh, 1997), 3. V. Salmon, "Orthography and Punctuation," in *The Cambridge History of the English Language*, vol. 3, *1476–1776*, ed. R. Lass (Cambridge, 1999), 38–39.

6. Scragg, *A History of English Spelling*. Salmon, "Orthography and Punctuation," 44–45. T. Nevalainen, *An Introduction to Early Modern English* (Oxford, 2006), 41 and chap. 3.

7. Joseph Moxon, *Mechanick Exercises; or, The Doctrine of Handy-Works. Applied to the Art of Printing* (London, 1683; fac. ed. London, 1962), 2:198, 228.

8. C. Houghton, "'This Was Tomorrow: Pieter Aertsen's 'Meat Stall' as Contemporary Art," *Art Bulletin* 86, no. 2 (June 2004): 277–300 (Van Mander quoted, 290). T. J. Clark, *The Sight of Death* (New Haven, 2006), 48.

9. Salmon, "The Spelling and Punctuation of Shakespeare's Time," p. xlvi. Salmon, "Orthography and Punctuation," 38–39. F. H. Brengelman, "Orthoepists, Printers, and the Rationalization of English Spelling," *Journal of English and Germanic Philology* 79 (1980): 347.

10. Daniel Defoe, *The History of the Devil, as Well Ancient as Modern* (London, 1727), 378. Cf. E. L. Eisenstein, *Divine Art, Infernal Machine: The Reception of Printing in the West from First Impressions to the Sense of an Ending* (Philadelphia, 2011), 2–3.

11. Jonathan Swift, *A Tale of a Tub* (London, 1704), dedication. A. Cline Kelly, "Swift's Battle of the Books: Fame in the Modern Age," in *Reading Swift*, ed. H. J. Real and H. Stöver-Leidig (Munich, 1998), 91–101. For Addison, see above, p. 51.

12. William Wotton, *Reflections upon Ancient and Modern Learning* (London, 1694), 172. William King in 1708, and Jean Theophilus Desaguliers in 1719 and 1734, as discussed in A. Johns, *The Nature of the Book: Print and Knowledge in the Making* (Chicago, 1998), 173, 181–82. For J. C. Zeltner's 1716 observation, see D. McKitterick, *Print, Manuscript and the Search for Order, 1450–1830* (Cambridge, Eng., 2003), 115–16. Both Johns and McKitterick offer more examples of the fault lines of print and their contemporary realization; and cf. also S. Mandelbrote, "The Authority of the Word: Manuscript, Print and the Text of the Bible in Seventeenth-Century England," in *The Uses of Script and Print, 1300–1700*, ed. J. Crick and A. Walsham (Cambridge, Eng., 2004), 135–53.

CHAPTER FOUR

1. D. Pring, "The Negotiation of Meaning in the Musical Vanitas and Still-Life Paintings of Edwaert Collier, c. 1640–c. 1709" (PhD thesis, University of London, 2010). I thank Debra Pring for many stimulating exchanges.

2. W. A. Liedtke, *Dutch Paintings in the Metropolitan Museum of Art* (New York, 2007), 1:130–32.

3. L. Jardine, *Going Dutch: How England Plundered Holland's Glory* (New York, 2008), 10.

4. See W. Slauter, "Le paragraphe mobile: circulation et transformations des informations dans le monde atlantique du 18e siècle," *Annales: histoire, sciences sociales*, forthcoming. I am grateful to Will Slauter for sharing his work and for valuable comments on my own.

5. In addition to the 1691 London sale of a Collier painting (p. 119 and p. 242n4), "A piece of still life with the K.S. [King's Speech?] by Collier" appears in *A Curious Collection of Pictures, to Be Sold at the Late Dwelling House of Mr. Herman Verelst, . . . on Thursday the 31st of This Instant December 1702 . . .* (London, 1702), lot 279 (of 281). Final lots in auctions tended to be the more expensive and attractive ones. I am grateful to Richard Stephens for this information.

6. C. Boschma-Aarnoudse, *Een curieus werck: Oorlog en vrede verbeeld in een zeventiende-eeuwse maquette* (Amsterdam, 2003).

7. *Notes and Queries*, 2nd ser., 12:170 (31 August 1861); 217 (14 September 1861); 257 (28 September 1861); 317 (19 October 1861). Cf. a similar letter that remained unanswered, describing a painting by "E. Collier," about whom the writer could find no information, in *Gentleman's Magazine*, June 1801, 494: the now-lost painting included an embedded self-portrait of Collier in his studio.

8. *Notes and Queries*, 5th ser., 6:428 (25 November 1876).

9. A. Frankenstein, introduction, *Reality and Deception* [Los Angeles, 1974], unpaginated; idem, *After the Hunt: William Harnett and Other American Still Life Painters, 1870–1900*, rev. ed. (Berkeley, 1969). And see Frankenstein's obituary by P. J. Karlstrom in *Archives of American Art Journal* 21, no. 2 (1981): 23.

CHAPTER FIVE

1. Alexander Pope, "Verses Occasioned by Mr. Addison's Treatise of Medals," in *The Works of the Right Honourable Joseph Addison* (London, 1721), 1:432.
2. L. Marin, "The Portrait of the King's Glorious Body," in his *Food for Thought* (Baltimore, 1989), 189–217. J. Caplan, *In the King's Wake: Post-Absolutist Culture in France* (Chicago, 1999), 1–2. A. Feros, " 'Sacred and Terrifying Gazes': Languages and Images of Power in Early Modern Spain," in *The Cambridge Companion to Velázquez*, ed. S. L. Stratton-Pruitt (Cambridge, Eng., 2002), 68–86; and quoting Diego de Saavedra y Fajardo, 68. For the problem of monarchy in the age of mass print, both textual and visual, see the forthcoming Indiana University PhD dissertation by Stephanie Koscak, "Multiplying Pictures for the Public: Reproducing the English Monarchy, c. 1660–1780."
3. Caplan, *In the King's Wake*, chap. 3.
4. Examples include *By the Queen, a Proclamation, for a General Fast* (London, 1702) and *By the Queen, a Proclamation, for Dissolving This Present Parliament, and Declaring the Speedy Calling Another* (London, 1702).
5. In 1704 the queen's printers experimented with three different designs for restoring her cyphers on various publications. One was awkward and off-center: e.g., *Anne, by the Grace of God . . . Queen, Defender of the Faith, &c. To All to Whom These Presents Shall Come . . .* (London, 1704). One, used for her speeches, restored the cyphers without the crowns. The third incorporated both cyphers and the crowns above them, much like those painted by Collier: the earliest example is *By the Queen, a Proclamation, for the Careful Custody and Well Ordering of the New River . . .* (London, 1703 [22 February 1703/4]).
6. The print based on Charles I's equestrian painting, with the same attribution to Van Dyck, was made by Edward Lutterell and published by Edward Cooper. (I am grateful to Stephanie Koscak for bringing it to my attention.) Interestingly, Lutterell—and thus Collier—introduced a change, replacing the chain on which Charles I's medallion of the Garter had dangled in Van Dyck's painting with the blue ribbon of the Garter. (Both were plausible historical possibilities.) When the royal image passed from medium to medium, its authentic integrity was not fully guaranteed.
7. C. Karpinski, "The Print in Thrall to Its Original: A Historiographical Perspective," in *Retaining the Original: Multiple Originals, Copies and Reproductions*, Studies in the History of Art 20 (Washington, D.C., 1989), 101–9; and 147 for Baldinucci's pioneering realization of this process in 1681.
8. G. Fyfe, "Art and Its Objects: William Ivins and the Reproduction of Art," in *Picturing Power: Visual Depiction and Social Relations*, ed. G. Fyfe and J. Law (London, 1988), 65–98. Also see J. Bayard and E. D'Oench, *Darkness into Light: The Early Mezzotint*, (New Haven, 1976); C. Wax, *The Mezzotint: History and*

Technique (New York, 1990); and National Portrait Gallery, "Early History of Mezzotint," www.npg.org.uk/research/programmes/early-history-of-mezzotint. php. The first known experimenter with this technique was a German soldier in 1642, from whom it came to Prince Rupert of Bohemia. In 1657 the prince hired the portrait artist Wallerant Vaillant, who thus became the first professional artist to use mezzotinting in prints resembling paintings. As it happens, in 1658 Vaillant also painted the first recorded trompe l'oeil of a letter rack.

9. See the interesting discussion in the introduction to J. Monteyne, *From Still Life to the Screen: Print Culture, Display, and the Materiality of the Image in 18th-Century London*, forthcoming. I am grateful to Joseph Monteyne for the opportunity to read his work.

10. Two prints of Erasmus after Holbein, one by Andries Jacobsz. Stock and one by Pieter van den Berge, display the same posture and carry the same text, and may have been Collier's model. Interestingly, neither is a mezzotint, and no corresponding mezzotint has been identified: either the source has been lost, or Collier "mezzotinted" Erasmus's engraving himself in his oil paintings. Cf. *Täuschend echt. Illusion und Wirklichkeit in der Kunst* (Munich, 2010), cat. no. 21.

CHAPTER SIX

1. C. Brusati, *Artifice and Illusion: The Art and Writing of Samuel van Hoogstraten* (Chicago, 1995), 51, 54–55.

2. *Sebastian Stoskopff, 1597–1657: Ein Meister des Stillebens* (Strasbourg, 1997), 101–5. S. Ebert-Schifferer, ed., *Deceptions and Illusions: Five Centuries of Trompe l'Oeil Painting* (Washington, D.C., 2002), 26, 186–87.

3. Cited in O. Koester, ed., *Illusions: Gijsbrechts, Royal Master of Deception* (Copenhagen, 1999), 65. For an earlier illusionist tradition in the Netherlands bordering sometimes on trompe l'oeil, see J. H. Marrow, *Pictorial Invention in Netherlandish Manuscript Illumination of the Late Middle Ages* (Paris, 2005), esp. ill. 2, 45–46.

4. H. Grootenboer, *The Rhetoric of Perspective: Realism and Illusionism in Seventeenth-Century Dutch Still-Life Painting* (Chicago, 2005). P. Steadman, *Vermeer's Camera* (Oxford, 2001), together with his "Gerrit Dou and the Concave Mirror," in *Inside the Camera Obscura: Optics and Art under the Spell of the Projected Image*, ed. W. Lefèvre (Berlin, 2007), 227–42. R. D. Huerta, *Giants of Delft: Johannes Vermeer and the Natural Philosophers* (Lewisburg, 2003). D. Hockney, *Secret Knowledge: Rediscovering the Lost Techniques of Old Masters*, new ed. (New York, 2006). Brusati, *Artifice and Illusion*, 90, and for Pepys, 201. L. Jardine, *Ingenious Pursuits: Building the Scientific Revolution* (New York, 1999), chap. 3.

5. Antoni van Leeuwenhoek, "Concerning the Animalcula in *Semine Humano*," *Philosophical Transactions* 21 (1699): 306; quoted in C. Wilson, *The Invisible World: Early Modern Philosophy and the Invention of the Microscope* (Princeton, 1995), 224. For the persistent scientific doubts about the powers of the eye and of the new optical instruments see Wilson, ibid., chap. 7, as well as O. Gal and R. Chen-Morris, "Empiricism Without the Senses: How the Instrument Replaced the Eye," in *The Body as Object and Instrument of Knowledge:*

Embodied Empiricism in Early Modern Science, ed. C. Wolfe and O. Gal (Dordrecht, 2010), 121–47.

6. Cf. the illuminating discussion of William Harnett's nineteenth-century trompe l'oeil paintings in M. Leja, *Looking Askance: Skepticism and American Art from Eakins to Duchamp* (Berkeley, 2004), 137–39.

7. *Journal des voyages de Monsieur de Monconys* (Lyons, 1665–66), 2:373–76 (the artist is named as "Corneille"). Wilson, *The Invisible World.*

8. W. Sumowski, *Die Gemälde der Rembrandt-Schüler*, suppl. vol. 6 (1994), nos. 2304 and 2305. C. Brusati, "Honorable Deceptions and Dubious Distinctions: Self-Imagery in Trompe-l'Oeil," in Koester, *Illusions*, 72 n. 26.

9. Signed "E. Colyer" and dated 1684. Sold most recently at Sotheby's Ashdown House sale, London, 27 October 2010, lot 89.

10. D. Pring, "The Negotiation of Meaning in the Musical Vanitas and Still-Life Paintings of Edwaert Collier, c. 1640–c. 1709" (PhD thesis, University of London, 2010), chap. 8. This discrepancy had been noted before: cf. F. Meijer in *The Hoogsteder Exhibition of Music and Painting in the Golden Age* (The Hague, [1994]), 180 n. 3, and M. Wurfbain in *The Dictionary of Art* (Grove), ed. J. Turner (New York, 1996), 7:568. There is a second self-portrait in a private collection that follows the 1684 one quite closely: the existence of such a copy can help explain how Collier was able to preserve and hold on to the same "original" over many years.

11. N. Popper-Voskuyl, "Selfportraiture and Vanitas Still-Life Painting in 17th-Century Holland in Reference to David Bailly's Vanitas Oeuvre," *Pantheon* 31 (1973): 58–74; and for Bailly's possible influence on Collier, 67. E. Jan Sluijter, "The Painter's Pride: The Art of Capturing Transience in Self-Portraits from Isaac van Swanenburgh to David Bailly," in *Modelling the Individual: Biography and Portrait in the Renaissance*, ed. K. Enenkel et al. (Amsterdam, 1998), 173–96 (cf. 193 for the influence on Collier). For doubts, see M. Wurfbain, "David Bailly's *Vanitas* of 1651," in *The Age of Rembrandt*, ed. R. E. Fleischer and S. C. Munshower (University Park, PA, 1988), esp. 53.

12. Cf. Brusati, *Artifice and Illusion*, esp. chap. 4.

CHAPTER SEVEN

1. *Vertue Note Books, Volume II*, vol. 20 of the Walpole Society (Oxford, 1932), 74. Horace Walpole, *Anecdotes of Painting in England . . . Collected by the Late Mr. George Vertue*, 2nd ed., 4 vols. ([Twickenham], 1765–80), 3:13. Celeste Brusati listed this painting as unknown in her Van Hoogstraten checklist (*Artifice and Illusion: The Art and Writing of Samuel van Hoogstraten* [Chicago, 1995], 380, D-54) but discusses it in her "Print Matters: Facticity and Duplicity in Trompe l'Oeil," in *Cultures of Communication, Theologies of Media*, ed. U. Strasser et al. (Toronto, forthcoming).

2. The 1684 vanitas with the English book title is in the Hyde Collection, Glens Falls, New York. The self-portrait of 1683 and the painting with the print of the Duchess of York are discussed below in chapter 11.

3. See J. A. Ganz, "Still-Life Mezzotints by Robert Robinson," *Burlington Magazine* 140, no. 1139 (February 1998): 93–98, and his "A City Artist: Robert

Robinson," in *City Merchants and the Arts, 1670–1720*, ed. M. Galinou (London, 2004), 103–18. The candlestick, which both artists repeated in other works as well (including Collier's undated vanitas with book, skull, and bubbles, sold by Sotheby's, London, on 20 November 1985, lot 93), is a hybrid of two plates in the Van Vianen family's *Constighe modellen van verscheijden silvere vasen* c. 1650 (nos. 23 and 25) and may have never existed as a material object. Robinson's candlestick mezzotint must have been published before the death of its publisher, Isaac Beckett, in 1688.

4. John Bullord, "An Appendix . . . Containing 150 Pieces, by the Best, Ancient and Modern Masters . . . Will Be Sold by Auction, May the 12th . . . ," in his *A Curious Collection of Paintings, Most Whereof Are Originals . . . Sold by Auction on Wednesday the 6th of this Instant May . . .* [London, 1691]. I am grateful to Richard Stephens for bringing this sale to my attention, and for many helpful exchanges.

5. The other 1692 letter rack is at the Detroit Institute of Arts and described in G. S. Keyes et al., *Masters of Dutch Painting: The Detroit Institute of Arts* (Detroit, 2004), 58–59. The writing on this postmark is hidden. A third letter rack painting (sold by Sotheby's, New York, 7 November 1984, lot 16, photograph at RKD) almost certainly belongs to this group as well: though dated 169? with the last digit deliberately hidden, it resembles the 1692 compositions rather than the later ones with materials in both Dutch and English, and is also signed "Edwart Coljer" next to an "EC/2" postmark.

6. D. Pring, "The Negotiation of Meaning in the Musical Vanitas and Still-Life Paintings of Edwaert Collier, c. 1640–c. 1709" (PhD thesis, University of London, 2010), 175: the record was discovered by Dr. Paul Taylor.

7. RAL, Notaris no. 85 Bruno van Noll, NA 1095, 1670, akte 165. Many of these notarial records are transcribed—albeit in paraphrase and without full references—in the copious notes of Abraham Bredius, director of the Royal Picture Gallery Mauritshuis in The Hague at the turn of the twentieth century, copies of which are kept at the RKD.

8. RAL, Kerkelijke Ondertrouw Leiden W, fol. 79v, 1 May 1674.

9. RAL, Notaris no. 85 Bruno van Noll 1097 no. 78, 17 November 1673; and Rechterlijk Archief 44 J, fol. 44, Dingboek van grote zaken, 21 February to 17 March 1674. Evert's baptism is recorded in Gereformeerde Dopen Pieterskerk, 20 December 1673. (This record also puts to rest the oft-repeated claim that "Evert Collier" is a belated scholarly copying mistake: Evert was, indeed, one of the names used by Collier.) Gerritje got much less from Collier than she demanded, and the case was declared closed. Two years later we hear of the censured, unwed mother departing Leiden for Nijmegen: Acta Nederlands Hervormd Kerkenraad Leiden 6, 3 May 1675.

10. RAL, Notaris no. 89 Johan van Noort, NA 1124 no. 77, 1 November 1672. Notaris no. 85 Bruno van Noll, NA 1097 no. 144, 9 March 1673.

11. RAL, Notaris no. 119 Quirijn Raven, NA 1429, nos. 151 and 154, 28 December 1681; NA 1430, no. 179, 24 March 1682; no. 188, 10 April 1682. Kerkelijke Ondertrouw Leiden X, fol. 300v, 27 November 1682.

12. G. A. Lindeboom, "David en Nicolaas Stam, apothekers te Leiden," *Pharmaceutisch Weekblad* 108 (1973): 153–60, and *Boerhaave and Great Britain: Three Lectures on Boerhaave . . .* (Leiden, 1974), 42–43. J. C. Powers, "Chemistry

without Principles: Herman Boerhaave on Instruments and Elements," in *New Narratives in Eighteenth-Century Chemistry*, ed. L. M. Principe (Dordrecht, 2007), 48–49. For Jacob de Bois, see P. H. Smith, *The Body of the Artisan: Art and Experience in the Scientific Revolution* (Chicago, 2004), 183–84: this is not, however, the same person as Eva and Anna's brother Jacobus du Bois, who was a minister.

13. Th. H. Lunsingh Scheurleer, C. Willemijn Fock, and A. J. van Dissel, *Het Rapenburg: Geschiedenis van een Leidse gracht*, 5 vols. (Leiden, 1986–92), vol. 3, pt. 1, 112, 128–29, and 196 n. 53.

14. RAL, Rechterlijk Archief, Poorterboek Leiden H, fol. 44, 27 March 1671. Edward Collier appears in Gereformeerde Dopen Pieterskerk, 17 June 1667, as witness to the baptism of the daughter of his brother Johannes. He did not join the St. Luke's painters guild until late 1673 and is recorded as a dues-paying member until 1680: Archieven van de Gilden, de Beurzen en de Rederijkerskamers 849, *Deecken ende Hooft-Mans Boeck St Luycas, 1648–1742*, fol. 192; and cf. his listing in 1685 in *Register van d'Fyn Schilders, 1648–1742*, fol. 8.

15. NH Trouwboek Pieterskerk, 27 November 1682.

16. RAL, Acta van de NH Kerkenraad Leiden 7, entries for 22 September, 27 November, 11, 18, and 22 December 1682; and regarding Anna's behavior earlier, 19 December 1681 and 2 January 1682. The elders reprimanded Sappius, whose behavior appeared to them as schismatic, and refused his exams, but later he surfaces as a preacher in Dordrecht.

17. RAL, Notaris no. 119 Quirijn Raven, NA 1430, no. 188, 10 April 1682; and cf. no. 198, 23 April 1682.

18. RAL, Acta van de NH Kerkenraad Leiden 7, 22 September 1682; 17, 21, 28 December 1683. Rechterlijk Archief 47, Vredemakersboek SS, 3 December 1683.

19. RAL, Acta van de NH Kerkenraad Leiden 7, 24, 28 March 1684.

20. RAL, Acta van de NH Kerkenraad Leiden 7, 5 April 1686. NH Kerkenraad Leiden, Uitgaande attestaties Hooglandse kerk D, 14 April 1686. GAA, Begraven Amsterdam, 1651–1700, Leidsche Kerkhof, 31 July 1686. Pring, "The Negotiation of Meaning," chap. 8.

21. Gereformeerde Dopen Pieterskerk, fol. 37, 15 June 1691. Nederlands Hervormd Kerkenraad Leiden, Uitgaande attestaties Hooglandse kerk E, 26 April 1693. W. J. Hardy, ed., *Calendar of State Papers, Domestic Series, of the Reign of William III. July 1–Dec. 31, 1695* (London, 1908), 31. The 1693 record of the couple's departure, like the English travel pass a couple of years later, shows the name "Johanna du Bois" as the woman leaving Leiden for London with Collier; but the name "Johanna" is crossed out to make it "Anna." For Joris Coljer's will, which also mentioned a third child of Edward's by the name of Sara, see RAL, Notaris no. 121 Johannes van Swanenburg, NA 1476 no. 58, 8 July 1727.

CHAPTER EIGHT

1. F. G. Meijer, *The Collection of Dutch and Flemish Still-Life Paintings Bequeathed by Daisy Linda Ward* (Zwolle, [c. 2003]), 31.

2. Guildhall Library, Ms. 5667/2, *Painter-Stainers' Company, Court Minutes, 1649–1793, Part 1: 1649–1737*, 99, 164, 329, 350–51; and Ms. 5668,

Painter-Stainers' Company, Freedom Admissions Register, 1658–1820, fol. 48v. W. A. D. Englefield, *The History of the Painter-Stainers Company of London* (London, 1923), 139, 225. Howell's court case for the charge of painting false arms is in *Reports of Heraldic Cases in the Court of Chivalry, 1623–1732*, ed. G. D. Squibb, Harleian Society Publication 107 (London, 1956), 51–52 (and cf. Howell's petition in G. D. Squibb, *The High Court of Chivalry* [Oxford, 1959], 88–89, 142, 269–70). For a 1670 commission for Howell to paint banners and shields for the funeral of the Duke of Albemarle see British Library, Harleian Ms. 1099, fol. 105r, and J. H. Parker Oxspring, "The Painter-Stainers and Their Dispute with the Heralds" (1966), typescript in Guildhall Library, 3 vols., 209.

3. National Register of Archives for Scotland 393, Bundle 148/2. J. M. McEwan, *A Dictionary of Scottish Art and Architecture* (Ballater, Scot., 2004), 579 (also the quote). J. Halsby and P. Harris, *The Dictionary of Scottish Painters, 1600–1960* (Edinburgh, 1990), 224. Cf. R. H. Saunders, *John Smibert: Colonial America's First Portrait Painter* (New Haven, 1995), 10. D. Macmillan, *Scottish Art, 1460–2000* (Edinburgh, 2000), 78–79. In spring 2012 the Warrender painting was examined with infrared light and no signs of alterations to lettering were found, which is significant for what follows. (My thanks to Helen Smailes at the National Gallery of Scotland.)

4. In most cases one cannot rely on shades of color, given that these are three-hundred-year-old paintings that typically deteriorated and underwent restoration, often more than once. This painting, however, I have been able to examine under magnification and ultraviolet light, and its excellent virtually unrestored condition makes such judgments possible.

5. J. Bernström, "Charles Field," in *Iconographica* (Stockholm, 1957), 49–52. This painting resurfaced again in a Sotheby's auction, 1 December 2000. I am grateful to Marta Johnson for her help in translation.

6. *James Norie Painter* (Edinburgh, 1890), 11; repr. in J. Holloway, *The Norie Family* (Edinburgh, 1994), 9.

7. Another painting (sold by Sotheby's, 31 October 1990, photograph at RKD) may also belong to this group: an unsigned, poorly executed Collier-like letter rack that includes Collier's typical King William's speech, a "memorie" notepad, etc., next to the 1705 Scottish pamphlet *The Danger of Popery Discovered* that appears in the Warrender painting. It also bears a miniature portrait of an unknown man that perhaps served as its "signature."

CHAPTER NINE

1. British Library, Add. Ms. 21017. In Shrewsbury Richard Chandles was admitted freeman as a painter on 24 June 1698: W. A. Leighton, "The Guilds of Shrewsbury," in *Transactions of the Shropshire Archeological and Natural History Society* (Shrewsbury), vol. 7 (1883–84), 407. Guildhall Library, Ms. 5668, *Painter-Stainers Company, Freedom Admissions Register, 1658–1820*, entries for 29 September 1676, 7 May 1684; and *The Booke of Orders and Constitutions . . . of the Company of the Painters-Steyners*, ff. 308, 363. W. A. D. Englefield, *The History of the Painter-Stainers Company of London* (London, 1923), 156. Deed no. 3905/4 in the Shropshire archives lists Richard Chandles as "Herald Painter." In 1718 "Richard Chandles of Shrewsbury, Painter Stainer" contracted with a herald painter in London to

apprentice "Richard son of the said Richard Chandles the Art of Armes Painting and Landskipp Painting": "Unpublished Mss. Relating to the Home Counties in the Collection of P. C. Rushen," *Home Counties Magazine* 9 (1907): 311. For the son's trade card as "Armes-painter and Undertaker," see J. Litten, *The English Way of Death: The Common Funeral Since 1450, rev. ed.* (London, 2002), 12.

2. C. Webb, comp., *London Livery Company Apprenticeship Registers*, vol. 38, *Painter-Stainers' Company, 1655, 1666–1800* (London, 2003), 66. V. Smith, ed., *The Town Book of Lewes, 1702–1837*, Sussex Record Society Publication 69 (Lewes, 1973), 17–20, 23–24.

3. *Extracts from the Records of the Burgh of Edinburgh*, vol. 12 (Edinburgh, 1962), 272 (25 November 1700); vol. 16 (Edinburgh, 1967), 108 (25 July 1705). Francis Bamford, "Some Edinburgh Furniture Makers," in *The Book of the Old Edinburgh Club*, vol. 32 (Edinburgh, 1966), 41–42. K. M. Brown et al., eds., *The Records of the Parliaments of Scotland to 1707* (St. Andrews, 2007–9), 1706/10/457, online at http://www.rps.ac.uk/ (date accessed: 3 July 2009). P. J. M. McEwan, *Dictionary of Scottish Art and Architecture* (Woodbridge, Eng., 1994). Cf. Artists Catalogue in the National Monuments Record of Scotland. For the meaning of *limner*, see K. Coombs, "From Limning to Miniature: The Etymology of the Portrait Miniature," forthcoming. I am grateful to Katie Coombs for sharing this paper with me and for many generous exchanges, and to Tasha Aburrow-Jones, Eleanor Rideout of RCAHMS Public Services, and Christopher Ferguson for their help in obtaining these records.

4. Scottish Record Office (now National Archives of Scotland), RD2/103/1 (Register of Deeds Second Series, Dalrymple's office), *Bond Smyth to Warrander* (registered copy 2 September 1713), and SRO, RD 12/53; copied in letter from William R. M. Kay to James Holloway, Esq., Scottish National Portrait Gallery, 11 July 1996, in National Gallery of Scotland, file for Thomas Warrender. In 1709 Norie was admitted as freeman of the Incorporated Trades of Edinburgh, and after 1710 his firm moved in to fill the gap created by Warrender's retirement. J. Holloway, *The Norie Family* (Edinburgh, 1994), and his *Patrons and Painters: Art in Scotland, 1650–1760* (Edinburgh, 1989), 61–62, 145. For Norie's imitation marbling, an illusionist skill in which he followed Warrender, see National Archives of Scotland, GD122/4/31, household and personal accounts due by Sir Charles Gilmour, record for June 1747.

5. W. Nisser, *Michael Dahl and the Contemporary Swedish School of Painting in England*, (Uppsala, 1927), esp. 147–49 and cat. p. 132. A photograph of the Peterson painting is in the Victoria and Albert Museum file for Collier: its low quality precludes a more detailed analysis. It is worth noting that Collier himself tried his hand in an oil on copper miniature portrait of an unknown man (signed and dated "16 . . ."); an experiment suggesting possible familiarity with miniature artists. Cf. K. Schaffers-Bodenhausen and M. Tiethoff-Spliethoff, *The Portrait Miniatures in the Collections of the House of Orange-Nassau* (Zwolle, 1993), 361, cat. no. 468.

6. Cole is quoted in *Ecclesiologist* 18 (1857): 277. *Country Life* 104 (8 October 1948): 725, letter by Mr. Michaelis, the owner of the Collieresque Ritz painting. C. W. Stubbs, *The Story of Cambridge* (London, 1905), 322.

7. Westminster City Archives, St. Martin in the Fields: Poor Rate (Ledger), Strand and Drury Lane, 12 June 1701 and 9 January 1702 (F1253), p. 4;

Churchwardens' and Overseers' Accounts, with Copies of the Poor Rate, 1702–3 (F431), pp. 86–87; Poor Rate (Ledger), Spur Alley and Exchange, 14 June 1704 (F1269); Churchwardens' and Overseers' Accounts, with Copies of the Poor Rate, 1707–8 (F437), pp. 113–14. The occupation "limner" is noted in the Poor Rate (Ledger), Strand and Drury Lane, dated 13 April and 13 September 1709 (F1293), p. 3). Turing may also be the same "Tureing" mentioned in *Vertue Note Books, Volume IV,* vol. 24 of the Walpole Society (Oxford, 1936), 86.

8. Westminster City Archives, St. Paul Covent Garden (West Division, Bedford Street, west side), Overseers' Accounts, with Copies of the Poor Rates and Receipts, 1703–4 (H483), p. 4; 1705 (H484), p. 4; and similarly through 1708, 1714–15, 1721–22, 1724–25. *The Registers of St. Paul's Church, Covent Garden, London,* ed. W. H. Hunt, Harleian Society Register Section Publications 33–37 (1906–9), 1:115, 25 February 1700/01. See also Patrick Abercromby, *The Martial Atchievements of the Scottish Nation* (Edinburgh, 1711), list of subscribers; *Daily Courant* 7613, 11 March 1726; and R. Edwards and M. Jourdain, *Georgian Cabinet Makers c. 1700–1800,* new ed. (London, 1955), 94. There had been another John Turing in Covent Garden in the 1640s, with connections to the brothers William and Sir John Turing of Foveran: they may well all have belonged to one Scottish family with a London branch and a persistent naming pattern. Cf. [H. M'Kenzie,] *The Lay of the Turings* (London, 1850?), 30–35, and West Sussex Record Office, "Agreement," ADD MSS/39,646–39,647.

9. "William Turing of St. Martin in the Fields, Middlesex. Probate inventory, or declaration, of the estate of the same, deceased," exhibits, National Archives PROB 31/81/466 and PROB 31/81/467, quoted; inventory, PROB 3/29/127.

10. Lincolnshire County Council, Archive Accessions, April 2006–March 2007, document reference MISC DON 1386/1; and East Suffolk County Record Office, FB/191/A8/1. J. Blatchly, *John Kirby's Suffolk: His Maps and Roadbooks* (Woodbridge, Eng., 2004), 245. For the variety of other art-related work in which surveyors often engaged, including engraving and even portrait copying, see M. Sponberg Pedley, *The Commerce of Cartography: Making and Marketing Maps in Eighteenth-Century France and England* (Chicago, 2005), 21. I am grateful to Alan Borg, historian of the Painter-Stainers, for pointing out to me their connection with surveyors.

11. *Country Life* 104 (8 October 1948): 725–26. William Salmon, *Botanologia* (London, 1710), title page engraved from a drawing by Eloas Knight. W. Connely, *Young George Farquhar* (London, 1949), 308–9. M. Kirby Talley, "'Small, Usuall, and Vulgar Things': Still-Life Paintings in England, 1635-1760," *Walpole Society* 49 (1983): 171.

12. Cf. the remarkable local history resources in www.fromeresearch.org.uk; e.g., the will of William Palmer, painter, of Frome Selwood, Somerset, 28 July 1798, PROB 11/1310, and the entry for Charles Palmer, "house painter" in Pilly Hill, Frome, in *Pigot's Commercial Directory* in 1822 and 1830. For Field see K. Rogers, *The Book of Trowbridge: A History* (Buckingham, 1984), 68; with his *Esau Reynolds of Trowbridge, Architect* (Devizes, 1967), 15–16. I am grateful to Ken Rogers and to the members of frome@yahoogroups.com for their generous help.

13. The Collier-looking painting signed by S. Goodwin was auctioned at the Hôtel Drouot, Paris, 19 June 1989, lot 56: record filed at the Louvre Museum.

The Goodwin trompe l'oeil with a dead bird and a *London Gazette* from 1 April 1749 was exhibited at the Hull Fine Art Gallery. It carries the inscription: "This remarkable bird was shot November 7th by one of the Earl of Gainsborough's servants and painted from the bird itself by S. Goodwin." (Record in Sam Segal's archive.) A second painting imitating or reusing Collier's composition recently surfaced in private hands, again carrying the names of both "E. Collier" and "Sam¹ Goodwin," and including a *London Gazette* and a legal book dating to the 1720s.

14. There is in fact a weakly painted name and 1653 date in this painting, opposite the book title page, that is certainly a later, unskillfully executed addition. Compare also a Collier vanitas sold by Sotheby's, London, on 24 July 1974 (photograph in Sotheby's archive), in which the standing book, the booklet overflowing the table, and the paper sticking out of another book are all blank.

15. Differences in quality of execution between the Field painting and its Collier near twin (fig. 8.12, top, p. 150) can be seen in the perspective on the inkwell (better in the Collier), the writing on the rolled up newspaper (rounded in the Collier, flat in the Field), the flow of the lines on the globes (more hesitant in the Field), and the dog ears of the book which in the Field painting leave one straight corner that should not be there. This discussion owes much to an early intervention by Ludmilla Jordanova and especially to the expertise of Ghiora Elon, the head of the Painting Conservation Laboratory in the Israel Museum.

16. There is no corresponding published royal speech in 1709.

17. The *Edinburgh Courant* in Norie's letter rack began appearing in 1705, which fits well the dates of the other two Scottish letter racks, but the *Caledonian Mercury* and Ramsay's *Gentle Shepherd* dated to the 1720s. The poet Allan Ramsay was a neighbor and close friend of James Norie's: cf. D. Wilson, *Memorials of Edinburgh in the Olden Time*, 2nd ed. (Edinburgh, 1891), 2:126–27.

CHAPTER TEN

1. Sotheby's, London, sale on 20 November 1985, lot 93. It is curious why Collier chose to paint twice the second volume of this work. Perhaps it is the only one to which he had access. Or perhaps he was aware that Constantine the Great was in fact acclaimed as emperor in York, England, and thus that this was the volume that claimed a more significant role for Britain in the story of the Roman Empire.

2. William Burton, MD, *An Account of the Life and Writings of Herman Boerhaave . . .* (London, 1743), 16.

3. L. G. A. Lindeboom, "David en Nicolaas Stam, apothekers te Leiden," *Pharmaceutisch Weekblad* 108 (1973): 153–60; Sylvius quoted on 157.

4. J. M. Montias, "Estimates of the Number of Dutch Master-Painters, Their Earnings and Their Output in 1650," *Leidschrift* 6, no. 3 (1990): 64. P. H. Smith, *The Body of the Artisan: Art and Experience in the Scientific Revolution* (Chicago, 2004), 26, 193, 196–97. H. Miedema, "Kunstschilders, gilde en academie: Over het probleem van de emancipatie van de kunstschilders in de Noordelijke Nederlanden van de 16de en 17de eeuw," *Oud Holland* 101 (1987): 1–29.

W. A. D. Englefield, *The History of the Painter-Stainers Company of London* (London, 1923),115; contrast this with the more cordial relationship between the two groups as recorded in 1640 (107–8), and again in 1677 (142); and on the other side, the distance between them as seen through the petition of the herald painters in 1685 (156–58).

5. Joseph Moxon, *Mechanick Exercises; or, The Doctrine of Handy-Works. Applied to the Art of Printing* (London, 1683), fac. ed., 2:228. L. Maruca, *The Work of Print: Authorship and the English Text Trades, 1660–1760* (Seattle, 2007).

6. James Watson, preface to *The History of the Art of Printing, Containing an Account of Its Invention and Progress in Europe* (Edinburgh, 1713), 4.

7. D. Macmillan, *Painting in Scotland: The Golden Age* (Oxford, 1986), 17. R. H. Saunders, *John Smibert: Colonial America's First Portrait Painter* (New Haven, 1995), 10. D. Macmillan, *Scottish Art, 1460–2000* (Edinburgh, 2000), 84–85. Norie and Chalmers were sometimes business collaborators: see their ad in *Edinburgh Courant*, 17 October 1711.

8. [Sir George Chalmers,] *Weekly Magazine*, 16 January 1772, cited in D. Irwin and F. Irwin, *Scottish Painters at Home and Abroad, 1700–1900* (London, 1975), 127. N. Prior, *Museums and Modernity: Art Galleries and the Making of Modern Culture* (Oxford, 2002), 135 n. 6. Norie's first known effort at painting on canvas is dated 1731, when he was forty-seven.

9. Quoted and discussed in G. M. C. Jansen, " 'On the Lowest Level': The Status of the Still Life in Netherlandish Art Literature of the Seventeenth Century," in A. Chong and W. Kloek, *Still Life Paintings from the Netherlands, 1550–1720* (Zwolle, [c. 1999]), 53–54. J. M. Montias, "Cost and Value in 17th-Century Dutch Art," *Art History* 10 (1987): 463. In 1713 the Earl of Shaftesbury confirmed that the "Term of Art we commonly call *Still-Life*" was "in reality of the last and lowest degree of Painting" (*A Notion of the Historical Draught or Tablature of the Judgment of Hercules*, [London, 1713], 34).

10. William Aglionby, *Painting Illustrated in Three Diallogues* (London, 1685), unpaginated preface, sig. C2, and p. 98. E. J. Sluijter, "The English Venture: Dutch and Flemish Artists in Britain 1550–1800," *Leids kunsthistorisch jaarboek* 13 (2003): 11–28. B. Cowan, "Art and Connoisseurship in the Auction Market of Later Seventeenth-Century London," in *Mapping Markets for Paintings in Europe, 1450–1800*, ed. N. De Marchi and H. van Miegroet (Turnhout, 2006), table 3.

11. Papers of the Kerr Family, Marquises of Lothian (Lothian Muniments), National Archives of Scotland, Lothian to Lady Lothian, GD40/2/8/78, 18 February 1694; GD40/2/8/102, 28 December 1695; GD40/2/8/112, 20 March 1698; and Lothian to Sir Patrick Murray, GD40/2/8/91, 12 April 1694. The letters were transcribed by Richard Stephens.

12. R. M. G. Wenley, *The Lothian Picture Collection: History and Content*, 2 vols. (Ph.D thesis, University of St. Andrew's, 1990), 1:45-50 (45 quoted), and Collier works in vol. 2, the collection catalogue, nos. 500 (*Still Life with Bread and Wine Glass*), 501 (*Still Life with Tea Service*), 515 (*Still Life with Violin and Books*), 533 (*Still Life: A Nautilus Cup, Book, etc*). Additionally, a large Collier vanitas from 1695 presently at Lord Lothian's Monteviot House, with book, violin, globe, crown, music score, and a print of Erasmus, does not correspond in content or inventory number to these four recorded paintings. For Van Roestraten's

Still Life: Shells see cat. no. 512. I am grateful to John Greenwell at Monteviot House and to Robert Wenley for their help.

13. RAL, NA, Notaris no. 107 Dirck Toornvliet, nos. 37–38, 2 May 1676. E. Croft-Murray, *Decorative Painting in England, 1537–1837*, vol. 1 (London, 1967), 233. One more piece of evidence attests to Collier's relatively modest financial standing. When Collier's wife died in Leiden in 1704, he paid three guilders as funeral tax. This placed him at the bottom rung of the propertied Leideners—there were four funeral tax classes, with the highest paying thirty guilders—but above the poor who were buried Pro Deo. (RAL, Impost begraven, 7 February 1704.)

14. On the rising number of foreigners in the company, see R. Johns, "Framing Robert Aggas: The Painter-Stainers' Company and the 'English School of Painters,'" *Art History* 31 (2008): 322–41.

15. A single oil still life painting of Robinson's is known (Christie's, South Kensington, sale 7008, 19 October 1995, lot 403). It is signed on a piece of paper dangling from a ledge with the oddly spelled "Robinsun," a variation Robinson is known to have used, and a curved line that may or may not hide an "E. C." My information is not sufficient to push this suggestion further.

16. Kenneth Smith was responsible in the 1720s for the first inventory of the Lothian paintings collection, on the occasion of his commission to clean over four hundred paintings (Papers of the Kerr Family, GD40/8/495; Wenley, *The Lothian Picture Collection*, 1:58). The letter rack painting with Smith's name from c. 1705 includes two specialized pamphlets that accord with the politics of the fourth Earl of Lothian and gesture toward his controversial tenure as high commissioner to the general assembly of the Scottish clergy in 1692–93, when he advocated the admission of jurant Episcopalian clergy to the kirk (see *DNB*). Lothian's actions then ended his active career and propelled him into a major improvement project at his house at Newbattle, for which he required many paintings, and presumably also the services of house painters. One of those was Thomas Warrender, who around the time of Lothian's death in 1703 received payment from the family for services rendered (GD40/8/485).

17. *Herrn Zacharias Conrad von Uffenbach merckwürdige Reise durch . . . Engeland* (Ulm, 1753), 2:496.

18. *A Catalogue of the Pictures, Prints, Drawings, Etc., in Possession of the Company of Painter-Stainers at Painters' Hall* (London, 1908), no. 7. The other big project of the same period was a new Painted Chamber in which Robinson was involved, and which included also some trompe l'oeil elements. See A. Borg, *The History of the Worshipful Company of Painters otherwise Painter-Stainers* (Huddersfield, 2005).

19. Support for this conjecture is lent by another likely Collier trompe l'oeil auctioned in 1927 whose low-quality copy is preserved at the Witt Library, which likewise refers to another contemporary engraver in a similar manner. Above the *London Gazette* in the two-strap letter rack is painted a print, as if attached to the board above the straps, with the caption: "P. Lely . . . pinxit . . . R. Williams fecit." The latter is probably Rowland Williams, a mezzotint engraver active c. 1680–1704 whose work included engravings after the Dutch immigrant to the English court Sir Peter Lely.

20. Matt Fountain, private communication, 20 September 2011.

CHAPTER ELEVEN

1. R. O. Bucholz, "Seymour, Charles," in the *DNB* online; and further sources there. The first quote is from Macaulay.
2. *Bishop Burnet's History of His Own Time . . . with . . . Notes by the Earls of Dartmouth and Hardwicke . . .* (Oxford, 1823), 13. R. O. Bucholz, *The Augustan Court: Queen Anne and the Decline of Court Culture* (Stanford, 1993), 196–97.
3. Bulstrode Whitlocke, *Memorials of the English Affairs* (London, 1732), 409. E. Scott, *The King in Exile: The Wanderings of Charles II. from June 1646 to July 1654* (New York, 1905), 104. A. Keay, *The Magnificent Monarch: Charles II and the Ceremonies of Power* (London, 2008), 61.
4. Their number is estimated at almost one hundred thousand. Cf. the introduction and M. Glozier's contribution to S. Murdoch, ed., *Scotland and the Thirty Years' War, 1618–1648* (Leiden, 2001). M. R. Glozier, "A 'Nursery for Men of Honour': Scottish Military Service in France and the Netherlands, 1660–1992" (PhD thesis, University of Western Sydney, 2001). K. L. Sprunger, *Dutch Puritanism: A History of English and Scottish Churches in the Netherlands in the Sixteenth and Seventeenth Centuries* (Leiden, 1982), 268ff. James Ferguson, *Papers Illustrating the History of the Scots Brigade in the Service of the United Netherlands, 1572–1782* (Edinburgh, 1899), 1:538–41. I am grateful to Matthew Glozier and Keith Sprunger for generous exchanges.
5. My thanks to Ton Kappelhof of the Institute of Netherlands History in The Hague for this information, and to Jochem Miggelbrink for sharing his dissertation, "Serving the Republic: Scottish Soldiers in the Republic of the United Provinces 1572–1782" (European University Institute, Florence), chap. 7.
6. Also his brother: RAL, Kerkelijke Ondertrouw Leiden S, fol. 160v, 24 March 1666, and V, fol. 28v, 6 November 1670.
7. Stadsarchief Breda, NH Dopen Grote kerk te Breda, baptisms on 7 November 1639, 18 January 1642, 18 January 1644, 15 September 1646, 27 December 1648, and 28 November 1650. Regionaal Archief (RA) Breda, Vestbrieven R 532, fol. 280–280v, 31 May 1642; R 534, fol. 106, 6 November 1647, and fol. 216–216v, 20 February 1649; RA Breda, Pondboek 1644–1676, fol. 203. For Coljer's military career, cf. The Hague, Nationaal Archief, Resoluties Staten-Generaal 68, 14 May 1638, and F. J. G. Ten Raa and F. De Bas, *Het Staatsche Leger, 1568–1795,* vol. 4 (Breda, 1918), 229n. That Joris Colier the husband of Aeltien Engelberts and Joris Coljer the Halberdier were one and the same is corroborated in a record of a debt owed in 1652 to "Mr. Georgius Collijer, lieutenant in the company of lieutenant-colonel Hinderson" that was subsequently marked as paid to his widow in 1659, the year of her remarriage (RA Breda, Vestbrieven R 535, fol. 93v, 16 February 1652). It is not clear, however, whether he is the same Joris Colier recorded in Breda in the early 1640s as a tobacco and a brandy merchant. My gratitude to Hans Endhoven for his expert help in the Dutch archives.
8. Ferguson, *Papers Illustrating the History of the Scots Brigade,* 1:319. Sir James Balfour Paul, *The Scots Peerage . . .* (Edinburgh, 1910), 7:88–90. *Burke's Landed*

Gentry, 18th ed. (London, 1969), 2:110. J. Maclean, *De huwelijksintekeningen van Schotse militairen in Nederland, 1574–1665* (Zutphen, 1976), 177. Miggelbrink, "Serving the Republic," 237–39. In 1664 Jean was living in Bergen op Zoom, Breda's sister garrison town some twenty miles away, where another Colyear had been recorded already in 1629.

9. The Hague, Nationaal Archief, Nassause Domeinraad, inv. no. 8014. A copy of the same document exists also in the Breda local archive, but without the signatures: I am grateful to Keith Sprunger for alerting me to this scribal variation.

10. J. H. Hora Siccama, "Het geslacht Colyear," *De Nederlandsche Leeuw* 20 (1902): 139, also suggests a connection between the two families. He also mentions a marriage record of a Joris Robbertson dict Coljert in The Hague on 20 December 1635 with Martina van Beeckesteyn, who may have been a former wife of Edward's father. Cf. The Hague, Gemeente Archief, NH Ondertrouw Den Haag, 30 December 1635.

11. Stadsarchief Breda, NH Dopen Grote kerk te Breda, 26 January 1642. There is also a record of the burial of one Joris Collier in 1651, who cannot be the same person (see note 7), but may be Joris's son, Joris junior, born in 1644 (Archief Hervormde Gemeente Breda Kerkvoogdij, Begraafregister Grote kerk, 7 December 1651). My gratitude to H. D. Wessels and P. Böschen of the Breda archive.

12. RAL, Gereformeerde Dopen Pieterskerk, 15 August 1668, baptism of Joris son of Johannes Colier. Nationaal Archief Den Haag, NH Trouwen Oegstgeest, 17 March 1675, marriage of Jacobus Bonaerts and Margarita Colier. RAL, Gereformeerde Dopen Hooglandse kerk, 12 December 1669, baptism of Lambertus son of Johannes Colier. Stadsarchief Breda, Notarieel Archief 225, fol. 240, 6 November 1670.

13. National Archives, SP 44/388, p. 14, 22 May 1697; reprinted with minor variations (most significantly "Englebregts" for "Engelbregts") in W. J. Hardy, ed., *Calendar of State Papers, Domestic Series, of the Reign of William III. 1 January–31 December 1697* (London, 1927), 164.

14. A. Hallema, "De Engels-hervormde gemeente te Breda gedurende de 17de eeuw," *Jaarboek van de Geschied- en Oudheidkundige Kring van Stad en Land van Breda "De Oranjeboom"* 1 (1948): 70–100. Sprunger, *Dutch Puritanism*, 268–73.

15. E. Scott, *The King in Exile*; and *The Travels of the King: Charles II in Germany and Flanders 1654–1660* (London, 1907). G. Smith, *The Cavaliers in Exile, 1640–1660* (New York, 2003).

16. Sold by Sotheby's, New York, 25 May 2000, lot 122. The title of the manuscript journal in the painting is taken from the second edition of the printed travel account by Seyger van Rechteren. My deep gratitude to Erik Löffler of the RKD for his enthusiastic help in this quest and so many others.

17. Note for instance the three *C*'s lined up in the Scottish pamphlet against the "lead" frame in the window. Next to the bottom *C* the *S* has a connecting flourish on top that looks like a cursive *ℰ*—a flourish that, significantly, has no corollary in the lettering of the original pamphlet, which is otherwise faithfully reproduced. Also note the enlarged first and last characters of the title of the music sheet.

18. Nationaal Archief in The Hague, 80 fol. 490, 20 December 1651, and 175 fol. 85, 30 April 1657. D. Thomson, *A Virtuous and Noble Education* (Edinburgh,

1971), 9, 13, 14, 16; based on M. F. Moore, "The Education of a Scottish Nobleman's Sons in the Seventeenth Century," *Scottish Historical Review* 31, no. 111 (1952): 1–15. Moore was unable to establish the precise relationship of Captain William Kerr to the Lothian family but was certain he was a near relative, since he was in communication with Lothian about money matters (3–4n.).

19. Thomson, *A Virtuous and Noble Education*, 14, 16. Murray's sister Elizabeth was the two youngsters' grandmother, wife to Robert Kerr, the Earl of Ancram, who himself was living in Amsterdam during this period.

20. Nationaal Archief in The Hague: Resoluties Staten-Generaal 68, 14 May 1638. Another captain in Robertson-alias-Colyear's company, one George Lauder, married another of Murray's daughters; he is also one of the signatories on the 1655 letter from the English community in Breda to the Princess Royal next to "George Robertson dijt Collÿer." In 1636 "Davidt Robbertson dit Coller," Alexander Murray, and George Lauder had all been officers together in the regiment of Sir James Livingston. Ferguson, *Papers Illustrating the History of the Scots Brigade*, 1:322, 325–36, 495.

21. See D. Pring, "The Negotiation of Meaning in the Musical Vanitas and Still-Life Paintings of Edwaert Collier, c. 1640–c. 1709" (PhD thesis, University of London, 2010), 181, based on information from the College of Arms.

22. Catharine Macleod, "Examination of Edward Collier self-portrait, 6069," 2 June 2009 (internal memo). I am grateful to Catharine Macleod and Tim Moreton for their generous help. The photograph before restoration is at the RKD.

23. Collier's practically identical visage is in *Self-Portrait with Vanitas* (1684) at the Honolulu Academy of Arts. For Valck in England, see J. Chaloner Smith, *British Mezzotinto Portraits from the Introduction of the Art to the Early Part of the Present Century*, 4 vols. (London, 1883), 3:1394–96, and M. B. H. Curd, *Flemish and Dutch Artists in Early Modern England* (Farnham, 2010), 132–49 (I am grateful to Bryan Curd for further information on Valck and his work). Collier is more likely to have encountered Valck's print in England in 1683 than in Holland, where Valck circulated another version of the same image with a Latin title. The date of Collier's painting appears at first glance to be 1681, but as far as can be seen in an inspection unaided by an ultraviolet lamp it is actually 1684, with parts of the *4* still visible.

24. J. Garrett, *The Triumphs of Providence: The Assassination Plot, 1696* (Cambridge, Eng., 1980), 140ff.

25. Quoted in L. Lunger Knoppers, "Reviving the Martyr King: Charles I as Jacobite Icon," in *The Royal Image: Representations of Charles I*, ed. T. N. Corn (Cambridge, Eng., 1999), 263. J. P. Kenyon, *Revolution Principles: The Politics of Party, 1689–1720* (Cambridge, Eng., 1977), 66. A. Lacey, *The Cult of King Charles the Martyr* (Woodbridge, Eng., 2003).

26. *The Life of Edward Earl of Clarendon, Lord High Chancellor of England . . . Written by Himself*, 2 vols. (Oxford, 1857), 1:256–57, 259–60.

27. There are other games in these two paintings, the meaning of which eludes me. In each title page of the "Description of the World" one letter is subtly altered into an *E*: "AERICA" rather than "AFRICA" in one painting, "WORED" instead of "WORLD" in the other. Also, in the royal speeches, one is painted as given on 30 March, the other 30 May.

28. Letter from Johan van der Kerckhoven, lord of Heenvliet, on behalf of Mary Stuart, to Professor Van Renesse, 2 December 1653; cited with additional information in A. Hallema, "De Oranjevorsten en het voormalige Norbertinessenklooster St. Catharinadal te Breda in de 17de en 18de eeuw (1646–1740)," *Jaarboek van de Geschied- en Oudheidkundige Kring van Stad en Land van Breda "De Oranjeboom"* 14 (1961): 115–48. *The Life of Edward Earl of Clarendon*, 1:257. M. F. Yates, "The Political Career of Laurence Hyde, Earl of Rochester" (Ph.D. thesis, University of London, 1934), 3–4 (and note Hyde's letter from Breda dated 1654).

29. See L. Jardine, *Going Dutch: How England Plundered Holland's Glory* (New York, 2008).

30. The last certain sighting of Edward Collier was in Leiden on 14 January 1706 as a witness in the marriage of his nephew Joris, son of Johannes. In February 1704 Anna du Bois, Collier's wife, died in Leiden, and he may have been there then. (RAL, Kerkelijke Ondertrouw Leiden DD, fol. 184v, 14 January 1706; Begraafregisters Leiden, buiten begraven 7 February 1704.)

31. The deliberate mixing of the Dutch and English parts of Collier's life is extended in one of the 1706 letter racks with the cartoons of the senses (smell— "De Rueck"; sold at Christie's, London, 7 July 2010, lot 119), in which the words "Painter at Leiden" are partly obscured by the strap so that "Leiden" appears rather ambiguously also to spell "Londen," the Dutch name for London. In another painting from the same series (sight—"Gesicht"), in the collection of Christoph Müller in Berlin, the same duality is further underscored through the parallel of two printed lions: an English one in the royal crest of Queen Anne's speech and a Dutch one in the logo of a Leiden newspaper.

32. There is a second single-strap letter rack painting in private hands with an antiquated print of Charles II and an old-fashioned-looking newspaper, which may well be a Collier painting repeating the same theme.

CHAPTER TWELVE

1. Several other examples before the eighteenth century include two by an enigmatic "H. Drost" at the Statens Museum for Kunst, Copenhagen, a few by Frans de Hamilton and by Ottmar Elliger the Elder portraying "prints" of religious subjects, and a "print" of a smoker by David Teniers the Younger: cf. O. Koester, ed., *Illusions: Gijsbrechts, Royal Master of Deception* (Copenhagen, 1999), cat. nos. 43–45, Sotheby's, Amsterdam, sale of 17 December 2007, and M. L. d'Otrange Mastai, *Illusion in Art: Trompe l'Oeil* (New York, 1975), 181.

2. For the two Rembrandt self-portrait prints, see C. White and Q. Buvelot, eds., *Rembrandt by Himself* (London, [1999]), 95 (Jan van Vliet after Rembrandt), 166. The Jan Lievens etching is reproduced in P. Schatborn, *Jan Lievens, 1607–1674: Prenten & Tekeningen* (Amsterdam, 1988), 49. For Silvestre's print, see the collections of the Fine Arts Museums of San Francisco, available online at www.famsf.org.

3 "Op de brieven en papieren ter Trezorie, geschildert door Kornelis Brize," in *De volledige werken van Joost van den Vondel*, ed. H. C. Diferee (Utrecht, 1930),

4:520; translated in A. Chong and W. Kloek, *Still Life Paintings from the Netherlands, 1550–1720* (Zwolle, [c. 1999]), 230.

4. The exception is the lines beneath the Bastille "print," which are not attributed and cannot be matched with Vollenhove's known work. They are closely related to the others in content and style, and may belong to an unpublished poem in the same group.

5. Joannes Vollenhove, *Poëzy* (Amsterdam, 1686), 493–94. See G. R. W. Dibbets, *Joannes Vollenhove (1631–1708) dominee-richter: Een biografie* (Hilversum, 2007), 177. I am grateful to Professor Geert Dibbets for his generous help, and to Professor William Z. Shetter for the translation.

6. Inventory for the property of Adriaen van der Goes, Delft 1734, as recorded in Bredius's notes for Willem van Nijmegen (RKD). Another Van Nijmegen trompe l'oeil with verses by Vollenhove next to a "print" of *The Miseries of War* by Jacques Callot was listed for sale in 1781 and 1798 (RKD, Hofstede de Groot card index, nos. 1377217, 1377219; and see there for records of several other paintings by Van Nijmegen sold in the eighteenth century).

7. E. de Jongh et al., *Still-Life in the Age of Rembrandt* (Auckland, 1982), 193–95.

8. W. S. Melion, *Shaping the Netherlandish Canon: Karel van Mander's Schilder-Boeck* (Chicago, 1991); quotes on 34, 46.

9. The catalogue of the sale of J. van der Marck's collection in Amsterdam in 1773 is quoted in C. Kramm, *De levens en werken der Hollandsche en Vlaamsche kunstschilders, beeldhouwers, graveurs en bouwmeesters* (Amsterdam, 1974; orig. 1860), 2:1215. "Alter Parasius" in Van Nijmegen's painting appears to refer to Rembrandt, though he was not associated particularly with illusionism, but it may also reflect back on the trompe l'oeil artist himself.

10. Translated by William Z. Shetter.

11. Cf. J. Goldberg, *Writing Matter: From the Hands of the English Renaissance* (Stanford, CA, 1990), chap. 5.

12. RAL, Archieven van de Gilden, de Beurzen en de Rederijkerskamers 849, *Deecken ende Hooft-Mans Boeck St Luycas, 1648–1742*, fol. 188; and *Register van d'Fyn Schilders 1648–1742*, fol. 8. E. Buijsen, ed., *Haagse schilders in de Gouden Eeuw* (The Hague, [1998]), 333; and further sources as cited there.

13. RAL, Weeskamer Archief, Voogdenboek I, fol. 199v, 14 April 1684; and Nederlands Hervormd Kerkelijke Ondertrouw Leiden Y, fol. 162, for the same day. J. M. Montias, "Estimates of the Number of Dutch Master-Painters, Their Earnings and Their Output in 1650," *Leidschrift* 6, no. 3 (1990): 61.

14. Brisé, Cornelius Gijsbrechts, Vaillant, Van Hoogstraten, and Dou died between 1670 and 1678. Stoskopff was already long dead, and Cornelis van der Meulen had moved to Sweden.

15. C. Willemijn Fock, "De kerkmeesterskamer in de Pieterskerk," *Jaarboekje voor geschiedenis en oudheidkunde van Leiden en Omstreken* 88 (1996): 114–25. I am grateful to Professor Fock for generous communications.

16. G. Upmark, "Ein Besuch in Holland 1687 aus den Reiseschilderungen des schwedischen Architekten Nicodemus Tessin," pt. 2, *Oud-Holland* 18 (1900): 151.

17. R. van Eynden and A. van der Willigen, *Geschiedenis der vaderlandsche schilderkunst, sedert de helft der XVIII eeuw* (Haarlem, 1816), 89–90; translated by Stella Hooker-Haase.

18. G. P. Rouffaer, "Vier kamper schilders," *Oud-Holland* 5 (1887): 296 (records for 27 November 1670). RAL, Gereformeerde Dopen Pieterskerk, 15 August 1668. Professor Geert Gibbets, private communication.

19. This may not be the only example of this practice from Collier's Dutch years. Another possible case is a painting signed "B van Eijsen" (sold by Christie's, London, 17 December 1999), which again bears a striking similarity to Collier's vanitas still lifes. Barent van Eijsen was a sculptor, recorded as such in Haarlem in 1679, though he appears to have begun his career as a painter. Was this artist-but-not-quite-painter another of Collier's hybrid-canvas collaborators? See A. van der Willigen and F. G. Meijer, *A Dictionary of Dutch and Flemish Still Life Painters Working in Oils, 1525-1725* (Leiden, 2003).

EPILOGUE

1. Haberle clipping quoted in A. Frankenstein, introduction to *Reality and Deception* (Los Angeles, 1974), unpaginated. Idem, *After the Hunt; William Harnett and Other American Still Life Painters, 1870–1900*, rev. ed. (Berkeley, 1969). W. H. Gerdts, "A Deception Unmasked; An Artist Uncovered," *American Art Journal* 18, no. 2 (1986): 5–23. D. Bolger, "The Early Rack Paintings of John F. Peto," in *The Object as Subject*, ed. A. W. Lowenthal (Princeton, 1996), 59–81; and see 75, n. 4, for the Charles Willson Peale memorandum of 1818 recording two probable Italian letter rack paintings, "upwards of a hundred years old," in his Philadelphia museum. For recent discoveries about Lewis, see J. Flavell, "A Trick on the Eye," *BBC History Magazine*, July 2007, 33–36 (for which I am grateful to James Mitchell); as well as W. Bellion, *Citizen Spectator: Art, Illusion, and Visual Perception in Early National America* (Chapel Hill, 2011), chap. 4.

2. A rather different echo can be found much later in the work of Andy Warhol, who often explored, of course, the repetitive and mechanical nature of art in the modern age of mass production. A recent exhibition (*Warhol Headlines*, National Gallery of Art, Washington, D.C.) shows how his works that included commercialized news headlines "chart a revolution in how the news was delivered in Warhol's lifetime, shifting from the rhythm of the daily papers to the nonstop 'headline news' of cable television." Uncannily, these works included frequent spelling variations in newspaper titles and texts as well as name substitutions, as in his *Princton Leader* c. 1956; see http://www.nga.gov/exhibitions/2011/warhol/headlines.shtm.

3. Edgar Allan Poe, "The Purloined Letter," *Chambers's Edinburgh Journal*, 30 November 1844, 346.

4. Edgar Allan Poe, "Charles Lever" (1842), in *The Works of the Late Edgar Allan Poe* (New York, 1850–56), 3:449; and "The Philosophy of Furniture," 2:299–305.

5. Lynn Russell in S. Ebert-Schifferer, ed., *Deceptions and Illusions: Five Centuries of Trompe l'Oeil Painting* (Washington, D.C., 2002), 192, 375 n. 2. C. Willemijn Fock, "Semblance or Reality? The Domestic Interior in Seventeenth-Century Dutch Genre Painting," in *Art and Home: Dutch Interiors in the Age of Rembrandt*, ed. M. Westermann (Zwolle, 2001), 83–101. Personal communication with Professor Fock, 23 June 2008.

6. For Van Heemskerck, see Westermann, *Art and Home*, 58; for Van Ostade, P. C. Sutton et al., *Love Letters: Dutch Genre Paintings in the Age of Vermeer* (London, 2003), cat. nos. 29, 30; and for Van Mieris, E. J. Sluijter et al., *Leidse Fijnschilders: Van Gerrit Dou tot Frans van Mieris de Jonge, 1630–1760* (Zwolle and Leiden, [1988]), 141. Dullaert's painting is in the Museum of Groningen, collection of Hofstede de Groot (and note that Dullaert's own oeuvre included a trompe l'oeil letter rack). Another relevant precedent is Hans Holbein the Younger's 1532 portrait of the Danzig merchant George Gisze in London (Gemäldegalerie, Berlin), with letters tucked behind the horizontal trim nailed to the wall: not a letter rack, but a possible inspiration for one.

7. Frankenstein, *After the Hunt*, pl. 50. It is also worth noting that when Samuel Lewis displayed what may well have been the first American letter rack trompe l'oeil—a drawing—in Charles Willson Peale's museum in early-nineteenth-century Philadelphia, he actually presented it right next to the actual object it imitated, complete with all the original paper objects. Peale Memoranda, 19 November 1808, quoted in Bolger, "The Early Rack Paintings of John F. Peto," 60–61.

8. A. Veca, *Inganno & Realtà, Trompe l'Oeil in Europa XVI–XVIII sec.* (Bergamo, Italy, 1980), pl. 10. Reproduced as Edward Collier's in M. Milman, *The Illusions of Reality: Trompe-l'Oeil Painting* (Geneva, 1982), 96.

Acknowledgments

The week I sent this book off to the press an old friend of my late father's, Jacob Wahrman, brought me a postcard my father had sent from Stockholm in 1985. The friend had sent my father to the Stockholm Museum on a kind of treasure hunt, to search for "an item of special interest" to him. My father sent back this postcard, writing on the back, "Was it a matter divine, my test? I am sorry, another solution I could not find." The postcard shows a painting c. 1700 that includes several documents, one of which has "God" written in Hebrew with a subtle unwitting mistake, which is presumably the hard-to-spot gaffe to which my father believed his friend had directed him. Titled *Trompe-l'oeil*, the painting is a one-strap letter rack. The painter was a virtually unknown Swedish artist of Dutch descent named Johann Klopper, a contemporary of Collier's who may well have met him in London in the mid-1690s, and with whose trompe l'oeils Klopper's shares some interesting elements, not least a self-portrait in an octagonal frame tacked on to the painted "board." A quarter of a century before I stumbled upon the early modern trompe l'oeil letter racks, my father had already been there.

Nothing could be more uncanny, or more fitting with which to begin my acknowledgments. Although my father did not get to hear about Collier, his spirit is all over this project. His exacting, insistent attitude to mistakes and typos, all of which he considered significant, primed me to understand Collier's idiosyncrasies. His lifelong pleasure in the methodical comparison of early photographs of the Middle East, which was my favorite pastime with him ever since I can remember myself, trained my

eye and made me realize the power of minute details. His patience as a natural historian and geneticist, building knowledge specimen by carefully analyzed specimen, was matched only by his doggedness as historical detective in pursuit of obscure episodes in the history of Palestine. Jacob Wahrman was Collier and myself combined, and as such would have loved this story, even as he would have disapproved of me publishing it with so many loose ends still loose. Dedicating this book to his memory is the least I can do.

I have written in these pages about the Web 2.0 as this project's condition of possibility, a modern technology of communication that allowed me to discover a story that had previously been too scattered to be put together. But the insistence on the novelty of our own media revolution hides another truth: how new media allow for the revival of a traditional, pre-modern economy of favors and gifts, albeit now with global reach. My chase after Collier was only possible because of the amazing number of people, many of whom I have never met, who generously responded to e-mail queries with information, images, documents, and advice.

First and foremost, numerous individuals have gone out of their way to help me locate, visit, or obtain records of paintings. In museums and public collections: Katie Coombs (Victoria and Albert Museum), Amy Simpson (Tate Britain), Erika Ingham, Tim Moreton, and Catharine MacLeod (National Portrait Gallery), Matthew Percival (Witt Library, The Courtauld Institute of Art), Charlotte Brunskill and Emma Floyd (Paul Mellon Centre, London), Alison Harpur and Alastair Laing (National Trust, London), Helen Smailes (National Gallery of Scotland), Peter Black (Hunterian Museum, Glasgow), John Greenwell (Monteviot House), Walter Liedtke and Patrice Mattia (Metropolitan Museum of Art, New York), Erin Elzi (The Frick Collection), Alba Fernandes-Keys (Indianapolis Museum of Art), Salvador Salort-Pons (Detroit Institute of Arts), James Clifton (Museum of Fine Arts, Houston), Kathleen Stuart (Denver Art Museum), Katrina Green and Joaneath Spicer (Walters Art Museum, Baltimore), Sarah Vargas (Fresno Metropolitan Museum, now defunct), Tracey Schuster (Getty Research Institute), Blaise Ducos (Louvre Museum), Gero Seelig (Schwerin Museum, Germany), Christiaan Vogelaar (Museum De Lakenhal, Leiden), Liesbeth van der Zeeuw (Historisch Museum Rotterdam), Cees Bakker (Westfries Museum, Hoorn), Erik Löffler and Fred Meijer (RKD, The Hague), Sam Segal (Still Life Studies, Amsterdam), Shlomit Steinberg and Ghiora Elon (Israel Museum, Jerusalem), Sarah Bernesjo and Karin Siden (Nationalmuseum, Stockholm).

Many more paintings were traceable only with the generous help of auctioneers and dealers specializing in old masters. At Sotheby's, Siane Keene, Katherine Marshall, Kristina Pearson, and Sophie Trevelyan Thomas (London), Elizabeth Pyne, Elizabeth Fievet, and Andrea Kust (New York), Sophie Bremers (Amsterdam). At Christie's, Richard Knight, Catherine Thompson, and Alexis Ashot (London) and Elizabeth Heil (New York). Others who sent me information and images: Toby Campbell at Rafael Valls Gallery (London), Johnny Van Haeften (London), Richard Green Galleries (London), James Mitchell at John Mitchell Gallery (London), Tim Warner-Johnson at Colnaghi (London), Annemarie van der Hoeven at Koetser Gallery (Zurich), Otto Naumann (New York), Richard Collins (New York), Eddy Schavemaker at Noortman Gallery (Amsterdam), Salomon Lilian Gallery (Amsterdam), Jaklic Nina at Galerie Fischer Auktionen AG (Luzern), Roeland Kollewijn at Bigli Art Broker (Milan), Sala Parés (Barcelona), Jolanda van Nijen Vurpillot at Elidor Invest SA. These quests were also aided by the kindness of Ron Lenney, Christoph Müller, John Robinson, Thomas Rusche, Olivier Sachs, Lawrence Swerdlow, Linda Taubman, Marc Thiebaut, and John Wyatt.

This project took me into many scholarly fields that were new to me. For sharing knowledge on matters related to Dutch and British art, I am grateful to Katie Coombs, Bryan Curd, Neil de Marchi, Willemijn Fock, Matt Fountain, Jim Ganz, Craig Hanson, Ludmilla Jordanova, Catharine MacLeod, Fred Meijer, Pamela Smith, Minna Tuominen, Robert Wenley, and Debra Pring, a fellow Collier aficionado. Many others have shared with me their specialized scholarly knowledge on often arcane matters: George Alter, Hall Bjørnstad, Sarah Blick, Alan Borg, Karin Bowie, Bernard Capp, Brian Cowan, Geert Dibbets, Falk Eisermann, Michael Finlay, Ian Gadd, Matthew Glozier, Ton Kappelhof, Mark Knights, Jochem Miggelbrink, Sarah Monks, Alasdair Raffe, Eunice and Ron Shanahan, Will Slauter, Keith Sprunger, Paul Taylor, Anthony Turner, Diederick Wildeman, and Catherine Wright.

For invaluable aid in research and translation I am grateful to Hans Endhoven, Stella Hooker-Haase, Erik Löffler, William Shetter, Richard Stephens, and Tim Wales.

Many friends commented on parts of the manuscript: Michel Chaouli, Raz Chen-Morris, Jonathan Elmer, Yaniv Farkas, Mary Favret, Susan Gubar, Don Herzog, Sarah Knott, Andrew Miller, Sarah Mitchell, Katherine Oliver, Susan Rabiner, Bret Rothstein, Robert Schneider, Yael Shapira, Jonathan Sheehan, David Shulman, Rebecca Spang, Tamar Tsvaigrach, Danny Unger, Carl Weinberg, and last, twice over, David Bell.

The illustrations were skillfully prepared by Christopher Martiniano. At production stage this book benefited from the extraordinary editorial talents of Susan Ferber, Joellyn Ausanka, and India Cooper, and from Adrianna Sutton's skillful graphic design.

In 2008 I was in the middle of writing a book about chance and serendipity in the eighteenth century, when because of that chance serendipitous encounter in the Indianapolis Museum of Art I had to put it aside for a long time. My final thanks therefore go, first, to Dina and Danny, whose visit to Bloomington that April, their insistence that we go visit the IMA, and then Dina and Noa's further insistence that "here is a painting we think you will like," were the true beginning of this book. Second, to Jonathan Sheehan, with whom I was writing that other volume, for his patience as Collier whisked me away. Third, to my Bloomington community—colleagues, students, friends—who accepted my new obsession with good cheer. And last to my family, Noa, Shani, and Maya, as well as Dennis and Nick, who all joined in with magnifying glasses whenever summoned and who humored me as I talked about Collier day, night, and every moment in between.

List of Illustrations

CHAPTER TWELVE

Index